BRITISH
ROMANTIC
ART

BRITISH
ROMANTIC
ART

Karl Kroeber

University of California Press
Berkeley
Los Angeles
London

University of California Press
Berkeley and Los Angeles, California

University of California Press, Ltd.
London, England

Library of Congress Cataloging in Publication Data

Kroeber, Karl, 1926–
 British romantic art.

 Bibliography: p.
 Includes index.
 1. Romanticism in art—Great Britain. 2. Arts,
British. 3. Arts, Modern—19th century—Great Britain.
I. Title.
NX543.K76 1986 700'.941 85-1164
ISBN 0-520-05484-9 (alk. paper)

Printed in the United States of America

1 2 3 4 5 6 7 8 9

To the resident stonecutter
and household mechanic,
fondly

Contents

9
Narrative Infolding, Unfolding 197

Illustrations

Acknowledgments

Parts of chapters 2, 4, and 5 appeared (sometimes in radically different form) in, respectively, *Articulate Images* (University of Minnesota Press); *Clio: A Journal of Literature, History, and the Philosophy of History*; and *English and German Romanticism: Cross-Currents and Controversies* (University of Heidelberg); portions of chapter 7 appeared in *ELH: A Journal of English Literary History* and *Images of Romanticism* (Yale University Press). I am grateful to the editors and publishers concerned for their permission to reuse these materials. To Martin Meisel, Stuart Sperry, and Larry J. Swingle I am indebted for helpful critiques of three different pieces of this work. To Amy Einsohn I am more profoundly indebted for her patient conscientiousness in editing the entire book: her insistence on precision, succinctness, and sobriety of tone expresses an inspiriting ideal of literary scholarship's form and function.

I regret that those wishing to judge my comments on graphic art will be disadvantaged by the publisher's decision to locate each illustration close to its discussion in the text; this arrangement, while handsomely improving convenience of reference, sacrifices clarity of detail in the reproductions.

Introduction

In this book I discuss works of art associated by time and place, Britain at the beginning of the nineteenth century. I concentrate on poems and paintings, touch lightly on music, and comment on most of the literary genres, including prose fiction, criticism, and history, trying to do justice to the unique quality of individual works and their place in the basic configuration of British Romanticism.

The leitmotif of this book, the flat side of my argument's wheel, is that we need to perceive Romantic art as a reshaping of the relation between artwork and audience. The earlier twentieth-century view of Romantic art as self-expressive—a view that prevailed until about two decades ago—now seems inadequate, the product of a tendency to explain by essentializing, a tendency reflecting the minimalizing impetus in much twentieth-century art. Today we prefer to see in Romantic art extraordinary heterogeneity.[1] We talk less than did earlier twentieth-century critics about Romantic works of art in terms of self-isolating essences. There is more reward for us, for reasons I try to make clear in the following chapters, in discussing how Romantic art provokes participative re-creativeness in its audience. I will try in delineating some of these provocations to suggest both why at the beginning of the nineteenth century there occurred such a self-conscious reorientation of the purposes of eighteenth-century art, and why, despite its liberating and invigorating effects, Romantic art was so quickly challenged and inverted by Victorian and early Modern art.

In the first two chapters I bracket Romanticism through comparisons between the Romantics and their predecessors and successors. A descriptive contrast of Blakean prophecy and Hogarthian progress (chapter 1) shows how the powerful appeal of Romantic art to its audience's imagination originates in a display to the audience of its unwitting internalizations of dangerous social anomalies. In chapter 2 I turn to the Romantics' immediate successors, the Victorians, who resisted the use of self-contesting uncertainties to arouse creative responses in readers and viewers. By

1

suggesting how Romanticism developed its special intensities out of the dynamic richness of eighteenth-century culture, and how Romanticism was subsequently subverted, I hope to suggest the movement's necessary transience. Moving against the surging confidence of post-Renaissance industrialized society, the Romantics' complex blend of idealism and skepticism was quickly diffused, circumscribed, distorted, or inverted. For example, the Romantics' concept of creativity was twisted into the doctrine of art for art's sake, which denies the Romantic commitment to the practicality of art's effects. Later generations subsumed creativity within formalistic systems that negate the antimechanistic, antifunctionalist basis of the Romantic preference for art as superabundance, its potency that of an ever-overflowing fountain.

In chapters 3 and 4 I turn to the context from which British Romanticism emerged in order to explore the origins of its nationalism and concern with eliciting creative responses from its audience. Part of that context is illuminated by Romantic poetry's subsuming of "musical" elements within purely verbal forms, a development linked both to an aesthetic competition between the two arts and also to sociopolitical conditions that produced new ideals of human community, as reflected in the confused but important theories of the picturesque. Romantic artists scorned picturesque theorizing, in part because it articulated in awkward abstractions several principles that in more subtle forms were fundamental to some of the Romantics' most revolutionary practices. Notable among these were reconceptions of the "moment" of art as evanescent as against the Neoclassical formulations of Burke and Lessing: the "single moment receives through art an unchangeable duration; therefore it must not express anything, of which we can think only as transitory."[2] Romantic art expresses very little else. With emphasis on the processes of emergence in both perception and artistic representation, the Romantics joined a desire to discover renewed wonder and delight within the familiar, within that to which one had become indifferent or had subconsciously disavowed.

Throughout the first three chapters my central poetic subjects illuminate the Romantic inauguration of new relations between artwork and audience. Chapter 4 centers on the inability of Coleridge to sustain to the end of the first decade of the nineteenth century the critical patriotism of "Fears in Solitude," written in 1798. Coleridge's failure I see as foreshadowing the situation of the second generation of Romantic poets, who endeavored to keep alive

the idealism of the first generation under increasing pressure from both their intensified skepticism and the movement of British society along lines hostile to such idealism. In chapter 4 I also suggest that the emergence of the picturesque aesthetic more or less concurrently with the flowering of Romantic art reveals the latter's nationalistic impulse—whose contribution to Romanticism appears most clearly in Walter Scott's prose romances of the first years of the nineteenth century's second decade, these romances being the focus of chapters 5 and 6, which I approach through the history of war.

In that exemplary Enlightenment treatise *The Social Contract*, Rousseau observed that war is not a relation between men but between states. The wisdom of this observation must impress everyone who has not had to fight in a war. Something more than half a century later Carl von Clausewitz, who fought both for and against his native Prussia, worked from the idea that war is an extension of politics to develop the principle that judgments about the nature of war must be derived from observations of what actually takes place during wartime. And what actually happens, he argued, renders inapplicable any abstract generalizations. The significance of the change from Rousseau's epigrammatic assurance to Clausewitz's self-challenging complexity is illuminated by the Waverley romances of insurrectionary war. Scott's fiction does not merely represent the experience of war, *the* dominating European experience from 1789 through 1815, but gives insight into war's revelation of modes by which states deconstruct and reconstruct themselves. Scott's Romantic art describes the penetrating effects that the processes of conflict exert on ordinary life when the political actuality to which Rousseau's linguistic formulation refers begins to destabilize itself.

Such historicizing tendencies in combination with the Romantics' picturesquelike reactions against Neoclassical spatializing and structuralizing contribute to the special character of the Romantics' self-querying Hellenism, and their search for an answer to the question, What does it mean that we are all Greeks? is my focus in chapter 7. In chapter 8 I deviate from my broadly chronological progress from Blake's *Book of Urizen* to Byron's *Don Juan* to use Wordsworth's *Prelude* and some of Turner's later canvases to exhibit the limitations in conceiving of Romanticism in the mirror-lamp terms popularized by Meyer Abrams. Emphasizing the "reflective" character of Romantic art in both its early and late phases, I illustrate how its polymorphic forms produced what might be called

a pluralizing style, or perhaps more appropriately, a maximalist aesthetic.

This penultimate chapter concludes with a comment on Turner's narrative paintings, suggesting why the inherent "double-dealing" and self-contradictoriness of narrative attracted the Romantics. I explore this preference for narrative form in the final chapter, treating Keats's narrative poems and Byron's *Don Juan* as examples of the infolding and unfolding of narrative in the second generation of Romantic poets. These complementary effects were produced by two major pressures. The first of these was exerted by an intrinsic evolution of the Romantic aesthetic, which compelled the second-generation poets into work simultaneously more idealistic and more skeptical than that of the first generation. The second pressure was external, the social resistance to Romantic ambitions (first described in chapter 4 in relation to Coleridge's patriotic lyricism) that gained strength with the swell of imperialistic conservatism upon Napoleon's downfall.

As this summary suggests, my perspective synoptically articulates a critical attitude, which has been taking shape through the work of many scholars during the past fifteen years, that rejects many of the assumptions and biases about Romanticism which prevailed in the first two-thirds of our century. These prejudices and biases, I believe, derive ultimately from the exciting development of Modern art, a richly complex and enormously influential movement that transformed music, sculpture, painting, architecture, and literature throughout eight decades, beginning around 1885. In recent years, however, as the tide of Modern art has ebbed, critics and scholars have begun to reassess its effects and to challenge its preconceptions. Critical interest in Romanticism as something more than a precursor to twentieth-century developments has been particularly lively: the forthcoming fourth edition of the Modern Language Association's *The Romantic Poets: A Review of Research* will be more than twice the size of the third edition, which appeared in 1973. So, although I do not claim much originality for my revisionary approach, in compensation I hope to endorse the healthy self-awareness that appears in recent criticism, perhaps most vividly dramatized by the burgeoning concern with canon formation.

When what we call Romantic literature was new in Britain, Walter Scott was a towering figure, Robert Burns widely admired, and William Blake unheard of. Over the past century that pattern of

preferences has changed, until we find Blake valued highly and Scott almost forgotten. For example, in *The Visionary Company: A Reading of English Romantic Poetry* (1961) Harold Bloom presents Blake as the towering figure of Romanticism, comments on Clare, Beddoes, Darley, and Thomas Wade, but does not mention either Scott or Burns. More significantly, Bloom nowhere advises his readers of the differences between his view and that the Romantics took of themselves. At issue is not who is "right" and who "wrong," but that all critical opinions inescapably dramatize the individual value systems of critics.

This banal point helps to explain why Romanticism has recently seemed such an attractive subject. It is difficult to think of a more spectacular transformation than Blake's rise and Scott's fall in so significant a canon as that of British Romantic poetry. The reversal compels us to consider that effective criticism must be, implicitly or explicitly, and better if the latter, a judgment not just on earlier art but also on earlier judgments of that art. What is it in Blake's art that made him incomprehensible to his contemporaries, yet for us makes his contemporaries fully comprehensible only in terms of what they shared with him? Or, concerning Scott, what shift of judgment as to the nature of his age makes it possible for later generations to regard him as less important to the understanding of his times than his contemporaries believed him? Such are the questions that gave rise to this book.

Dialogic interrogations into critical judgments can be established with the history of any period, but Romanticism poses peculiarly interesting problems because it orginated the challenge to the classic concept of absolute canonicity. We may now perceive Romanticism as less immediately a "revolutionary" movement because we see it as not merely rejecting Neoclassical standards but calling into question any possibility of unchanging standards of judgment. Romantic historicizing of values inevitably becomes a recurrent point for questioning in this book. What is the significance of Wordsworth's and Shelley's claim that an adequate "defense" of poetry must be a historical task depicting "revolutions not of literature alone but likewise of society itself"? From this angle Byron's *Don Juan* does not appear peripherally Romantic, as it has been described by many commentators, but as quintessentially Romantic because it presents itself as intrinsically anticanonical, most obviously through a self-mocking insistence on the regularity of its design and the rigor of its adherence to rules of social and literary

decorum. The recentering of Byron's work within Romanticism, a major aim of this book, is, I think, symptomatic of a conscious re-directing of criticism during the past fifteen years.

Yet we should bear in mind that the renewed interest in Roman-ticism in the past decade and the curving back of present critical attitudes toward it only metaphorically bring us "closer" to the Ro-mantics than our immediate predecessors. We may be more sympa-thetic to some Romantic impulses and aspirations and better able to comprehend why they took the forms they did, but our horizon remains only *a* perspective; its privileges are as limited and transi-tory as those of any other.

Of course, no single view dominates today. My approach, for in-stance, obviously differs from the Marxist one espoused by Jerome J. McGann in *Romantic Ideology: A Critical Investigation*, though I share his conviction that Byron is a central Romantic figure, and like him I hope to situate Romanticism in its historical context without merely dismissing it to history. But I reject McGann's assertion that, except for himself, all contemporary critics unthinkingly reiterate a "pure" Romantic ideology essentially unchanged from the original one. What fascinates me, to the contrary, is that although Roman-ticism remains inescapably a force in our cultural heritage, over the past century and a half it has been drastically modified, distorted, even turned upside down.[3] By contrasting successive twentieth-century responses to and interpretations of Romantic art, I hope not only to clarify how and why Romantic art assumed its distinc-tive forms but also to throw a glimmer of light on why those forms have been so diversely evaluated.

Although I am concerned with recovering something of the Ro-mantics' own sense of their task and the obstacles to accomplishing it, I have found it useful to introduce terms that can be accused of being anachronisms. The first of these, possibly the most impor-tant, is *unconscious*, which I apply to Blake's perceptions, intuitions, and concepts of human psychology.[4] Blake's art, as I observe in chapter 1, marks a watershed in the ethics of art: before Blake, evil in art is represented as essentially conscious, deliberate; after Blake, such evil begins to seem trivial, and serious problems are increasingly identified with activities and efforts of what is done unwittingly. What made a work such as *The Book of Urizen* so baf-fling to Blake's contemporaries (and so captivating to us) is that it compels its reader-viewer to confront psychic forces below the con-scious level. I argue in later chapters that throughout the Romantic

era we can detect similar tendencies to reshape the sociopsycho-logical functions of art, above all, to arouse in the audience an awareness of what we now call the internalizing of social conven-tions. This approach leads me to compare Romantic practices to the engineers' concept of *feedback*, the formalist critics' insight into *defamiliarization*, the biologists' use of *ecological*, and physicists' speculations about *dissipative structures*. Though such concepts have been named only in this century, the ideas they encapsulate were in circulation long before. I use such terms not to make the Romantics "relevant" (I have elsewhere argued for their irrele-vance)[5] but to elucidate the Romantics' explorations of concepts that had not yet been systematically formulated. As M. M. Bakhtin observes, a poet interacts with a vital "ideological environment" al-ways in a "process of generation," and "the resistance of the mate-rial we feel in every poetic work is in fact the resistance of the social evaluation it contains," as the creative mind enters into what is unknown, shapeless, in ferment.[6] Only long after the artist has helped to foment ideas are they abstractly formulated, and only then can critics and historians recognize the artist's participation in a concept's obscure, tumultuous origin.

To use an example that I do not treat in this book, consider the scientific concept of molecularity, which was not formulated until the early nineteenth century. The idea of atomic structure, of course, is very, very old, but in the late eighteenth century, with the advance of life sciences and chemistry, a conception began to take shape of processes being determined by diverse kinds of what might be called intermediate structures, molecules. Historians of science would point to Amadeo Avogadro, best known for his work on gaseous forms, yet certain Romantic works of art could be re-wardingly studied as experiments with the same ideas that led to the discovery of molecules, which might be contrasted with atoms in being "historical" rather than permanent and timeless entities.[7]

The resurrection of Shelley's position that artists truly create is a subpolemic of this work. Although many pay lip service to creativ-ity,[8] Shelley's vision of artistic creativity has been largely ignored or dismissed, not infrequently by literary critics, many of whom have taken to claiming something like equality with those who create literature. False claims to creative power, however, debase the mod-est but honorable work of criticism, which I regard as the endeavor to increase the respect due artists who have enhanced our lives by their benefactions of wisdom and pleasure.

1

Inventing the Unconscious

Both Hogarth's and Blake's greatest artistic successes are linked to engraving, and the overlapping of their professional lives is suggested by Blake's having been apprenticed to William Basire, who had worked for Hogarth. But their styles are as different as the history of their reputations, Hogarth becoming famous in his own lifetime and Blake dying in obscurity, though today Blake is far more widely admired. The origin of their differences, both of manner and of popular esteem, lies in Blake's development of a self-antagonistic art that eliminated a contradiction in Hogarth's moral realism, a contradiction the earlier artist perceived but could not resolve for it was in fact unresolvable within his aesthetic of mimetic realism. Artistic radicalism, then, was to a degree forced upon Blake, and in his transforming of Hogarthian narrative we can discern three fundamental and interlocking features of the Romantic revolution in art. Romantic artists aimed to upset their audiences' moral conventionality, often compelling the audience suddenly to confront the profoundest metaphysical issues; they conceived of order as energy, not as the control of energy; and they preferred polymorphic or allotropic forms that required a creative, participatory response from their readers or viewers. To demonstrate the intertwining of these characteristics, we may contrast the system of Hogarth's pictorial narrating with Blake's, to which end I shall juxtapose *Industry and Idleness* with *The Book of Urizen*.

To understand Hogarth's appeal—but also his aesthetic limitations—we may begin by noting that he is an unusually literary painter: "Other pictures we look at, his prints we read," as Charles Lamb observed. Less aphoristically and more systematically, Ronald Paulson has described the effects of this literary quality:

> The painting is followed in time by an engraved copy with more clearly denotative structures, which include a title and often verses that assist the translation of images into words. The engraving is then prefaced by an engraved subscription ticket with a programmatic de-

9

sign and inscriptions which explain Hogarth's artistic or political or moral intentions in the print itself. Publication is followed in many cases by a written commentary, explaining the print's meaning, at first for French readers, and later for English as well. Hogarth authorized these . . . but after his death other commentators appeared to carry on a conversation about the meaning of his designs.[1]

Hogarth's highly literary pictorialism is transmuted by Blake's transgressive originality, which comprehensively and even violently interpenetrates verbal and visual modes. Blake's art thereby reveals to its audience an internalizing of social anomalies that are only inadvertently brought toward awareness by Hogarth's pictorial storytelling.

A Hogarthian progress one views as one views a play; the spectator is safely outside the work, never in doubt that he is looking at pictures, representations of realistic phenomena. Hogarth's progresses are regular, logical, without reverses in descent. Blake's *Book of Urizen*, on the contrary, denies the reader the security of detached observation, indeed, persistently assaults the reader's comfortable security. Text and picture in *The Book of Urizen* are almost constantly recursive and frequently do not cohere—unlike Hogarth's coherent depictions of disorder. Even the story line, the *récit*,[2] of Blake's prophecy is difficult to follow: is it, for example, an unfolding of creation or of destruction? Blake's characters are oddly named, and they seem to change in bewildering fashion. One is not even sure whether this book "of" Urizen is by Urizen as well as about him.

The secure, spectatorly role of Hogarth's audience is a function of the overtly mimetic character of his realism, in which manifestly "unreal" pictures refer to "real" circumstances. What is depicted is easily recognized as real, while the image itself is plainly unreal, distinctly a picturing, and therefore secondary to and dependent on the objects it depicts. Blake's pictures, on the contrary, do not imitate something they are not but constitute a reality. The absoluteness of the distinction in Hogarth's work between secondary "imitation" and primary objects of imitation encourages representations of recognized fictions, as in his portrait of *Garrick as Richard III*. The preposition in the title is crucial, for so realistic is the rendering of the actor in authentic costume that it would be impossible—but for the title—to be sure whether we see a portrait of Richard as imagined by Shakespeare or of an actor pretending to embody what he believes to have been Shakespeare's vision of

Richard. Hogarth's art, one might say, enjoys its own overt fiction-ality without confronting the implications of its exposure of illu-sionism. Hogarth's mimetic realism, however shocking, however satirically pointed, reassures so far as it affirms that things are as they are conventionally presumed to be. Thus one is not compelled by Hogarth's art, as one is compelled by Blake's, to question what may be real; one never wonders with Hogarth, as one does fre-quently wonder with Blake, what the hell is going on. Hogarth's art neither unsettles his viewers' relation to that art nor asks them to engage in the dubieties of representation as representation. He never asks us to participate in his performance; like playgoers, we are spectators and not actors.

In Hogarth's progresses incidents abound, but always on a single mimetic plane. The movement of plot from plate to plate is uni-directional and uncomplicated; we see an uninterrupted progress down, the movement of a falling object. So, too, each plate, however crowded with visual incident, is iconographically one-dimensional; all plates and all their constituent parts are to be read in the same logical fashion. As Paulson observes, Hogarth's pic-tures evoke a puzzle-solving response: looking at his pictures, we are pleased and reassured to recognize how each of a multitude of details articulates a single meaning. We can solve the puzzle by re-ferring to the artist's strict cause-and-effect logic, a logical system dramatized by the unmitigated frontality of the scenes and the un-varying temporal succession of the sequence of plates, as fixed as the stage-set form of the pictures. There is, one might say, no in-trinsic dubiety in Hogarth's narrative art—until he creates *Industry and Idleness*.

FALSE APPRENTICES
AND UNWITTING HYPOCRITES

Paulson argues persuasively that *Industry and Idleness* contains a hidden counterargument to its overt moral lesson, that the fashion in which the career of Goodchild is portrayed forces us to recognize that his career possesses unattractive aspects, even if it is the op-posite of Idle's descent into crime. The reiterated structures of the plates, for example, tend to associate the bad apprentice with open spaces and freedom, the good apprentice with imprisoning inte-riors. In the progress of the story Goodchild's face becomes less visible, until in the final scene, when he is carried off to be invested

as Lord Mayor, he is as anonymous as Idle in the cart bound for Tyburn in the preceding plate.[3] Certainly the moral quality of the crowds in the final two scenes is disturbingly similar. Even the visual simplifications of the plates support this reading: simpler and more popular in form than the earlier progresses, *Industry and Idleness* emphasizes contrastive actions of social rising and falling that open up possibilities for a variety of responses by viewers to the ambiguities in their interweavings. Thus the eighth plate, showing Goodchild made sheriff, is dominated by a foreground of gluttons more suggestive of Dickensian Bumbles than high-minded supporters of justice, and plate 5 displays Goodchild "promoted" to a supervisory position over women confined to wearisome, repetitive loom-labor.

But the series's concealed countermeaning must be, given the nature of Hogarth's art, in some sense "unconscious," not fully part of his deliberate intent. For if Hogarth has given his own features to Idle, while portraying Goodchild in line with his own career—for example, marrying his master's daughter—this confusion does not result in any conscious and overt recommendation of Idle's course. In plate 5 Goodchild is to supervise labor of the most alienating kind, yet nothing in this plate or in others suggests that an appropriate response to such demeaning drudgery might be Idle's behavior. Even plate 1 does not hint at the origin of the differences between Idle and Goodchild; instead, it displays physical evidence of the results of already well-established differences, apparently innately temperamental. Hogarth's commitment to mimetic realism impedes his questioning of *why* things appear as they do—the questioning Blake continuously strives to provoke. The irony in Hogarth's series, therefore, remains to a degree unorganized: there can be no genuinely dialectical relation between Goodchild and Idle. Perhaps both are wrong, one overtly, the other covertly, but their wrongnesses never engage, just as literally the two major characters never touch—a point worth remembering when one considers that Blake's Los is literally part of Urizen. Ambiguity in *Industry and Idleness*—does the alderman in plate 10 (Figure 1) cover his eyes from sorrow at his old acquaintance's degradation, or so as not to see the bribery and false-swearing on which his justice is founded?—remains a disturbing connotation; its implications are not fully realized, are not fully realizable in Hogarth's art. This limitation explains why the series was presented often as a salutary lesson for idle apprentices, as was George Lillo's play *The London*

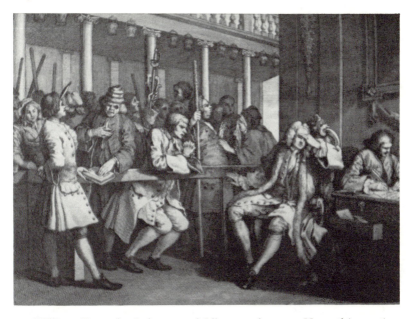

1. William Hogarth. *Industry and Idleness*, plate 10. Hogarth's caption reads: "The Industrious 'Prentice Alderman of London, the Idle one brought before him & Impeach'd by his Accomplice." We see Goodchild *not* seeing the bribery and false-swearing to the left.

Merchant, or George Barnwell. Indeed, Hogarth first chose Barnwell as the name of his idle apprentice, a singularly appropriate choice in that parallel problems of mimetic realism arise in Lillo's play and Hogarth's series of plates.

The London Merchant (1731), sometimes called the first English realistic tragedy (it is in prose), at its most dramatic moment throws its own moral structure into doubt. Millwood, the prostitute who has seduced the apprentice Barnwell into a Hogarthian progress from lust to theft to murder, is physically overpowered by the "heroic" merchant Thorowgood and his loyal apprentice Trueman, but only after desperate resistance—she defends herself with a pistol. She refuses, moreover, to yield morally or psychologically to her physical conquerors, articulating a defiance that draws strength less from Calvinistic theology than from Hobbesian philosophy.

> MILLWOOD: I hate you all; I know you, and expect no mercy. Nay, I ask for none; I have done nothing that I am sorry for; I followed my inclinations, and that the best of

you does every day. All actions are alike natural and indifferent to man and beast, who devour, or are devoured, as they meet with others weaker or stronger than themselves.

THOROWGOOD: What a pity it is, a mind so comprehensive, daring, and inquisitive should be a stranger to religion's sweet, but powerful charms.

MILLWOOD: I am not fool enough to be an atheist, though I have known enough of man's hypocrisy to make a thousand simple women so. Whatever religion is in itself—as practised by mankind, it has caused the evils you say it was designed to cure. War, plague, and famine, has not destroyed so many of the human race as this pretended piety has done, and with such barbarous cruelty—as if the only way to honour Heaven were to turn the present world into hell.

To this tirade Thorowgood responds peculiarly, since he has been the one addressed by Millwood, and the bigots to whom he refers are not identified.

THOROWGOOD: Truth is truth, though from an enemy and spoke in malice. You bloody, blind, and superstitious bigots, how will you answer this?

Millwood knows how. She carries her condemnation of Thorowgoodian society into an assertion so passionate that she breaks into verse, neither great nor free, but suggesting that her truth shatters the logical order of realistic prose.

MILLWOOD: What are your laws, of which you make your boast, but the fool's wisdom, and the coward's valour; the instrument and screen of all your villainies, by which you punish in others what you act yourselves, or would have acted had you been in their circumstances. The judge who condemns the poor man for being a thief, had been a thief himself had he been poor. Thus you go on, deceiving and being deceived, harassing and plaguing, and destroying one another. But women are your universal prey.

Women, by whom you are the source of joy,
With cruel arts you labour to destroy.
A thousand ways our ruin you pursue,
Yet blame in us those arts first taught by you.
Oh, may from hence each violated maid,
By flattering, faithless, barb'rous man betrayed,
When robbed of innocence and virgin fame,

From your destruction raise a noble name;
To right their sex's wrongs devote their mind,
And future Millwoods prove to plague mankind.[4]

Thus not untheatrically ends act 4. Act 5, however, provides no answer to Millwood's climactic charges, other than validating her argument by having her executed, while several "good" people piously regret that she is unwilling to repent. But nothing she has said is refuted: she dies, but she is not defeated, and her self-interested motives, which create "evil," are not entirely distinguishable from Thorowgood's, which create "good."

Lillo's play hereby has uncovered problems of both personal and political relations that it cannot solve in terms of its formal ordering; such problems would in turn stymie Hogarth and later become Blake's central focus. In the opening scene of the play, for example, the merchant boasts to Trueman how a cartel of London merchants has coerced Genovese bankers into breaking their legal commitments to Spain, so as to deny that country funds needed to equip the Armada. Thorowgood claims the justification of patriotism: "The storm that threatened our royal mistress, pure religion, liberty, and laws, is for a time diverted" (p. 187). One thinks, of course, of Johnson's observation that patriotism is the last refuge of a scoundrel, but more to the point is whether such mercantile national self-interest differs from Millwood's mercenary egoism. Certainly her feminist anger is justified by the circumstance of Thorowgood's daughter Maria, who pines away with repressed desire and passion for Barnwell. "Your inevitable fate," she tells him just before he is to be executed, "hath rendered hope impossible as vain. Then why should I fear to avow a passion so just and so disinterested?" (Why, indeed, fear to avow a just passion, Blake was to ask.) Her confusion provokes Barnwell to a reply uncharacteristically Blakean in its cogency: "So aromatic spices are wasted on the dead" (p. 226). Even more revolting is the interplay of sexual and economic motives in her father's "loving care," a hypocrisy that Blake soon was savagely to expose. Maria asks to be excused from a dinner her father is giving for some courtiers (after all, she loves the apprentice), but Thorowgood objects:

You are not insensible that it is chiefly on your account these noble lords do me the honour so frequently to grace my board. Should you be absent, the disappointment may make them repent their condescension, and think their labour lost.

(p. 188)

Who, Millwood might ask, is using whose body for financial gain? *The London Merchant* thus naively raises issues that Lillo is unable, either substantively or stylistically, to resolve. Most important, I think, is the problem of unconscious evil. We are impressed by Millwood because she is self-aware—she does not claim to be better than she is. But Thorowgood does; he pretends to a purity of motive that is suspect, but he does so sincerely. Yet Lillo's art cannot dramatically present the figure of the unconscious hypocrite. Because Lillo portrays merchants in the prosaic language they "actually" use, he uncovers, as poetizing classicizers could not, inner inconsistencies in the merchants' lives. But because these contradictions are hidden from the merchants themselves, they appear in Lillo's play accidentally, as it were. Hogarth's *Industry and Idleness* catches itself in the same bind: Goodchild's hypocrisy is, like Thorowgood's, unconscious; and Hogarth, like Lillo, working in a style of mimetic realism, cannot readily present his hero's shortcomings, except subliminally. As a result, neither Hogarth nor Lillo can deliberately dramatize the internal contradictions of the unconscious hypocrite, and their audiences' professed morality remains unchallenged.

Were Hogarth and Lillo to have exercised aesthetic command of their protagonists' unconscious hypocrisies, they would have altered their audiences' relation to their representations, demanding of them a questioning of their own hidden motives, motives shared with the good protagonists embodying conventional social morality. Hogarth was conscious of a formal aspect in this problem of aesthetic control and commented on his difficulty in portraying a good man:

> It is strange that nature hath afforded us so many lines and shades to indicate the deficiencies and blemishes of the mind, whilst there are none at all that point out the perfections of it beyond the appearance of commonsense and placidity. Deportment, words, and actions must speak the good, the wise, the witty, the humane, and the generous, the merciful and the brave. Nor are gravity and solemn looks always signs of wisdom.

Hogarth also remarked on the impossibility of portraying hypocrisy of the conscious and deliberate kind:

> Very handsome faces of almost any age will hide a foolish or a wicked mind till they betray themselves by their actions or their words . . . but the bad man, if he be an hypocrite, may so manage his

muscles, by teaching them to contradict his heart, that little of his mind can be gathered from his countenance, so that the character of an hypocrite is entirely out of the power of the pencil.[5]

Hogarth's surprising awareness of this failure of moral realism in his art signals a genuine crisis in art history: stylistic self-contradiction will compel artists to venture into new modes. When Hogarth confesses his art to be incapable of representing goodness or serious evil, Blake, who believed fervently that art should reveal truth, has no choice but to examine critically the premises on which Hogarthian mimetic realism is founded and to begin developing innovative techniques. Careful attention to the differences between Hogarthian and Blakean pictorialized narratives thus privileges us to observe the particular conjunctive pressures of stylistic and thematic instabilities in which the art we call Romantic originated.

ENERGY ORGANIZES

Hypocrisy, especially unconscious hypocrisy, is the main focus of Blake's work from *The Marriage of Heaven and Hell* through *Jerusalem*. In *The Marriage of Heaven and Hell*, for instance, the reader is challenged to determine whether what he believes to be good and evil is identical with what he calls good and evil, to discover if his true desires contradict the moral precepts he espouses. In plate 4 Blake presses his reader to query his fundamental beliefs and impulses by identifying the words there as "The Voice of the Devil." The crucial issue thus posed is not whether the assertions express Blake's views, but how a reader will respond to statements urging him to reflect on the source of his acts and attitudes. In this fashion, from the title forward, the prophecy continually threatens the reader's conventional moral perspective.

This threat becomes truly menacing in *The Book of Urizen*, in which orthodox expectations are repeatedly transgressed, and the prophecy even challenges the idiosyncratic expectations it arouses. For example, the abrupt stylistic contrast to the preceding illuminations that is thrust upon us by plate 26 (Figure 2), showing child and dog at the door, may be peculiarly startling to a modern reader who has just begun to familiarize himself with a mythopoetic style. But even for Blake's contemporaries, the switch to a chapbook-like form was shocking, as W. J. T. Mitchell observes, in the Christian

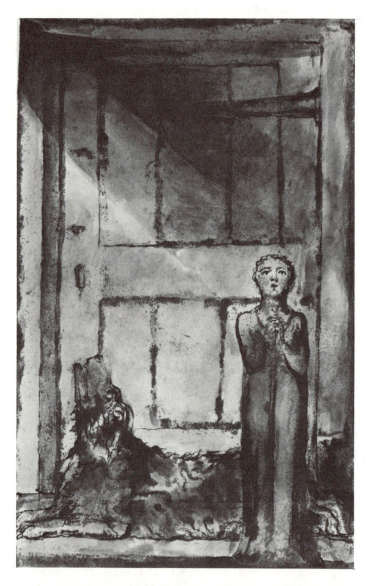

2. William Blake. *The Book of Urizen*, plate "26." Lessing J. Rosen-
wald Collection, Library of Congress, Washington, D.C. Praying
child with his "dog at the wintry door" recalls a sentimental
graphic tradition of impoverished children; in "The Human Ab-
stract" Blake wrote: "Pity would be no more / If we did not make
somebody Poor."

reminder that the waif is less in need of our help than we are of his.[6] Blake's almost coarse rendering of the fundamental Christian message is empowered not only by contrast to the preceding plates but also by contrast to the final plate showing Urizen's "net of religion." The pictorial opposition gives emotional, almost visceral, impact to the significance of the text of the final plate, which more than any other in *The Book of Urizen* seems nearly "normal" in its manifest similarities to parts of the Old Testament. So even the conclusion to this prophecy awakens us to the sinister effects of religion in its familiar form, not simply as an external social edifice but also as an internalized institutional system.

Throughout, the prophecy disrupts the reader's expectations. Exemplary is the problem posed by Urizen's question in chapter 2, "Why will you die O Eternals?" just sixteen lines after "death was not, but eternal life sprung."[7] The seeming contradiction enforces our attention to minute particulars in the Urizenic question: the meaning of "why," the tense of "will," the conjoining of "die" and "Eternals," and that substantive plural which itself challenges a conventional idea of eternity. The following line, furthermore, rather than clarify the issue, reflexively drives the reader back into dubiety: "Why live in unquenchable burnings?" The verses, in sum, both intensify our need to understand and incite our consciousness of the difficulty in understanding who the Eternals may be and what may be their relation to Urizen, whoever he may be. But almost any hypothesis we pose forces an acknowledgment that death may be a Urizenic decreation, a fallen human invention, rather than a "natural fact." As Urizen invents the body of fallen humankind, so he creates death, a bane that had not existed before his separation from the Eternals. "Death" thus is not allowed to remain abstract, a condition outside the work, but comes into being as a mystery we must face within our reading of Blake's prophecy.

Without making a detour into Blake's metaphysics or theology, we may note the sheer speed with which we are plunged by his prophecy into ultimate issues, for this swift directness is typically Romantic. The immediacy with which Romantic art confronts us with basic uncertainties perhaps best distinguishes it from the art immediately preceding and following it. Romantic art excites because it attacks, attacking most significantly its audience's assumptions, precepts, and self-deceptions, a strategy that often encourages unmediated encounters with radical—and therefore *common*—problems of human existence.

This quality of Romantic art becomes apparent when we contrast Blake's treatment of death in *Urizen* with that of his antagonist-inspirer in *Paradise Lost*. Milton's epic condemns disobedience, but in *The Book of Urizen* the fall seems to originate in a demand for obedience, as Mitchell phrases the reversal, "the primal crime is promulgation of law, not the violation of it."[8] For Milton, Eve and Adam bring death into the world by transgressing God's edict. For Blake, death is Urizen's destructive creation of nothingness. But *The Book of Urizen* neither celebrates nihilism nor recommends disobedience for the sake of disobedience. Yet the genesis and significance of Urizen's decreation are difficult to determine because the "problem of death" appears in abrupt isolation, cut free from traditional contexts, unmediated by the concepts, attitudes, and feelings that are implanted by social tradition and usually serve as surrogates for a solution. Death is not so isolated in *Paradise Lost*. Milton takes his story from the Bible, adhering closely to the familiar outlines of the "official" narrative, and he makes full use of the intellectual traditions of Western culture to embed that narrative in a context as rich as possible. In contrast, Urizen, Blake's original invention, addresses a problem antecedent to Eve and Adam's disobedience: What is the origin of that death which is promulgated in God's edict—whence comes the very *possibility* of death?

Herein resides much of the difficulty in understanding Blake's prophecy. In seeking to uncover what lies beneath received tradition, Blake, like other Romantic poets, not only relies less on allusion than does Milton, but also, and more importantly, prefers (as do other Romantics) deceptive allusions. As I earlier suggested, perhaps the most disturbing feature of the concluding lines of *Urizen* is their ominous biblical echo. Blake—and the other Romantics—cannot adopt Milton's easy reliance on reference to accepted conventions that artist and audience agree they share. Blake's skepticism regarding the tradition within which his art takes shape requires from his audience a skeptical response, one commensurate with the threat posed by the artist's challenge to his audience's assumed bonds of community.

We can see how this mutuality of unease functions by returning to the theme of death. Blake presents the fall of man, which in Milton's words "brought death into this world," not in the past tense, not as a single event, not as an inherent condition to which we are passively subject, but as a mistake reinvented and reenacted by each of us, a continuous possibility, an individual choice. *The*

Book of Urizen displays the fall of man, which makes death possible, as the power of life to bereave itself, and the prophecy dramatizes that what defines life as life is the capacity for self-injury. Something totally nonvital, let us say a rock, can be damaged, can be destroyed, but cannot damage or destroy itself. The more vital a being, the greater its potential for self-destruction, and man, in whom vitality has attained the intensifying power of reflexivity and self-consciousness, can even make the power of life to bereave itself into a system. Urizenic society is systematic self-mutilation, because it strives to contain or inhibit natural energy, which Blake conceives of not as an anarchic, disorganizing force but as the organizing power that brings any order into being.

Reason, when confining energy or acting to control, is therefore inherently perverse and self-destructive. The breaking off of Urizen from the Eternals leads to systematizations of self-mutilation—Urizen's net of religion and the Eternals' tent of science—structures of containment, attempts to impose limits, negative and false organizations. True organization created by vital energy is quite different, resembling a process of evolution that brings into being an endless variety of definite forms with their infinite number of distinct identities (all affiliated in multifarious fashions) and *in so creating* sustains its power to continuously generate entirely new forms and unique individuals. *The Book of Urizen*'s display of life's capacity to injure itself offers perverse evidence of life's potency. Urizen's worst mistake testifies to the life in him and—however troubled he may be by it—a potential within him for regeneration. Self-redemption remains possible only so long as a potentiality for self-destruction persists.

Because it is structured by the conception of energy as organizing force, Blake's prophecy clarifies the surprising fact that Romantic concentration on unwitting hypocrisy so often leads toward hope, allows for coexistence of skepticism and idealism. To become conscious of how we have erred in internalizing society's incoherences is to exert our energy, giving ground for hope—another exercise of energy—that we might redeem ourselves, a first step toward the redemption of society. That self-injuring falsity can be recognized suggests the possibility of replacing it by more positive relations both within the psyche and within the social order. Romantic hope, indeed, depends on a view that the condition of an individual psyche and the condition of its society are inextricably conjoined. Unless social arrangements that impose hypocrisy are

changed, a single individual's awareness of internalized evils does little more than reinforce his isolation from his more "normal" fellows. And, of course, without individual awareness of what has been internalized, no meaningful social transformation can be instituted, whatever political changes may be initiated. We misunderstand Romantic art if we fail to recognize that Romantic artists' celebrations of individuality inevitably imply need for improvements in society, and that their ideals for social reform invariably imply an enhanced potency of individual psyches.

THE EVIL OF UNCONSCIOUSNESS

Romantic hopefulness, however, because founded on awareness of unconscious hypocrisy, tends to begin in discomfort, with threats to the reader's confidence. Among Blake's preferred models are the biblical prophets who criticize the behavior and attitudes of their fellows, thereby attacking their own community. Blake's primary aim is to make fellow Englishmen face up to their unintentional self-deceptions. So the protagonist of *The Book of Urizen* endeavors to establish an ideal existence, with the sincerity of his belief that he alone is on the right path proved by his willingness to suffer intensely to attain his goal. The reader, however, perceives that Urizen, that is, the reader's reason, produces hellish conditions. The perception that a claimed "creation" may in fact be a destructive falsification encourages the reader to consider how and why Urizen—his reason—might be self-defeating. Here the full implications of Blake's transforming of Hogarthian art emerge distinctly: when badness becomes in its essence unwitting hypocrisy, deliberate villainy is reduced to the merely melodramatic. There are few villains and little overt evil in Romantic art because it so deeply engages its audience in assessments of what the audience has unthinkingly taken to be "good" and "bad."

We call the mustache-twirling villain melodramatic because he is conscious of acting villainously; his awareness keeps us, the audience, at a distance from evil: his evil does not touch us. Yet if one had to name three outstanding hypocritical villains in British literature before Blake, one could scarcely do better—or worse—than Shakespeare's Iago, Milton's Satan, and Fielding's Blifil, all villains because conscious hypocrites. Evil until Blake's time was inseparable from consciousness; the truly malign person had to intend evil. With Blake and the Romantics there is a dramatic change: con-

scious evil becomes melodramatic, trivial; serious danger now appears in those who do not understand their true motives and impulses. Urizen is the new prototype, repressing distress at the disastrous results of his sincere idealism. Blake is the first artist principally concerned with exposing how we become unwitting hypocrites, perverting our truest desires and belying our sincerest professions. *The Book of Urizen* explores the Thorowgood-Millwood and Goodchild-Idle paradoxes that the "good" are open to the charge of being less honest than those whom they justly condemn. Blake consciously develops the implication appearing in Hogarth and Lillo that "good" people in fact cause situations that produce the evil they abhor, and then compound their error by blaming their victims as "bad" instead of acknowledging their own responsibility. As Blake phrased it in *The Marriage of Heaven and Hell*: "Prisons are built with stones of Law, Brothels with bricks of Religion."

A MULTIFUNCTIONAL AESTHETIC

In Hogarth's art everything follows a cause-effect pattern: the order of the plates can no more be changed than can the left-right order of printed words. But in each of the seven copies of *The Book of Urizen*, several plates are in different sequences; there is no one "correct" order. And whereas our ability to interpret Hogarth's plates, to find meaning in them, depends on their consistency of representation, every effect being the result of a discernible precedent cause, for Blake, linear order is deceptive, false, a mode of hypocrisy. In *The Book of Urizen* we do not encounter a fixed fiction but evocations of the processes by which one creates fictions, *how* plays and kings, pictures and gods, and even hypocritical moralities are invented. The viewer must participate in the presentation; he is forced to invent, and in inventing to find his own actions opened to self-criticism. Both verbal and visual elements in *The Book of Urizen* rupture expectations and conventions; texts and illustrations do not cohere simply. Incompatible syntaxes, grammatical and graphic, compel us to think about how we arbitrarily impose order so as to understand but thereby misunderstand.

Further, the relation of pictorial scene to poetic text often is not lucid, these uncertainties reinforced by indeterminacies within the text itself, including grammatical incongruities and inconsistencies, such as failure in agreement of subject and verb and dubious antecedents. These are verbal, poetic equivalents of the structural

polymorphism Stephen L. Carr finds central to Blake's graphic designs, arguing that Blake does not derive aesthetic coherence from "any *a priori* idea of space," or from "defining figures according to abstract precepts of composition." Blake's pictorial unity, on the contrary, "emerges only through the bounding lines that generate space as they delineate the figures that constantly enact their own pictorial logic." Blake resisted the "tyranny of seeing the design in accord with one schema," striving to shape a coherent form that would not simply "reflect some abstract ideal of unity," but would be constituted by its own idiosyncratic, and thereby nonreductive, lineations.[9]

By eliminating the conventional matrices of ideas and behavior, Blake drives us to imagine what might be (not what is) the import of his words and pictures. We create possibilities. To understand by so inventing is to raise for ourselves the possibility of inventing otherwise—by the very act of apprehending we perceive our potential misapprehension. This is the chief focal point for all Romantic art: the creation of an aesthetic entity whose apprehension enforces the audience's awareness of the possibility of alternate apprehensions. To do this, Blake required systems of organization sufficiently complex to embody polymorphic structures. A simple verbal example is the Preludium's first line—"Of the primeval Priest's assum'd power," in which the duplicity of "primeval" (= prime-evil?) compels us to question the moral and historical validity of the power assumed (= presupposed or seized?).

A simple pictorial example of the complexity of Blake's organization is provided by plate 27 (Figure 3), in which we see only the back of a figure, apparently moving away from us, so that we imagine a space behind the figure, that is, *between* it and us. Blake thus enforces our awareness of how conventionalized is that "distance" between us and what is "within" the picture. Difficult text, pictures that turn interpretation back upon itself, provocative interplay of text and design are all necessary because Blake seeks to evoke our imagining, since only by imagining can we release that energy whose very products confine and reduce it—as is shown in the brilliant balancing of the restrictive controls of the Eternals' *tent of science* and Urizen's *net of religion*. However opposed our religion and science may seem, both are systems of enclosure through which we deceive ourselves as to our capacities. Imagination breaks the internalized fettering of institutionalized science and religion

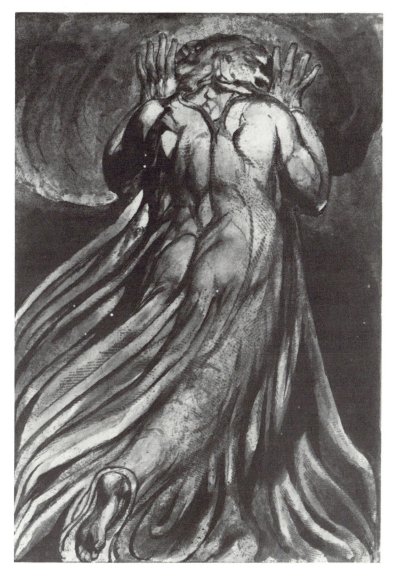

3. William Blake. *The Book of Urizen,* plate "27." Lessing J. Rosenwald
Collection, Library of Congress, Washington, D.C. In Copy B of *The
Book of Urizen* this plate appears early, perhaps Urizen "creating" his
world? Or does the figure retreat, shielding his head? His robe and
body, one notices, are almost indistinguishable.

by restoring access to the power of believing and attaining knowledge in which they originated, in recovering the processes by which we are able to create systems.

To arouse our apperceptions of the constrictiveness of reason, of how we perceive and conceive, Blake's art must be more than "composite," must be self-antagonistic, making us aware of its limits and releasing our power for imagining more minutely articulated and flexibly comprehensive modes of ordering. To Blake, what conventionally passes for organization are hypocritical systems of disorganization that pretend to be orderly, like federal tax laws or the New York subway system.

Blake's aesthetic impulse is perhaps most easily understood by an analogy to politics, where, to use Shelley's terms, the anarchism of tyranny is often writ large. The superficial order of a tyranny is reductive: coercion betrays the tyrant's incapacity to maintain the social structure under a more complex and free system, such as appears in a democratic society's self-regulation. For citizens long accustomed to tyranny, a revolt may seem an outbreak of disorder, though in truth the revolt brings possibilities for more complex and liberating organization. Just so, those whose vision has been shaped by Hogarthian realism may perceive Blake's verbal and visual amalgams as confused, incompetent, or meaningless. Once freed from the limits of Hogarthian realism, however, one recognizes that Blake is neither uncertain nor confused in his arrangements. He employs polymorphous structures because they are an effective means to reveal our unwitting perversions of our potential for creative organizing. Blake's art must transgress the normal bounds of both verbal and visual art because only a formalistically dialectical art is adequate to the sudden transformation he would work in his audience. For example, one may interpret the graphic horror of expression in plate 9 of *The Book of Urizen* as arising from an imaginative perception of the fetal skeleton (plate 10), a perception or awareness of the nature of our mortality that we ordinarily choose not to recognize, or that we prefer to misperceive. To this kind of self-troubling self-understanding Hogarth's mimetic realism gives no insight.

To the commonplace that Blake's pictorial designs do not merely illustrate his text, we may add that the interactions of text and graphic design exemplify the principle of allotropic structuring, which requires that relations among and of a design's parts are not merely based on subordination, a mechanistic functionalism that

minimizes the individuality of parts; in Coleridge's terms, the work of art "proposing to itself such delight from the *whole*, as is compatible with a distinct gratification from each component *part*." In art polymorphously structured, moreover, the principal function of neither parts nor whole can be merely referential. Much of the "obscurity" of Romantic art derives from explorations into the use of forms and images for purposes beyond referentiality. As with some of Turner's paintings, so in *The Book of Urizen* we are frequently led to wonder, as in plate 17 (Figure 4), just what it is that we are seeing. Is this an image of the "globe of life blood" that "trembled, Branching out into roots . . . Fibres of blood, milk and tears" (78:18:1–4)? Is it large or small? Though the total unity of the design is impressive, we also ask, Which, globe or figure, is part and which whole? The design illumines, moreover, Blake's contention that a line is a line in its minutest subdivisions: the whole lives through, and only through, each infinitesimal phase that constitutes it. As we ponder the plate's narrative line, we cannot be certain who the figure is, because the action of the prophecy does not depend on conventional discriminations of characterization. Whereas in Hogarth's plot we can perceive Idle and Goodchild *only* as differentiated, because they exist only through their differentiation, the "plot" of *The Book of Urizen* is of how Urizen and Los, Los and Enitharmon, and so on, are both different and of the same body. To use terms to which I'll return in chapter 8, Blake's figures are *participatively* individualized, Hogarth's *privatively* individualized; the uniqueness of Blake's characters is established through modes of relation and connection, rather than separation and exclusion.

Differences between Blake's graphic structuring and Hogarth's, therefore, imply not just a new aesthetic style but also a new concept of human relations, of how a true community is constituted—a conception antagonistic to the kind of community Hogarthian realism both embodies and represents, a community Blake regards as false and hypocritical, a noncommunity pretending to be a community. Blake, like other Romantics, responded to new social conditions by imagining the possibility of still newer ones. Perceiving their world penetrated by unconscious hypocrisy, the Romantics, followed in time by Marx, Nietzsche, and Freud, and still later their disciples, responded by seeking to redefine how people truly do relate in their societies and to imagine different, better fashions of relating and constituting communities. As artists, rather than

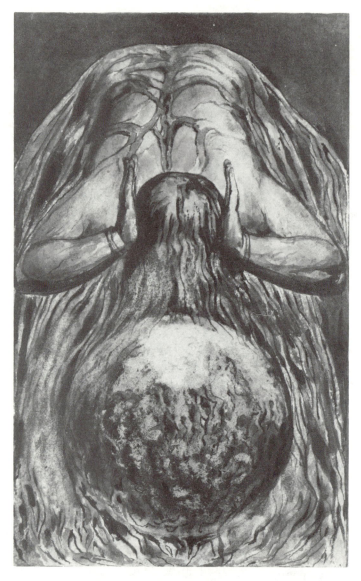

4. William Blake. *The Book of Urizen*, plate "17." Lessing J. Rosenwald Collection, Library of Congress, Washington, D.C. This design is relevant to the "dark globe of Urizen" where "rivers in veins / Of blood pour down" (plate 5), "Down sunk with fright a red / Round globe" (plate 13), and "The globe of life blood trembled" (plate 18).

economists, philosophers, or psychologists, Romantics like Blake necessarily found themselves involved in revising those features of artistic structuring crucial to how a work of art is received by its audience. Romanticism's most fundamental commitments, consequently, assure that it cannot be an isolated aesthetic movement, nor can it define itself adequately through *simple* antagonism to prevailing social mores. At its most intensely personal moments of exploration and expression Romantic art engages itself with the problematics of its potential audience's response.

REDEFINING THE IMAGINABLE

This issue of audience response may be illustrated by a major formal contrast between Hogarth's progresses and Blake's prophecies. The former relies on segmented sequences, and within each segment the visual separation of every detail from all else, whereas *The Book of Urizen* allows a continuous interplay between plates and within each plate, a process that makes the relation between graphic design and verbal text more dynamic than mere illustration, in which one element is "passive" or subordinate. Unlike the action of Hogarth's progresses, the action of Blake's prophecy is not susceptible to being segmented, is indeed intended to make us recognize how we falsify by segmenting or analyzing. In plate after plate in *The Book of Urizen* we confront the act of dividing *as* anguish, an agony the Goodchild-Idle story conceals from consciousness by celebrating the triumph of Goodchild over Idle.

The contrast between Hogarth and Blake extends to the processes by which their works came into being. Hogarth's productions were so readily piratable that he needed a new copyright law to protect his interests, while Blake's work is literally inimitable.[10] Hogarth usually produced his series by first painting the scenes and then having them engraved, thus separating invention from execution, idea from embodiment. Blake's method of illuminated printing, as Robert Essick and Joseph Viscomi have reconstructed it, depended on the identity of invention and execution—which Morris Eaves shows to be the keystone of Blake's aesthetic.[11] The viewer of Blake's art, likewise, must participate in a dialectical interplay of perception and interpretation. When we look at a picture, our perceptions of its visual forms usually lead us to form mental conceptions, whereas in reading poetry our conceptual construal of its linguistic patterns leads us to form mental images. Blake's fus-

ing of the verbal and the visual tends to effect a confounding of these processes of response, thereby endowing his concepts with something of the substantiality of physical perceptions and enriching his percepts with powers of conception.

This is why one does not, for example, respond to plate 17 of *Urizen* as a puzzle to be solved logically. One is confronted with a perfected intensity of form, a self-sufficient perceptual whole, whose "meaning" is inseparable from one's direct perception of its active self-congruity, which, nevertheless, is simultaneously "obscure" because as unpredetermined as the identity of the figure who either acts or is acted upon. One does not properly read any plate of *Urizen*, in Blake's terminology, *with* the eye and afterward explain it verbally, rationally interpret it. One properly perceives each plate *through* the eye, imaginatively, by entering into the processes by which the plate constitutes its reality, so that the plate exists as it is imaginatively perceived, its "reality" involving its audience's participative re-creation. Blake's viewer is not reduced, as Hogarth's is, to the position of spectator-consumer–puzzle solver faced with an artwork's separating of sensation and reason. Instead, Blake challenges the viewer to something much like an artist's creativity by demanding an imaginatively constituting response.

The demand that our response include confronting the problem of our internalizations, how what we assume to be "self-evident" may signal a self-deception—that, like Milton, we may be of the Devil's party without knowing it—denies us the relief of finding external references for Blake's representations. Blake's figures are not *of* something other than themselves, as Hogarth's ostentatiously are. Blake's reader in the very act of deciding what this figure or that "is" must consider why he so imposes such a decision, since he cannot appeal to any extrinsic fixed code or guide. This self-destructive, self-constituting rhetorical effect is most easily illustrated by Blake's namings of his characters. Unlike Hogarth's transparent *Idle* and *Goodchild*, or Lillo's *Thorowgood*, Blake's *Los, Enitharmon*, and *Orc* have no moral meanings, that is, they have no pre-established, normalized referential value. The reader must create their significance for himself by what he makes of the picture and poetry, determining, for instance, what *Los* "must be," but then at once wondering if this determination is the most accurate and complete possible. So there are a variety of interpretations of Blakean names, with some critics linking *Urizen* to "horizon," while others sound the name closer to "your reason," and not everyone shares my interpretation of *Los* as "loss."

This involving of the audience in the artwork so that perception and interpretation are unified produces effects that tempt one to define such Romantic art as "expressive," for its diminishing of extrinsic referentiality enforces a concentration on the psychically dramatic as opposed to the interpersonally theatrical. In Hogarth's series humanity is defined in all respects by its surroundings, what imprisons it. Just as each series is contained within the referential actualities to which its pictures appeal topically, so the theatrical quality of Hogarth's representations springs from his defining of every bodily gesture by its opposition to resistive elements or countergestures. Necessarily, therefore, to Hogarth clothing is all-important. Through its condition, its excess or inadequacy, its disorder or inappropriateness, its ostentation, and so forth, clothing defines a constrained body that is *not* clothing; the nonhuman defines the human. Blake's figures, to the contrary, are usually nude, lone bodies in indefinite surroundings. They display their naked humanity, compelling the viewer's attention to human *self*-imprisoning, *self*-tormenting impulses. Human gesture and posture thus divested of context deny the viewer the refuge of referentiality, interpretation *away from* self. Blake's scenes, therefore, are seldom as *theatrical* as Hogarth's but regularly are more psychologically dramatic in evoking in the observer intensities of desire and desire self-thwarted without mediation.[12]

By cutting away ordinary physical accoutrements of social life, Blake frees his reader from the prison of conventional vision and morality, and compels him to face dramatizations of his own fears, aspirations, rages, desires, and self-torturous anxieties. Whatever meaning *The Book of Urizen* possesses is defined by this participating self-reflexivity, engaged in which we, the audience, find ourselves, like Urizen, "a self-contemplating Shadow, / In enormous labors occupied" (71:3:21–22). Just as Los and Enitharmon are originally one, so both are modes of the reader's being. Consequently, instead of Hogarth's segregated representations, Blake's interpenetrations of foregrounds and backgrounds present us with a continuous experience of the agony of dividing and separating. This anguished continuity is sustained by his multidimensional art's self-regulation, a process of feedback in which, of course, "regulation" includes "provocation." As a thermostat and furnace form a self-correcting system to maintain a given temperature, so Blake's art provokes interpretive responses that are self-challenging.

Similarly, while Hogarth relies on sequential linearity, in which the principal connection between major elements is empty space

and blank time, a void, Blake depicts a continuity of interactions in which there are no voids: Major elements of the prophecy are richly interrelated (backward as well as forward, outward as well as inward, laterally as well as sequentially) and in a provocative fashion, with verbal and visual elements challenging rather than merely reiterating or reinforcing one another. These qualities are not matters solely of thematic complexity but actively demand the involvement of the audience. What Romantic art discovers is a self-regulating quality in the use of ambiguity, paradox, and the like that transforms perceiving and interpreting into a reflexively dialectical process. The simplest way to describe this innovation is to say that Romantic art makes a particularly strong appeal to the audience's imaginativeness.[13] Romantic artists are no more imaginative than earlier artists; but unlike their predecessors, the Romantics directed their artistry to evoking an imaginative response from readers, viewers, and listeners.

The Book of Urizen usefully illustrates the evocativeness of Romantic art in that Blake's prophecy heads off any sentimentalizing of imagination. The Romantics indubitably celebrated imagination, but its exercise for them inevitably entailed risk, danger, fear, possible disorientation. The prophecy in The Book of Urizen uncovers its readers' unconscious hypocrisies, and the work disturbs us by dissolving conventional boundaries, thereby redefining what may be imaginable. While reading such a self-provoking, self-reconstituting prophecy one cannot feel a safe, if illusory, separation from its vital destructiveness. Rather, one experiences an agonizing yet exhilarating responsibility to try to *make* order out of the release of the frighteningly dangerous energies of one's own imaginative perceptions. To read The Book of Urizen one must organize what one does not yet understand, that is, act like an artist who courts pain, uncertainty, and self-injury.

Those who don't oversentimentalize the imagination often misperceive it as anarchic in its disruptiveness. But what most grips our imagination in The Book of Urizen, once we become acclimated to its self-regulative form, is that its difficulties do not suggest reality to be inevitably random, chaotic, or absurd in the modern sense. To the contrary, Blake's polymorphic or multidirectional art encourages awareness of diversely complex possibilities of organization. A somewhat oversimplified analog of this imaginative awareness is suggested by our understanding of water: To become fully aware of the reality of water, its true identity, we must realize that it may *ap-*

pear as vapor, fluid, or solid; that the form in which we now happen to perceive it is neither final nor privileged; that water has no one perceptible form because its nature is to change in response to changing conditions of pressure and temperature. For Blake, human identity is founded in each individual's unique possibilities for ever-greater diversity of being. Each of us has innate self-transformative potencies, but the primary effect of the false, hypocritical self encouraged by Urizenic society is to confine and reduce these potencies.

Though Blake's art deals with internalized experience, it is not private or asocial. His work demands the engagement of the reader, which assures an honest, rather than a pretended, relation between artist, artwork, audience. In contrast, pretended relations are characteristic of the society represented *in* and *by* a work like *Industry and Idleness*. Both its form and substance betray in diverse ways dishonesty as the essence of Hogarthian community. Hogarth cannot visually expose hypocrisy nor portray goodness, and his so-called society is little more than a class war, just as his typical family is an encounter of egoistic lusts. The unconscious hypocrisy detectable in Goodchild reflects a surfacing of this essentially delusory and disorganized character of the social existence Hogarth portrays. Goodchild's hypocrisy we call unconscious because it is not merely a personal failing but a symptom of social falsity. Such grave faults can be unconscious, that is, inaccessible to the individual's normal awareness, because, despite the individual's professed desire to be good, society compels him to act selfishly, uncharitably, or greedily—behavior that society, and therefore its members, then define as "good." The faults of the unconscious hypocrite, therefore, manifest his society's incoherence, its commitment to what is in fact antisocial behavior. Romantic art begins—and remains anchored—in a commitment to exposing such fundamental social self-contradictions.

2

Victorian Anti-Romanticism

If the contrast between Hogarth and Blake helps to define how Romantic art emerged from its eighteenth-century matrix, equally illuminating is the contrast between Romantic and Victorian art, the first to react against Romanticism. In this chapter a juxtaposition of two pairs of representative works, Constable's *Salisbury Cathedral, From the Meadows* and Millais's *The Blind Girl* with Wordsworth's "Michael" and Tennyson's "Enoch Arden," serves to highlight central features of Romantic art by illustrating Victorian resistance to Romantic fondness for the interpenetrative. An important achievement of Romantic graphic artists was the transposition of the relative importance of history painting and landscape painting, the elevation of the latter paralleled by the new intensity Romantic poets brought to the evocation of emotional responses to natural scenes. But the Romantics did not merely subordinate the cultural to the natural. Some of Turner's greatest canvases are history paintings, and historicism is at the root of all Romantic art. The Romantics' intricate interrelating of nature and history may be suggested by Constable's argument that landscape painting itself had an important history, moving from its subordinate position in the background of religious works to the distinct independence manifested in his own canvases. The Victorians tried to clarify and simplify the deliberate confusions of Romantic art and rejected the Romantic arousal of self-conscious activity in viewers, readers, and listeners. They sought to focus sharply, even to melodramatize, the diffusiveness and decentering of Romantic art that led to representations of continuity as endowing with significance, even tragic significance, unspectacular lives of ordinary people.

VICTORIAN CLARITY, ROMANTIC CONFUSION

Millais's *The Blind Girl* (Figure 5) and Constable's *Salisbury Cathedral, From the Meadows* (Figure 6) share dramatic rainbows and em-

34

phatically English landscapes, although in Millais's picture landscape is but background. In Constable's picture foreground and background are not easily distinguishable, however, as all parts of the picture flow into one another. Millais stresses distinction and separation in every way. Edges are sharply defined, and each detail could, as one of my students observed, be cut out with scissors. This lack of visual interaction between the composition's parts and Millais's reliance on clear, bright, nearly primary colors perhaps explains the effect of flatness in Millais's work, in contrast with Constable's dense texturing of sky, building stone, and vegetative growth. Millais's emphasis on the formal elements of distinctness, clarity, and simplicity are central qualities of Pre-Raphaelite realism, which is in large measure a realism of visual surface in and for itself.[1] In such realism human figures stand out theatrically from natural backgrounds. The rents and stains on the blind girl's blue skirt, for example, or the patch on her dress, are not visually related to other portions of the painting: they exist in themselves as nothing more than parts of the clothing. The intensity of this realism, indeed, springs from the self-sufficiency and visual autonomy of details. Consider the black birds in the middle distance. In themselves they are depicted carefully, but their size is disproportionate both to the cattle behind them and to the people in front—a disproportion so striking that we are compelled to wonder as to its cause, provoked to consider its significance. We "read" the picture not as a visually coherent object but as a set of self-sufficient details unified by a coherence of affective *significations*.

Everything in the painting encourages a viewer thus to read symbolically. Each element by its clear distinctness encourages us to find a "meaning" for it more important than its purely visual function. This, I suspect, leads to the common, but not very helpful, designation of *The Blind Girl* as a narrative picture. It does, like many Victorian paintings, "tell a story," but not in the same fashion as other narrative pictures, including masterworks painted by Giotto and Breughel. The nature of Millais's special Victorian mode of "narrating" is revealed by the butterfly, literalistic to the point of being photographic. Visually the detail seems gratuitous. But it clinches the simplest affective purport of the picture: the poor girl cannot see, as we do, either the fragile beauty of the butterfly or the grandeur of the rainbows.

The microscopic accuracy with which the butterfly is portrayed, furthermore, compels us to attend to it, though visually it has no discernible relation to the cloak on which it rests nor to the black

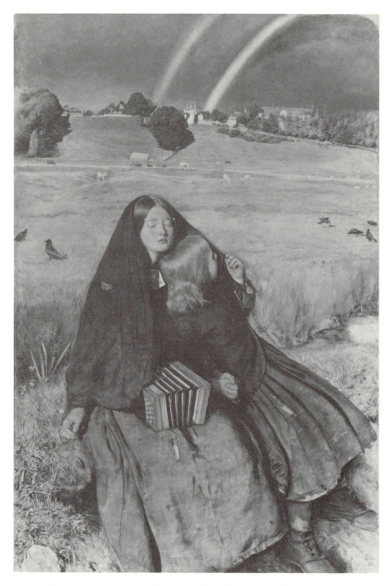

5. John Everett Millais. *The Blind Girl*. Courtesy of Birmingham Museums and Art Gallery. The theme of blindness appears also in Turner's *Ulysses Deriding Polyphemus* (Figure 16), the contrast illustrating well how narrative opacities and self-questionings distinguish Romantic from Victorian narrative structure in graphic art and poetry.

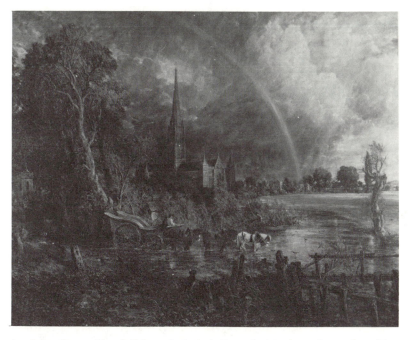

6. John Constable. *Salisbury Cathedral, From the Meadows*. Reproduced by courtesy of the Trustees of The National Gallery, London. Characteristic of Constable are the relatively diminutive figures but significant human artifacts amid nature's forces, and characteristic of the Romantic "spot" is the soaked but brilliant empty field.

birds or the rainbows. In the exactness of its rendering, we feel a lack of proportion analogous to the physical disproportion of the black birds. Why, we are driven to ask, is this trivial creature presented with such hypervivid literalness? What, in short, does it symbolize? Less troubling at first, but still puzzling, are the bright rainbows as backdrops to a scene no longer very wet. Whatever storm there was has definitely cleared off. Then there is the sign pinned to the girl's blouse, literally "telling" us of her condition, "Pity the Blind." This last is impressive because so unnecessary. Surely the painting's title, the girl's dress, expression, and accordion, and her one hand fingering the grass, the other clutching her comrade's hand, "tell" her condition adequately. Why the verbalized overdetermination?

One reason is that the picture signifies so definitely that no de-

tail of its realism *can be* too distinct. We are to be so impressed by the butterfly-as-butterfly we see (though the girl, pathetically, cannot) that we will remember, at least if we are learned enough, that the butterfly once symbolized the soul. Analogously, the black birds of mortality are exaggerated so that as our eyes move back from the foreground plane we will recognize a symbolic movement to the hope of heaven embodied in the rainbows. The desire for distinctness with consequent minimal visual interrelating explains why Millais also is redundant. The unusualness of the double rainbow, to cite the obvious feature, impels us to think about the sight as something more than a natural phenomenon, just as we are "told" of the girl's blindness in more than one way.

All these characteristics serve to distance the viewer from the picture, to urge us to regard the picture as a finished painting to be studied, read, interpreted from a distance. Pre-Raphaelite painters "place" their viewers in much the same position as the audience of a Victorian stage performance. This distance is most clearly enforced in paintings of interior scenes, which tend to be filled with reflections and see-through devices—mirrors, windows, reflective surfaces, and reiterated shapes—that emphasize the spectator's role as spectator.[2] *The Blind Girl* functions in the same fashion, allowing us a single, sharply defined view, a simple emotional attitude of pity. In it we see people not in action but as spectators, the blind girl overtly not seeing while her companion looks at the rainbows. As with interior scenes, say Hunt's *Awakened Conscience*, what is demanded of us as viewers is less a complex visual response or intricacy of emotional reaction than a strong, because non–self-contesting, affect. There is little question about what is going on; our task as viewers, as Ruskin liked to insist, is to decide on the significance of what is clearly portrayed and is forcibly direct in its emotional appeal in accord with conventionalized patterns of feeling.

Thus the viewer's interpretation of *The Blind Girl* is closely controlled: we are not permitted much range of interpretation. Linear clarity of details is used to *preclude* ambiguity, as is the uncomplicated compositional scheme. Redundancies assure we will understand *the* point. The whole painting is like the butterfly within it: elaborated meticulousness in surface rendering to enforce an uncomplex response. By its nature, microscopic exactness of the Pre-Raphaelite kind works against Romantic provisionality and incertitude. The viewer is firmly positioned by the painting in the role of

detached spectator, an implied physical situation symptomatic of the moral-intellectual-emotional view enforced upon him. Visually, *The Blind Girl* is built on principles of clarification and detachment; narratively, it conveys an equivalent singleness of meaning and affect.[3]

So it might be fair to call Millais's painting conceptual rather than narrative. There is little action *in* the painting, and the stillness of the human subjects is reinforced by the lack of interplay betwen visual elements—the scene strikes one not merely as static but as strangely empty. In part this effect is produced by the clarity of minutiae, a clarity that unlike the clarity of, say, Caspar Friedrich, excludes the enigmatic. The butterfly, for instance, is motionless, not the smallest part of it blurred by the palpitations of life. The stains, tears, and broken stitching of the girls' skirts likewise prevent us from sensing any of the intricate foldings and fallings of cloth over living limbs. The intense exactness of literal detail may not betray Millais's lack of emotional involvement in his ostentatiously pathetic subject, but it encourages an uncomplicated affective response.

Often the narrative in a Victorian painting is not so immediately clear as that of *The Blind Girl* and must be puzzled out by the viewer, who reconstructs the story by determining the narrative significance of various details. But what is reconstructed is usually a single story, so the readable situations of Victorian painting attract something closer to the puzzle-solving interpretations demanded by Hogarth's pictures than the kind of creative response provoked by Romantic art. And early modern art rejected Victorian readability as vigorously as Pre-Raphaelite clarity distinguished itself from the blurriness of Constable and Turner.

To turn from *The Blind Girl* to *Salisbury Cathedral, From the Meadows* is to feel plunged into a densely muddled, bewilderingly interactive world of continuously interpenetrating sensations.[4] Lines are lost in blots and blurs; hues are shadowed, dominated by mixtures of brown, olive green, and bluish gray in which nothing is totally distinct in itself. Though there are several human figures in the scene, all are small, almost lost amid the landscape. Chiaroscuro details are suggested by relations between dashes of paint contrasting light and dark. At a distance from Constable's picture, one imagines one sees objects; but on closer inspection, these turn out to be flecks of pigment. The closer one comes to Millais's painting the more distinctly the butterfly appears as a butterfly. But

Constable's brushstrokes work in an opposite fashion, assuring that as one comes nearer his painting ambiguities increase. What at a distance is perceived as light flashing on the stream, up close appears as squiggles of white paint. Up close one sees the man in the cart is accompanied by a woman whose arm seems tucked under his. What is their relation?

The viewer's "ideal" position before Constable's work is difficult to define because the picture, itself densely complex, changes as one draws near to or away from it, although what one has seen from an earlier position remains in one's mind. When one backs off after a close inspection, one can no longer actually *perceive* the woman, mostly hidden by the man in the cart, but one *imagines* her vividly. Herein lies the excitement of Constable's landscape: it arouses the viewer's imaginative perceptions. One apprehends more *in* the painting the longer and the more often one views it from different vantage points. After one has closely inspected the dashes of paint that had seemed from a distance the flash of reflected sunlight off the stream, one backs away again to find that the image of reflected light is recreated more strongly than before. No longer merely "taken in" by an optical illusion, we understand how and why the illusion has been worked and then consciously participate in recreating the illusion. Thus each viewer re-enacts (to a degree at least) the painter's creative artifice.

The canvas's spatial appeal to our imagination is complemented and heightened by our temporal experience of the picture: a single viewing cannot exhaust the range of imaginative participation made possible by the painting. When, say, one returns at a later time to re-view the picture, subliminal memories of transformations in one's earlier perceptions enhance and complicate the new response. One cannot offer a single, definitive meaning for *Salisbury Cathedral*; conceptually as well as visually it is deliberately indefinite. Filled with uncertainties, that is, with possibilities and obscurities, it does not tell a simple story but renders the tensions of contradictory forms and significances. Natural growth and decomposition interpenetrate: the dead trunk at the right puts forth new shoots, and the river banks ooze with a luxuriant decay of muddy fecundity. The clouds above surge in such a turbulence of light and dark that one may at first be unsure as to whether they are dispersing or reassembling, whether the rainbow signals a full clearing or is about to give way to renewed storm.[5]

This chiaroscuro of meaning is reinforced by the fitful light on

the stream and meadow, indeed, by all the events in the painting. The horses, seeming to feel for footing on mucky bottom, draw what I take to be a hearse against the movement of the wind, which sweeps the leaves and branches to the left. And the counteractive tonal movement from dark left to bright right is intersected by the shadowed vertical upthrust of the cathedral under the arc of the rainbow, whose apogee lies beyond the frame of the painting. Just as the frame thus arbitrarily cuts off the painting, compelling us to imagine what lies beyond, so the meaning of the cathedral or of the rainbow is not definitively delineated. If the woman in mourning in the hearse "moves" from darkness to light, from somber graveyard to the plunge of the heavenly bow to earth on the luminous right, as the cathedral rises from decaying earth toward prismatic light, the very naturalism of life and death on the earth, the turbulence of the clouds, the flickering changes of light, even in the bow itself (no illustration of Newton but a water-dimmed arc that scarcely gleams beyond the blue portion of the spectrum)—all these features render the message of hope and salvation uncertain. The cathedral rises magnificently with the decisive rational lines of geometric planning toward the arch of heaven. But the angle of view makes the dark trees to the left seem to tower almost ominously above the edifice, as they tower over the cemetery. And against the cathedral's magnificence stands another contrast of the anonymous people in the foreground, unattending to either the greatness of the church or the grandeur of the sky, between land and water, bound to their absorbing but commonplace purposes. We glimpse for a moment a dark-light movement seeming to follow upon a darkening of light in a scene ever-changing and self-opposing, of which the people are among the smaller and less imposing elements. The dog stops, turning his head toward—what?

Dubiety enters every aspect of the painting, which creates a dialectical tension between its representation of a famous monument and its representation of anonymous rural life and death, a veritable conflation of genres, whose significance is signaled by the indifference of the figures in the painting to the grandeur, natural and cultural, which the spectator admires. Millais's blind girl cannot see the rainbow, toward which her companion turns, but in Constable's scene none of the figures pay attention to either cathedral or sky, so the spectator's admiration is contaminated by a recognition of possible estrangement. Whereas in Millais's picture significance develops through either-or contrast (we and the com-

panion see as the blind girl cannot), in Constable's we must construct possible meanings out of less clearly delineated differences and relations.

One can, finally, even perceive these indeterminacies refracted through Constable's many "versions" of Salisbury Cathedral.[6] Like Wordsworth revising *The Prelude*, Constable tends to return repeatedly to the same subject, not to perfect one rendering, but rather to emphasize the endless diversity of views and perspectives of ever-changing contingencies of natural existence. Constable's re-visions of the cathedral in a series of canvases parallel a viewer's re-visions of a single canvas, and the viewer's complex of responses to any one version of the cathedral is enhanced by encounters with the others.

Any interpretation of *Salisbury Cathedral* must to a degree be indeterminate. Interpreting this painting is not, as with *The Blind Girl*, finding a single meaning but engaging imaginatively in diverse, even opposed, possibilities. To interpret Constable's picture is to admit various potentialities as one enters into the dubieties of creating a vision of hope out of a world of evanescence where life out of death is the natural order of things. We see the sublime soar of the cathedral as enduring, the very opposite of a ruin, yet we see it across rotted remnants of human structures already proved transient. And in the muck of the river banks, the shimmer of the soaked field, the dirty flow of the clogged stream, and the bending branches under a wet wind there is a beauty against which the aspiration embodied in the cathedral may seem almost strained and futile. Indeed, the central image, the cathedral spire lifting to the fading heavenly arc, is powerful largely because it condenses all the ambiguities of conjunctions appearing everywhere in the painting. We turn from the picture, finally, not possessed by an idea or a concept, but with a confused sense of an experience whose significance resists formulation.

PASSIVE AND ACTIVE READERS

In turning now to a comparison of Tennyson's "Enoch Arden" and Wordsworth's "Michael," I follow the lead of Walter Bagehot, who, more than a century ago, first used "Enoch Arden" to develop a contrast between what he called the "ornate" art of Tennyson and the "simple" art of Wordsworth, though it may seem that I am reversing his designations.[7] My contrast is to a degree unfair.

"Michael," of course, has long been regarded as one of Words-worth's most successful and important poems. "Enoch Arden" is not usually so regarded; Tennyson probably thought of it as an ex-periment in Pre-Raphaelite technique. But Bagehot was justified in treating "Enoch Arden" as representative of some essential quali-ties in Tennyson's poetry. There is cogency, for example, in Bage-hot's objection to Enoch feeling "nothing else but these great splen-dors" on the tropical island upon which he has been marooned, and justice in the critic's praise of the poem's skillful depiction of the "half-belief" he saw as characteristic of the Victorian era. But most revealing is Bagehot's attitude toward Enoch himself, who "could not have been charming," for "people who sell fish about the country (and this is what he did, though Mr. Tennyson won't speak out, and wraps it up) never are beautiful." More explicitly, Bagehot observes:

> Many of the characters of real life, if brought distinctly, prominently, and plainly before the mind as they really are . . . are doubtless very unpleasant. They would be horrid to meet and horrid to think of. We fear it must be owned that Enoch Arden is this kind of person. A dirty sailor who did *not* go home to his wife is not an agreeable being. . . . Nothing is more unpleasant than a virtuous person with a mean mind. A highly developed moral nature joined to an un-developed intellectual nature, an undeveloped artistic nature, and a very limited religious nature, is of necessity repulsive.

We don't know how Tennyson felt about Bagehot's judgment; so far as I know he never publicly objected to it. But we do know that Wordsworth wrote "Michael" with the conscious hope of enlight-ening snobs of Bagehot's sort. Wordsworth sent a copy of the sec-ond edition of *Lyrical Ballads* (in which "Michael" appears as the final poem, having been written as a substitute for "Christabel") to Charles James Fox with a letter explaining he did so because of two poems, "The Brothers" and "Michael." These, the poet says, deal with "a rapid decay of the domestic affections among the lower orders of society," which Wordsworth maintains "the present Rulers of this country are not conscious of, or they disregard." Words-worth goes on to observe that "spreading of manufactures" and new social measures, such as work houses, are much to blame, and that

> the evil would be the less to be regretted, if these institutions were regarded only a palliatives to a disease; but the vanity and pride of their promoters are so subtly interwoven with them, that they are deemed great discoveries and blessings to humanity. . . . Parents are

separated from their children, and children from their parents; the
wife no longer prepares with her own hands a meal for her husband,
the produce of his labor; there is little doing in his house in which his
affections can be interested, and but little left in it which he can love.[8]

These domestic affections, Wordsworth explains, he has tried to
portray in Michael, who belongs to "a class of men who are now
almost confined to the North of England":

> small independent *proprietors* of land here called statesmen, men of
> respectable education who daily labour on their own little proper-
> ties. The domestic affections will always be strong amongst men
> who live in a country not crowded. . . . But if they are proprietors of
> small estates, which have descended to them from their ancestors,
> the power which these affections will acquire amongst such men is
> inconceivable by those who have only had an opportunity of observ-
> ing hired labourers, farmers, and the manufacturing Poor. Their little
> tract of land serves as a kind of permanent rallying point for their
> domestic feelings . . . a fountain fitted to the nature of social man
> from which supplies of affection, as pure as his heart was intended
> for, are daily drawn.
>
> (pp. 314–15)

Asserting that Fox has long publicly supported policies which
would preserve these virtues, the poet observes:

> You have felt that the most sacred of all property is the property of
> the Poor. The two poems I have mentioned were written with a view
> to shew that men who do not wear fine cloaths can feel deeply. . . . I
> hope, whatever effect they may have upon you, you will at least be
> able to perceive that they may excite profitable sympathies in many
> kind and good hearts, and may in some small degree enlarge our
> feelings of reverence for our species, and our knowledge of human
> nature, by shewing that our best qualities are possessed by men
> whom we are too apt to consider, not with reference to the points in
> which they resemble us, but to those in which they manifestly differ
> from us.
>
> (p. 316)

Wordsworth's letter is specially significant in revealing the poet
to be free at this time of the sentimentalizing that enfeebled so
much overtly picturesque art of the epoch, which frequently repre-
sented rural figures and scenes as if there had been no violent
agrarian dislocations in the later eighteenth century. We strike here
upon one of the principal reasons that Wordsworth, like all the
major Romantic artists who were sensitive to the profundity of so-
cial transformations in their day, rejected "official" picturesque

doctrine even while adopting some of its central tenets (see chapter 4). For "Michael," Wordsworth claims, originates in an anguished awareness of the devastation being wreaked in traditional rural life, and the poem is meant to challenge and improve its readers, to change people's minds and hearts on a specific social issue. Though the polemic in "Michael" is not quite so simple as Wordsworth's letter may suggest, the poem's composition is intended to force readers to imagine aspects of the shepherd's situation not distinctly delineated by the poet.

The contrasting passivity imposed on Tennyson's reader is apparent from his poem's first line:

> Long lines of cliff breaking have left a chasm;
> And in the chasm are foam and yellow sands;
> Beyond, red roofs about a narrow wharf
> In cluster; then a moulder'd church; and higher
> A long street climbs to one tall-towered mill;
> And high in heaven behind it a gray-down
> With Danish barrows; and a hazel-wood,
> By autumn nutters haunted, flourishes
> Green in a cuplike hollow of the down.[9]

This ostentatiously pictorial image makes sense from one position only, from the sea, with the eye gradually traveling upward (after descending from the distantly seen skyline of cliffs). But the restriction of the viewer's position toward this nameless village is disturbed by the temporal uncertainty of "breaking," which at first can be read as "now breaking" rather than "having been broken off."

This detail dramatizes an important contrast between "Enoch Arden" and "Michael," which begins with a less restrictive positioning of the reader but a more specific location, Green-head Ghyll, and a clearer temporal ordering:

> If from the public way you turn your steps
> Up the tumultuous brook of Green-head Ghyll,
> You will suppose that with an upright path
> Your feet must struggle; in such bold ascent
> The pastoral mountains front you, face to face.
> But, courage! for around that boisterous brook
> The mountains have all opened out themselves,
> And made a hidden valley of their own.
> No habitation can be seen; but they
> Who journey thither find themselves alone
> With a few sheep, with rocks and stones, and kites
> That overhead are sailing in the sky.

Immediately, we notice Wordsworth's bold use of the perpetual present, the present moment of a person who begins to read the poem, so different from Tennyson's time-confusing "breaking" followed by the "timeless" present of description. Wordsworth's "you" is any reader, but always the particular person reading the poem "now." The events in the poem, therefore, are oriented toward the moment of reading, as the conditional "If" and "you will suppose" emphasize. Like Constable, Wordsworth desires and structures his art to accommodate some freedom on the part of his audience. Their art both portrays diverse possibilities of life and encourages diverse possibilities of response. The end of the introduction to "Michael," in which the poet looks ahead to his "followers" after his death, likewise provides a continuing link to him for all future readers and readings. Time is important in "Michael," but temporal processes *in* the narrative are connected to both the poet's and the reader's necessarily special temporal perspectives. History is thus made intrinsic to the experience of reading the poem: the history of Michael, that of the poet, and that of the reader are interrelated. This is why one ends at the same place one begins, the boisterous brook of Green-head Ghyll. Time has passed while we read, and our consciousness of how time may be experienced by human beings has been intensified, as we become aware when we find ourselves once again where we turned off "the public way."

In contrast, Tennyson's poem is not itself involved in temporal processes. Both Tennyson and his reader stand outside the poem's flow of time. Although Tennyson's tale is, like Wordsworth's, about the effects of time, the narrative is presented as purely past, definitely separated from the current experience of poet or reader: "Here on this beach a hundred years ago" (line 10). The reader's detachment is reinforced by this line, which now, a hundred years after its composition, confounds the date of the poem's events. Wordsworth's perpetual present and his comment on his followers allow us a specific and personal perspective (though different from that of a reader of 1800 or 1880) on the events of his poem even 180 years after it was composed. As a result, a reader is likely to feel closer to Michael and his history than to Tennyson's protagonist.

Tennyson, however, does not so much want to leave us free to imagine from our own viewpoint as to provide a typological orientation that will allow us to feel fully his story's pure pathos. He consistently precludes dubieties that the situation of "Enoch Arden" would permit, might even seem to encourage, ambiguities which

might provoke us into complex imagining. Like Millais, he uses microscopically precise details to separate and distinguish and thereby articulate a single affective meaning. Even granting Bagehot's objection to the account of Enoch on the island, that passage develops some real power because, unlike much of the poem, it builds around a paradox: the sailors

> Set in this Eden of all plenteousness,
> Dwelt with eternal summer, ill-content.
> (lines 557–58)

But even this contradiction is kept as clear and simple as possible. Tennyson does not seek to evoke in us any kind of self-contradictory complexity of response (such as is evoked by "Michael"), as is illustrated by his stylizing of economic motives, his simplifying of possible conflicts between emotional and financial necessities. Though the last lines of "Enoch Arden" have been condemned as vulgar, the "costlier funeral" corresponds to the characters' consistent motivations throughout the poem. Enoch labors diligently and saves frugally to be able to marry Annie and then to give his children "a better bringing-up than his had been." He sails off to earn money, setting up Annie with a store. It is Philip's wealth that saves her, and it is the affluent comfort of his family, seen through the window, that impels Enoch to repress his urge to reveal himself on his return. At no point, however, does Tennyson permit us a response other than approval of these motives and pity for their unfortunate results. We are meant to sympathize with, if not admire, Annie's incapacity as business woman as a sign of her moral worth. Yet, aside from its sexism, this appeal is incompatible with approval of Enoch's drive for economic betterment. But we are not intended to make that complicating connection. Just as Tennyson strives to make us sharply visualize features of place or building, figure or scene, so we are regularly directed by him to admire without qualification the sorrowful nobility of Enoch's situation and behavior—and if we resist, as Bagehot's critique shows, we ruin the poem's "readability."

Tennyson's simplifications and clarifications seem literary equivalents to Millais's pictorial stylizations in that both works require us to perceive and respond emotionally to objects presented as separated from ourselves. The exactness of so-called microscopic realism emphasizes separation—the microscope is an instrument for seeing systems of existence different from that of the observer. The

analogy between painting and poem is illustrated forcibly by the crucial, and most celebrated, passage in "Enoch Arden," that describing Enoch looking through the window—another example of Victorian protagonist as spectator.

> For cups and silver on the burnish'd board
> Sparkled and shone; so genial was the hearth
> And on the right hand of the hearth he saw
> Philip, the slighted suitor of old times,
> Stout, rosy, with his babe across his knees;
> And o'er her second father stoopt a girl,
> A later but a loftier Annie Lee,
> Fair-hair'd and tall, and from her lifted hand
> Dangled a length of ribbon and a ring
> To tempt the babe, who rear'd his creasy arms,
> Caught at and ever miss'd it, and they laugh'd;
> And on the left hand of the hearth he saw
> The mother glancing often toward her babe,
> But turning now and then to speak with him,
> Her son, who stood beside her tall and strong,
> And saying that which pleased him, for he smiled.
> (lines 738–53)

This description recalls to us many Victorian paintings—Martineau's *Last Day in the Old Home* may ironically come to mind, for example—but it is unlike "Michael." The contrast between the two poems is vivid because the plot of each turns on a journey away from home to seek economic reward in order to establish "home," and at the climax of each the protagonist meets with failure. Enoch does not cry out; Michael does not finish the sheepfold; both suffer loss and absence. Tennyson's source, however, is literary; he elaborates on previous poems.[10] Wordsworth writes from daily life, of events that really happened but of a kind never before treated in literature; he confronts his reader with actual experience valued as actual experience, and the reader must, in the language of "Simon Lee," "make something" of material not before transformed into literature.

REVELATIONS OF CONTINUITY

A comparison with Constable's practice may clarify the significance of Wordsworth's singularity. To a viewer of *Salisbury Cathedral* the painter's careful studies of actual cloud formations are irrelevant, except that through what he learned in making those studies Con-

stable succeeds in presenting clouds one is tempted to study as if they were real. Even more germane, however, are Constable's compositional devices for rendering the individuality of his scene. One might find the exact positions from which Constable worked, but the conditions he depicted are irrecoverable (if they once actually existed): the Romantic artist retrieves for us what he perceives as irretrievably lost to us. The Romantics enable their audience to appreciate an individual and evanescent moment valued for its individuality and evanescence. This requires the Romantics to explore new modes of representation, including some radical decenterings. In Constable's painting, for example, the proliferation of centers of interest precludes any dominant visual hierarchy. Some of these foci seem contradictory, and, because the scene is windy, much of what we see is in motion, literally destablized, while the meadow in the middle distance appears brilliant because empty. The meadow, defined by transient gleams of light, is literally indeterminate in form, even as its place in the scene is off-center in a middle distance.[11]

Analogously, Wordsworth lures his reader into a kind of off-center middle distance of the historical actuality of Michael's life. Addressing the reader directly in the first line of the poem, Wordsworth calls our attention to a specific locale, the brook of Green-head, wherever that may be, but presumably a locale unfamiliar to the reader, and then, anticlimactically, to a more sequestered spot in the mountains, a spot that seems to me a literary equivalent of Constable's illuminated empty meadow:

> a few sheep, with rocks and stones, and kites
> That overhead are sailing in the sky.
> It is in truth an utter solitude.
>
> (lines 11–13)

This empty scene prepares us for the final experience of the poem's anticlimactic climax. What engages the reader throughout "Michael" is not simply what happened (a central concern for the reader of "Enoch Arden") but what we are to make of what happened. The unique specificity of unfamiliar Green-head Ghyll and the sequestered spot foreshadows the specificity of Michael's actual experiences of places and persons, experiences unknown and in any direct sense unknowable to the reader. The poem works to enable the reader to recreate and thus to know the unknown Michael. This process, paralleled in "Tintern Abbey," is the inverse of defamiliar-

izing, the stripping away a veil of familiarity from commonplace phenomena; rather, the poet enables us to share his unique familiarity with a particular scene presumably unknown to us.

How does the poet lead us to know the unknown? Wordsworth calls attention to the "heap of unhewn stones" that one "might pass by, / Might see and notice not," which led to "the first / Of those domestic tales" and enables him as a boy "to feel for passions that were not my own," that is, to have experienced what the reader of "Michael" will experience. The poet then says that he will retell the story

> for the sake
> Of youthful Poets, who among these hills
> Will be my second self when I am gone.
> (lines 37–39)

This is the sole occasion upon which Wordsworth so speaks of poetic followers among his hills. I am persuaded that we are meant at the end of the poem to realize retrospectively the concealed truth of what Wordsworth foresaw: there will be no followers for the poet, no second self, as for Michael there was no son, no inheritor. The failure and loss that beset the shepherd's life reflect the fate of the poetic tradition.

Wordsworth is not playing a clever game. He enables his reader to achieve the difficult feat of imaginatively feeling for something that happened long ago to an unimportant human being—that is to say, to experience a unique, unrepeatable confluence of contingencies. Wordsworth's art gives life to the significance of unique experience *as such*. So the poem, though dependent on the existence of literary tradition, must nevertheless not be traditional, must be, as Michael himself was, singular. The poem is, as its subtitle indicates, a pastoral, but not a conventional pastoral. Only human tradition can redeem what has permanently vanished from the physical natural world. A literary tradition is composed of singular works from whose partial similarities we fabricate the "tradition" to which no one poem completely adheres. This fictiveness of tradition illumines the paradox that individual human experience can be preserved only through "tellings" of it. Individual actuality is preserved by fiction, as the opening lines of "Michael" make clear. Here, as throughout the poem, we are aware that the reality of which the poet tells us was never part of his own experience, was only something he had been told about. Wordsworth deals in things

heard, not seen, with verbal fabrications, not sensory actualities, because only so can Michael live on in others' imaginations.

Yet traditional tales and myths fare badly in "Michael." The career of Richard Bateman, the local Dick Whittington, is inverted by Luke, as is the overarching pattern of Abraham's sacrifice of Isaac and the parable of the Prodigal Son from the Gospel of Luke. "Michael" remains particular, peculiar, unique; its story is deliberately ectypal, not archetypal. Like Constable's brushstrokes, Wordsworth's details are not sharp, clear, distinct; his narrative elements blur, blend, and interact. They, too, provoke the audience to imagine rather than try to reproduce literal perceptions. Since "Michael" is a poem, its strokes of art are temporal rather than spatial. The shifting and layering of time that begins in the opening lines continues throughout, and "Michael's" anticlimactic climax is the reverse of the frozen momentary visualization of the family seen through the window in "Enoch Arden." The tragic culmination of Michael's story is, like the place to which we are first conducted in the introductory lines, an "utter solitude" in which nothing sublimely impressive is to be seen.

There is in "Michael" no instant of culmination. The experience of the shepherd (like that of those who sympathetically watch him or those who later hear of him) is not momentary, is not represented through what can be rendered as a timeless image. The conclusion does not allow us any single or simple perspective on Michael's situation. We are reminded that we are hearing only what the poet himself heard only diffusely and diversely: "I have conversed with more than one who well / Remember the Old Man [at the time of Luke's defection] and what he was / Years after he had heard the heavy news." This presentation of a span of time *as* a span of time is characteristic of the entire poem, in which no event is separated from the flow of time. Each instant is to be apprehended as part of a temporal continuity in which "now" is undetachable from "before" and "after."

The life of the shepherd is conceived as meaningful only in its continuity: the individuality of Michael is the nature of his entire life. Uniqueness of experience is not a feature of one or more specific episodes, of any dramatic moment or epiphanic event, but of the continuity of an entire life. This is why mythic patterns are not fulfilled in "Michael," for they would but reduce the entirety of an extended temporal continuity to a timeless structure of meaning. But no such structure can define Michael's life experience.

Even the episode of Luke laying the cornerstone of the sheepfold avoids pictorial effects, foregrounding instead temporal relations by presenting the event almost entirely through Michael's words to Luke.[12] At first the shepherd speaks principally of "our two histories," and throughout speaks of the present as a continuity between past and future.

> To-morrow thou *wilt* leave me; with full heart
> I *look* upon thee, for thou *art* the same
> That *wert* a promise to me ere thy birth,
> And all thy life *hast been* my daily joy.
> (lines 332–35, my emphasis)

Michael says that in him and Luke "the old and young / Have played together" as a kind of repayment for the gift of love bestowed on him by his parents,

> for, though now old
> Beyond the common life of man, I still
> Remember them who loved me in my youth.
> (lines 364–66)

And Michael wishes his son "should'st live the life they lived."

The poignant overtones in Michael's words spring from his half-awareness of a temporal disorder precipitated by his decision to send Luke away. His "we both may live / To see a better day" thus appropriately introduces the powerful ambivalences of his final exhortation. "I will begin again," he says, promising to take up once more tasks he had resigned to his son, but he observes that Luke's "heart these two weeks has been beating fast / With many hopes" for his new life. The contradictions inherent in his emotional honesty are rendered by inconsistency in his words that follow:

> it should be so—yes—yes—
> I know that thou could never have a wish
> To leave me, Luke; thou hast been bound to me
> Only by links of love; when thou art gone,
> What will be left to us! But I forget
> My purposes.
> (lines 398–403)

The confusion of father and son's interlocked, uncompleted "histories" impel the reader to imagine the shepherd's perplexed ambivalence of the moment in terms of the long relation of deep affection. Luke "should" have hopes away from his father, who "knows" the

boy could never wish to leave him. Subtler is the omission from the following phrase of an expectable introductory "for," so that we understand Luke has been "bound" firmly to his father because their only "links" were "of love." Yet, simultaneously, we appreciate the shepherd's hidden fear that links of love alone may not be enough, as indeed they prove not to be. Beyond that ambiguity lies the sure emptiness in the life of Michael and Isabel when Luke pursues his hopes, aroused by the shepherd himself. Given this context, Michael's plural "purposes" seems all too correct, though we might be hard put to define all of them.

The foregoing prepares us for the curiously uncertain admonition to Luke as he lays the cornerstone of the covenant. In a presentiment of evil, Michael urges his son to think, not of this scene, but of "this moment," and to remember "the life thy Fathers led." Again the reader is moved beyond the immediate circumstances to imagine "things thou canst not know of," both past events and future possibilities. So Luke's going is evoked in terms of his possible return, then to perceive what now does not exist.

> Now, fare thee well—
> When thou return'st, thou in this place wilt see
> A work which is not here.
> <div align="right">(lines 412–14)</div>

The ironic potential of these lines, refracting the earlier irony of the assertion that God will strengthen Luke in his need, is deepened by Michael's fears:

> whatever fate
> Befall thee, I shall love thee to the last,
> And bear thy memory with me to the grave.
> <div align="right">(lines 415–17)</div>

The full import of the last line will register on us when at the end of the poem we imagine the shepherd's desolate last years, desolate *because* he remembers.

Even the immediate instant of the covenant making, then, is presented less as a definite scene, as a visual image, than as the *sound* of Michael's words to Luke, words evoking passionate ambivalences, fears and desires bound in with experiences of times past and possibilities of a doubtful future. The reader, rather than seeing, hears, almost as if he himself were Luke, even to but partly comprehending the old man's conflicting feelings. Michael's speech is

not muddled, but its coherence derives from so many years' experience, so much silent thought and unarticulated affection, that his expression must resonate confusingly.

As no single view of *Salisbury Cathedral* in either time or space is definitive, so for Wordsworth "experience" is falsified if rendered through the isolation of one or more "dramatic moments." Even the poet's representation of the shepherd's crushing sorrow, therefore, must consistently draw us from temptations to reduce that experience to a singular, neatly visualized image. Wordsworth gives us a blurred impression of diverse acts, not one distinct picture of the shepherd but an indefinite outline of his years of sorrow; not sights but tales of remembered glimpses, and imaginings of what he may have done or how he may have appeared. It is worth rereading the celebrated final "description" to observe how indefinite and undescriptive it is.

> I have conversed with more than one who well
> Remember the Old Man, and what he was
> Years after he had heard this heavy news.
>
> [he] as before
> Performed all kinds of labour for his sheep,
> And for the land, his small inheritance.
> And to that hollow dell from time to time
> Did he repair, to build the Fold of which
> His flock had need. 'Tis not forgotten yet
> The pity which was then in every heart
> For the old Man—and 'tis believed by all
> That many and many a day he thither went,
> And never lifted up a single stone.
>
> There, by the Sheep-fold, sometimes was he seen
> Sitting alone, or with his faithful Dog,
> Then old, beside him, lying at his feet.
> The length of full seven years, from time to time,
> He at the building of this Sheep-fold wrought,
> And left the work unfinished when he died.
> (lines 451–72)

No visualization of a dramatic instant, as when Enoch looks in the window; rather, Wordsworth, like Constable, arouses our imaginatively creative response by diffusing and destabilizing visual clarity, by dissipating definiteness: "all kind of labor," "from time to time," "sitting alone, or with." Such details are in keeping with the manner of the entire poem, which always encourages us to respond creatively, from our individual perspective, to people, places, and

actions as inseparable elements in unified temporal processes. All of life Wordsworth represents as "in motion," ongoing, so experience never cleanly separates now from then (for characters in the poem or readers of it), each moment being an interaction of half-felt memories, present sensations, uncertain prospects.

<div align="center">

THE COMMONPLACE TRAGEDY OF
A HUMANIZED WORLD

</div>

Just as Constable's painting embodies a complexity of vision of humanity's insecure relations with the natural world and with the divine that Millais in his painting simplifies, so Wordsworth's poem inscribes within its narrative self-contradictions alien to Tennyson's art. The plot of "Enoch Arden" is founded on sheer repression: Enoch's supreme act is to suppress his desire to cry out. Deliberately, though with anguish, he keeps silent. And we are asked to admire him for so acting, or rather not acting. Most of us can do so, but we are likely to feel that Tennyson hardly does justice to the ambiguities of repressive behavior. Bagehot's acute objection to the "long convulvuses" and "scarlet shafts of sunrise" not in themselves but as unmitigated by the small pains and dull incertitudes of actual experience points us toward Tennyson's reluctance to confront the moral doubtfulness that must be a part of Enoch's stoic heroism. But such reluctance is inseparable from Tennyson's style of presentation, which is an essentializing style.

 Wordsworth does not morally oversimplify, even though, as I have noted, "Michael" is polemical. Wordsworth's poem, unlike his letter to Fox, recognizes a contradiction in Michael's love for his land. He tells Isabel

<div align="center">

the land
Shall not go from us, and it shall be free;
He [Luke] shall possess it, free as is the wind
That passes over it.

(lines 244–47)

</div>

"Free" here arouses ambiguous implications, as is emphasized by a second use of the word when Michael speaks to Luke:

<div align="center">

And till these three weeks past the land was free.
—It looks as if it never could endure
Another Master.

(lines 378–80)

</div>

The land was "free" because owned by Michael. The freedom of possessing property is not the freedom of the wind, blowing where it listeth. Wordsworth is no proto-Marxist, and he certainly admires his shepherd statesman. But because his art works against separations of every kind and against singleness of meaning, he cannot shrink from representing the ambiguity at the core of Michael's heroism. Unlike Tennyson, Wordsworth must explore the doubtful and dangerous relation of affectional and economic desires. Michael is not evil, but his love is possessive. Subtly, if sympathetically, Wordsworth shows us Michael's admirable, ennobling love for his son inevitably tinged by selfishness, for which we cannot condemn him, if only because it is he himself who makes the last seven years of his laborious life an empty hell. Like other aged tragic figures—Lear and Oedipus at Colonus come to mind—Michael reveals the corruption in the most human of hearts. "Michael" goes beyond its polemic purpose in demonstrating how the bonds of human affection at their purest make us vulnerable to moral confusion and terrible accidents.

The poem reveals that human beings are exposed to frightful suffering because our affections can adequately be articulated only through cultural modes. The love of a parent for a child is in no significant sense merely biological (a point whose significance in Blake's art I discuss in the next chapter). Parental love exists through purely human, that is, cultural relations, and is, like the ownership of land, unnatural—animal territoriality, for instance, never includes inheritance. What makes us distinctively human is what makes our lives tragic, which is why the ceaseless, senseless, "boisterous brook" of Green-head frames, at first so brightly, at the conclusion so darkly, Michael's experience.

If "Michael" is tragic, it is not theatrical in the usual sense. Even the completeness of the story is dependent on the undramatic trailing off of the shepherd's life. The poem is totally without the theatricality of the climactic scene of "Enoch Arden," in which we see, as in a theater, Enoch looking through the window into a brightly lit stage set. Tennyson tells us that this perception affected Enoch more than his landlady's account of the situation, "because things seen are mightier than things heard" (line 762). Yet the poet would seem to contradict himself when he describes how Enoch immediately after the sight

> Stagger'd and shook, holding the branch, and fear'd
> To send abroad a shrill and terrible cry,

Which in one moment, like the blast of doom,
Would shatter all the happiness of the hearth.
(lines 763–66)

Sound possesses the power to destroy the picture. That Tennyson should slide into inconsistency is not surprising, for poetry is an aural, not a visual, medium, yet the poet has committed himself to primacy of visual imagery, to instants of sight, the distinct, isolated, essential moment of physical perception. The inconsistency epitomized by line 762 perhaps expresses Tennyson's unhappy awareness of loss of an effective *voice*, the surfacing of strain in relations between an artist and his audience. For in light of Tennyson's many ostentatious auditory splendors—which tend, however, toward inhuman roars, murmurs, and the like—the hyperpictorial vividness of the poem's climactic vision impresses me as a symptom of art in stress. The hyperbolic repression of lines 763–66, then, may be regarded as a kind of desperate protest against the devocalization of art toward which the Victorian artist, however reluctantly, is carried.

Such a view is supported by Joseph Frank's famous discussion of spatial form in modern literature, especially through his linkage of literary and graphic phenomena, for example:

> Just as the dimension of depth has vanished from the sphere of visual creation, so the dimension of historical depth has vanished from the content of the major works of modern literature. Past and present are apprehended spatially, locked in a timeless unity that while it may accentuate surface differences eliminates any feeling of sequence by the very act of juxtaposition.[13]

Not yet adequately understood is how antithetical to Romantic practice is this aspect of Modernism, which Victorian art, especially in its visual intensity, initiates.[14]

To Wordsworth poetry is an art of sound: words not sights, the verbal not the visual, are to him—as to all the Romantic poets—primary. As Constable seems a more painterly artist than Millais, less drawn from the purely perceptual and the intensely visual toward the verbal and conceptual, so Wordsworth seems more committed than Tennyson to poetry as aural art.[15] All the artistry of "Michael" stands in contrast to Tennysonian visualizing, from the poem's introduction, which assures us that only through story, through tellings, through things heard, can the actuality of Michael's experience be preserved, to its conclusion in which the antagonism

of the human and the natural is dramatized by the deliberate dark-
ening of what had seemed originally a casual pathetic fallacy of the
"boisterous" brook. The fallacy is, of course, a verbal device, ex-
hibiting the creative linguistic response of a man to sensory experi-
ence. The "fallacy," in fact, embodies a conscious attribution of
human desire to phenomena recognizedly nonhuman, the situa-
tion near the heart of Romantic efforts to humanize their world.[16]
They seek not to impose man's artifice on nature but to articulate
possible conjunctions between the exterior world of sensation and
the inner world of psychic impulse. So to humanize gives no as-
surance of specific happiness; indeed, it is to open the way to
seeing more profoundly into the tragedy of the human condition,
as "Michael" permits us to perceive. Yet, simultaneously, it is the
possibility of fit meeting between natural world and human imag-
ination that allows a poem to celebrate the dignity of an ordinary
man in the very revelation of his vulnerability.

3

Ditties of No Tone

If the poet in "Kubla Khan" could "revive" within himself the "symphony and song" of the Abyssinian maid, he would "build" with "music." Coleridge's poem, beginning with its fictionalizing prose "preface," is a paradigm of the Romantic subsuming of music into poetry. To explore the Romantic poets' particular uses of music, I want to contrast songs by William Blake, *Songs of Innocence* (1789), with songs by Burns, *Poems Chiefly in the Scottish Dialect* (1786). Whereas Burns's songs, like authentic ballads, are meant to be sung and performed for and with others, for his Romantic near-contemporaries, song and ballad are rhetorical, rather than melodic, forms. Simply put, neither Blake's brightly colored *Songs of Innocence* and *Songs of Experience* nor Wordsworth's *Lyrical Ballads* are primarily intended to make us sing. I conclude my analysis by extending my comparison to Wordsworth's "Solitary Reaper," wherein some of the most significant effects of the Romantic poets' fictionalizing of music become dramatically apparent.

FALSE SONGS OF TRUE INNOCENCE

Let us begin our consideration of *Songs of Innocence* with the Tyger's antithesis, "The Lamb," the poem which Vaughan Williams had the most difficulty setting to music.[1]

> Little Lamb who made thee
> Dost thou know who made thee
> Gave thee life & bid thee feed.
> By the stream & o'er the mead;
> Gave thee clothing of delight,
> Softest clothing wooly bright;
> Gave thee such a tender voice,
> Making all the vales rejoice!
> Little Lamb who made thee
> Dost thou know who made thee

Little Lamb I'll tell thee,
Little Lamb I'll tell thee!
He is called by thy name,
For he calls himself a Lamb:
He is meek & he is mild,
He became a little child:
I a child & thou a lamb,
We are called by his name.
Little Lamb God bless thee.
Little Lamb God bless thee.[2]

Modern critics tend to encrust this poem's simplicity with distorting complexities. "The Lamb" is deliberately superficial, directly evoking identity in multiplicity, three who are one: child, lamb, Christ. Rational analysis would divide this unity and from the division fabricate what—to Blake—would be a false coherence. Innocence for him is a condition in which integral, independent entities exist with other such entities in a unified mutuality antithetical to any conventional ("fallen," in Blake's view) conception of "harmony." As a Christian discovering Christ within himself finds his identity by realizing a potential he shares with all mankind, so the poem is entitled "The Lamb," though the child-speaker addresses only a lamb. In a condition in which one can *be* many and the many can *be* one, naming is not naming as we usually practice it. *Songs of Innocence* tends to identify by means of terms that in the realm of Experience we think of as generalizations or abstractions—Little Boy, Little Girl, The Shepherd, Little Lamb—but in Innocence function with peculiar specificity. Thus the language of Innocence differs from linguistic practices employed in rationalized critical analysis.

Innocence is a state of inclusiveness that precludes distinctions, unlike Experience, which is a condition of excluding and being excluded. The inclusiveness of Innocence posits a metaphysics in which things are what they are called. So the language of Innocence is repetitive, as in "The Lamb," and verbal tautologies predominate: the lamb is made by the Lamb who has named himself after his creation, as in another poem "the Shepherd's sweet lot" is defined as "sweet." In Experience name and being are separated, a manifestation of the Fall, as they are not in the innocent world of "The Lamb" or of the two-day-old infant who is joy and so is called Joy. In Innocence, the name is what it names, sweet sweet, joy Joy, lamb Lamb.[3]

What we call simplicity in *Songs of Innocence*, then, is more than

absence of ornamentation, and critical endeavors to characterize its power are often self-defeating, for experiential distinctions tend to contaminate innocent inclusiveness. B. H. Fairchild, intelligently analyzing the "music" of these songs, locates their essential form in their combination of short-stress sequences, couplet rhyme, and trochaic rhythm, the last of which he perceives to work against the "naturalness" of iambic:

> The vocabulary and syntax of modern English run counter to trochaic meter. . . . Our most ubiquitous nouns are words of one or two syllables (in the latter the stress usually falls on the first syllable) and . . . these are usually preceded by unstressed articles, prepositions, or conjunctions.[4]

Yet the trochaic rhythm characteristic of *Songs of Innocence* is counterpointed by heavy diaeresis, which emphasizes the cadence of the rhythm. In "The Lamb," for instance, there are seventeen disyllabic words of which twelve are trochaic, but the vast preponderance of monosyllables produces an almost continuous conjunction of lexical units and metrical units. Fairchild observes that "much as we try to repress this innocent rhythm . . . we never stop sensing the pull of temporal regularity" (p. 136). Herein he finds the "magic" of the songs: "through a submerged but insistent tempo Blake pulls us closer to a childlike, 'innocent' sensitivity by appealing to the child's ear within the adult ear." This identification of a submerged music is exactly to the point, but one must be careful in defining childlike characteristics.

One can illustrate the problem by attending to another simplification in the collection, omission of punctuation. In "The Lamb" the final couplet's lack of punctuation permits

> an identification which is also found in the other "Little Lamb" couplets of lines 1 and 2, 9 and 10, 11 and 12. All eight lines are similar . . . however, by the end of the poem, the substantive noun "Lamb," has become a descriptive noun, almost even an adjective, denoting a great many godlike qualities; the "Little Lamb" becomes the "Little Lamb God." In this way the verbs of donation, gentle command, and naming become a verb of benediction, "bless," and the child thus blesses God when he blesses the lamb, and in his organized innocence blesses himself.
>
> (Borck, "Blake's 'The Lamb,'" p. 173)

Although the minimal punctuation and the unified effect of the poem tempt one to describe it as childlike, the childlike response provoked is easily misconceived. The likely misconception is drama-

tized by Hans Christian Andersen's story of the emperor's clothes, in which childish innocence allows the boy to see truthfully and thereby expose adult pretense. For Anderson, as for most modern critics, the "innocent eye" is objectively accurate. But Blake asserts that the essence of childlike vision is the innocent child's ability to believe, to see something where adults have persuaded themselves there is nothing. (This, in essence, is what Blake means by seeing *through* the eye.)

Such belief recurs throughout *Songs of Innocence*, notably in "The Little Black Boy," in which the speaker's generosity to the English child manifests his acceptance of his mother's tale—a generosity likely to jar the experienced reader by arousing, say, memory of how ungenerous English whites have been to blacks. But that secondary effect on the experienced mind should (ideally) enhance our regretful appreciation of our vanished innocence: how foreign to typical experience is the black child's protective kindness. Analogous are the Little Boy Lost and Found poems, in which God comes to the lost child in the guise of his father. If Experience tells us that flesh-and-blood fathers are rarely confusable with God, the child's self-comforting faith reminds us how all fathers *ought* to behave to their children, the true meaning of "God the Father." The child's capacity to believe is epitomized by his conviction that things are what they are called, the basis, for example, of "The Divine Image."[5]

This belief in words is perhaps best illustrated through the subversion of a simpler, second-order convention, that of pastoralism, which in *Songs of Innocence* becomes "true." For adults, pastoral is deliberate artifice: neither artist nor audience believes in its literal actuality—we all recognize Marie Antoinette playing at shepherdess. Children, however, don't play *her* way. Children's play—in a phrase that carries to the heart of Blake's accomplishment—is true make-believe: the shepherds and sheep in *Songs of Innocence* are not naturalistic for the children in the poems truly believe in conventionalized sheep and shepherds. Even in our fallen world, a small child may prefer a toy animal to a live one. The stuffed, conventionalized animal is better for sleeping with, dreaming on, and may provide something like the satisfaction little Tom Dacre finds in "The Chimney Sweeper."

Tom's dream keeps him "happy and warm" as he goes to work, "Tho the morning was cold." But the following line, "So if all do their duty they need not fear harm," is neither a sudden expression

of "sourness," as Harold Bloom thinks, nor, as E. D. Hirsch claims, a "vestige" of Blake's "earlier identification of 'Innocence' with 'virtue.'"[6] Always for Blake, virtue is irrelevant to innocence, which is a power of believing that has been lost by the adult readers of the poem, the employers of chimney sweepers—"*your* chimneys I sweep." Poor Tom inhabits *our* godless world in which "duty" for all of us has become self-interest and exploitation of the weak. Perhaps more difficult for us to accept than our guilt for his situation is the vision that if Tom retains his capacity to believe he need not fear ultimate "harm," even though our misarrangements assure he will soon be cold again and quite likely will break his neck before long. Yet if we are incapable of such vision we must, like Bloom and Hirsch, regard little Tom not as innocent but as an ignorant sucker. And unless we appreciate the Christian view that enables Blake to judge otherwise we are sure to mistake how *Songs of Innocence* works.

Let us return for a moment to pastoralism. To enjoy traditional pastoral one must perceive its falsity, just as a sophisticated reader is wary of ambiguities, ironies, and other self-subverting, self-contesting characteristics of the language of Experience. The Experienced reader, schooled in verbal suspiciousness, is careful not to be taken in by words. But when we were children, even the deconstructionists among us, we believed in words. To that child lost within each of us, *Songs of Innocence* appeals by using words as being what they profess to be. Such use, inevitably, evokes in us a sense of loss: in our adult world of experience innocence cannot survive, except as imagined memory or imagined hope; we are no longer innocent. Blake's representation thus condemns our fallen condition with a profundity denied to any specific ideological criticisms. What could be worse than experience that persuades us a desirable world must be a "pastoral" one, not "real"? For each of us can imagine something better than what we actually experience. The stuffed animals we once hugged were not poor imitations of the "real" thing but a means for imagining what could be, might be, ought to be.

Although not true songs, not meant to be sung, the poems of *Songs of Innocence* are rich with sounds; indeed, the children in these poems do little other than use their vocal cords. More seems to happen in *Songs of Experience*, but most of the activities reflect the frustration, self-mutilation, and diseased routine of Experience's victims. The acts of Experience are nonacts, unreal acts,

because they are not manifestations of energy but repressions of energy. Blake's *Innocence* is not static, though the collection emphasizes sleep, which, as in "The Cradle Song," is presented as a condition not merely of peace and rest (with the possibility of a splendid vision, such as occurs in "The Dream") but also as a state of unabashed, one might say uninhibited, vulnerability. Peaceful sleep comes from the sleeper's assurance of being benignly guarded; innocent tranquility is founded on the child's belief that he possesses the sympathy of others—often expressed by weeping, as in the "Cradle Song," in which the mother's loving tears reflect Jesus' love for us, his pity being the "smile" of our salvation. With such inactive activities as sleep and sympathy, Blake illustrates the life-affirming uses of energy. In "Another's Sorrow" or "The Ecchoing Green," the movement from youth to age is as felicitous as the movement from sunrise to sunset for the happy community. And in "To Night," when the angels do not save the sheep, "each mild spirit" inherits a new world wherein the lion not only lies down with the lamb but even becomes its guardian.

The children in innocence may at first appear inactive, though noisy, but in fact they are authentically active because they directly manifest their desire. Blake concentrates on their voices, I suspect, as a means of emphasizing that the energy of genuine desire is more than mere biological vitality. Because innocent language directly manifests desire, it does not, like the language of experience, require interpretation; indeed, interpretation deforms it. Without Babel, there would be little employment for linguists; without the Fall, there would be none for critics. In innocent language there is no dubiety of meaning, no division between word and thing, name and act, utterance and impulse, because innocence is a condition without inhibition or fragmentation of desire.

Innocent language therefore appears meaningless to the experienced—"the sweet chorus of Ha Ha He!" Consider the second verse of "To Spring":

> Little Boy
> Full of joy.
> Little Girl
> Sweet and small.
> Cock does crow
> So do you.
> Merry voice
> Infant noise
> Merrily Merrily to welcome in the Year.
> (Erdman, p. 15)

Throughout *Songs of Innocence* words are used with the conviction that they mean what they are "supposed" to mean, that their conventional significations are true and adequate. This conviction is not derived from any judgment about the world nor from any assessment of the nature of language, but simply from the uninhibited nature of the speakers.

For Blake there can be no innocence in our fallen world, and the *Songs of Innocence* are only metaphoric songs, articulating desires of which the authentic songs we really sing may be regarded as fragments. True songs are expressions of inhibited desires; ordinary singing is inherently uninnocent, a manifestation of the effects of repressions, the essence of Experience. To carry us through Experience, Blake eventually moves from metaphoric songs into prophecy, always urging that we do away with the circumstances that give rise to singing. This suggestion that song reflects the pressures of natural life is not far from more elaborately phrased explanations of musicologists, philosophers, and anthropologists who predicate the origin of song in man's primary needs, in the rhythms of his work, his prayer, his love—historical explanations that may remind us of how "unnatural" are the *Songs of Innocence*.

The collection is characterized, moreover, by the ubiquity of affection; everything in this innocent world is humanly sexualized. One does not know who the speaker of "The Blossom" may be, but no matter so long as narrow Sparrow and sobbing Robin are "near my bosom." Innocence is a condition of polymorphous affection, and for Blake, as for Freud, conventional sexual maturity is a narrowing of full bodily potency. In this view the onset of puberty marks the defining of a loss. Experience effects a diminution of innocent energy. *Songs of Innocence* portray human sexuality not as a natural but as a purely human (in contemporary terms, a cultural) phenomenon. The uninhibited desire of innocence expressing a capacity to believe is for Blake the fountainhead of imagination, which he calls "poetic genius" and claims is the basis of all religion, the root of beliefs and aspirations sustaining society. The special power of imagination is to conceive the previously inconceivable, by which one can then change whatever is given.

MUSIC THREATENS POETRY

The most successful lyricist of the mid 1780s was undoubtedly Robert Burns, a poet almost exactly Blake's age but, unlike him, committed to celebration of the local, the secular, and above all the

natural, in a style reliant on the peculiarities of his provincial dialect. The publication of *Poems Chiefly in the Scottish Dialect* made Burns famous, while Blake remained unknown in his lifetime. Over time, their relative positions have steadily shifted; today Blake is the most widely read and admired eighteenth-century English poet, whereas Burns seems forgotten outside Scotland and the Soviet Union. The reversal reflects how *Songs of Innocence* inaugurates a change in the relations between poetry and music that is decisive to defining the preoccupations of Romantic literature.

A central, if unexamined, premise of modern criticism is that poetry and music have become "utterly different as human enterprises."[7] In our century the Anglo-American critical tradition has largely ignored the musical dimension of poetic art. And perhaps Burns's fondness for writing singable songs is largely responsible for the decline in his reputation.[8] To understand how different was the situation in the eighteenth century, we need at least a summary view of several hundred years of developments in musical art:

> During the Renaissance, the forms of vocal music were to a great extent determined by the words, whether the latter were, in the case of secular song, poems written for this purpose, or, in sacred music, texts of Biblical or liturgical origin. . . . With the rise of modern tonality in the seventeenth century, however, abstract and completely independent musical forms evolved. . . . Songs came more and more to be based on these abstract forms, and the texts had to be written accordingly. . . .
>
> One result of the triumph of musical over poetic form was that the most serious poets began to turn their attention elsewhere. The poet-musician of the Renaissance disappeared. . . . But toward the end of the eighteenth century composers began to look longingly in the direction of the great poets, and the poets themselves, inspired by the growing interest in folk song and balladry, thought once more of music. But the old days of verbal supremacy were gone forever.[9]

Goethe's preference for a lesser composer than Schubert, one who would fit his music to Goethe's text, illustrates both the interest of late–eighteenth-century poets in music and their accompanying awareness of the threat to poetry posed by song.

> When words and music come together in song, music swallows words; not only mere words and literal sentences, but even literary word-structures, poetry. Song is not a compromise between poetry and music . . . song is music.[10]

The evolution of musical art to the point that it could dominate vocal expression is perhaps fairly illustrated by Schubert's songs,

one of the peaks of Western art. But Arthur Jacobs identifies even Haydn as contributing to this advance, for he was responsible for some of the first songs published in English with the right-hand parts fully written out. Previously,

> composers wrote songs on only two staves, not three. The upper stave could accommodate an accompanist's right-hand part only in what were then called the "symphonies"—that is, the introduction, postlude, and any intermediate bars where the singer was silent. At other points the lower stave held the bass-line and the upper the vocal line. . . .
> The change from this two-stave song-writing to the three-stave plan, with full right-hand parts for the accompanist, was a necessary condition for the development of song as we understand it.
> (*History of Song*, p. 148)

There was, then, a triumph of musical art over linguistic expression, whereas even so recently as the Renaissance, as Cone puts it, "the forms of vocal music" had been "to a great extent determined by the words" ("Words into Music," p. 4). Hollander documents the importance of this ordering in the Renaissance, of which he observes, "perhaps at no other time was music a more fruitful subject for poetic treatment." He then traces a change during the seventeenth century from "an interpretation of music as an *imitative* art to that of music as an *expressive* one," locating in George Sandys's commentaries on Ovid a specific illustration of what he calls the progressive "demythologizing of poetry's view of music."[11] This demythologizing (which is related to parallel movements in both arts from imitative toward expressive during the eighteenth century) compelled poets to reassess the relation of language to music in lyricism, a reassessment that produced what I call *fictional music*, in which the "musical" is subsumed by the "poetical." Such subsuming is illustrated by *Songs of Innocence*, but a more widespread form of the same process appears in the creation of literary ballads—balladlike lyrics completely detached from any musical setting. These ballads, of course, are not to be sung, but, for that very reason, frequently refer to singing. Walter Scott is perhaps the most interesting Romantic practitioner in this vein. One might expect him to follow the lead of his compatriot Burns, only a dozen years his senior, but rather he treats the union of music and words as part of a vanished past. *The Lay of the Last Minstrel* and the antiquarianism of *Minstrelsy of the Scottish Border* represent minstrelsy as an extinct or dying form. For Scott, a singer-poet has no place in

the sophisticated modern world: "bard" and "minstrelsy" evoke the memory of a *former* union of music and poetry.

Scott, like Burns, collected, remade, and invented "traditional" folk ballads and songs, but unlike Burns, Scott usually eliminated the music. Like Wordsworth and Coleridge, Scott absorbed musical features into purely verbal structures, reasserting the superiority of language over music. The only "music" of Coleridge's "Ancient Mariner," or "La Belle Dame sans Merci," to cite obvious examples, is in the prosody. Whatever else one does with the "Ancient Mariner" or Keats's ballad, one does not sing them.

But real balladry, the creation of ballads to be sung, flourished in the last years of the eighteenth century. As Bertrand H. Bronson has established, the so-called ballad revival of the eighteenth century was no mere revival:

> What we today know as British balladry at its best is a mass of texts taken down by interested persons from a living Scottish tradition in the latter half of the eighteenth century. . . . It is merely silly to speak of the fourteenth or fifteenth century as "*The* Golden Age of British Balladry" . . . there is even reason to surmise that Scottish balladry was of comparatively late growth. There is at least no evidence that it reached its fullest development much before the eighteenth century . . . in the day of Burns . . . as good versions were burgeoning as perhaps had ever flowered.[12]

The late eighteenth century, Bronson insists, was itself "a Golden Age of Balladry," whose products should be admired for a conjoining of verbal and musical elements "not instinctively and unconsciously but as intelligently and artistically as might be" (p. 73). It was not, therefore, eccentricity that led Burns to give so much attention to what today critics regard as "mere" folk songs. But his commitment to a musical poetry locates him on the far side of a gulf dividing folk song from Romantic poetry, however much the latter may celebrate the former.

UNINNOCENT COMMUNITY SINGING

Burns does not participate in the poetic fictionalizing that the Romantics fostered. In a sense, Burns really *is* the last minstrel, his work both the climax and conclusion of a traditional mode that subsequently is abandoned by the Romantics, who grant ascendancy to the verbal over the musical. And the experience from which Burns's true songs emerge is significantly different from Blakean Experience; Burns's naturalistic world of experience has no Blakean

dialectical counterpart of innocence. This distinction rewards examination because it focuses some essential Romantic aspirations. Burns composes songs we are meant to sing, which some of us still do sing today, and most are intended for group singing. Blake mentions taverns, but several of Burns's songs were written in taverns, many are of tavern life, and few are inappropriate for social public singing in a tavern. Burns's songs often are of and for holidays, not religious celebrations but days blessed by release from physical labor and cheered by communal singing, drinking, dancing, joking, and lovemaking. His songs arise from and are meant to animate crowds of simple, friendly, honest men and their lasses—unlike most Romantic poetry in which there is no simple unification of individual with social but a dialectical interplay between them, as in *The Book of Urizen*, in which Blake seeks to lead us to examine the social attitudes we have internalized. So the "radicalism" expressed in Burns's songs tends to be simpler than Blake's, even though his political circumstances—Burns held a governmental position for a time—were more complicated than Blake's.

Burns's libertarianism is founded in a sociable sensuality that opposed itself to any instance of formal regulation, as is proclaimed in the final chorus of what many think his finest single work, "Love and Liberty: A Cantata," usually known as "The Jolly Beggars."

> A fig for those by LAW protected,
> LIBERTY's a glorious feast!
> COURTS for Cowards were erected,
> CHURCHES built to please the Priest.[13]

The singers are outside law; jolly or not, they are vagabonds:

> With ready trick and fable
> Round we wander all the day;
> And at night, in barn or stable,
> Hug our doxies on the hay.
> (1:208)

Burns's trite pun on "doxies," the beggars' religion, points up by contrast Blake's more literary orthodoxy. Though eloquent in revealing the horrors of social repression, Blake knew little of the traditional modes by which the rural poor had for centuries responded to oppression. These modes Burns understood, and his songs celebrate without sentimentalizing or idealizing the attitudes of the country poor. He claims no virtues for his beggar-vagabonds, never suggesting that they are owed a fair share of this world's goods, and he is as careless as the worst of them about their

souls. In representing the beggars as they regard themselves, in-
stinctively opposed to the affluent and their decorous orderings of
society, Burns registers not so much protest as the intuitive antago-
nism of the have-nots to the haves.

The unthinking and therefore relentless yet oddly unembittered
hostility of "us" to "them" is the bedrock of many of his best songs,
even those entirely personal. So there is an appropriateness in the
addition of a "postscript," made by hands unknown, to the poem
Burns called "the best love song I ever composed":

> The kirk and state may join and tell;
> To do sic things I manna:
> The kirk and state may gae to h–ll,
> And I shall gae to Anna.
>
> (2:556)[14]

Behind such opposing of private feeling to religious and secular
rules lies the communal strength of the dispossessed. Burns gives
voice to a peasant's perception that "they" make all the rules. So in
the second and third stanzas of this poem he spoofs the possibility
of his love for Anna as a grand passion—a possibility only for so-
ciety's possessors. Lovemaking in Burns never transcends the "give
and tak" of ordinary sexual fulfillment. It is one of his achieve-
ments never to overdramatize the finest enjoyment available to the
impoverished.

Critics have been tempted, therefore, to read "Love and Liberty"
as pure antipastoral. But those who have done so have tended to
obscure how Burns at his best adapts the literary to the popular,
how he enriches the latter with the sophistication of the former
without surrendering his commitment to the forms, conventions,
and attitudes of popular communal singing. Burns's response to a
challenge to produce an original Ode to Spring shows his prefer-
ence for sliding satire and parody into the simpler pleasures of
humorously bawdy singing. He pledged himself "to bring in the
redolent fields, the budding flowers, and a love-story into the bar-
gain, and yet be original."[15] He succeeded:

> When maukin bucks, at early f–––s,
> In dewy glens are seen, Sir;
> And birds, on boughs, take off their mo–s,
> Amang the leaves sae green, Sir;
> Latona's sun looks liquorish on
> Dame Nature's grand impètus,
> Till his p–––– go rise, then westward flies
> To r–ger Madame Thetis.

Yon wandering rill that marks the hill,
 And glances o'er the brae, Sir,
Slides by a bower where many a flower
 Sheds fragrance on the day, Sir;
There Damon lay, with Sylvia gay,
 To love they thought no crime, Sir;
The wild-birds sang, the echoes rang,
 While Damon's a–se beat time, Sir.

First, wi' the thrush, his thrust and push
 Had compass large and long, Sir;
The blackbird next, his tuneful text,
 Was bolder, clear and strong, Sir;
The linnet's lay came then in play,
 And the lark that soar'd aboon, Sir;
Till Damon, fierce, mistim'd his a–––,
 And f–––'d quite out of tune, Sir.
 (2:761–62)

Much of the delight in this ode-song (Burns wished it sung "with expression" to the tune of "The Tither Morn") lies in its ingenious elegance: being in tune with nature has seldom been presented so literally yet with such ostentatious care for the decorum of sophisticated literary taste. Yet the "thrust and push" are controlled by the ode's formal strategy—the use of popular attitudes and language to resuscitate, briefly, a moribund refinement.

In Burns's best work, in contrast, parody, burlesque, and satire extend the power of "irregular," "low," and "popular" singing. The squalid reality of the beggar vagabonds in "Love and Liberty" is celebrated in and for itself, not in contrast to another reality. Unlike Gay's superficially similar *Beggar's Opera*, to which the cantata has been compared, Burns's poem is independent of corruptions of "good" society. So burlesque and parody in "Love and Liberty" function principally on the level of verbal detail; they do not control the totality of the cantata, which in its very inchoateness transcends satiric form. The ironic juxtapositions that are the essence of Augustan satire, for example, disappear in Burns's joyously bawdy blurring of distinctions. Thus the second singer in the cantata begins:

I once was a Maid, tho' I cannot tell when,
And still my delight is in proper young men.
 (1:198)

"Proper" retains the connotation of "handsome" as well as its newer, more respectable meaning of "polite," and the dubiety of *both* meanings is elicited by this singer and her situation. A pick-

pocket made a widow by the hangman, she has barely concluded her rousing lament for her lost Highlandman when two replacements thrust and push forward. "Faithful" love for "proper" men is easy, as long as there are swaggering blades and lusty tinkers to clout the cauldron. As her "father" was the regiment in general, this pickpocket's "old boy" is any soldier. Discrimination is not her forte, nor the cantata's, in which satire is swallowed by voracity of appetite, for singing as well as sex.

In "Love and Liberty" songs are interspersed with "recitativo" descriptions by a narrator, presumably responsible for naming the tune for each song. Each singer draws upon a collective store of musical literature to find an adequate statement of his or her situation and feelings. The tunes are communal property, each singer defining himself or herself through the typicality of a chosen song. The singers, then, are not "individualized" as are romantic protagonists; another beggar could appropriately sing each of the songs. But while the tunes are traditional, the lyrics are Burns's invention, and their communal and unindividualized nature is his creation. That we are led to think of the beggars singing authentically popular songs is Burns's remarkable accomplishment, what decisively separates his aim and achievement from that of Blake and subsequent Romantic poets, all of whom seek originality, uniqueness.

The vagueness of plot and the entirely loose structure of the cantata help to reinforce the illusion of spontaneous folk singing, an illusion reflecting Burns's commitment to poem-song as communal act. Burns conceives of poetry as social, performed on occasions of festivity to bring people together. Blake preaches community but does not practice it in his art, which is invariably original. There is nothing "common" about any of Blake's illuminated books. He is "creative" in the modern sense of making unique works of art. Such originality makes no demand that the audience *perform* the poet's art *for* and *with* others. Burns, however, does urge us to sing together.

Yet Burns cannot accurately be described as a "folk" poet, nor, despite his peasant background, can he be classed properly with "peasant poets." He was an educated and assiduous, even scholarly, collector, editor, and reviser of folk songs, a skilled poet who chose to write in the style of popular song, not a man of the lower classes surprising the sophisticated literary world by his cleverness in its formal art. For instance, he preferred trite similes, "my luve

is like a red, red rose," to complex metaphors, and liked a well-positioned cliché as well as verbal ingenuity. The limitations of his language are reflected in his jokes, allusions, and double entendres, which are seldom witty and often on the level of "nine-inch will please a lady." But obscenity serves to affirm social-linguistic bonds: an important function the learned who object to the restricted vocabulary of common obscenity often ignore. Writing out of and for a localized, essentially communal tradition, Burns relied less on unusual attitudes and original linguistic effects than on standardized locutions and unashamed appeals to what I. A. Richards condemned as stock responses. After the success of his first volume, Burns devoted much of his literary labor to projects such as the *Scots Musical Museum*, collections of popular songs. He found himself by losing himself in what today we might call a dialect subliterature. For Burns poetry was a mode of neighborly sociability—not an articulation of self or self-alienation—a local interchange, intimately associated with bodily closeness, what he calls physical "give and tak," singing in a tavern. These are not the ambitions of the great Romantics.

As I have suggested, a measure of the difference between Burns and the Romantics is their attitudes toward indecencies. None of the major Romantics was prudish, but only Byron in *Don Juan* made bawdiness a significant constituent of his art, and he relied on suggestion and clever verbal ambiguities rather than outright obscenity. Even more important, Byron idealized sexual love. The Romantics did strive to liberate conventionally restricted minds—and none more valorously than Blake; but for Blake the health and goodness of sexuality depend on purity of inner being, which commands little of Burns's attention. Blake believed that in our fallen world *all* respectability is evil, a form of repression. But his vision of regenerated life seems to transcend adult sexual passion; the condition of Innocence is a polymorphous joy and receptivity. So, unlike Burns (and, one must add, Chaucer and Shakespeare), Blake, though not averse to expressing himself scatologically, does not seem to relish bawdry and dirty jokes because they depend for their effect on an acceptance of repressive conditions.

Thus Blake's uninhibited visual displays of genitalia and his poetic outspokenness on sexual matters are the antithesis of the indecencies Burns elaborates in poems such as "Ode to Spring." Blake seeks a totally liberated life, whereas Burns accepts the limiting conditions of repression. In this, Blake sets a pattern for Romantic

poets, who, discerning themselves as free from some social prejudices that surround them, come to regard their role as that of exposing society's faults in order to encourage their readers' independence. To do so, they must resist the falsifications in the language and behavior of their fellows. The measure of Byron's genius, for instance, is his ability to combine earthy geniality with an intensity of idealism comparable to Blake's. Byron's accomplishment is singularly impressive because he so successfully displays the unconscious hypocrisy of his readers in a humorous rather than prophetic mode. Burns, though he savages the canting hypocrisy of the *unco guid* with Byronic verve, is usually ready to accommodate himself to the prejudices of ordinary folk, one of which is not to expose unconscious motives. Burns liked to sing of what he and his neighbors agreed they already knew, and so he cheerfully accepted the conventions that limited and compartmentalized expressions of what his society would admit as known. For example, respectability encourages a certain kind of sentimentality toward experience; in polite company one does not describe sensuous actualities in detail. Burns seems comfortable writing within such restrictions. Of course he knows the truth of other sides of life, but "a fig for those by law protected" expresses not so much a resistive ideology as an acceptance of the condition of vagabond existence. This is why the potential dangerousness of the vagabonds is so muted in the cantata, one of its accomplishments being an implication of how its protagonists if personally menacing are socially harmless. The beggars' vitality, in fact, is inseparable from the formlessness of their "politics." The liberty they enjoy is that of indulging their bodies, especially their tongues. They rise up momentarily to raise their voices, then fall back into silent anonymity. Through them Burns dramatizes, one might say, the biological force of "common humanity," the exact opposite of what Blake called "poetic genius," the imaginative potency antithetical to natural being.

The relation of Burns to his audience, and to the traditions within which he composed, is the reverse of that which gives rise to the Romantic drive for originality. Illustrative of the difference is Burns's use of popular bawdy songs as a basis for new, respectable compositions, among them some of his most famous songs, "John Anderson, my jo," for example. As suggested by his readiness to compose different kinds of songs, parallel but not intersecting, so to speak, one decent and one bawdy, his art does not confront the conscious with unconscious, the pretense of conventionalized be-

havior with actuality of private impulse, the collision-point out of which originates much Romantic defamiliarizing poetry. In contrast to Burns's genuine songs, some appropriate to singing in middle-class parlors and some appropriate to singing in lower-class taverns, Romantic "songs" are founded on the mutual infiltration of public and private, a dynamic engagement of the audience in a challengingly self-reflexive experience. The significance of this antithesis is illustrated by the indecent version of "Comin' Thro' the Rye," which appears to be known today only because Burns made use of it.

> O gin a body meet a body,
> Comin' thro' the rye;
> Gin a body f--k a body,
> Need a body cry.
>
> Comin' thro' the rye, my jo,
> An' comin' thro' the rye;
> She fand a staun o' staunin' graith,
> Comin' thro' the rye.
>
> Gin a body meet a body,
> Comin' thro' the glen;
> Gin a body f--k a body,
> Need the warld ken.
>
> Gin a body meet a body,
> Comin' thro' the grain;
> Gin a body f--k a body,
> C--t's a body's ain.
>
> Gin a body meet a body,
> By a body's sel,
> What na body f--ks a body,
> Wad a body tell.
>
> Mony a body meets a body,
> They dare na weel avow;
> Mony a body f--ks a body,
> Ye wadna think it true.[16]

Only the commonest diction and least individualizing phrases are appropriate for the pure physicality celebrated in this song. Any verb but "fuck" would be overly sophisticated, as would any elaboration of the stark "Cunt's a body's own," for this version evokes the haunting truth of nature that "a body" is anybody. The song's acceptance of natural physicality *requires* what we may call linguistic impoverishment; in Blake's view such indulgence in "natural" freedom circumscribes truly human potentialities. Not be-

cause he was prudish but because he believed that the realization of genuine humanity lay in transforming the biological through imaginative action, Blake *had* to create a poetry antithetical to "Comin' Thro' the Rye." Implicit in this ambition was an inevitable transformation of song from literal vehicle for singing into a quite different art. The community Blake and the Romantics sought, however impressive as an ideal, could not be the literal, local, physical, unselfconscious companionship in which Burns participates through his songs, both respectable and bawdy. Burns's songs are meant to be sung communally, that is, to be interpreted physically, and to that degree they are sparing in the use of imagined sensory detail.

IMAGINATION'S SOUNDLESS VOICE

We are even less tempted to sing *Songs of Experience* than *Songs of Innocence*. The horrors of Blake's second collection establish a distance between reader and world that, though nearly equivalent to the distance between reader and innocent world in the earlier collection, is of a different nature.[17] The figures in the lyrics of Experience are usually without imagination, knowing only what their fallen senses allow them to know. They are victims, and feel themselves to be helpless victims, as the preponderance of passive verbs indicates and the famous sick rose emblematizes. The reader, however, is not so imprisoned; the reader, though fallen, too, need not be cruel, selfish, jealous, hopeless, or masochistic, need not be a victim, for he is encouraged by the songs to exercise not his voice but his imagination, and it is imagination that can redeem us from dehumanization.

Like the *Book of Urizen, Songs of Experience* are addressed primarily to the problem of unwitting self-injury and are organized to arouse the reader to awareness of how he cripples himself by internalizing anti-imaginative attitudes fostered by his society. Again and again the lyrics force us to feel something is terribly wrong, as in "London," but, simultaneously, they stimulate us, unlike the speaker in "London," who only reports as a victim, to assess our part in the wrongness, thereby leading us to learn to disassociate ourselves from participation in sustaining the horror the poem compels us to imagine. We do not, after all, literally see the soldier's sigh run in blood nor literally hear the harlot's curse. Blake's art permits us to imagine the sigh of blood and blighting shriek, just as Keats enables us to imagine the Grecian Urn and singing night-

ingale, not to see and hear them. This intense imagining of the sensual springs from the poets' efforts to liberate their readers' minds. Just as they fictionalize song, so they fantasize sensations that readers may break free from unconscious self-imprisonment in limiting conceptions and restricted patterns of feeling. Through imagination one can realize a potency in oneself that is restrained and confined by the internalization of social norms. Imagination, in Shelley's words, enables us to create "forms of opinion and action never before conceived" as well as freeing us from subjection "to the accident of surrounding impressions." The uniqueness, originality, and individuality of Romantic poetry—its radical difference from the mode of true song—arises from the artist's perception that he and his fellows are bound by what Blake calls "mind-forg'd manacles." Such manacles, of which perhaps the most insidious is the false conviction fostered by industrial society of individual powerlessness, can be struck off only by imaginative hammerblows. As Shelley asks,

> Why shake the chains ye wrought? Ye see
> The steel ye tempered glance on ye.
> ("Song to the Men of
> England," lines 27–28)

I hesitate to illustrate what seems an obvious point by so familiar a work as "The Tyger," Blake's most famous lyric of experience. Yet the poem has often been misread, usually because critics fail to recognize that, although we do not know who the speaker is, everything he or she says implies viewpoints so conventional that we ought to regard them with suspicion, since conventionalized conceptions of deity are the root cause of social suffering. Is a tiger a fearful beast? So we have all been taught (just like Lyca's parents) to regard tigers. What are the "forests of the night"? They sound like a creation of the fear-laden misperceptions of fallen vision. And the framing immortal is conceived in savage terms, grasping deadly terrors, twisting sinews, and using chains for unnamed (sadistic?) purposes. The incoherence in the third and fourth stanzas, then, seems not just the poet fumbling his syntax (as he does in no other song of experience) but a foundering by the speaker that tells much about the self-contradictoriness in such frighteningly conventional speculations. Of course, the marvelous opening and closing stanzas seem "just right," the perfect realization of our preconceptions of a tiger, though so unlike the animal pictured. In short, one must dis-

tinguish between the experience of reading *Songs of Experience* and being caught up in, being a victim of, experience—a distinction one is not meant to make when singing one of Burns's songs.

Thus the emergence of Romantic lyricism prompts the development of new relations between literary work and audience. For the Romantics, the adjustment of musical and verbal elements in poetry was a crucial matter—as is shown in a different fashion by Wordsworth's controversial denial of important differences between prose and poetry. A crisis existed in part because of a threat posed by burgeoning musical art, but also because Romantic poetry aimed at reconstituting the consciousness of what social normality entailed, exposing the unwitting falsity and self-imprisonment in which social forces encourage us to participate. This, rather than any particular ideology, is the revolutionary essence of Romanticism, and the Romantic revolution is one to which even the politically conservative may contribute. And a natural focal point for a lyricist who would challenge normalized community feeling is the conventionalized expression of such feeling in song. In establishing lyricism as a mode in which the verbal definitively subsumes the musical, the Romantics were drawn to the *subject* of singing. The resulting fictionalizing of song, or lyricizing of balladry, is perhaps most sharply focused by the contrast to "Comin' Thro' the Rye" posed by Wordsworth's "Solitary Reaper."

> Behold her, single in the field,
> Yon solitary Highland Lass!
> Reaping and singing by herself;
> Stop here, or gently pass!
> Alone she cuts and binds the grain,
> And sings a melancholy strain;
> O listen! for the Vale profound
> Is overflowing with the sound.
>
> No Nightingale did ever chaunt
> More welcome notes to weary bands
> Of travellers in some shady haunt,
> Among Arabian sands;
> A voice so thrilling ne'er was heard
> In spring-time from the Cuckoo-bird,
> Breaking the silence of the seas
> Among the farthest Hebrides.
>
> Will no one tell me what she sings?—
> Perhaps the plaintive numbers flow
> For old, unhappy, far-off things,
> And battles long ago:

Or is it some more humble lay,
Familiar matter of to-day?
Some natural sorrow, loss, or pain,
That has been, and may be again?
Whate'er the theme, the Maiden sang
As if her song could have no ending;
I saw her singing at her work,
And o'er the sickle bending;—
I listened, motionless and still;
And, as I mounted up the hill,
The music in my heart I bore,
Long after it was heard no more.[18]

In recent years this lyric about song has been subjected to elabo-
rate analyses whose intricacies prove how fully in Wordsworth's
poem the verbal has taken precedence over the musical. No Burn-
sian song meant for singing, Wordsworth's poem requires intellec-
tual interpretation, critical reading. That all critics and readers
schooled in poetic conventions assume the speaker in the poem to
be a man (its effect would change were one to consider the speaker
to be a woman) suggests how Wordsworth sinks possibilities of
"Comin' Thro' the Rye" into a psychological undercurrent. He has
not obliterated possible sexual implications but has rendered them
discoverable only through interpretation. Submergence of direct
experience into imagined experience is most significant, of course,
in the fate of the reaper's song. The speaker buries it inside himself
(or herself)—"The music in my heart I bore / Long after it was
heard no more" —and communal song becomes self-sufficing lyric.

The poem, Helen Reguiero observes in one of the subtler modern
readings, "that recollects the protagonist's experience of listening to
the reaper *denies itself* access to the very world it recollects. . . . The
poem *consciously remains outside* its [the song's] confines" (p. 87).
The curiously dependent autonomy of the poem is further evi-
denced by our inability to identify it with a single, originating
source. Biographical facts—the poet's trip to the Highlands, his
reading and quotation from his friend Thomas Wilkinson's yet un-
published *Tour in Scotland*, and his brother's death, which occurred
between the Scottish tour and the composition of the poem—are
not irrelevant to "The Solitary Reaper," but the poem is not reduc-
ible to explanation by means of these facts, although they may en-
able one fully to appreciate the poem's richest implications.[19] "The
Solitary Reaper" is characteristic of Romantic lyrics in thus reveal-
ing a sensitivity to the dangerous if potentially liberating difference

between the experience created by the poet's words and "actual" experiences giving rise to them, producing what I have elsewhere called a style of assured uncertainty.

The phrase "will no one tell me what she sings" reminds us both of our separation from the "originating" event and of the doubtfulness of what the poem would have us imagine. Equivalent are the last lines of "Kubla Khan," the exclamation of imagined spectators who do not comprehend the inspired singer. This kind of complexity signals the Romantic poets' awareness that they cannot through their verse record directly, transparently, as it were, their experiences, nor appeal to any "natural" community with their readers. A poet who undertakes to expose to his readers how they have internalized the contradictions of their shared social system can claim no direct access to community. But the Romantic poet is much interested in reconstituting community with its mind-forged manacles struck off. The intricacy of this task is perhaps most directly dramatized by Wordsworth's lyric "The Tables Turned," in which we learn from reading the poem that we may learn more from experiences in nature than we can learn from reading. Such lyrics resemble the old philosophical problem of the Cretan who tells us that all Cretans are liars. Romantic poets tell us truly that their tellings are not the whole truth.

In the troubling challenge of "Will no one tell me what she sings?" a key term is *tell*. The poem is oriented toward aural, not visual, intricacy, containing only two verbs of vision and ten of singing and hearing, as well as a variety of aural words. Yet the reader does not actually hear any of her song, which intensifies for us the speaker's feelings of incertitude. Uncertainties dominate the reader's experience of the poem: ambivalences in tonalities, imperatives that produce puzzling questions, and welcome notes and thrilling voice that convey plaintive numbers implying sorrow, loss, and pain. We become aware of our separation from the matrix of shared thoughts, acts, feelings, aspirations, and language upon which any song such a reaper could actually sing would be founded.[20] We and the speaker have no need, do not really want, to understand the girl's words. The questions in the third stanza reinforce the fact that from the first the reaper is aestheticized, stylized as a human being, used for purposes of arousing the reader's imagination—as Urizen or Los is presented "unnaturalistically" so as to be "imaginable." Imagination is not antisensory, but imagination forms or shapes our sensations. The Romantics use language to activate

imagination, to alert readers to how human beings need not be prisoners of particular sensations or of patterns of perceiving but can, through power best embodied in language, humanize, that is, make humanly acceptable to themselves, experience that seems beyond the range of language.

Wordsworth's mode of simplifying is, of course, very different from that used by Blake to create Urizen, but Blake's and Wordsworth's stylizings are equally different from the stylization of "Comin' Thro' the Rye," in which the individual vanishes within the wordless physicality of biological impulse. Wordsworth's Highland Lass focuses imaginings of Arabian deserts and Hebridean seas, of a past neither the speaker's nor ours, just as her physical labor or language and "sorrow, loss, or pain" are neither his nor ours. Emphasizing what may be imagined from all that is implied in the woman's reaping-singing, the poem's initial visual distance evolves into a more equivocal distinction built on speculating and telling, and the shifting aural imagery at last dissipates the sensory actuality of folk song and folksinger: "The music in my heart I bore, / Long after it was heard no more."[21] Within the poem physical actuality is transformed into imaginative possibility, physical singing becomes silent lyric. "The voice which is the voice of my poetry," wrote Wordsworth, "without Imagination cannot be heard."[22]

"The Solitary Reaper" thus confirms what *Songs of Innocence* suggests, that Romantic lyricism originates in the recognition of a division between poet and audience: the poet reveals to his audience what it conceals from itself. Romantic lyricism, therefore, is self-consciously rhetorical, even, or especially, when it presents itself either simply or nostalgically as autobiographical. Wordsworth calling for poetry written in language "really used by men" appeals to us to become aware that our ordinary discourse is far more complicated and imaginatively humanizing than we have been taught. To strike off internalized self-manaclings, Romantic lyrics must be, as well as being about, "unheard melodies."

4

Natural Patriotism

The ideology of the Romantic poets was not always as politically radical as some twentieth-century critics have suggested, nor was it usually regarded by the poets themselves as spectacularly innovative. The driving force of their social and political ideals was nationalism. Frequently they claimed to support a traditional Englishness against its debasement by contemporary politicians. In the early 1790s Wordsworth and Coleridge often objected to what they felt to be violent overreactions in England to the French Revolution, and twenty years later Byron and Shelley somewhat analogously opposed the extremist conservatism that triumphed with the fall of Napoleon. In most nations of the world the bonding of Romanticism and nationalism is taken for granted. The great Romantic writer of a given country is likely to be admired for articulating aspirations for political-cultural independence and regarded as the founder or re-establisher of his country's literary (and sometimes even linguistic) identity. At the beginning of the nineteenth century Britain was powerful and unified, so that the nationalistic impulse among its artists tended toward self-criticism, resistances to violations of traditional (real or mythical) practices. The Romantics especially resisted imperialistic tendencies. Even J. M. W. Turner, a true-blue Englishman, in several canvases warns against the dangers of imperialism. As I propose in chapter 5, complicated rather than simple Romantic nationalism is neatly dramatized by the Prussian general Carl von Clausewitz, whose loyalty to his country compelled him to serve in a foreign army fighting against the Prussian government.

But the best evaluation of the Romantics' nationalistic impulses is accomplished through an examination of the relation of their political idealism to their admiration for the natural world. Even a cursory investigation of British Romantic "nature poetry" reveals a ubiquitous undercurrent of nationalism. Theirs is a poetry of natural patriotism.

To develop this point adequately one ought to deal at length with Wordsworth. *The Prelude*, after all, tells the story of the poet's recovery of a psychic health natural to him. What had sickened him was his aberrant venture into a political radicalism literally foreign to the land that had nurtured him. He could regain his native strength because he had been reared

> in a poor district, and which yet
> Retaineth more of ancient homeliness,
> Manners erect, and frank simplicity,
> Than any other nook of English land.
> (*The Prelude*, 9:215–18)

The poet is restored by return to his native soil and the affection of family and friends. He realizes, and would have us realize, how mistaken was his attempt at French theorizing about man and nature and human life. This return to home truths has been called, not unjustly, a reactionary move. But we ought to remember that it was the poet's commitment to self-reflexive evaluation that encouraged him to risk both new ideas and open recantation.

A kind of forerunner of this "inconsistency" appears in Edmund Burke's support of the protests of English colonists in America followed by his condemnation of the French revolutionaries. In a speech in 1775 he defended the colonists for representing "the ancient, rustic, manly, home-bred sense of this country." The adjectives anticipate the qualities Wordsworth will praise as those best fostered by England. This kind of nationalism lies behind *The Prelude*'s rejection of Rousseau's principles in the *Social Contract* and the *Discourse on the Origin and Foundation of Inequality*. Rousseau, of course, assumes an absolute separation between "the state of nature" and human culture, between "savage man" and "civil man," arguing that our cultured condition makes it almost impossible for us to conceive the true state of nature corrupted by our culture. Wordsworth, in good Romantic fashion, tries to fuse nature and culture. Indeed, he finally identifies the thrust of mind that would absolutely distinguish the two as a prime cause of moral confusion producing treacherously delusory utopianism. Wordsworth goes as far as he can toward identifying nature and nurture. In *The Prelude* he describes his recovery as a return to natural feelings, habits, and attitudes. These are recoverable (not impossible even to conceive) because sound culture extends, refines, and develops natural tendencies.

A return home is possible in *The Prelude* because for Wordsworth there is no precultural condition. For him, the newborn infant is already human, and its further development ought to be *not* away from nature into culture but into an ever more complex interaction between the two forces. The poet suffers when, misled by the false ideals of the French, he tries to separate nature and culture.

A difficulty in this kind of summary is that, as Raymond Williams has brilliantly demonstrated in *Keywords: A Vocabulary of Culture and Society*, no word has ever been used in so many different ways as *nature*. But one may note that in defining English health against French disease Wordsworth emphasizes a paradoxical quality of nature as understood by the Romantics, though ignored by their predecessors in the Enlightenment: nature endures by changing. For Rousseau, "the state of nature" is an absolute condition. But what Wordsworth describes as most natural about himself, in many poems such as "Tintern Abbey" as well as in *The Prelude*, is that he changes. So what makes possible the poet's successful return home is an awareness that he and it are not identical with what they were. A healthy psyche, this is to say, is one possessed of continuity, able advantageously to interconnect different phases of being, to find satisfying coherence in transformations.

For the Romantics, nationalism did not imply rigidity or unchangingness, and this had significant implications for their artistic practices. Before the end of the eighteenth century there was, so far as I am aware, no concept of art as functioning transformatively. The impact of art was always defined in terms of instantaneousness and permanence. In the latter half of the eighteenth century in England, however, there emerged the aesthetic of the picturesque which admitted transformationalism as fundamental in the experience of both nature and art. Adherents of the picturesque tended, moreover, to be nationalistically patriotic. There was reason, then, for a degree of convergence between Romanticism and the picturesque, a convergence whose outlines I sketch in this chapter. But this congruence was always tenuous and unstable, for the relation of the Romantic artist to his audience was a precarious one. Artists whose work evoked in their audience a self-awareness of cultural attitudes they had perhaps unwisely internalized necessarily jeopardized the communicative intercourse they desired. Anyone who alerts me to my unwitting prejudices risks offending me, to the point where I am likely to condemn this informant as uncivilized, antisocial, and politically unreliable. The Romantic poets thus ap-

peared dangerous, subversive, and unpatriotic, even though it was precisely loyalty to their native country that led them to challenge their society. These poets were willing to take this risky—because so easily misunderstood—position because they believed passionately that only thus could they be truly faithful to the most fundamental qualities of their, and their audience's, shared national identity, which qualities were ultimately rooted in the natural environment.

Ideally, one ought to work out the intricacies of the situation I have so hastily sketched through detailed attention to a major work such as *The Prelude*. But to highlight the central principles of the Romantic poets' natural patriotism, I find Coleridge's 1798 conversation poem "Fears in Solitude" paradigmatic of the Romantic interplaying of nature and nationalism. This is to burden heavily a poem of moderate merit, but the lyric offers us an unusually direct insight into the increasingly isolated situation of the second generation of Romantic poets as they attempted to sustain the idealism of the first generation. If the later poets tended to become more radical in their politics than their predecessors, this owed something to Britain's political and military successes. These, as Coleridge had at least unconsciously understood, necessarily weakened poets' confidence in their ability to appeal successfully to their contemporaries as fellow countrymen, to the possibility of a natural patriotism.

In the second number of *The Friend*, June 1809, Coleridge defended his moral and political rectitude to reassure subscribers who, if tolerant of delays in publication of his journal, might cancel subscriptions because of the author's reputed radicalism. The poet-editor denounced as "calumnies" suggestions that he had ever entertained seditious or irreligious views. As evidence of his long-standing patriotism and orthodoxy, he quoted part of a poem he had composed in April 1798, and then published as "Fears in Solitude." In *The Friend*, however, he identified the poem as "Fears of Solitude," a slip of more than casual significance.

Coleridge's self-defense in *The Friend* had to be disingenuous. The decade following 1798 had been unhappy for the poet, not least because of deteriorations in the relations between personal and political life, which are the subject of "Fears in Solitude." Only the political half of what Coleridge had hoped for had come to pass. Invasion was no longer a threat—indeed, England had invaded the continent. Coleridge's statement of political orthodoxy in

1809 betrays his unwillingness to admit the accuracy of his earlier prophetic warning, that the price of national success might be moral self-defeat, the betrayal of what was best in English life.

To understand this unwillingness we must look back to the time when the poet felt his country could meet a threatened invasion by summoning its latent moral power. The first twelve lines of "Fears in Solitude" describe the loveliness of "a green and silent spot amid the hills," a "spirit-healing nook," especially soothing to a "humble man" who, musing alone, finds "Religious meanings in the forms of Nature."[1] But it is "a melancholy thing / For such a man" that now, in April 1798, he must anticipate invasion, strife, "fear and rage, / And undetermined conflict" (lines 37–38). Armed destruction of the peaceful scene is to be feared because "we have offended, Oh! my countrymen! / We have offended very grievously, / And been most tyrannous" (lines 42–43). All the English, the speaker included among the evildoers, have drunk "pollutions from the brimming cup of wealth," and "gabble o'er the oaths we mean to break," swearing to "one scheme of perjury" (lines 60, 72, 78). Thankless for peace, men, women, and children read of war, "best amusement for our morning meal" (line 107), without imagining the horrors of organized slaughter. The poet prays that he and his countrymen be spared the just rewards for such failings. Hope lies in facing the home truths he has dared to tell. If the English do not mislead themselves in thinking that salvation can be sought in mere meaningless change of government, if they rather accept the responsibility as shared by each individual, they can redeem themselves. Redeemed, they will not only repel the French but also transform Britain into a model of the nation as natural, beneficent home. Such it has been for the poet, who attributes all that is best in him to the effect of England's land and climate.

> There lives nor form nor feeling in my soul
> Unborrowed from my country! O divine
> And beauteous island! thou hast been my sole
> And most magnificent temple.
> (lines 192–95)

After this lonely confession of thanksgiving, the poet leaves the dell, pausing at its rim, "startled" by the "burst of prospect" of hills, sea, and "elmy fields." Then with "quickened footsteps" he returns toward his "lowly cottage," all his heart by "nature's quietness / And solitary musings . . . made worthy to indulge / Love, and the thoughts that yearn for human kind" (lines 229–32).

Coleridge's gratitude for being made worthy to yearn for the good of his fellow men is specially impressive considering the circumstances in which he wrote. April 1798 was a low point in British fortunes in the war against the French, and the previous year had seen naval mutinies at home and Buonaparte's success for the Directorate in Italy. Earlier, the British had been expelled from the Netherlands and had suffered frightful losses in the Caribbean. The importance of the victories at St. Vincent and Camperdown was not yet apparent. But the French had evidently found a leader capable of harnessing energies liberated by the Revolution. Fear of invasion was justified. Coleridge's exhortation was a wise and courageous response to an immediate, significant crisis.

But, to pose the issue baldly, what if the British did not behave as Coleridge urged? Then, whether British armies won or lost, the poet would be morally isolated from his countrymen. The political and social fears he expresses *in* his present idyllic solitude intimate his personal fears *of* a future moral solitude. The dangerous ambiguity and vulnerability of his present solitude shape the poem, which represents a crossing of late–eighteenth-century sermons and patriotic rhetoric with traditions of meditative-descriptive lyricism of a melancholy cast. As Coleridge observed in one of his partly undeceptive self-deprecations, "Fears in Solitude" is "perhaps not Poetry,—but rather a sort of middle thing between Poetry and Oratory—*sermoni propiora*," a phrase best translated by Carl Woodring's "on the verge of conversation."[2] In "Fears in Solitude" we have a poet talking to himself with the aim of validating a hortatory appeal. The poet would speak to others by talking to himself. Alone amid beautiful nature Coleridge feels admirably situated to advise his countrymen toward a naturally virtuous rather than a fanatically bellicose patriotism.

The stylistic implications of *sermoni propiora* involve Coleridge's subtle understanding of the place of actual speech in poetry, illustrated by his remark on *Osorio*: "I have endeavored to have few sentences which *might not* be spoken in conversation, avoiding those that are *commonly* used in conversation."[3] Verbal realism is not the mechanical reproduction of speech, but an adapting of perceived principles of conversational usage. So a political poem ideally should render modes of usage that constitute the linguistic community of the nation, the English of England. Because the poet and his countrymen belong to the same community, Coleridge can speak to them by speaking to himself. This process not only affirms a common language but also manifests patriotism as the realiza-

tion of individualized independence. As with language, so with moral behavior: the individual does not reproduce mechanically the mores, beliefs, and emotions of his fellows. Rather he uses the same patterns, mingling them in a particular way, testing them against private experiences; such usage thus embodies, even as it modifies, principles of social being. Authentic patriotism, then, articulates a system of community through which individual political consciousness may be realized even as principles of common language permit intensely individualized speech—such as that of "Fears in Solitude."

This patriotism is the opposite of the patriotism of "mad idolatry," which would silence some by defining "all / Who will not fall before their images, / And yield them worship" as "enemies / Even of their country!" (lines 172–75). True loyalty can be critical because founded on a mode of self-awareness, a visible sign of which is indolence: the ever-active person is probably not self-reflective. This paradox of reverie as public-spirited is sustained by a structural progress from "he," the humble man to "we," in line 41, reaching the first-person singular in this lonely meditation only at line 153. The poet talking to himself foregrounds the sociability of self: the individual, after all, is the sentient element of society—he alone experiences the suffering of threatened invasion, or any other "social" ill, for societies suffer or enjoy only metaphorically.

A poetry that verges on conversation also permits the telling of "bitter truth without bitterness," because exhortation is filtered through solitary musing, through the self-reflections of an *ordinary* person. The poet in himself is not important. But the social, political, and religious affirmations upon which he meditates are not mere abstractions; they are the ultimate significance of what is sensorially manifest in the beauty of the dell, one small part of a diversely beautiful nation.

The audience of "Fears in Solitude" is the poet's countrymen, individuals who share a geography and a climate, localized affections and loyalties, common experiences of the blessings of English nature from which the poet invokes a natural patriotism. As his solitary musings link him first to nation then to race, so his countrymen may be enabled to feel how, as Wordsworth was to say, the heart by keeping its own "inviolate retirement" makes possible "joy in widest commonalty." An inclusive spirit of humanity arises from taking the pleasures offered by an intensely localized situation—a process that is the psychological foundation for Romantic national-

ism. For Coleridge takes "country" as a geographical construct upon which a social and political community is founded:

> O native Britain! O my mother Isle!
> How shouldst thou prove aught else but dear and holy
> To me, who from thy lakes and mountain-hills,
> Thy clouds, thy quiet dales, thy rocks and seas,
> Have drunk in all my intellectual life,
> All sweet sensations, all ennobling thoughts,
> All adoration of the God in nature,
> All lovely and all honorable things,
> Whatever makes this mortal spirit feel
> The joy and greatness of its future being?
> There lives nor form nor feeling in my soul
> Unborrowed from my country!
>
> (lines 182–93)

The poet's most personal ideas, sensations, and feelings derive from the natural beauty of his nation. Its land and skies have maternally nourished him, and his reciprocating love is like the gentle fidelity of child to mother. But the affectional responses of the patriot poet exceed the instinctual: he finds "religious meanings in the forms of Nature" (line 24) and translates the local blessings of his lonely nook into an ideal of the English naturally sanctified by England, a community virtuously bound together by the earth on which its members dwell. This connectedness between man and nature stands as a model for a vital interconnectedness among all men, in all their diverse native places. Thus Coleridge accommodates nationalistic patriotism to ideas of human brotherhood, finding in Christian spiritual democracy a unifying principle for the cultural uniqueness of each national identity.

The poem discovers the larger significance of a specific historical-political threat through an intense spatial particularizing that makes possible an opening out of imaginative power.

> A green and silent spot, amid the hills,
> A small and silent dell! O'er stiller place
> No singing sky-lark ever poised himself.
>
> (lines 1–3)

The triply silent spot has affiliations to the ancient topos of the *locus amoenus*, but Romantics like Coleridge characteristically blur the distinction between the ideal place and its circumambient environment. This is why the Romantics like the word "spot," an area distinct and limited yet whose form and boundaries are difficult to

define exactly. The word's definite indefiniteness is appropriate to the poet's solitary musing upon his sensations so as to create for the reader a felicitous experience supervening upon historical crisis. A definite indefiniteness equally characterizes the unspectacular complexity of phrasing that makes it doubtful that a lark has ever so poised where the poem compels us to imagine a lark. The reverie from which "Fears in Solitude" arises is to a degree reconstituted in the poem's interpenetration of linguistic and phenomenal forces. A noncomparing comparative conjoins with infolded negative— "O'er stiller place / No singing sky-lark ever"—to permit an imaginative superimposition of the song upon silent spot. The second sentence advances from the conversational, exclamatory syntax of the first, and the verb "poised" carries us into the poise of this April morning, when "the hills are heathy" and the furze "now blooms most profusely." But "the dell, / Bathed by the mist" is pictured by comparison to other places at a different time, as

> fresh and delicate
> As vernal corn-field, or the unripe flax,
> When, through its half-transparent stalks, at eve,
> The level sunlight glimmers with green light.
> (lines 8–11)

As the dell is imaginatively realized through other places and times, so many others "would love" (line 13) the spot, though chiefly the humble man, for "here he might lie" (line 17), a potentiality actualized when "half-asleep" he dreams "of better worlds" (line 26).

The "spot" encountered by the reader of "Fears in Solitude" is both a literal place and a verbal construct, both signifier and signified. The poem manifests a patriotism founded on a peaceful affection for nature and a love of country antithetical to conventional forms of patriotism. These encourage passions by appeals to abstractions rather than to feelings derived from specific sensory experiences. In the rhetoric of aggressive patriotism "my country," whether "right or wrong" or "'tis of thee," aims at allegiances having little to do with Coleridge's localized imagining.

"Fears in Solitude" resists patriotism that corrupts imagination by separating language from sensation. Language properly used, to the contrary, is the artifice through which one may perceive and create global meaning in local phenomena personally experienced. The poet, therefore, attacks his society's misuse of language as a cause, not merely a symptom, of its present evil condition. The as-

sault with which England is threatened is retributive; the English are learning the significance of the words by which and through which they have established false social relationships. Already "dainty terms for fratricide" prevail, and for many imagination has atrophied:

> Terms which we trundle smoothly o'er our tongues
> Like mere abstractions, empty sounds to which
> We join no feeling and attach no form!
>
> (lines 114–16)

To speak such a language is to have forgotten the debt the poet recognizes: "There lives no form nor feeling . . . unborrowed from my country" (lines 192–93).

"Fears in Solitude" describes arrogant nationalism as destroying the connective fabric of society by debasing language. The poem shows how language undebased may imaginatively strengthen that fabric by making sharable private, unique experiences, such as the poet's reverie. Pretentious patriotism's self-congratulating language dehumanizes by detaching itself from individual sensory experience, upon which depends the emotional potency of our words, and by breaking the moral bonding of act to word:

> And what if all-avenging Providence,
> Strong and retributive, should make us know
> The meaning of our words, force us to feel
> The desolation and the agony
> Of our fierce doings?
>
> (lines 125–29)

Among these are "our mandates for the certain death / Of thousands and ten thousands" (lines 103–4), orders "Stuffed out with big preambles, holy names, / And adjurations of the god in Heaven" (lines 101–2). As misusers of the language that makes them English, the poet's countrymen must reap the harvest of their hypocrisy. Recovery of language's potency requires a quiet, lonely spot and a style verging on conversation, that is, place and manner returning poet and reader to root principles of shared nature and culture. The poem represents true patriotism as loyalty to the unspectacular power in "a common language" whose source is, literally not metaphorically, one's country.

After April 1798 England went on to victory, beginning with Nelson's success at the Nile in August, but the nation did not acquire the virtues of self-awareness that for Coleridge would have

justified victory. In the Napoleonic wars, a proud, aggressive British nationalism defeated a proud, aggressive French nationalism, and the virtues of the "conversational" and "natural" patriotic poetry embodied in "Fears in Solitude" appealed to fewer and fewer readers. The "advance" of English society betrayed the poet by fulfilling the worst of his fears: self-corruption through an increasing abstraction of language that separated it from a healthy rootedness in particular sensory experiences. The use of language by which Coleridge defended the naturally patriotic power of language became a less viable mode, not so much because of his failure but because of his society's frightening successes, which we commonly subsume under abstractions such as industrialization.[4] The fashion in which British society developed made it difficult for solitude to serve as a means toward commonalty. Solitude became, rather, means for private self-expression through which a poet defined self *against* society, and patriotism steadily declined into the enunciation of abstract slogans. But that is exactly what Romantic poets wished not to have happen: their "attacks" on their audiences were motivated by the hope of reconstituting genuine social bonds. In "Fears in Solitude" Coleridge sought, through imaginative deployment of ordinary language, to reconcile claims of nationalism with those of international amity, localism with the brotherhood of man, self with others. The poet affirms the dependence of nationalistic emotions on sensual links to specific locales: nationalism should foster an individual's sense of sharing with his countrymen diverse experiences of their country, and their togetherness results from their analogous attachments to different places. In 1798, therefore, Coleridge saw himself as possessed of a definable social-political function by virtue of being a poet. Ten years later he could not claim such public significance for private reverie.

The difference is apparent when one compares *The Friend* with *The Watchman*, a journal of the preceding decade. As Barbara Rooke observes, each journal was "a civil libertarian tract for the times. To recall men to principles, to ask what human society is for, what the human individual is and what the organized community is." But "from the beginning, *The Friend* was to differ markedly from . . . *The Watchman* (1796), which had been avowedly concerned with events of the day and current politics. . . . He planned to exclude just those things."[5] This significant shift away from engagement with specific political events, which had brought the poet to *sermoni propiora* in 1798, helps to explain why by 1809 Coleridge wanted

to treat in his new journal only "whatever . . . of a political nature
may be reduced to general Principles," and why he insisted on the
"exclusion of the Events of the Day, and of all personal Politics"
(2:13).

Indeed, his error in citing "Fears in Solitude" as "Fears of Soli-
tude" foretells the evolution of the sociopolitical situation of artists
from the first Romantic generation of poets to the second. Cole-
ridge's uncomfortable position in 1809 is closer to that of Byron and
Shelley a few years later than to his own situation in 1798. Byron
and Shelley, however, sustained hopes for recovery of the ideals ex-
pressed in "Fears in Solitude." Exiled in Italy, they wished to re-
store the public effectiveness of English poetry. That the difficulties
in so doing were clearer to them than they had been to Coleridge
twenty years earlier only sharpened their awareness of the com-
plexity of relations between poetic and political language. For By-
ron, that awareness culminated in the extraordinary richness of
Don Juan's conversational style, so different from yet not unrelated
to Coleridge's conversation poems, while for Shelley the climactic
expression of this interest appears in the "Defence of Poetry," with
its remarkable analyses of the interdependence of imaginative lan-
guage and sociopolitical practice.

Continuity between the first and second generations of Roman-
tic poets may thus be defined along a line leading from Blake,
Wordsworth, and Coleridge, who hoped that their art would play a
beneficial public role, to Byron, Shelley, and Keats in their painfully
increased consciousness of the doubtful political efficacy of such
art. Nonetheless, the younger Romantic poets sought to avoid the
solitude that Coleridge had subconsciously feared. Like him, the
later poets wished intensely individual experience to be a means
for improving or enhancing community, not an end in itself. In the
twentieth century critics have tended to overlook this persistent
structure of feeling, in good part because, accepting alienation as
inevitable, we like to abstract poetic acts from their historical cir-
cumstances and define them according to psychological principles.
For this reason we emphasize sublimity, and have lost sight of more
intricate and peculiar aspects of the Romantic aesthetic.

PICTURESQUE OUT OF SUBLIME

The recent surge of studies of Romantic sublimity has been strongly
biased also by a critical concentration on the relation of artwork to

author, a focus that parallels psychoanalysis' focus on the isolated individual.[6] Such commentaries tend to ignore the relationship between artwork and audience, the social situating of aesthetic accomplishments, and thereby tend to obscure Britain's principal contribution to the pan-European movement that Sir Isaiah Berlin has called the counter-Enlightenment. This contribution is most succinctly defined as the concept of picturesqueness.[7] Although the Romantics' direct debt to picturesque theorizers is negligible, and there is even a degree of hostility between Romantic art and picturesque theory, the comparison illuminates these phenomena at those points where they do converge.

The unintentional begetter of picturesque theorizing was the greatest popularizer of sublimity, Edmund Burke, whose enormously influential *Inquiry into the Sublime and the Beautiful* (1757) took shape in good part as a rebuttal of Lord Shaftesbury. Shaftesbury had praised the "creativity" of the artist, but he exalted beauty over the sublimity celebrated by its first significant enthusiast in England, John Dennis. For Shaftesbury, the artist is "a second *Maker*" who "forms a whole, coherent and proportioned in itself, with due subjection of constituent parts"; moreover, "all beauty is truth," both qualities being "plainly joined with the notion of utility and convenience," so all that is beautiful "is harmonious and proportionate."[8] Beauty, harmony, and proportion are "true"—as Shaftesbury means them to be understood as products of reason— but fantasy is dangerous: "Every man indeed who is not absolutely beside himself must of necessity hold his fancies under some kind of discipline and management. The stricter this discipline is, the more man is rational . . . the looser it is . . . the nearer to a madman's state" (1:208). In consequence, Shaftesbury has a low opinion of "what commonly passes for sublime," an enthusiastic experience that carries its victim beyond rational proportion and harmony: "Amidst the several styles and manners of discourse or writing, the easiest attained and earliest practised was the miraculous, the pompous, or what we generally call the sublime" (1:157). Similarly, he associates the sublime with astonishment, which is "of all other passions the easiest raised in raw and unexperienced mankind" (1:157). Such emotions are the antithesis of the civilized qualities of naturalness and simplicity:

> In poetry and studied prose the astonishing part, what commonly passes for sublime, is formed by the variety of figures, the multiplicity of metaphors, and by quitting as much as possible the natural

and easy way of expression for that which is most unlike to human-
ity or ordinary use.

(1 : 157–58)

One of Shaftesbury's key principles is that the best art, "natural and
simple" art, will be

> the completest in the distribution of its parts and symmetry of its
> whole . . . so far from making any ostentation of method, that it con-
> ceals the artifice as much as possible, endeavoring only to express
> the effect of art under the appearance of the greatest ease and
> negligence.
>
> (1 : 168–69)

Burke, who admires the disproportion and asymmetry of sub-
lime art, which cannot be self-concealing, points to a different re-
lation between audience and artwork. In place of Shaftesbury's
audience of connoisseurs, Burke proposes an upper-middle-class
or gentrified audience, and it is from Burke's observations on the
relation of viewer to scene that the picturesque aesthetic emerges as
a democratic mode, one addressed to an audience that is lower on
the social scale, and a mode that can accommodate more casual ex-
periences, such as those encountered in tourism.[9]

Burke's *Inquiry*, although it encouraged those who, like him,
thought the pain and terror of sublimity more powerful than beauty,
rhetorically balances the two. He structures his treatise accord-
ing to a system of binary oppositions, with the sublime and the
beautiful in either art or the natural world rooted in mankind's
two equally fundamental drives, for self-preservation and for self-
propagation.[10] This dualism of Burke's structuralist rhetoric created
an opening in Britain for the picturesque. However much an en-
lightened cosmopolitan, Burke was enough of a phlegmatic Briton
to suggest that only a relatively few situations were absolutely
beautiful or sublime; the latter, especially, was but rarely experi-
enced: "The human mind is often, and I think for the most part, in
a state neither of pain nor pleasure, which I call a state of indif-
ference" (1 : 4, p. 32). As Hannay observes, denial of this Burkean
view and insistence on the interestingness of the unspectacular be-
came a focal point for picturesque theorists, and just this attitude
underlies Wordsworth's attack on the factitious excitements sought
by boredom in the Preface to *Lyrical Ballads*, where he claims, for
example, that "the human mind is capable of being excited without
the application of gross and violent stimulants."[11]

The picturesque transformed Burkean indifference into a turn of mind appreciative of continuously self-regulating interactions between an observer and what he observes, whether natural scene or work of art. For the first time aesthetics entertained the concept we now call *feedback*, a major feature of Romantic art. The idea was so radical that theorizers of the picturesque groping to articulate it became depressingly confused. However muddled, the beginnings of the concept of feedback are significant in the aesthetic matrix out of which Romantic art emerged.

Both picturesque theorizers and Romantic artists seriously considered the vast range of experience Burke dismisses within "indifference"; they renewed attention to the ordinary, both in human relations and the natural world, in the latter focusing on places "homely," "familiar," and often, like Coleridge's dell, literally "low." Such attention was also stimulated by changes taking place in the British countryside as a result of the agricultural revolution of the late eighteenth century,[12] as well as by the war with France, which interrupted travel to the Continent and encouraged patriotism of diverse kinds. Proponents of the picturesque insisted that Britain, though lacking continental beauty or sublimity, was well worth looking at, and that if one stripped away the veil of familiarity that makes "ordinary" scenes appear uninteresting to "indifferent" eyes, exciting and complex possibilities of pleasure were to be found in the English countryside—as happens in "Fears in Solitude." In their way, partisans of the picturesque thus helped to originate defamiliarizing techniques; the picturesque emphasized, as no other aesthetic theory ever had, the difficulties and uncertainties of perceiving. Picturesque attitudes depended, moreover, on the recognition that perceiving is a temporal process, whereas earlier theories had assumed the effect of impressive natural scenes or well-constructed art to be immediate and unchanging. Burke's *Inquiry* is an extended discrimination between experiences treated essentially as timeless and nondevelopmental.[13]

Illustrating the revolution from a static to a dynamic aesthetic is the contrast of Henry Fielding likening himself as author of *Tom Jones* to an innkeeper presenting a bill of fare to a reader-eater and Walter Scott likening himself as author of *Waverley* to a post-chaise driver carrying his reader-traveler through a varied countryside. Within a decade of Burke's *Inquiry* appeared Lessing's *Laokoön* (1766), perhaps most interesting in its defensiveness against premonitions of an oncoming Romantic aesthetic, of which Scott's metaphor is

representative. As E. H. Gombrich points out, Lessing's distinctions between arts of succession and simultaneity had been anticipated by Shaftesbury; but in contrast to his lordship's calm assurance, Lessing seems insecurely polemical in asserting systematized polarities analogous to Burke's and insisting that the painter's "most fruitful moment," though suggestive of past and future, is not itself evanescent, not transitory. None of the Romantics followed Lessing in his distinctions between the arts, because they redefined Lessing's—and his predecessors'—conception of "moment." What Romantic artists realized in their art, and picturesque theorists struggled awkwardly to articulate in their treatises, was an understanding of "moments" or "instants" as inherently evanescent, existing as changes within a continuum of perpetual tranformations.[14]

The thrust of the Romantic and picturesque movements was against any conception of *instant* as an autonomous entity definable through its separation from other moments. Rather, they conceived of an instant as intrinsically transformational and "ecologically participative"—a position far too radical for any vocabulary of the time, a position that was ontological, not merely psychological. As Romantic art displays the indeterminacy of spatial forms, so it displays the mobile indefiniteness of temporality, that continuousness of change that the Romantics viewed as the nature of mortality. For them, Lessing's distinct, segregated, durationless moment appeared an artificial construct of a mind unable to function with imaginative responsiveness to the full fluid vitality of being. Lessing and Burke, in the Romantics' view, failed to recognize that true individuality is the opposite of mere autonomy; it exists, rather, as an evanescence of being participating in a wholeness constituted by a ceaseless continuity of changes. This, in effect, is a reconceiving of time that encourages attention to phenomena of participative interactivity and to conditions of continuity.

From such attentiveness evolve literary and graphic artworks whose subjects can be ordinary, unsensational, commonplace events, whether in human life or in nature—concerns far removed from the sublime.[15] Rather, such works engage with complexities in mundane continuities of transformation appropriately represented through conversational and self-reflexively narrative modes of expression. This Romantic fascination with transformativeness did not appeal to the melodrama-loving Victorians' yearning for transcendental truth; nor was it understood by twentieth-century crit-

ics committed to formalistic and structuralist ways of thought that made pre-Romantic, timeless aesthetics more congenial. These post-Romantic attitudes illustrate by contrast how distinctively Romantic are Shelley's imaging of imagination as "the colour of a flower which fades and changes as it is developed" in his "Defence of Poetry," and Coleridge's delineation of the inherent uncertainty of experience through comparison to the chameleon that changes color under the shadow of him who bends to examine it.

A shared premise of picturesque thinking and Romantic art is that perceiving usually is not a simple and direct process, and that it frequently leads neither to clarity nor to a stable relation between perceiver and perceived. Romantic-picturesque concepts of the perceptual process tend to stress its uncertainty and potential for continuous transformation, so obscurity does not necessarily evoke sublimity, as it does for Burkeans.[16] To Romantics and admirers of the picturesque the gentle obscurities of everyday, commonplace experience—morning mists, say—are worthy subjects of art, in part because they may gradually be penetrated or may gradually dissipate. Looking at art that derives from this attitude, one is likely after a time to discern details not distinct at first; different qualities come into view as one adopts different vantage points. Before the rise of the picturesque movement, one searches aesthetic treatises in vain for any significant analysis of such pleasures.

But proponents of the picturesque were deeply interested in gratifications found in the gradual emergence of perceptions at first obscured either by natural conditions (shadow, haze, fog, over-brightness) or by familiarity, that is, by a viewer's conventionalized expectations. Homely and "low" subjects were often favored by picturesque theorizers, as they were by Wordsworth and Constable, for even the most ordinary object—a loaf of bread—has its peculiarities, irregularities, and character, if only one pauses to attend to it. This celebrated picturesque example of a loaf of bread helps us to appreciate the characteristic Romantic combining of sharpness of detail with indeterminacy of form. So, too, the spot in "Fears in Solitude": an indisputably unique locale whose exact configuration is not definable. Romantic aesthetic unity can comprehend such paradoxical qualities, for it consists of an ensemble of transformational activities. This concept of unity anticipates one more fully articulated and named only in our century: ecological wholeness. For the essence of Romantic unity is a coherence of distinct forces that cannot be ordered by a simple proportioning of physical structurings because integral to this unity are temporal

processes of change, both developmental and deteriorative, pro-
cesses such as intensification and softening, fading and brighten-
ing, growing and diminishing. The unity striven for in Romantic
art is not that of timeless, unchanging form.

But neither is it in the commonly accepted sense organic form.
No term has more confused criticism of Romantic art—in particu-
lar, readings of Romantic nature poetry—than "organic form." For
example, those following the New Criticism tend to misinterpret
organic form as merely a kind of functional efficiency. But Cole-
ridge perceived the danger of such mechanistic conceptions invited
by the beguiling metaphor of the seed. For the Romantics the com-
parison between the artistic and the biological depends primarily
on both being inclusive processes. The Romantics distinguished or-
ganic forms from mechanical structures principally by insisting on
the former's existence through vital relations to other forms. In this
view the organic is unique but *not* autonomous. The substantial
body of twentieth-century criticism founded on a conception of
works of art as autonomous entities is, therefore, antithetical to the
Romantic conception of ecological organicism.[17]

NATURAL PATRIOTISM AND
THE ART OF RESEEING

To achieve an aesthetic completeness that accommodates the transi-
tory and the modulating—phenomena shifting or unfolding, fad-
ing or intensifying—Romantic literary forms tend toward narrative
orderings in which temporal sequence and continuity play deter-
mining roles. Many Romantic lyrics advance from visual to aural
imagery, creating an effect of progress from the more particular and
definite to the more diffuse and inclusive. And one notices that the
Coleridgean spot of land, the Wordsworthian spot of time, or Con-
stable's brightly lit meadow in the middle distance possess edges,
boundaries that are not obliterated, as they would be in sublimely
apocalyptic events, but that are uncertain, indistinct, irregular. The
margins attractive to the Romantic artist are vital margins (examine
Constable's foregrounds), not the defined distinctness of a geo-
metric intersection of inanimate objects, but a woodland border of
pasture or an unobtrusive supersession of sight by sound, as in the
conclusion of Coleridge's "This Lime Tree Bower." Romantic art
dwells on the surface interactions through which living complexes
interpenetrate.

This focus not only encourages narrative rather than dramatic

forms of representation but also suits the expression of nationalistic sentiments of the kind appearing in "Fears in Solitude." This natural patriotism celebrates pleasures and virtues to be discovered within commonplace existence. It depends on recapturing the complex vitality within familiar modes of living to which one has become indifferent. And it therefore accords with many ideals of picturesqueness, above all, the conviction that the ordinary is worth attention because more equivocal than is usually recognized.[18] The literature of the early nineteenth century at its best destabilizes its audience's expectations less by sensationalistic devices than by taking time to disclose something deeply rewarding if surprising (perhaps even upsetting) concealed within the apparently casual, commonplace, and everyday. Implicit in this defamiliarizing, which constitutes a reformulating of relations between art and audience, as is suggested by Jane Austen's sly trick of criticizing people who have internalized novelistic conventions, are all kinds of possibilities for diversifying interactions between observer and observed. When viewing a mist-covered lake from a distance, a traveler finds that his impression changes both as he approaches and as the mist lifts. Even in unspectacular situations one may be confronted by surprises and revelations, disclosures of secrets and the appearance or emergence of something hidden. In the quietest, least pretentious Romantic works the conjunction of these meanings is often the core revelation. Some critics stress the violence, extremism, and apocalyptic tendencies in Romantic art, but more characteristic is what Wordsworth called the "gentle shock of mild surprise" that carries "far into the heart." Such mild yet deep penetrations usually conclude in an equivocal manner, as is true of the "Boy of Winander" passage itself, requiring of the reader a response comparable to the negative capability Keats ascribed to great poets. The audience is led to reproduce, in effect, the same attitudes of response that the artist experienced in creating his work when he undertook to reveal, let us say, a significant transformativeness within an ordinary event.

But if Romantic and picturesque converge in valorizing the significance of unspectacular transformations, Romantic artists put more emphasis on imagination, on how perceivers shape their perceptions. The Romantic extension of this emphasis to audiences, and the inclusion of imaginative response in their concept of art's appropriate functions, was encouraged by popularizing tendencies that underlie some fundamental picturesque arguments. Emblematic of this popularism are the many occasions on which the

Romantic poet appears not in a prophetic role but as a humble man speaking to his countrymen in a manner verging on the conversational. This tendency, however, was subsequently misunderstood by critics schooled in an anti-Romantic elitism led by Ezra Pound and T. S. Eliot, who provoked a misleading "defense" of the Romantics that placed undue stress on their claims to a conventionalized vatic function for the artist. Both elitists and defenders seemed unwilling to entertain the possibility that Wordsworth might have expected his readers to respond to "Tintern Abbey" in a fashion analogous to that in which he responds to the scene on the Wye, half-creating what they perceive in his art.

"Of eye, and ear—both what they half create, / And what perceive": Wordsworth's phrase is perhaps best understood in relation to Alexander Cozens's technique for aiding beginning landscape artists to make use of remembered perceptions while stimulating their powers of invention, that is, simultaneously to develop "mnemonic-perceptive" and "imaginative-creative" powers. Cozens would present a student with an inkblot from which to form a landscape; the rationale for this exercise is explained by Hannay:

> The blot technique is not simply an aide-memoire, but neither is it an activator of imagination alone. The blot-maker in effect reenacts the original act of perceiving a landscape, stressing in his re-vision the creativity of perception rather than its passivity . . . Cozens' *New Method* demands that landscape be re-seen in order to be seen properly. But the re-seeing of landscape grants access not only to the "secrets" of nature, but of the observer as well, for buried in his memory are ideas which, like the organic details hidden beneath the surface of landscape, emerge only gradually.[19]

Although neither Wordsworth nor Coleridge owed anything directly to Cozens, the purpose and effect of Cozens's pedagogic technique illuminate one aspect of Romantic practice. For a great deal of Romantic art is devoted to arousing this kind of dual response in its audience: gradual emergence of deepening insight into how the perceiver determines what is discerned. Romantic lyrics such as "Fears in Solitude," "This Lime Tree Bower My Prison," and "Tintern Abbey" provide the reader with a kind of model in the narrator of how to respond in this complicated fashion to a richly affective stimulus, the poem itself. Like the scene in "Tintern Abbey," most Romantic works of art are not just to be viewed but to be re-viewed, are meant to be re-created by observers whose perceptive powers are reshaped by their conscious re-experiencing.

This may remind us of the nationalistic impulses common to the

picturesque and the Romantic. The picturesque aimed to awaken "the naive or insensitive or prejudiced eye to an appreciation of the peculiar beauty of English landscape" (Hannay, p. 21)—an intention quite removed from that of arousing awe at the classically beautiful or sublime landscapes of the Continent. The picturesque is a British form of the nationalistic impetus that emerges in the latter half of the eighteenth century across Europe. Although William Gilpin is the best-known celebrant of the picturesque, he was by no means isolated in his polemical patriotic admiration for British landscape. Horace Walpole in the 1760s urged, for example, the importance of England's "homely and familiar" scenes as against Italianate beauty and Alpine sublimity.[20] It is understandable, therefore, that much in the natural patriotism of "Fears in Solitude," particularly the interplaying of physically registered and imagined perceptions, appears congruent with picturesque procedures.

Yet it is important to emphasize that we never find in a major Romantic poem any direct application or illustration of picturesque theorizing. The affinities between the picturesque and Romanticism are especially rewarding to explore because they are so equivocal. Consider Coleridge's "This Lime Tree Bower My Prison." The poem is most significantly related to picturesque attitudes not through a superficial contrasting of scenes shaped to conform to "officially" recognized definitions of sublime, beautiful, and picturesque landscapes but through its interplaying of actual sensations and the poet's imagined memories of what his friends may be seeing.[21] Upon this interplay depends the effect of the lines tracing the varied and changing effects of sunlight, dappling shade, and the "lighter" gleams of late twilight in the bower, yielding finally to the "silent" bat and the "humble-bee" that "sings" unseen in the bean-flower (lines 45–59). The passage reveals how such concentration encourages awareness of transformative powers both in the natural world and in perceptive acts, thereby developing the oxymoron of the bower-prison. The conventional bower is first metaphorized into a prison, then changed back into a natural spot conducive to strengthening the emotional bond between friends perhaps permanently separated, "whom I never more may meet again" (line 6). The seeming artlessness of Coleridge's opening "Well, they are gone," permits the overtly imaginative reconstruction of the dell (lines 10–19) to be inscribed within a sincerity established by the speaker's casualness. The final restoration of the bond with his friend Charles, moreover, is thus founded in

the emergence of the originally disregarded beauty of the poet's "prison"—whose beauty he comes to appreciate because his isolation and enclosure compel him to attend to the marvelously subtle changes the spot undergoes as the sun follows its ordinary, daily course. His perceptions, in turn, become the ground for the vision through which he affirms a spiritual union with his physically absent friend. In the rook's *creaking* feathers culminates the poet's imagining, now not just what his friend may perceive but what he may make of what he hears, because to Charles "no sound is dissonant that tells of life" (line 76). This second shift from visual to aural carries the poem's listener back to the conversational mode of the poem's opening sounds, but with an awareness enriched by recognition of how incomplete is natural life unanimated by the power of human consciousness, that capability to make, for example, a sound "tell." [22]

The single characteristic best distinguishing Romantic practice from picturesque doctrine is the poets' emphasis on how the natural world is fulfilled by the entering into it of human consciousness. This is the basis of what I have called their natural patriotism. A community of diverse people completes the processes of physical changefulness that constitutes the place to which they belong. They have a right to this country because they are right for it; they realize fully the potential of its peculiar quality of being. Such a view helps to explain why many of the "greater Romantic lyrics" seem rather unpretentious, are meditative in manner, and are shaped by a movement toward the completion of natural processes in imaginative ones.

A good if unexpected illustration is Keats's "To Autumn." The poem might be described as about picturesque experience, since Keats's subject is not a physical scene but a temporal entity, a season, a passage of time. What is gradually revealed is the coherence in autumn's transformation into diminishment as that implies the self-regulating integrity of the complete annual cycle. This coherence enables our imagination to find satisfactions in following through processes of ripening into those of loss and emptiness, "last oozings" and "bare stubble-fields." This revelation must be a gradual one, because what is revealed is not unusually beautiful nor spectacularly sublime but what is most commonplace and familiar—seen with awakening eyes. The success of the poem consists in its disclosure of the perfect adequacy of what is entirely transition, what we all know (and therefore forget) to be the nature

of the season: change, change toward death that makes possible continuing vitality.[23] There is no better example of Romantic quiet defamiliarizing.

The wholeness of the annual system is presented through a movement from enclosed specificity to spreading indefiniteness. The key transformation is from the tactile sensations of contained and enclosed entities in stanza one, through the vividly sharp yet less limited and precisely defined visual figurations of stanza two (the sex of the figure, for example, being indefinite), into the diffused and less locally focused aural phenomena of the final stanza. It is this transformation that permits the reader to experience imaginatively how the season's abundance consists in evanescence. The merely physical superfluity of stanza one is transformed into a greater temporal plenitude that encompasses diminishment and deprivation in the third stanza. Were "To Autumn" not about continuity and the self-regulating qualities of the seasons, the poem could not so satisfyingly evoke imaginative fulfillment through its final landscape so emptied of the lush, overflowing fecundity of its beginning.[24]

5

Friction

In his day Walter Scott was an impressive, even dominating figure of European literature, but his fall from critical favor has been precipitous. The fragility of Scott's popular appeal at least in part results from the special historical power of his imagination and the unusual imagination his works demand of a reader. In this chapter I hope to illuminate the kind of imaginative response Scott's fiction requires by juxtaposing his romances with Carl von Clausewitz's *On War*, a document remarkably illuminating of the Romantic spirit so far as it is primarily concerned with the historical rather than the transcendental, centering its energies on the difficulties of representing and giving higher value to the ectypal than to the archetypal. Clausewitz assembled the text of *On War* during the greater part of his professional career, but late in life he decided totally to revise the work. He died after having recast only his first chapters, leaving an unfinished manuscript that, like many Romantic works, was not intended to be a fragment but, instead, evidences an author's willingness continuously to rethink the fundamental principles he espouses. Full appreciation of *On War* demands an analogous lability of mind on the part of a reader, as do, in a surprisingly similar fashion, Scott's romances.

CLAUSEWITZ: THE NATIONALISTIC IMAGINATION

Clausewitz's career, which he described as eventful but not exceptional, was representative of the central experience of the Romantic epoch in that it was deeply engaged in nationalistic wars. Born in 1780, the son of a minor Prussian official, Clausewitz first went to war in 1793 as an infantry ensign when Austria and Prussia combined against the new French Republic. Conflicts deriving from this struggle continued until 1815, by which time Clausewitz was a leading figure in the Prussian general staff, raised to prominence

by Gerhard von Scharnhorst, the man principally responsible for reorganizing Prussia's army after its defeat by Napoleon in 1806. Clausewitz helped Scharnhorst lay the foundations of Prussian-German military success for the next 125 years, and was equally useful to Gneisenau, who succeeded Scharnhorst as chief architect of Prussian militarism after the downfall of Napoleon. Clausewitz died of cholera in late 1831, shortly after returning from the Polish front, where he served, ironically, with forces sent to control the nationalistic uprising triggered by the French Revolution of 1830.

A decisive event in Clausewitz's life was the humiliating rout of the Prussian armies by Napoleon in 1806. Shortly afterward Clausewitz wrote:

> The poverty of the German spirit is revealing itself more and more . . . the feebleness of character and principle emerging everywhere is enough to make one weep. I write this with infinite sadness, for no one on earth feels a greater need for national honor and dignity than I do; but . . . the facts cannot be denied . . . I [would] stir the lazy animal and teach it to burst the chains with which out of cowardice and fear it permitted itself to be bound.[1]

Fortunately for those concerned for "national honor," the degradation of the army compelled King Frederick William III and his court bureaucrats to give Scharnhorst's reformers power to reorganize the military system. By 1812 Scharnhorst and Clausewitz believed that Prussia's army was a match for Napoleon, who was demanding that Prussia help his invasion of Russia. The patriotic reformers opposed yielding to imperialistic tyranny, and when the king chose to collaborate with Napoleon many leading generals resigned their commissions, including Clausewitz, who, with several others, joined the Russian army to fight the French.[2]

Clausewitz was welcomed into the Russian army, served under Kutuzov at Borodino, and then was appointed chief of staff to the Russian forces defending Riga and the approaches to St. Petersburg. He was to take the place of a Prussian friend who had been killed in action by Prussian troops serving under Napoleon. His journey from south of Moscow was difficult, requiring him to circle through territories dominated by bands of Russian partisans who sometimes, not surprisingly, took him for a Napoleonic spy. From St. Petersburg he joined the Russian troops pursuing the northern wing of the retreating *Grande Armée*. A principal unit in this wing was the Prussian contingent under the command of General von Yorck, who was sympathetic to the patriotic reformers. On Christ-

mas Day, 1812, a small Russian force managed to slip between the Prussians and the rest of the French troops, and Yorck took the opportunity to open negotiations. On December 31 Clausewitz brought Yorck an ultimatum, in the form of an assertion that overwhelming Russian forces would soon appear. Yorck seized Clausewitz's hand, saying, "You have me," and two weeks later he wrote in a letter:

> "Have men sunk so low that they will not dare to break the chains of slavery that we have meekly borne for five years? Now or never is the time to regain liberty and honor. . . . With bleeding heart I tear the bonds of obedience and wage war on my own."
>
> (In Paret, *Clausewitz and the State*, p. 231)

Yorck and Clausewitz immediately set about establishing an East Prussian *Landwehr* (militia) supported by a *Landsturm* (home guard) to fight Napoleon. This was a startling act, for

> the raising of a popular army by a province, financed by the province, without prior permission of the King . . . [was] something unheard of in an absolutist state. It was undoubtedly a revolutionary act, all assurances of obedience and pious faith in the subsequent agreement of the king notwithstanding.
>
> (Paret, p. 231)

The East Prussian arming enabled Scharnhorst and the anti-French party in Prussia to overturn the pro-French administration and, in March 1813, to persuade King Frederick William to change sides and declare war on France, an action that assured the downfall of Napoleon.

Thus in Clausewitz's public life one sees a logic of patriotism that impelled him to fight against the nation to whose honor he dedicated the chief energies of his life. The experience of being drawn by loyalty into acting "traitorously" may have strengthened his conviction that moral commitment was a key to success in war. The French, he argued, had triumphed because Buonaparte had tapped the moral resources of the French nation. Clausewitz thought moral strength empowered a nation to not only resist an enemy but also overcome what he called "friction," perhaps his most innovative contribution to military studies. *Friction* is the inescapable inertia in all human enterprises, including the effects of ineptness, fatigue, confusion, timidity, laziness, and all the unpredictable factors of chance that frustrate planning—all the characteristics of life that no organization, no foresight, however meticulous, can fully

anticipate.[3] These contingencies, which may delay, distort, even defeat excellent preparations, this friction, may be compensated for, or at least accommodated to, in an army energized by moral fervor.

Clausewitz's conception of friction exemplifies how *On War* is "theoretical" in a paradoxical fashion. Written in deliberate opposition to Enlightenment geometricians of war, such as von Bülow, the book was composed in conjunction with Clausewitz's practical experiences and endeavors to modernize the Prussian army. His central principle is the antithesis of a theorem, for it names what cannot adequately be defined theoretically.

As Clausewitz's patriotism led him into temporary betrayal of Prussia (which he regarded as having betrayed him), so the key to his revision of his life work is his development of the observation that war, his subject, is not a single subject—there are various kinds of war—and that no easily unified theory of war is possible. For Clausewitz "war" is an abstraction specifically realized only in diverse wars, historically unique phenomena.[4] Thus, like the Romantics, rather than subordinate the multiplicity of phenomena to a unitary principle, Clausewitz seeks a coherence of differences, the unity of multeity, in Coleridge's phrase. By insisting that there is more than one kind of war, he liberates himself from the domain of pure theorizing and commits himself to the realm of multiform historical truths. Such involvement leads him to conclude that the political objectives of a war-making state determine the character of its particular wars, that war is an extension of politics and is meaningful only in relation to the rest of social life.[5]

To understand war, then, one must apprehend the nature of diverse warring societies. The reasonable aspect of war Clausewitz delineates as whatever most directly expresses political leaders' intentions. These blend with, though they are distinguishable from, emotional forces: hatred, enmity, the primordial violence of which war is a developed manifestation. Reasoned aim, political intent, is most likely to be realized if bound in with violent passions that animate the populace; the widespread hatred of an oppressor may enable a leader to attain his political goal with what appear to be inferior military resources. But perhaps not, for neither reason nor emotion nor both together are absolutely determinative in war; a third factor, Clausewitz insists, plays its role: chance.[6] Unpredictability gives scope in war for military skill that requires imagination, the creative spirit. Clausewitz finds appropriate comparisons

in the domain of art to explain military genius, and he observes that great generals act intuitively, attaining their ends by means that are neither purely rational nor fervidly emotional, though they make the best use of both reason and passion. They triumph through their imaginative power, their sensitivity to shifting immediacies of infinitely complicated situations, their intuitive ability to respond effectively to unforeseeable accidents and to seize unexpected opportunities.[7]

Clausewitz's treatment of war as an ever-varied interplay of multiple contingencies distinguishes his work from both his Enlightenment predecessors and present-day armchair strategists of game theory and computer modeling. Like the Romantics, Clausewitz stands between Neoclassical and Modern intellectualizers of human phenomena. Unlike either of these, he embeds theoretical judgments in specific facts of historical actualities. The historical events out of which principles may be articulated are to him essential because in themselves they are unique and can only be distorted by the imposition of systematic patterns, by abstract theorizing, or by reductive analyses of intentions. To understand history one needs to know how intentions were shaped by, as they helped to shape, the peculiar passions of one time and one place, and how intentions and emotions may have been sustained, modified, or thwarted by the ever-changing, apparently trivial but in fact crucial contingencies whose unrepeatable configurations make up the frictionality that is historical actuality.

The largest significance of the connection between the frictional and the individual begins to emerge when one observes that Walter Scott's fiction may be grounded on an equivalent valuation of friction.[8] It is certain that no major novelist devotes so many pages to warfare as does Scott. Just how Clausewitzian Scott's battle descriptions can be is illustrated by the battle of Loudon Hill in *Old Mortality*, usually regarded as one of his most successful fictions. The conflict is between British Royalist troops commanded by John Graham Claverhouse and a gathering of Covenanting Scottish Presbyterians provoked to desperation by the Stewart government's repressive measures after the Restoration. The battle occurs—a classic instance of friction—because Claverhouse's scouts are careless, so he unexpectedly finds his small body of troops faced by a larger group of ill-equipped but zealous Covenanters. Led by a few Cromwellian veterans, the Presbyterians have developed a strong defensive position behind a marshy gully. In a hastily called council

Claverhouse must reject tactically good advice to retreat, because
he realizes that a retirement of royal troops will spread the rebellion
across western Scotland—a sound Clausewitzian judgment. The
political dimension of the decision facing him is reinforced when
Lord Evandale, one of his principal officers, urges a parley with the
"misguided subjects" to offer them pardon if they will disperse
peacefully. Claverhouse agrees to this attempt, since it represents
official policy, although he fears the messenger sent may be killed
by some of the desperate zealots. The officer sent to parley is, in-
deed, killed, and Evandale, feeling he should have been the emis-
sary, disregards Claverhouse's warning and leads the cavalry in a
charge to avenge the killing.[9] This impetuosity mires the Royalists
in swampy ground, and Claverhouse's efforts to repair Evandale's
blunder fail when the leader of the dragoons sent in a flanking ma-
neuver is by chance killed at a critical moment in the operation; the
zealous fervor of the Covenanters enables them to rout the Royal-
ists, and serious rebellion breaks out. But Scott dramatizes the con-
fusion attending this unexpected success as foreshadowing the
Covenanters' subsequent defeat resulting from the political inco-
herence of their cause.[10]

If Scott's overtly Clausewitzian bent appears most vividly in such
battle scenes, which exemplify his preoccupation with fighting,
particularly fighting linked to political insurrection, the signifi-
cance of his Clausewitzian tendencies is more subtly realized in his
plots, which foreground the social rather than the personal dimen-
sions of loyalty and betrayal, enriching private conflicts with im-
plications of patriotism and treason. About a century later, Conrad
ushers in Modernist literature by dramatizing personal, psycho-
logical dimensions of treason and betrayal, with correspondingly
less attention to problems of patriotism as a social phenomenon.
For Scott personal psychology and the private dramas of betrayal
are secondary.

This decisive difference between Romantic and Modernist em-
phases is illustrated by the odd circumstance that Clausewitz's ac-
tual experiences in 1812 are paralleled by the adventures of Edward
Waverley, the protagonist of Scott's first prose romance, which ap-
peared in 1814. Waverley, an officer in the Hanoverian army, is led,
through circumstances that open him to suspicion of being a spy,
into fighting for the Stewart cause, though he finally returns to his
original loyalty. The illuminating feature of this parallel is negative:
neither the Prussian general nor Scott's protagonist was desperately

agonized by his own acts of disloyalty. Each felt that he was the be-
trayed rather than the betrayer, and neither suffered extreme conse-
quences for defection. The validation of such feelings and such
noneffects is close to the core of Scott's romancing.

That it was not causistry for Clausewitz to regard Prussia as
having betrayed him is shown by General von Yorck's view of his
situation. Edward Waverley, although at one point he feels betrayed
by the Hanoverians, does not so deliberately change sides. He
drifts into transferring allegiance through accidents, an infatua-
tion, and machinations by politicians. Scott's hero, in fact, is more
victim than agent, a fictional character employed to make it pos-
sible for the reader to empathize with a paradoxical Clausewitzian
situation in which honor conduces to "treasonable" acts. Waverley's
function in the romance does not permit him to be psychologically
divided, and Waverley's psychic depths are immaterial to Scott.
Throughout harrowing adventures he must remain a rather super-
ficial, genially social being, of whom Scott himself could speak dis-
paragingly. For Scott values Edward Waverley as an ectype, not an
archetype, as a historical individual. Scott means his readers to be
intrigued by Waverley's unique sociohistorical situation, an unre-
peatable complication into which the mild young man is led by his
parentage, his special taste in women, the falling out of the intri-
cate interplay of mid–eighteenth-century Whig and Tory politics,
the conflicting vagaries and ambitions of some acquaintances and
relatives, and sheer physical chance. Indeed, one of Waverley's de-
cisive adventures occurs through the accident of his horse throw-
ing a shoe, followed by the accident of the nearest blacksmith being
engaged in a domestic dispute.[11]

IMAGINING ANOTHER CULTURE

War and insurrectionary turmoil provide Scott with situations in
which the significance of the manifold complex of contingent forces
that Clausewitz calls friction becomes inescapably apparent. Scott,
like Clausewitz, perceives historical events to be constituted of a
multiplicity of interpenetrating subjective actions and reactions of
diverse kinds and purposes, and, therefore, falsely represented if
reduced to any patterned intellectual structure. One might say that
as Clausewitz defines war as an extension of sociopolitical activity,
so Scott uses war to provoke the imagination of his readers into an
apprehension of the confused violence intrinsic to sociopolitical ac-

tivities. As Clausewitz rejected bloodless geometricians, so Scott rejected typological history. Scott's imagination, and his appeal to his readers' in his historical fictions, begins from the premise that traditional historians have oversimplified the frictional truth of human experience, both its social and personal aspects.

Friction results from the opposed movement of surfaces. Depicting friction, Scott resists typological, archetypal, or pattern-thinking by foregrounding superficialities. His romances demand that we be as alert to the outward realm of contingent happenings as to the inner permanencies of psychology, as conscious of the efficacies of immediate impressions and circumstances as of the ultimate structures of being. Scott, in other words, refuses to subordinate unique historical particularities. His minute descriptions of topography, localized variations in the earth's surface, have been criticized as a wealth of contingent detail signifying nothing; indeed, such details are resolutely nonsymbolic, devoid of latent content. But Scott deals in localized particularities because he renders historically ectypal truths of unique situations and unique experiences. In parallel fashion Clausewitz demonstrates how the terrain of East Prussia is *not* suited to the guerrilla war waged by the Spanish, that one cannot educe principles by hazarding abstractions from invariably local, specific, peculiar conditions. In this attention to superficial particularities, Scott and Clausewitz participate in the Romantic transformation of the picturesque.

Rather than offering his reader satisfaction in sublimity or symbolic abstractions, Scott gives insight into connections between trivial contingencies of human events and their larger, but still historical rather than transcendent, significances. In the clash of Loudon Hill, for instance, the mountainous, boggy terrain is not only decisive in the battle but also crucial to our understanding who the Covenanters are. They hold their prayer meetings on just such open hillsides. Their battle position is their religious-social situation, emphasized by their hymn-singing before the conflict. Unlike their Royalist opponents, who represent land-owners, the Covenanters *work* the harsh soil of Scotland. Some of them carry guns, but the majority consists of "countrymen armed with scythes set straight on poles, hay-forks, spits, clubs, goads, fishspears, and such other rustic implements as hasty resentment had converted to instruments of war" (chap. 15, p. 163). Their "cavalry" is composed of "landholders of small property, or farmers of the better class" (p. 164) who have ridden their work animals to the fight.

The Presbyterian soldiers, moreover, are demonstrably family men, for on the hill behind them are drawn up their women and children, "spectators of the engagement by which their own fate, as well as that of their parents, husbands, and sons was to be decided" (pp. 163–64). Scott thus presents the Covenanters with both their strength and weakness residing in their intimate relationship to the natural world. Their political dividedness, which emerges so destructively after their victory, is implicit in their weaponry, so unlike the identical, specialized equipment of the royal soldiers. Each weapon is peculiar, representing each family's form of daily engagement in a separate struggle with nature; but these separate struggles provide each individual with a sense of wholeness, as all aspects of his life are interconnected. The political disorganization of the Covenanters is inseparable from their agrarian existence, which, simultaneously, gives them their special strength.[12] The Covenanters literally fight for their lands and their families, the latter by their physical presence manifesting the fecund "naturalness" of their cause. Their uniformed opponents are antagonistic to the natural world, in which they appear as transient intruders.[13] Royalist unnaturalness is registered by the seemingly irrelevant circumstance that their leaders have no immediate families—the emissary killed at the parley is Claverhouse's only heir, a nephew. Thus Scott represents the participants so as to enable us imaginatively to apprehend how and why the Presbyterians win the battle, are subsequently defeated militarily, yet finally survive while the Stewarts are driven out. Then Presbyterian religious convictions win tolerance, whereas the leaders of their persecutors, Claverhouse and Evandale, die fanatically opposing the government they had served, their fanaticism being the reverse of the logic of patriotism that enables Henry Morton, the protagonist, to survive as a loyal soldier even though at one time he acts treasonably.

Just as in the description the battle's details are not presented for their sensory verisimilitude but to concretize the workings of social forces, so the protagonist is presented as part of movements larger than individual destiny. But the primary movement in which Morton is caught up is an individualizing one, and the same as that determinative in Clausewitz's career: nationalism. Nationalism is usually defined as devotion to the interests of a particular nation, especially the desire for national independence from foreign political or economic domination. Such nationalistic aspirations play a part in most of Scott's best fiction, but a larger, less determinant

nationalism shapes Scott's romances in a more profound fashion. This broader nationalism is described by Sir Isaiah Berlin, who identifies it as central to the counter-Enlightenment and demonstrates how it transcended purely political phenomena. Berlin argues, like Herder, that a variety of aspirations in art, history, religion, and natural science found structuring efficacy in nationalistic drives:

> The notion of a creative faculty, working in individuals and entire societies alike, replaced the notion of timeless objective truths, eternal models, by following which alone men attain to happiness or virtue or justice or any proper fulfillment of their natures. From this sprang a new view of men and society, which stressed vitality, movement, change, respects in which individuals or groups differed rather than resembled each other, the charm and value of diversity, uniqueness, individuality, a view which conceived of the world as a garden where each tree, each flower, grows in its own peculiar fashion and incorporates those aspirations which circumstances and its own individual nature have generated, and is not, therefore, to be judged by the patterns and goals of other organisms. This cut athwart the dominant *philosophia perennis*, the belief in the generality, uniformity, universality, timeless validity of objective and eternal laws and rules that apply everywhere, at all times, to all men and things, the secular or naturalistic version of which was advocated by the leaders of the French Enlightenment, inspired by the triumph of the natural and mathematical sciences.[14]

The intellectual root of nationalistic impulse Berlin traces to Vico, who insisted on the plurality of cultures. From the contention that different societies have different ways of structuring reality, Vico argued that a culture can be described or understood only in its own language, which expresses its peculiar artistic, social, intellectual, and religious self-formations; for the social observer there is no universal neutral language that is equally logical or valid for all cultures. Fully to understand another culture one must enter into its unique conditions.

Such understanding requires above all else the ability to exercise one's imaginative sensitivity to the unpredictabilities and individualities of cultural friction. Scott's efforts to arouse such imaginative perceptions are aided by the deliberate "superficiality" of some of his protagonists. One may criticize Edward Waverley, for instance, as wavering, passive, colorless, a mere victim, but his lack of strong personality makes him a useful explorer of the differences between peoples, a helpful translator (who *ought* to be "colorless") between otherwise mutually incomprehensible languages.

An example is Scott's representation of Fergus's superstitious be-
lief in the Bodach Glas, a vision foretelling his doom.[15] Scott, of
course, was addressing enlightened readers, whose skepticism and
disbelief in the supernatural Scott embodies in Waverley's response
to Fergus's tale of the ancestral ghost: "How can you, my dear
Fergus, tell such nonsense with a grave face?" Fergus, after observ-
ing "I do not ask you to believe it," then tells the story of his own
encounter with the spirit on the previous night. Waverley has "little
doubt that this phantom was the operation of an exhausted frame
and depressed spirits, working on the belief common to all High-
landers in such superstitions," though, decent person that he is,
Waverley "did not the less pity Fergus." Thus the reader is pre-
sented, first, with a traditional tale, recounted by Fergus (a sophis-
ticated man) as appropriate to picturesque local anthropology:

> "Ah! it would have been a tale for poor Flora to have told you. Or, if
> that hill were Benmore, and that long blue lake, which you see just
> winding towards yon mountainous country were Loch Tay, or my
> own Loch an Ri, the tale would be better suited to the scenery."
> (chap. 59, pp. 396–98)

After this tale and after Fergus's emotional recounting of his recent
experience, Waverley's rational skepticism asserts itself in contrast
to Fergus's indubitable fervency of belief. The event proves Fergus
correct: the omen *is* realized when Fergus is captured and con-
demned to death. Just before he is taken to his execution he asks
Waverley what he now thinks of the omen. But Waverley, like the
enlightened reader committed to believe only in what is reason-
able, and therefore facing apparent confirmation of impossible
suprarational events, prefers "to avoid dispute upon such a point at
such a moment" (chap. 69, pp. 458–59). Scott's adroit dramatiza-
tion of the intellectual cowardice of rational skepticism thus en-
courages the reader to imagine a belief he does not share.

It is the plot of Scott's novel, the form of his romance, not merely
authorial comment, that brings the reader face to face with prob-
lematics of the supernatural. In moving the reader to imagine feel-
ings outside the norms of usual emotional experience, the romance
urges appreciation of the foreign, the alien, and the exotic as as-
pects of "our" world.[16] Unlike most of his eighteenth-century pre-
decessors, Scott does not present us with a rationally systematized
cosmos; nor, like many modern novelists, does he represent a
metaphysically absurd cosmos. For Scott, as for Clausewitz, there

is no single, uniform human reality, no "common" commonplaceness; but neither is there anarchic randomness, no essential heart of darkness visible equally on the Congo or on the Thames. What Scott asks us to confront is perhaps even more troubling; his romances encourage us to conceive of a human world composed of unfamiliar coherences, a world that affords ontological securities— but of different and incompatible kinds.

6

Historical Fiction to Fictional History

The Heart of Midlothian is built upon a complicated interplay between fictionality and factuality. The novel's central events, Jeanie's refusal to tell a lie in court and her walk to London to win through the Duke of Argyle pardon for her sister, are, as Scott from the first proclaims, retellings of the true actions of a Scotswoman named, incredibly, Helen Walker.[1] But Scott radically changes the relations of Helen Walker and her sister, particularly in the final chapters, in which Effie's deliverance results in her tensely uneasy success in London society, which leads, finally, to physical and moral destruction: the murder of her husband by their son, the son's outlawry among Indians in America, and her withdrawal into a convent. Fictitious variations of historical facts compose a large part of this novel of multiple secrets, disguises, false appearances, and ironic transformations.[2] Madge Wildfire is a key figure in the novel because the chief feature of her personality—she does not in normal fashion distinguish fact from fiction—represents the social disjunctions that the book dramatizes. And her primary plot function—to be the victim of George Staunton's first seduction and the vehicle for the disappearance of the child born from his second—enables Scott to give historical resonance to the sociological problems his novel explores.

Staunton seduces Effie Deans as he had Madge, but with different consequences, these constituting in good measure the "historical development" depicted by the novel. The differences are not due solely to the different personalities of Madge and Effie; rather, the differences between their personalities are representative of social changes that Scott dramatizes through the story of two seductions by the same man. To simplify, for brevity, Staunton's sexual relation to Madge resembles that of a feudal lord to a dependent; but that their circumstances are not literally feudal is essential to Scott's purposes. Madge and her mother are "backward," and their contemporaries—the novel is set in the 1730s—regard them as

117

"strange." Madge's dependence is illustrated by both her mental incapacity and her actual position as servant. Her relation to Staunton is thus feudalistic so far as there are no important social consequences to Staunton's lust. The child vanishes, Madge loses her reason and wanders off, but later she is willing to associate with Staunton, bearing him no conscious grudge, even lending him her clothes to free Effie.

By the time of his relations with Effie, however, Staunton is no longer lord but outlaw though, as his later retransformation into elegant gentleman proves, not totally lost within the Scottish underworld. In Scotland his criminality can be associated with the respectable, even patriotic, practice of smuggling. With Effie, then, Staunton is involved in the legal and moral complexities that were absent from his relation with Madge. Effie, moreover, is the daughter of an independent farmer, who is financially self-sufficient, with a definite, recognized, and morally fortified and respected position in society. The results of Staunton's second seduction, therefore, have social consequences, intricate ramifications that constitute much of the novel's plot. So it is reasonable to argue that *The Heart of Midlothian* dramatizes a change from postfeudal to prebourgeois society by delineating the consequences of illicit sexual relations.

Historical transformation in *The Heart of Midlothian* is depicted not merely as a series of variable sociological facts but also as the changes in how these facts are perceived and judged. Throughout, the Waverley novels focus on how social relations are imagined by the participants, that is, how in good part social reality is a fictionalizing of facts. *The Heart of Midlothian* openly fictionalizes the facts of Helen Walker's life so as to transform a historical anecdote into meaningful historical narrative. This intention is strengthened and refined by analogous, second-order transformations of fact into fiction within the novel, among them Madge Wildfire's fictionalizing of her own experiences. Like Jeanie, Madge is modeled on an actual person, "Feckless Fanny," who

> "attracted much notice, from being attended by twelve or thirteen sheep, who seemed all endued with faculties so much superior to the ordinary race of animals of the same species, as to excite universal astonishment. She had for each a different name, to which it answered . . . and would likewise obey . . . any command she thought proper to give. . . . When she lay down at night in the fields, for she would never enter into a house, they always disputed who should lie

next to her, by which means she was kept warm. . . . She would sometimes relate the history of her misfortune . . . 'I am the only daughter of a wealthy squire in the north of England, but I loved my father's shepherd, and that has been my ruin; for my father, fearing his family would be disgraced by such an alliance, in a passion mortally wounded my lover with a shot from a pistol. I arrived just in time to receive the last blessing of the dying man, and to close his eyes in death. He bequeathed me his little all, but I only accepted these sheep to be my sole companions through life, and this hat, this plaid, and this crook, all of which I will carry until I descend into the grave.'

"This is the substance of a ballad. . . . Old Charlie, her favourite ram, chanced to break into a kaleyard, which the proprietor observing, let loose a mastiff that hunted the poor sheep to death. . . . She would not part from the side of her old friend for several days, and it was with much difficulty she consented to allow him to be buried. . . . This is altogether like a romance; but I believe it is really true that she did so. . . .

"To the real history of this singular individual, credulity has attached several superstitious appendages. It is said, that the farmer who was the cause of Charlie's death, shortly afterwards drowned himself in a peat-hag; and that the hand, with which a butcher in Kilmarnock struck one of the other sheep, became powerless, and withered to the very bone; a young man . . . plagued her so much that she wished he might never see the morn; upon which he went home and hanged himself in his father's barn."

(chap. 40, pp. 393–95)

Scott's source is in itself a mixture of fact and fiction. Fannie's story of the events that caused her to behave as she did is, indeed, "the substance of a ballad." To what seems a romance but "is really true," "credulity" then attaches "superstitious appendages," just as superstitious credulity in the novel leads to Madge's death at the hands of an English mob. To the popular imagination of the 1730s Madge's alienation seems witchlike, though the sophisticated reader of the early nineteenth century may regard her as a ballad-singing figure out of a quaint romance. By playing off differences between the view of Madge expressed by her contemporaries in the novel and the view of her that contemporary readers might have, Scott makes diverse historical perspectives illuminate one another. If Scott's readers feel sympathy for Madge, few characters in his romance do. And although readers can see that, however brokenly, Madge's songs articulate her fate, to her fellow characters her singing makes little sense. The novel, then, is designed to dramatize changes not merely in behavior but also in ways of perceiving

behavior, imaginatively expressing personal experience, and responding to such expressions.

Madge cannot come to terms with her world; her madness is to a considerable degree her living out a fantasy life, one not in accord with current actualities. The socially superior characters in *The Heart of Midlothian* are usually not unkind to Madge, but they dismiss her as mad; the romance of her life does not appeal to them. Scott, however, expects his readers to respond sympathetically to Madge's strangeness, to find the incomprehensible attractively quaint and intriguing, as Wordsworth was intrigued by the Solitary Reaper.

Specially worthy of note is Jeanie Deans's little care for Madge's songs and fantasies. Jeanie is, as all Scott's admirers say, a heroine. But like Antigone, who also found herself "sted between God's law and man's law," Jeanie is heroic because she is not perfect. Her limitations, moreover, are portrayed by Scott as bound up with her family background, her social class, and the demanding mores of her society. The significance of these limitations is brilliantly elucidated in chapters 29 through 31, when Jeanie, having been captured by robbers, seizes the opportunity offered by Madge to wander off with her, and then escapes into the house of George Staunton's father, where the seducer of Madge and Effie is recuperating. The coincidence is not so contrived as summary makes it seem, for Madge compulsively revisits her former haunts and the places where her father and child are buried. And in bringing Jeanie and Madge together, Scott not only clarifies one thread in his complex plot but also focuses the meaning of the contrastive effects of Staunton's two seductions.

In chapter 30 Jeanie overhears Madge's mother explaining to one of the robbers why she is so determined to destroy Effie Deans. He cannot understand her motive for, like the thieves depicted by Gay and Fielding, he is thoroughly embued with the spirit of commercialism: "'Where there is aught to be got, I'll go as far as my neighbours, but I hate mischief for mischief's sake.'" To this mercantile spirit Madge's mother replies:

> "And would you go nae length for revenge? . . . for revenge, the sweetest morsel to the mouth that ever was cooked in hell.'
> "The devil may keep it for his own eating, then," said the robber; "for hang me if I like the sauce he dresses it with."
> "Revenge!" continued the old woman; "why, it is the best reward the devil gives us for our time here and hereafter. I have wrought

hard for it—I have suffered for it, and I have sinned for it—and I will
have it,—or there is neither justice in heaven nor in hell!"

(pp. 294–95)

The old woman, who believes in the justice of hell in her commit-
ment to the emotional satisfaction of revenge, reflects the motives
and attitudes of a society more bloodthirsty and vindictive than the
robber's. He then asks "Mother Blood" why she does not seek re-
venge " 'on the young fellow himself' "?

> "I wish I could," she said, drawing in her breath, with the eager-
> ness of a thirsty person while mimicking the action of drinking—"I
> wish I could!—but no—I cannot—I cannot."
> "And why not? . . ."
> "I have nursed him at this withered breast. . . . No, I cannot,"
> she continued with an appearance of rage against herself; "I have
> thought of it—I have tried it—but, Francis Levitt, I canna gang
> through wi't!—Na, na—he was the first bairn I ever nurst."
>
> (p. 295)

Unlike Levitt, the old woman's heritage is a society in which the
bonds of blood and personal service are determinative, even of the
forms of criminality—it is the personal pass signed by the thief
Ratcliffe that first saves Jeanie from the English thieves' violence.

The power of such bonds is also illustrated by the stone at the
grave of Madge's father. He had been a much cherished servant of
George Staunton's father, who raised for him an eloquent grave
monument bespeaking the mutual personal loyalty upon which
feudalistic relations depended:

> "This monument was erected to the Memory of Donald Murdockson
> of the King's XXVI, or Cameronian Regiment, a sincere Christian, a
> Brave Soldier, and a Faithful Servant, by his Grateful and Sorrowing
> Master, Robert Staunton."
>
> (chap. 31, p. 308)

No wonder Meg Murdockson "rage[s] against herself": to hate
one's lord is to hate oneself. Furthermore, as Levitt's very different
attitudes dramatize, Mother Blood's mind works in a compulsive,
reiterative fashion not so different from her daughter's more wan-
dering and superficially less coherent fantasizing. Madge's delu-
sions return ever to the same two points, her seduction and the
murder of her child, just as her wanderings instinctively return her
to her seducer, whose home is her only real home, and to the hid-
den grave of her infant. Madge's madness is a consequence of her

displacement; she wanders "like Wildfire" over the country be-
cause, like a feudal serf, for good or ill she belongs to the place
where she was born. Only by returning to the place of her suffering
can she escape the persecution she endures elsewhere, lost in the
modern world.

Off for London Jeanie is away from her home ground, too; but
that she can even think to undertake so fantastic a trip reveals
a modernity in her consciousness. (Her sister originally believes
London separated from Scotland by the ocean.) And if ever a Pu-
ritan had a purpose and determination to achieve it by unflinching
adherence to a righteous path, it is Jeanie. Jeanie's reliance on the
Bible, the only book she knows and which she interprets literally,
contrasts against Madge's fantasizing of their journey into a revi-
sion of *Pilgrim's Progress*, "the fanciful and delightful parable" that
Jeanie has never read:

> "I may weel say I am come out of the city of Destruction, for my
> mother is Mrs. Bat's eyes, that dwells at Deadman's Corner; and Frank
> Levitt and Tyburn Tam, they may be likened to Mistrust and Guilt,
> that came galloping up, and struck the poor pilgrim to the ground
> with a great club, and stole a bag of silver, which was most of his
> spending money. . . . But now we will gang to the Interpreter's
> house, for I ken a man that will play the Interpreter right weel . . .
> that's Mr. Staunton himself, will come out and take me—that's poor,
> lost, demented me—by the hand, and give me a pomegranate, and a
> piece of honeycomb, and small bottle of spirits to stay my fainting."
> (chap. 31, p. 305)

Madge, and in a darker fashion her mother, possesses a power of
fantasizing and a skill in expression that seem anachronistic in
eighteenth-century Britain. Mother and daughter's religiosity is far
more imaginatively superstitious than doctrinal. Madge has felt
the devil's "broad black loof" in her mouth, as her mother seems
literally to "thirst" for revenge.

Indeed, Madge is as distant spiritually from Jeanie as the Queen
is socially, and the Queen and Duke of Argyle, however diverse
their political commitments, are both closer to Jeanie's "whiggery"
than is Madge. Jeanie's whiggery leads her, even in her distress, to
disapprove moralistically of Madge's singing and traveling on Sun-
day, and enables her to attend to the "sensible, energetic, and well-
composed discourse, upon the practical doctrines of Christianity"
(p. 310) delivered by the Reverend Staunton, while, nonetheless,
being alertly critical of his surplice and his reading of the sermon.

Jeanie is scrupulously moral but totally unimaginative, whereas Madge's fantasies and superstitious religiosity are actively imaginative, repeatedly transporting her to the depths of human experience that Jeanie's practical, moralistic pieties would evade or repress. The differences between the two young women's conceptions and responses to experience are illuminated when Madge, pursuing her reallegorizing of *Pilgrim's Progress*, observes that if she had her little dog,

> "[it] would be Great-Heart their guide, ye ken, for he was e'en as bauld bark at ony thing twenty times his size; and that was e'en the death of him, for he bit Corporal MacAlpine's heels ae morning when they were hauling me to the guard-house, and Corporal MacAlpine killed the bit faitfu' thing wi' his Lochaber axe—deil pike the Highland banes o' him!"
> "O fie, Madge," said Jeanie, "ye should not speak such words."
> "It's very true," said Madge, shaking her head; "but then I maunna think on my puir bit doggie, Snap, when I saw it lying dying in the gutter."
> (chap. 30, p. 300)

To Jeanie, spoken words are crucial; her words at the trial, after all, have set her on the road to London; to Madge, emotionalized images compel language.

These differences ramify when the women come to the church. They wait outside for the service to begin, for Madge hopes to avoid persecution from the children and the beadle—"as hard upon us as if it was our fault," she says. Jeanie uses the time to make herself appear respectable; she

> sate herself down . . . and by the assistance of a placid fountain . . . which served her as a natural mirror, she began . . . to arrange her toilette . . . and bring her dress, soiled and disordered as it was, into such order as the place and circumstances admitted.
> (chap. 31, p. 306)

This activity inspires Madge, who "had a most overweening opinion of those charms, to which, in fact, she had owed her misery" to "bedizen and trick herself out with shreds and remnants of beggarly finery" (p. 306). Scott details Madge's bizarre accoutrements:

> Across the man's cap or riding hat which she wore, Madge placed a broken and soiled white feather . . . then stripped off the coarse ordinary shoes which she wore, and replaced them by a pair of dirty satin ones, spangled and embroidered to match the scarf, and furnished with very high heels. She had cut a willow switch . . . and

when it was transformed into such a wand as the Treasurer or High
Steward bears on public occasions, she told Jeanie that she thought
they now looked decent, as young women should do upon the
Sunday.

(chap. 31, pp. 306–7)

When a blind old woman, "only conscious that something very fine
and glittering was passing by . . . dropped as deep a reverence to
Madge as she would have done to a Countess" (p. 307), the de-
mented girl's vanity is rewarded, though Jeanie follows her, "her
eyes fixed on the ground" in "mortification" at the spectacle. De-
spite the danger posed by the robber gang and her desire to con-
tinue rapidly to London, Jeanie's chief feeling with Madge in the
church congregation is embarrassment. Madge's "decent" reso-
nates ironically, for Jeanie is consistently described as "decent." She
is, in fact, a canny, self-controlled young woman who epitomizes a
lower-middle-class respectability of thought and behavior. Jeanie
breaks away from Madge outside the church, seeking refuge with
"respectable parishioners," and is finally aided by the beadle, who
accosts the madwoman, " 'Hast thou brought ony more bastards
wi' thee to lay to honest men's doors? or does thou think to burden
us with this goose, that's as gare-brained as thysell, as if rates were
no up enow?' " (p. 312).

Having taken her place by the decent, affluent members of the
congregation, Jeanie easily makes her choice: " 'I am not going back
with you, Madge,' said Jeanie, taking out a guinea and offering it to
her" (p. 311). This vivid representation of the psychology of the
cash nexus in no way diminishes Jeanie's heroism. But she is a cool
heroine who understands the relation of money and respectability,
whose provincialism never obscures her clear-sightedness of the
economic foundations of morality. After all, her first stop on the
road to London had been at the home of the Laird of Dumbedikes,
from whom she borrows twenty-five guineas that will enable her to
pay her way respectably: " 'Ye ken,' she tells him, 'my father's a man
of substance, and wad see nae man . . . come to loss by me'" (chap.
26, p. 261). A final meeting between careful Jeanie and disoriented
Madge will force us to recognize the *cost* of Jeanie's heroism.

IMAGINATIVE FAILURE
IN HISTORICAL CHANGE

After her successful encounter with the Queen, Jeanie is driven
back to Scotland in the Duke of Argyle's carriage, attended by his

supremely respectable servants. Outside Carlisle, near the Eden river, the carriage meets with a crowd of rough Englishmen who have just hanged an old woman. Some of them are now persecuting "a tall female fantastically dressed," who finally

> broke out of the noisy circle of tormentors who surrounded her, and clinging fast to the door of the calash, uttered in a sound betwixt laughter and screaming, "Eh, d'ye ken, Jeanie Deans, they hae hangit our mother?" Then suddenly changing her tone to that of the most piteous entreaty, she added, "O gar them let me gang to cut her down!—let me but cut her down!—she is my mother, if she was waur than the deil, and she'll be nae mair kenspeckle than half-hangit Maggie Dickson, that cried saut mony a day after she had been hangit; her voice was roupit and hoarse, and her neck was a wee agee, or ye wad hae kend nae odds on her frae ony other saut-wife."
>
> (chap. 40, p. 388)

Mr. Archibald, the duke's man, "embarrassed by the madwoman's clinging to the carriage," looks for "a constable to whom he might commit the unfortunate creature" (p. 388) but finding none, he endeavors unsuccessfully to loosen her hold on the carriage in which Jeanie sits, distressed and mortified but incapable of doing anything useful.

Scott does not let Jeanie escape easily. Madge "held fast," and "renewed her frantic entreaties to be permitted to cut down her mother. 'It was but a tenpenny tow lost,' she said, 'and what was that to a woman's life?'" (p. 388). A cruel question in the light of Jeanie's housewifely attention to pounds and pence, and Madge's plea reverberates painfully, for "tow" echoes the conclusion of Jeanie's eloquent plea to the Queen. The toughs of this English mob, a blatant contrast to the "lawful" Porteus rioters, finally do drag Madge away. Archibald and Jeanie drive off to look for a magistrate in Carlisle; as they leave

> they heard the hoarse roar with which the mob prefaces acts of riot or cruelty, yet even above that deep and dire note, they could discern the screams of the unfortunate victim.
>
> (p. 389)[3]

By the time Archibald and the authorities return, Madge has been mortally injured. Carried to the workhouse, she is there visited by Jeanie (seeking information to benefit Effie), whom she does not consciously recognize. Madge dies shortly, but not before Jeanie has continued on her way back to Scotland, having "satisfied herself that no elucidation of her sister's misfortunes was to be

hoped from the dying person" (p. 392). Jeanie here seems scarcely a good Samaritan, but she is also a victim of the inhumanity of her social situation. In a duke's carriage, surrounded by all the appurtenances of affluent respectability, Jeanie is shown to be *helpless*. And, as Scott repeatedly makes clear, Madge is a surrogate for Effie, whom Jeanie does not finally "save," even though she wins her a pardon from the Queen. Of course, Jeanie is distressed when Madge is hustled by the crowd and appeals to her, but in fact she can do nothing for her victimized "sister."

In demonstrating Jeanie's ineffectuality, Scott in no way implies that the madwoman would have fared better in an older, bygone social order. To the contrary, the English mob that kills Madge is made up of feudalistic, "backward" rural types whose credulity and sadism lead them to perceive her as a witch:

> "Shame the country should be harried wi' Scotch witches and Scotch bitches this gate—but I say hang and drown."
> "Ay, ay, Gaffer Tramp. Take awa yealdon, take awa low—hang the witch, and there will be less scathe amang us; mine owsen hae been reckan this towmont."
> "And mine bairns hae been crining, too, mon," replied his neighbour.
>
> (chap. 40, p. 387)

This credulous crowd is, unlike the Porteus "mob," both intellectually and physically brutal. No aspect of Madge's death is rendered with unqualified sympathy: one feels an authentic inhumanity in every one of the participants and onlookers.

The circumstances of Madge's death might be called a social reflection of the problem of George Staunton, who seems neither hero nor villain though both active sinner and passive victim. Although the narrator casts Staunton in a predominantly negative light, most of the characters in the novel admire and approve of him, not only in his role as a well-to-do landowner but even as "criminal." Readers perceive Staunton's seductions of Madge and Effie to be reprehensible because of the suffering they bring, yet characters within the novel, both prebourgeois and postfeudal, only mildly condemn him, for the evil of his acts is not clearly defined by the moral views of either "new" or "old" society within the novel.

In short, within the novel there is no ready-made answer to the conflict it represents; Scott's romance recommends neither nostalgia nor cheerful faith in progress.[4] *The Heart of Midlothian*, instead,

depicts how diverse moral systems may be mutually incomprehensible so that the process of social change can be defined in imaginative failures, and historical truth becomes elusive. The central dramatization of imaginative failure is Madge Wildfire's dying, as she croons four songs to herself. She rejects the "modern" world in which she has suffered, begging, " 'nurse, turn my face to the wa', that I may never answer to that name [Madge] ony mair, and never see mair of a wicked world'" (chap. 40, p. 391). In that "wicked" must be included, even if unconsciously by Madge, Jeanie. To only one of Madge's four songs, and that the most nearly contemporary in resembling a Methodist hymn, do her auditors respond, even "Archibald, though a follower of the court, and a poco-curante by profession, was confused if not affected; the dairymaid blubbered, and Jeanie felt the tears rise spontaneously to her eyes" (p. 391).

"No longer able to express her wandering ideas in the wild notes of her former state of exalted imagination" (p. 390), Madge reveals "death in the plaintive tones." None of her songs is complete: "of the words only a fragment or two could be collected by those who listened to this singular scene" (p. 392). The scene consists primarily in aural fragments "collected" by those sharing nothing of the life from which Madge passes. In her death is the death of a fashion of living: "there could always be traced in her songs something appropriate, though perhaps only obliquely or collaterally so, to her present situation" (pp. 391–92). At the last the only access to her life is through its tangential embodiments in traditional forms, now as incomprehensible as her articulation is broken. Her first song is "of what had been, *perhaps*, the song of a jolly harvest-home"; the second "*rather* resembled the music of the Methodist hymns"; the third "*seemed* the fragment of some old ballad"; and the last tune is described only as "wilder, less monotonous, less regular," of whose words "only a fragment or two" could be understood (pp. 390–92, my emphasis).

Madge's version of this last lyric, Scott's own composition and usually printed in anthologies as if complete under the title of "Proud Maisie," is presented in the novel as a fragmentary song. Madge's broken rendition conveys a mood of inadequacy, inaccessibility, failure, death. The reader is made to feel the impossibility, except collaterally or obliquely, of experiencing Madge's experience; a configuration of inaccessibility distinguishes Madge's social being both from characters in the novel and from the reader. Like the singers in Burns's "Jolly Beggars," Madge is a remnant of a

society in which the individual could conceive of his or her life as accurately represented by a traditional narrative. The songs Madge sings do in fact articulate the nature of her individual life—her history is a balladic story. Like Burns, Scott understood how ballads and folk songs manifest in their own special way real conditions of a social existence, though Scott presents these conditions as already obsolete in the 1730s.

The "proud lady" of Madge's final song thus can function in an unexpectedly complicated manner. As we have been told, Madge's pride in her feminine charms is a cause of her ruin, so "Proud Maisie" applies to her. But the ballad fragment here appears within a different literary form, a realistic prose fiction, one which is as appropriate to the depiction of Jeanie's pre-bourgeois individuality as the balladic form is appropriate to the rendering of Madge's feudalistic personality. The reader, then, could reasonably be expected to imagine that Jeanie's way of life, with its peculiar forms of individualization, is as much a part of historical processes as Madge's. Jeanie's way of life, too, will become—in fact for post-Napoleonic readers has already become—antiquated, as Madge's life style was in the 1730s. So, too, Jeanie may eventually become incomprehensible—the fall in Scott's reputation suggests that for many readers she already is.

The dying Madge's "Proud Maisie" warns an alert reader that structures of imagination are mortal too: like the ballad, realistic prose fiction may become obsolete, for different prides find the same end.

> The glow-worm o'er the grave and stone
> Shall light thee steady;
> The owl from the steeple sing,
> "Welcome, proud lady."
> (chap. 40, p. 392)

The resonance of Madge's final song provides a keynote for the final chapters of Scott's romance, which have rightly troubled many readers, for the incidents in them are meant to be troubling. Jeanie and Reuben Butler have been set up in an idyllic situation, but the idyll does not end the book. Effie reappears to provoke renewed tensions, and the novel concludes with parricide, several other murders, and Jeanie's foolish freeing of Effie's son, who sets fire to her house and escapes to perpetrate at least one more murder. Despite the dismissive paragraphs on the last page, the final chapters

create an impression of social disorientation, psychological anxiety, and incoherent physical violence; the novel's conclusion is somehow not conclusive. For Scott's historical imagination includes imagining how imaginative styles—the forms through which individuals and groups define their understanding of experience—have changed. These changes, manifesting historical dislocations and sociological shiftings, produce incomprehension; social transformations are marked by communicative failures of one kind or another. Gradually or abruptly the conventionalized forms by which the inner, predominantly emotional significance of experience has been articulated begin to make no sense, begin to seem antiquated, grotesque, finally incomprehensible. Such a change is dramatized in the failure of effectual sympathy between Madge and Jeanie. That failure, moreover, is reflected in the total form of *The Heart of Midlothian* itself, whose unsatisfactory ending turns back on its readers the shadow of the impermanence of their own "romantic" mode of imagining.

A SELF-DESTRUCTIVE CONCLUSION

In the triumph of Jeanie and Reuben's respectability, the events of Madge's life recede into the realm of quaint romance. But a cost of that distancing is the emergence of destructive forces more aberrant, inchoate, and threatening. Whether Madge's mother or Effie's son is more criminal is scarcely determinable, but with Whistler crime becomes more impersonalized, and therefore more frightening in its meaninglessness. While Meg Murdockson was committed to revenge on an individual whom she felt had personally injured her and hers, Whistler pledges "death on all and sundry" for the murder of his gang's leader, and he kills his father without knowing or caring who he is. In Whistler, Meg's rage is diffused into a generalized destructiveness, a vendetta against society. The principal authority in the final chapters, significantly, resides in the depersonalized militarism of Knockdunder, whose code is more blindly and mechanistically brutal than that of Ratcliffe and Sharpitlaw, whose dubious political maneuvers in the early portion of the novel are an entertaining battle of wits founded on clear if intricate motives of interest and power by two very human, if not entirely admirable, human beings.

The contrast between Ratcliffe, thief turned jailer, and the incorrigible Whistler is particularly revealing. Both are self-interested,

but Ratcliffe is more emotionally outgoing and generous, as well as more intelligent. One agrees with the city clerk:

"if James Ratcliffe be inclined to turn to good, there is not a man e'er came within the ports of the burgh could be of sae muckle use to the Good Town in the thief and lock-up line of business."

(chap. 13, p. 144)

One expects Ratcliffe to become a successful turnkey because as a criminal he has been "honorable," really more so, Scott makes it plain, than the formally respectable Sharpitlaw. Ratcliffe's reversal of roles, moreover, reflects his intelligent perception of how his society is changing: he trades feudal loyalty for bureaucratic responsibility. Of course, Ratcliffe from first to last remains a rogue, but whether breaking or enforcing the law Ratcliffe affirms the importance of sociality. Whistler, by contrast, is an asocial being who glories in the senseless violence and unmitigated savagery of the socially alienated.

Out of compassion for Whistler, Jeanie secretly visits him in the room where he is imprisoned after the murder of his father. She brings him food, for which "he stretched out his hands, still smeared with blood, perhaps that of his father, and he ate voraciously and in silence" (chap. 52, p. 496). Jeanie decides to "try fair play" with him:

She cut his bonds—he stood upright, looked round with a laugh of wild exultation, clapped his hands together, and sprung from the ground, as if in transport on finding himself at liberty. He looked so wild, that Jeanie trembled at what she had done.
"Let me out," said the young savage.

(p. 496)

After his escape, by firing the house, Whistler is sold as a slave, murders his master, and flees to a tribe of wild Indians:

He was never more heard of; and it may therefore be presumed that he lived and died after the manner of that savage people, with whom his previous habits had well fitted him to associate.

(p. 497)

As Jeanie cannot "trace the likeness of either of his very handsome parents" in Whistler's face, so too he does not belong in the novel of which she is the appropriate heroine. What is most troubling about the final chapter is the seemingly inevitable emergence of characters and events incompatible with either the novel's real-

ism or its romance. Just as Madge's songs mean little to Jeanie, so will Jeanie's story hold little interest for subsequent generations, in which characters like Whistler will have become more common, and the general reading public will have little patience with her quiet pietistic morality.

That Scott should seem to foretell the failure of his style of fiction is in keeping with his historical vision. Few writers have been as conscious as he that modes of imagination change just as radically as other social institutions, and he stands virtually alone in refusing either to commend such changes as indicative of a desirable progress or to condemn them as a regrettable deterioration. What fascinated Scott was simply the fact of change and the variety it enforced, although he recognized unflinchingly that such variety entailed tragic failures in comprehension and understanding. This historical vision extended to Scott's keen awareness of the transiency of his own literary success. Throughout his career he testified with unfailing consistency to the temporal limits of his popularity.[5] The creator of Madge Wildfire, indeed, could have had few hopeful expectations about the lasting popularity of his art.

HISTORICAL FICTION AFTER SCOTT

Scott's historicism and Romantic historicism in general have received little critical attention in our century. Thorough analysis of the reasons for this neglect of so important a matter would carry one into the murkiest depths of the history of literary criticism. But valuable insight into the significance of Victorian and twentieth-century antipathy to the Romantic historicizing imagination is provided by even a superficial glance at how, in England especially, the historical novel as created by Scott was almost at once subverted. While the external characteristics of Scott's romance form were retained, his historical vision was very nearly reversed.

This is a fascinating, if virtually unexplored, chapter in the evolution of fictional art, but my purpose here requires only a schematic outline of the principles by which the historical novel after Scott was used for purposes entirely different from his. This curious turn in literary history is peculiarly revealing of how and why the modernist understanding of Romanticism is so different from that which has begun to emerge in the past few years. The transformations, amounting to perversions, of Romantic historicism in Victorian and early modern historical fiction throw into the sharpest

relief fundamental impulses in the reaction against Romanticism by artists indebted to its inspiration. From their work derived the principal critical judgments about Romanticism that are now coming to seem biased and imperceptive.

Briefly then, let me suggest why we should make more than we customarily do of Charles Dickens's resistance to Scott's fiction. Were the radical contrast between *Barnaby Rudge* and *The Heart of Midlothian* more generally recognized, for example, the powerful originality of Dickens's first historical novel would be more appreciated. In rejecting so decisively the model of his greatest immediate predecessor, in effect the founder of the form he adopted, Dickens in *Barnaby Rudge* created a work not flawless, not so finely fashioned as his later masterpieces, but brilliantly innovative.[6]

Dickens of course made use of Carlyle's *French Revolution*,[7] but Dickens's orientation is more consistently psychological than sociological, acutely described in Steven Marcus's analysis of *Barnaby Rudge* as a study in "fathers and sons." Dickens dramatizes timeless psychic patterns rather than processes of social change, and, accordingly, ties his story to fixed, revisitable spatializations. On the simplest level, physical places (notably the Maypole Inn) center meaning and structure in *Barnaby Rudge* as, say, the Tolbooth does not in Scott's romance, the prison that gives the novel its name serving as an origin point for a narrative that leads away from but not back to it. Because places that serve crucial functions in other Scott novels (such as Tillietudlem and the Baron of Bradwardine's estate) primarily accentuate by their anachronistic qualities social changes that have passed them by, such places cannot serve as symbolic foci as do Dickensian locales.

Dickens's strength as an artist is increased by his rejection of Scott's historical specificities. Dickens's mobs, to take a striking instance of contrastive parallelism, owe less to the historical facts that Dickens had conscientiously studied than to the blazing dramatic vision subsuming them that seems to have seized him in the heat of composition. Unlike Scott's ectypal Edinburgh mob, so different from the usual mob, Dickens's rioters are spectacularly model rioters, archetypal realizations of suburbanite fears. Physiological probabilities are, for example, not at issue when Dickens tells us that "on the skull of one drunken lad—not twenty by his looks— who lay on the ground with a bottle to his mouth, the lead from the roof came streaming down in a shower of liquid fire, white hot; melting his head like wax" (chap. 55, p. 423). The image is perfect

in representing the intoxicated self-destruction that is the quintessence of mob spirit. It is that essence, not historical peculiarity, that Dickens pictures with such unique vividness.

There is none of *The Heart of Midlothian's* interplay of fictional and factual in *Barnaby Rudge* because Dickens's novel is built upon powerfully essentializing imagery. Contrast Madge with Barnaby: not only is the latter a more conventional "natural," but Barnaby, whose mental defect is the stain of his father's guilt, is presented as entirely innocent (chap. 1, p. 5). Whatever "innocence" Madge may claim is more dubious, for Scott's novel is structured by differing interpretations of *innocence* and *guilt*. In *Barnaby Rudge* guilt and innocence are givens, fixed, even transcendental entities. Gabriel Varden before Newgate telling the warden to do his duty in defying the mob even at the cost of Varden's life is melodramatic because the locksmith's righteousness is represented as unquestionable. Scott's reader is faced with more intricate questions of justice. The Porteus mob, extraordinary in its unmoblike self-control, lynches Porteus. Jeanie for narrowly sectarian reasons will not tell a lie to save her sister, for whom she gains temporary respite by appealing to the mercy of an autocrat. Justice in Dickens's novel is simpler and more definitive: Joe Willet loses an arm for deserting his father, Sim's legs are smashed because he rose up against a good master, the hangman is hanged, and the smiling villain dies, smiling, from a sword thrust by his most morose victim. When *Barnaby Rudge* moves away from such definite simplicities it weakens. Hugh of the Maypole is an effective characterization because not complex: what impresses us most is the opposition of his animality to his father's overcivilized decadence. There is no parallel contrast in Scott's work, in which characters are imagined as parts of particularized sociological movements. Even the "savage" Whistler emerges out of highly specified social circumstances. Hugh, like his father, Chester, could appear in many, perhaps most, societies: neither is determined by unique historical circumstances—what matters is the psychic drama of the confrontation between father and son.

An interesting contrast is provided by Ratcliffe and Dennis the hangman, for their plot functions are somewhat parallel and both shift allegiance. Dennis, however, chooses the losing side while remaining unflinching in his claim to represent true lawfulness, whereas Ratcliffe slides from an admitted, but unfanatical, lawbreaker to an accepted, but unfanatical, law-enforcer. Ratcliffe's successful transformation issues from his correct evaluation of spe-

cific changes in his society, and his act helps to define these as central foci of *The Heart of Midlothian*. Dickens creates in Dennis an original figure who, although unique, seems meant to function as a type, an embodiment of an essential, ever-recurring problem in all complex societies. And although the historical figure on whom Dennis was modeled did win a pardon, in Dickens's novel the hangman *must* be hanged to fulfill the symbolic role that is his aesthetic raison d'être. Dennis's final desperate claim, that a hangman ought not to be hanged, epitomizes the issue he was created to pose: What authority compels the enforcers of authority?

Dennis remains a static character throughout, repeating the same words and insisting tirelessly on the constitutionality of hanging as against burning—which strikes one as the ultimate inanity of religious bigotry, depicted in *Barnaby Rudge* as the motive for the Gordon riots. Indeed, lacking Scott's sensitivity to the historical determination of religious as well as secular law, Dickens presents all religious fanaticism as pathological per se. In contrast, Scott enables us to appreciate the historical conditioning of Jeanie's religious scruples: nowhere in *The Heart of Midlothian* is there one transcendental truth that gives definitive order to the diverse ideas of righteousness and justice held by various characters.[8] Religious fanaticism is not scorned, for Scott's novel as a whole works to make an enlightened reader regard Jeanie's religious conviction as her peculiar but legitimate faith, not *the* truth, yet a truth, and not to be despised.

Finally, Dennis exemplifies the intensely pictorial quality of Dickens's novel. Whereas Madge's demented attention to her finery is functional to Scott's *narrative* and is not pictorially important, Barnaby with his fantastic garb and Grip, the raven who lives so long as to make human history trivial, exists through visual accoutrements. But it is Dennis with his stick, whose head is a carved image of his own, who dramatizes best the difference between Dickens's pictorialism and Scott's narrativity, paralleling differences between Tennyson's "Enoch Arden" and Wordsworth's "Michael." The self-duplicating representation of the hangman increases his symbolic power, since it makes visible what he "stands for," the law-enforcer's need for a sustaining image of himself, an image obtainable only through his victims (one of whom carved his stick). Ratcliffe, to cite Dennis's counterpart again, denotes a less universal meaning. Bound to a specific historical transformation in which he participates, Ratcliffe's activity is more important than his appearance.

Dickens's mode of characterizing is but one aspect of his anticipation of a major development in fictional art in the mid-nineteenth century, the increasing emphasis on archetypal and symbolic imaging. Although apparently historical fictions, many Victorian "historical" novels follow Dickens in his hostility to Scott's historicism. *Middlemarch*, for example, surely as Victorian as can be and surely different from *Barnaby Rudge*, is a work overtly concerned with history and gives every evidence of Eliot's careful historical research as well as her intelligent admiration for Scott. But Scott would never have subtitled one of his romances "A Study," as Eliot does *Middlemarch*, and, despite his interest in the rural, the backward, and the exotic, he never adopted the cosmopolitan position Eliot does in defining her subject as "Provincial Life." Further, Eliot opens her novel with a section entitled "Prelude," a heading that introduces the ostentatious aestheticism of her fiction, whereas Scott's superimposed "historical" introductions disguise his aesthetic purposes. As the first sentence of Eliot's "Prelude" demonstrates, history for her is the study of "man," not particular individuals, and the personification of events as the "varying experiments of Time" illustrates her preference for the abstract and universal. "Theresa's passionate, ideal nature," Eliot continues, "demanded an epic life," though St. Theresa appears in *Middlemarch* only as a heroic prototype, a model for the heroine. Convinced that the "Spanish woman . . . was certainly not the last of her kind," Eliot dramatizes one of the "many Theresas" who have lived in various eras and various places.[9] In contrast, Jeanie Deans is a fictional presentation of a specific Scottish woman, neither saint nor model, and her experience is to engage the reader because it is unique.

A subtler but more profound contrast is these heroines' attitudes toward leading "an epic life." Jeanie does not yearn for heroic action; like most of Scott's protagonists, epic adventure is thrust upon her. But of the many Theresas, Eliot's narrator notes that

> to common eyes their struggles seemed mere inconsistency and formlessness; for these later-born Theresas were helped by no coherent social faith and order which could perform the function of knowledge for the ardently willing soul. Their ardour alternated between a vague ideal and the common yearning of womanhood; so that the one was disapproved as extravagance, and the other condemned as a lapse.
>
> (*Middlemarch*, p. 3)

Here, too, Eliot introduces a crucial distinction between "common eyes" and the narrator's vision, a privileged insight the reader is en-

abled to share through her art. But the Victorian distinction reacts against the Romantic tendency to subvert its audience's unconsciously internalized attitudes. The Victorian novelists' preference for a short historical perspective—locating the fictive action thirty to fifty years before the date of publication—frees both narrator and readers from personal involvement: they assume a privileged position, recognized as such.

The narrator of *The Heart of Midlothian*, to the contrary, takes a tone that seemingly aligns him with the attitude of an ordinary person, a role facilitated by locating the tale in a more distant past. Scott's strategy inverts Blake's prophetic mode but is directed to a similar end—undermining the audience's confidence in its unanalyzed assumptions. The target for Romantic writers is what lies below full awareness, so they do not, like their Victorian successors, urge primarily reform of conscious modes of thought. Scott's narrator, like Wordsworth's narrator in "Michael," makes no claim to a definitive wisdom, professing only the advantage (that assures uncertainty) of a temporal perspective different from that of the story's protagonists. *The Heart of Midlothian* cannot be organized by any contrast of privileged insight to superficial vision, because no perspective in Scott's novel, including that of the narrator, is awarded the absolute superiority implicitly affirmed by confident derogations of "common eyes" throughout *Middlemarch*. For although much is made in the later novel of presenting the reader with complex and inconsistent characters, the narrator's perception of those complexities and inconsistencies remains always indisputable. However we may judge Dorothea Brooke, our judgments begin from the "fact" that her Theresa-like yearnings are unobserved or misinterpreted by the "common eyes" around her. The final image of Eliot's "Prelude" is of Dorothea as a swan incomprehensible to ducks, and the point that because she is unusual she is by ordinary folk misunderstood is reiterated vigorously in the counterbalancing "Finale."[10] So, however ambiguous Dorothea's behavior and motives may at times be, the kind of concealed critique of Jeanie's attitudes developed implicitly by Scott's narrative is impossible in *Middlemarch*. In Eliot's novel Scott's form, founded on continuously shifting perspectives derived from persistently destabilizing historical changes, is transformed into a more overtly aesthetic structuring.

In subverting its ostensible moral and undercutting its audience's assumptions without providing stable and certain alterna-

tives, Scott's romance works in a fashion analogous to "Michael" and *Urizen*. Although Romantic form can be defined as allotropic or multidimensional, it seems as fair to suggest that Romantic art has a strong tendency toward the formless. Yet in provoking the audience to an intrinsically unsteady—because self-reflexively imaginative—response, the Romantic artist is more likely than not to sustain a "historical" approach rather than suggesting transcendent solutions or turning to the comfort of symbolic patterning. Herein lies a crux of later resistance to Romanticism and its essentially historical bias.

Henry James's self-serving sneer at loose, baggy monsters notwithstanding, the best Victorian fiction, like *Middlemarch*, is notable for foregrounding its significant order. Just as in a Pre-Raphaelite painting in which every detail, however minute, possesses an intentional and intelligible significance that contributes to the picture's symbolic meaning, in *Middlemarch* each of the novel's images contributes to the novel's structural coherence, and the images are arranged to be *discerned* as so contributing. Like its dominant image, the novel is presented to be appreciated as a perfectly woven web; its form reiterates the form it attributes to its social materials. Eliot took pride in such design:

> I have always exercised a severe watch against anything that could be called preaching, . . . and if I have ever allowed myself in dissertation or dialogue anything which is not part of the *structure* of my books, I have there sinned against my own laws.[11]

The manifest intricacy of Eliot's design is proclaimed throughout *Middlemarch*, and the patterning of images is especially impressive in contrast to *The Heart of Midlothian*'s minimal image-patterning. For Eliot works principally with the dramatic results of accumulated change over a span of time, and so can make use of sharply pictorialized distinctions, while Scott's focus on the imperceptible continuousness of the changes that constitute historical life precludes the patterns of an imagery essentially dependent on visualization.

Visible differences between the period in which her novel is set and the present also concern Eliot. For example, she frequently calls the reader's attention to manifest differences between "then" and "now," such as changes in styles of dress. Scott's romance emphasizes instead the differences between his novel's setting and an earlier time still—precisely those differences that are likely to ap-

pear to his contemporary readers as romantic, attractively repre-
sentative emblems of a long-vanished way of life. Just as Madge
Wildfire seems out-of-date to her contemporaries in the 1730s, so
most if not all the Waverley novels include similar figures or groups
notable for their adherence to what is already antiquated at the
present time within the novel. The Baron of Bradwardine as well as
the Highland clans are examples from *Waverly*; another is Cedric in
Ivanhoe, whose Saxon patriotism is anarchronistic in King Richard's
time. But like most nineteenth- and twentieth-century historical
novels, *Middlemarch* contains little mention of the era preceding the
fictive present, the time of the first Reform bill; this "prehistory" is
dismissively referred to as a timeless, changeless state: "old provin-
cial society."

Focus on sharp contrasts between the novel's present and the
author's present permits Eliot's novel a dramatic vividness rarely
found in Scott's work but foreshadows the intellectual dilemma
posed by Nietzsche, whose *Uses and Abuses of History* best defines
late–nineteenth-century ambivalence. The massive corpus of his-
torical material then being unearthed by scholars roused a yearning
for a transhistorical organizing truth, a yearning that religion was
no longer able to satisfy. The sheer diversity that had satisfied Ro-
mantics like Scott had to be given an overarching meaning. History,
it was felt, could not be merely a record of unimportant lives, like
those of Michael or Jeanie; such lives had to reveal patterns or in
some way signify beyond themselves. Eliot's resistive participation
in such yearning is suggested by the last sentence of *Middlemarch*'s
"Finale," which identifies Dorothea's life as "unhistoric," a label in-
applicable to the heroine of *The Heart of Midlothian*, in which every
human being is conceived as intrinsically historical.

Much of early Modernism challenged the illusoriness of late–
nineteenth-century efforts to transvalue historical values, and Con-
rad's *Heart of Darkness* may be regarded as, among many other
things, an exposé of the practical consequences of idealizing a su-
perhero.[12] Yet, as the more comprehensive *Nostromo* suggests, early
Modernism tended to intensify the late Victorian dilemma rather
than to resolve it. One at first might think of *Nostromo* as an acutely
perceptive historical narrative. But the wind-scattered pages of José
Avellanos's history of Costaguana, blowing disregarded about a
Sulaco plaza, represent aptly the futility of the history *Nostromo*
purports to embody. The basic fact about Conrad's book is the most
obvious, that it is fictional history—in this the exact reverse of

Scott's historical romance. The controlling paradox of Conrad's work, its underlying pretense, refracts into multiple facets of its symbolic ordering, most notably the breaking up of the conventional linear chronology of history so as to make the principal effect of the novel its vital self-sufficiency as a fabricated artifact distinct from the historical report that it duplicitously parades itself as being.

This self-sufficiency goes far to explain why for Conrad, unlike Scott, modes of telling within the primary tale become essential to the complex structure of overall narrative action. The technique of fragmented narration increases the power of the writer to shape, limit, and direct his material, and thereby effectively to design symbolically significant forms out of the mere chronological flow of historical phenomena. But, as Scott's romances illustrate, it was the intrinsically unshaped, contingent, and continually changing quality of history that made it attractive to Romantic artists, who adapted their narratives to the unpredictable and indefinite tendencies of history, rather than forcing history to conform to an ahistorical pattern of significance. The simple narrational mode the Romantics favored permits art to accommodate itself to the inconclusiveness of developing lives. The contrary determination to assert aesthetic form against the formlessness of history is spectacularly exemplified by the total fictionality of *Nostromo*.

The concluding judgment of *Middlemarch*, which asserts that a private life is not "historic," is extended in *Nostromo* to acts by figures of public consequence. The self-betrayals of Gould, Decoud, and Nostromo (like that of Kurtz before them) are deployed in a situation characterized by the absence of any meaningful history for the *natives* of Costaguana. The narrative of Costaguana's non-history begins with, ends with, and throughout involves only Europeans or Europeanized Costaguaneros. Costaguana in itself has no history; its aboriginal life and authentic nationalistic being remain as dark as those of the Africans in *Heart of Darkness*. All that *Nostromo's* art enables us to see is that darkness—and the fictional artifact displaying darkness. The only sure value we are left with is that of art itself, art exposing the meaninglessness of historical affairs through the passionate intensity of its self-shaping integrity.

How important to an understanding of Romanticism is the recognition of its quite different bias, a bias toward engaging art with historical processes conceived not as nightmares but as the most intense and richest manifestations of vitality, may be dramatized fi-

nally by a contrast of Conrad's *Heart of Darkness* with a novel com-
posed at virtually the same time, Tolstoy's *Hadji Murad*, because
Tolstoy is almost unique among later nineteenth-century novelists
in retaining a powerful commitment to the Romantic view of his-
tory, as will be further illustrated in the next chapter.

Differences between the point of view in *Hadji Murad* and *Heart
of Darkness* are so radical as almost to make one forget that both
novels center on European imperialism's impact on native peoples.
Conrad allows us to see Africans only through the eyes of Euro-
peans, whereas Tolstoy presents a multiplicity of viewpoints, in-
cluding that of the victims of imperialist aggression, and in *Hadji
Murad* he goes so far as to present the death of a non-European
from the "native" viewpoint. Consider the exteriority, which mod-
ern critics justly admire as dramatic objectivity, of Marlow's famous
description of the death of his native helmsman:

> "The man had rolled on his back and stared straight up at me; both
> his hands clutched that cane. It was the shaft of a spear that, either
> thrown or lunged through the opening, had caught him in the side
> just below the ribs; the blade had gone in out of sight, after making a
> frightful gash; my shoes were full; a pool of blood lay very still,
> gleaming dark-red under the wheel; his eyes shown with an amazing
> lustre. The fusillade burst out again. He looked at me anxiously,
> gripping the spear like something precious, with an air of being
> afraid I would try to take it away from him. . . .
>
> "We two whites stood over him, and his lustrous and inquiring
> glance enveloped us both. I declare it looked as though he would
> presently put to us some question in an understandable language;
> but he died without uttering a sound, without moving a limb,
> without twitching a muscle. Only in the very last moment, as though
> in response to some sign we could not see, to some whisper we
> could not hear, he frowned heavily, and that frown gave to his black
> death-mask an inconceivably sombre, brooding, and menacing
> expression." [13]

In contrast, Tolstoy's imagination carries us inside Hadji at the very
moment of his death, so that we experience subjectively, ectypally,
the brute fact of imperialistic destruction.

> This wound in his side was mortal and he felt that he was dying. One
> after another images and memories flashed through his mind. Now
> he saw the mighty Abununtsal-Khan clasping to his face his severed,
> hanging cheek and rushing at his enemies with dagger drawn; he
> saw Vorontsov, old, feeble and pale, with his sly, white face and
> heard his soft voice; he saw his son Yusuf, Sofiat his wife, and the
> pale face, red beard and screwed up eyes of his enemy Shamil.

And these memories running through his mind evoked no feel-
ings in him, no pity, ill-will or desire of any kind. It all seemed so
insignificant compared to what was now beginning and had already
begun for him. But his powerful body meanwhile continued what it
had started to do. Summoning the last remnants of his strength, he
lifted himself above the rampart and fired his pistol at a man running
towards him. . . . A number of militiamen rushed with a triumphant
yell towards his fallen body. But what they supposed was a dead body
suddenly stirred. . . . Hadji Murad pulled himself fully up. . . . But
suddenly he gave a shudder, staggered from the tree, and like a
scythed thistle fell full length on his face and moved no more.
 He did not move, but could still feel, and when Hadji-Aha, the
first to reach him, struck him across the head with his great dagger,
he felt he was being hit on the head with a hammer and failed to
understand who was doing this and why. This was the last conscious
link with his body.[14]

This passage, the climax, perhaps, of Tolstoy's many efforts to imag-
ine death, draws power from its intimate connections to the imme-
diately preceding narrative of Hadji's consciousness of his own life
history, so that the reader experiences his death both as a realiza-
tion of the song of the death of Hazzad (as Madge Wildfire's death
is a realization of Proud Maisie's) and as the appropriate conclusion
of a life beginning with a song about Hadji composed by his mother
just after he was born:

"Your damask blade slashed open my white breast, but I pressed to it
my darling boy, and washed him in my hot blood, and the wound
healed without help of herbs and roots. I did not fear death, no more
will my boy-*djigit*."
 The words of the song were addressed to Hadji Murad's father . . .
when Hadji Murad was born the khanoum also gave birth to a son
. . . and sent for Hadji Murad's mother to be his wetnurse. . . . But
Patimat had not wanted to leave her son and refused to go. Hadji
Murad's father got angry and ordered her to. When she still refused
he stabbed her with his dagger and would have killed her if she had
not been taken away. . . . Hadji Murad remembered his mother sing-
ing it to him as she put him to bed alongside her, under the fur top-
coat on the roof of their house, and he asked her to show him her
side where the scar was. He could see his mother just as she was—
not all wrinkled and grey with missing teeth as when he left her
now, but young and beautiful and strong, so strong that even when
he was five or six and heavy she carried him in a basket on her back
to his grandfather over the mountains.

(pp. 255–56)

Through these narrative overlayings the reader is enabled to ap-
preciate the continuity of Hadji's life as he experiences it. Like

Scott's Madge or Wordsworth's Michael, Hadji experiences a dramatic moment not just as an instant of intense sensation but as an event within the continuity of an entire life, which is an idiosyncratic evolution of being shaped by special circumstances of society and culture. *Hadji Murad* continues the Romantic tradition by resisting the limitation of point of view upon which Conrad's novel is built, because Tolstoy tries—Romantically—through his art to give readers imaginative access not just to an experience of aesthetic unity but also to exotic, alien, or foreign ways of being human.

Hadji Murad is particularly interesting because, while retaining much of the Romantic spirit, it also shows some of Tolstoy's significant Modernist tendencies, as in the framing image of the thistle with which the novel begins and ends. Yet the very simplicity of the thistle as simile suggests Tolstoy's unwillingness to surrender what I have called Romantic formlessness. The thistle remains outside Hadji Murad's story, only a simile, without the portentous symbolic self-referentiality of Conrad's more elaborate frame, Marlow speaking on the *Nellie* riding at anchor on the darkening Thames. The thistle may, indeed, express Tolstoy's awareness of the difficulty in retaining at the end of the nineteenth century the openness to multiple perspectives that Scott at the height of Romanticism possessed with seeming effortlessness. Be that as it may, *Hadji Murad* indubitably retains what might be called a narrative relaxation accommodative of diverse modes of imagining a life's continuity.

Against this profoundly Romantic method Modernism defined its more intensely symbolic aesthetic. For example, the self-imaging that appears in only a single character in *Barnaby Rudge* is expanded to constitute the total form of the novel in *Heart of Darkness* and *Nostromo*. The temporal continuity that is the foundation of Scott's historical fiction is by Modernism entirely spatialized.[15] Perhaps Conrad's finest achievement in *Nostromo* is his creation of Sulaco and the Occidental Province, for it is the place that makes possible his story. Lacking an intrinsic history, Costaguana must have a vivid geography. Thus the full import of Dickens's innovative emphasis on visualization in his historical fiction flowers dramatically in Conrad's work. Significance in Modernist historical fiction inheres in what can be imaged, what is spatially organizable, rather than, as in Scott's work, what is continuously self-transformative, meaningful principally in the dimension of time and so to a degree unimagable.

7

History, Hellenism, and Eternal Evanescence

The genuine historical consciousness evinced by Scott is an important aspect of the Romantic sensibility. Such awareness derives from a recognition of alternatives, of diverse possibilities. Authentic history records not simply what happened, but what happened in a situation in which other things might have happened. The Romantics' sensitive appreciation of contingency and variety, as well as their fondness for exploring what might be, is interwoven with their historical mode of enriching the systematizings of their predecessors. Diversification of cultural perspective is therefore a significant feature of the Romantics' questioning of the Enlightenment's uncommon faith in common humanity. Consider Montesquieu on the universality of experience:

> Modern history furnishes us with an example of what happened at this time in Rome. . . . Great occasions which produce great changes are different, but, since men have had the same passions at all times, the causes are always the same.[1]

Or as David Hume puts it:

> Would you know the sentiments, inclinations, course of life of the Greeks and Romans? Study well the temper and actions of the French and English: you cannot be much mistaken in transferring to the former most of the observations you have made in regard to the latter. Mankind are so much the same, in all times and places, that history informs us of nothing new or strange.[2]

But the beautiful rationality of Neoclassical history did not last long, for the political and social upheaval of the French Revolution also upended complacent historiography. By the beginning of the nineteenth century Hume's concept of immutable, unitary human nature had been rejected—witness Niebuhr:

> The state of the law concerning landed property and the public domains of ancient Rome differed in such a degree in its peculiarities

from the rights and institutions we are used to, that the confounding
of our ordinary notions of property with those of the ancients . . .
gives rise to the most grossly erroneous opinions on the most impor-
tant questions of Roman legislation; opinions under which the voice
of justice must pronounce condemnations against actions and mea-
sures perfectly blameless.[3]

This awareness of the profound difference between the histo-
rian and those whose lives he recounts inverts the Renaissance-
Enlightenment concept of heroic events, even as the emergence of
the concept of the unconscious transformed the nature of villainy.

By 1830 Carlyle dismisses those who clung to uniformitarianism
by appeals to inner, psychological consistency and extends his cri-
tique to externalities:

> Neither will it adequately avail us to assert that the general inward
> condition of Life is the same in all ages. . . . The inward condition
> of Life . . . is the same in no two ages; neither are the more impor-
> tant outward variations easy to fix on, or always well capable of
> representation.

Carlyle also uses history to challenge conventional historical hier-
archies:

> Which was the greatest innovator, which was the more important
> personage in man's history, he who first led armies over the Alps,
> and gained the victories of Cannae and Thrasymene; or the name-
> less boor who first hammered out for himself an iron spade? When
> the oak-tree is felled, the whole forest echoes with it; but a hundred
> acorns are planted silently by some unnoticed breeze.[4]

One can best understand this historiographic revolution by con-
trasting the style of Gibbon, one of the last great Neoclassical histo-
rians, to that of Carlyle, whose *French Revolution* vigorously mani-
fests a Romantic historical sensibility.

Gibbon's opening paragraph of *The Decline and Fall of the Roman
Empire* reads:

> In the second century of the Christian era, the Empire of Rome com-
> prehended the fairest part of the earth, and the most civilized por-
> tion of mankind. The frontiers of that extensive monarchy were
> guarded by ancient renown and disciplined valour. The gentle but
> powerful influence of laws and manners had gradually cemented
> the union of the provinces. Their peaceful inhabitants enjoyed and
> abused the advantages of wealth and luxury. The image of a free con-
> stitution was preserved with decent reverence: the Roman senate
> appeared to possess the sovereign authority, and devolved on the
> emperors all the executive powers of government. During a happy

period (AD 98–180) of more than fourscore years, the public admin-
istration was conducted by the virtue and abilities of Nerva, Trajan,
Hadrian, and the two Antonines. It is the design of this, and of the
two succeeding chapters, to describe the prosperous condition of
their empire: and afterwards from the death of Marcus Antoninus, to
deduce the most important circumstances of its decline and fall; a
revolution which will ever be remembered, and is still felt by the na-
tions of the earth.[5]

Like the antique garb in Neoclassical history painting, Gibbon's first
phrase establishes a distant perspective: we, the now living, look
back on the long-dead. The hierarchism of the relation permits Gib-
bon's magisterially defining language, which renders superfluous
geographical or sociological detail. The second sentence reinforces
this superlative comprehensiveness by its heroic personifications,
"ancient renown and disciplined valour": the doubtful and dark lie
outside the frontiers of enlightened civilization, frontiers that are
barriers, not leading edges. The diction and tropes confirm the
continuing solidarity of the civilized as a timeless condition of
being that links a distant past to the present: it is the nations (not
people) that still remember and feel the fall of Rome. Sentences
built on syntactic and semantic parallelisms ("fairest part . . . most
civilized portion") linked by *and* create strongly balanced, stable
compositional units.

The overt architectural ordering subdues rhetorical figures as
strong as oxymoron to unobtrusiveness: "gentle but powerful in-
fluence." Paradoxes and even ironies are controlled by exact ra-
tional discriminations: what the "peaceful . . . enjoyed and abused"
was not wealth and luxury, but the even more abstract "advantages
of wealth and luxury." A construction characteristic of Gibbon, the
plural abstract noun followed by "of" enables him to delineate the
kind of conventionalized social behavior pictured in Neoclassical
history paintings. Gibbon's concern is that which "will ever be re-
membered," a past event that remains always the *same* event, im-
mutable and fixed, now timeless because it *has* happened. The sub-
ject, the fall of a definitely fallen object, is a felicitously Hogarthian
reflection of Gibbon's Newtonian classicism. The method, a se-
quential presentation of chronological certainties from a stable, un-
shifting place and time, allows Gibbon to inform us at the end of
his first paragraph exactly how he will proceed.

Such orderliness of conception and perception Carlyle's *French
Revolution*, the most efficaciously revolutionary of British Romantic
histories, disrupts and complicates by resurrecting experiences

from obscurity into the violence of chiaroscuro representations. Carlyle is fascinated by how much has been already forgotten—in just forty years—of what never was entirely clear. Against Gibbon's decisive definitions, Carlyle opens with clouded speculations:

> President Hénault, remarking on royal surnames of honour how difficult it often is to ascertain not only why, but even when, they were conferred, takes occasion, in his sleek official way, to make a philosophical reflection. "The surname of Bien-aimé (Well-beloved)," says he, "which Louis XV bears, will not leave posterity in the same doubt. This prince, in the year 1744, while hastening from one end of his kingdom to the other, and suspending his conquests in Flanders that he might fly to the assistance of Alsace, was arrested at Metz by a malady which threatened to cut short his days. At the news of this, Paris, all in terror, seemed a city taken by storm; the churches resounded with supplications and groans; the prayers of the priests and people were every moment interrupted by their sobs; and it was from an interest so dear and tender that this surname of Bien-aimé fashioned itself—a title higher still than all the rest which this great prince has earned."
>
> So stands it written, in lasting memorial of that year 1744. Thirty other years have come and gone, and "this great prince" again lies sick; but in how altered circumstances now! Churches resound not with excessive groanings; Paris is stoically calm; sobs interrupt no prayers, for indeed none are offered, except priests' litanies, read or chanted at fixed money-rate per hour, which are not liable to interruption. The shepherd of the people has been carried home from Little Trianon, heavy of heart, and been put to bed in his own château of Versailles: the flock knows it, and heeds it not. At most, in the immeasurable tide of French speech (which ceases not day after day, and only ebbs toward the short hours of night), may this of the royal sickness emerge from time to time as an article of news. Bets are doubtless depending; nay, some people "express themselves loudly in the streets." But for the rest, on green field and steepled city, the May sun shines out, the May evening fades, and men ply their useful or useless business as if no Louis lay in danger.[6]

The first paragraph of *The French Revolution* is mostly quotation, from someone of whom probably few readers have heard. Carlyle, not citing Hénault out of admiration ("sleek, official way"), immediately plunges us into doubts and difficulties of every kind. After reading the first sentence, we are left to puzzle what royal names, let alone Hénault's speculations about them, have to do with the French Revolution. True, Louis XV was a king of France, but he died fifteen years before the Revolution, and we are attending a passing illness thirty years earlier. Even if such questions were an-

swered by the next paragraph—and they are not—we have already left behind Gibbon's *Decline and Fall*, in which each paragraph is a self-sufficient, coherent structural unit. Carlyle flings us into unique experiences and subjective comments about them; we are unsure about what is happening and why what is said about what happens is worth hearing. Indeed, the full significance of what is said in these opening paragraphs surfaces only after Carlyle has written of another king "arrested," a different "Paris all in terror," and diverse "supplications and groans" until the Bastille is "overturned by a miraculous *sound*." Carlyle's history is ordered by polymorphous resonances unheard in Gibbon's; his arrangements subvert sequential coherency and logical causality. Analogously, Carlyle transmutes Gibbon's enlightening irony and phrases such as "decent reverence" into the self-satirizing of Hénault's particular sycophancy, which introduces us to an evolving experience of uncertainties in which we, the readers, must learn to suspect all reporting, beginning with the very names reported. Nor is Carlyle himself above suspicion, as he tells us in his recording of the misreported *Vengeur* incident.

Gibbon never directs his skepticism about sources against himself. Nor is his irony self-directed—as Carlyle's can be, for Carlyle accepts as the first condition of history its absolute uncertainty. He begins by impressing on us how totally forgotten has been a "lasting memorial" of 1744, even as indifference overtook a "great prince" in thirty years. Gibbon's rhetoric, above all his irony, detaching us from the confusion of the moment (much of which he believes ought to be forgotten because trivial) distinguishes lines of causal sequentiality. Carlyle's irony engages us in the equivocality of specific experiences and the fuzziness of reports of them. Thus Louis's final illness is described by the fashion in which it was disregarded by ordinary citizens, and in the second paragraph the narration arrives at the present tense, a tense scarcely known to Gibbon. With Carlyle's history, we are in the picture, caught up by the processes of history as it is made and as it is reported—and forced to recognize how often the making and the reporting fail to coincide. Throughout *The French Revolution* Carlyle denies us the advantage of simple and consistent retrospectiveness. The historical event of the first paragraph, Louis's illness in 1744, has been forgotten by the second paragraph, the subject of which is the absence of activity. Carlyle thus emphasizes the discrepancy between a historical account of an event and the event itself. The historian

selects from, and thereby distorts, the entirety of the situation; multidimensional actuality is concealed—not revealed—by intellectual essentializing. Although Carlyle apparently was unfamiliar with Clausewitz's work, his history strives to recover the frictions of social reality, frictions that Gibbon smoothes out or bypasses.

The Romantic historian perceives memorable events to be made up of what Wordsworth called "little, unremembered acts." Deeds that may in retrospect seem important may be but an opportunity for casual wagering among the actual bystanders. The essence of history, then, is its equivocal reconstructing of intrinsically uncertain experiences. At the height of the Terror, Carlyle reminds us, nearly a hundred theaters were crowded nightly, and one could follow home from public celebration a "Goddess of Liberty" who prepared dinner in a modest flat for a pedantic husband. So, too, Carlyle seldom forgets what the Neoclassic historian seldom mentions, the weather.

Most interesting, however, is how Carlyle's specificities of detail call into doubt the validity of sensory evidence. Just as Turner paints so accurately how confused one's vision becomes in a storm that the viewer has difficulty in ascertaining what he is seeing on the canvas, Carlyle, however eager to make us visualize his scenes, never forgets how unreliable are our perceptive powers, how untrustworthy is the evidence of our senses, which, at their best, give one perspective out of many, none of which, even the historian's, is privileged. So Carlyle's history resounds with confusing echoes, partial repetitions in shifting contexts and inversions of situations. Analogously, syntax and semantics intersect violently, even counteracting one another on occasion. Diversified negatives, abrupt tone changes, syntactical reversals, and startling interrogatory and exclamatory interjections are used to maneuver from dramatization to narration to speculation—both retrospective and prospective.[7]

The significance of the French Revolution to *The French Revolution* is never simple, in part because the historian is involved in imaginative deconstructions, as in Carlyle's final evaluation of the Reign of Terror, which he claims was no truer to its name than Louis XV was to Bien-aimé: "there is no period to be met with, in which the general Twenty-five Millions of France suffered *less* than in this period which they name Reign of Terror" (2:356). This judgment has been disputed, lost sight of, or concealed by subsequent commentators—a development that accords with Carlyle's feelings about the intrinsic unreliability of history and historians.

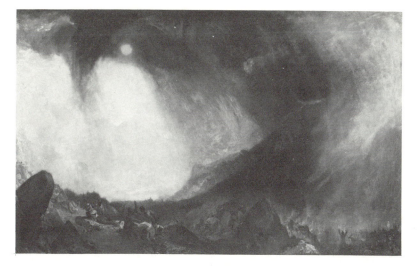

7. J. M. W. Turner. *Snowstorm: Hannibal and His Army Crossing the Alps.* Reproduced by courtesy of the Trustees of The National Gallery, London. Turner's concern for his audience's perspective appears in the dispute he provoked about the proper level for hanging this painting at its first exhibition. Contrast this storm with that in *Snowstorm: Steam-boat off a Harbour's Mouth* (Figure 15).

THE IMPOSSIBILITY OF HISTORY

Romantic historical vision is founded upon the impossibility of any definitive, unchanging representation of historical phenomena. The past no longer exists but remains open to modification and interpretive revisionism. Even when the past was the present its significant events were largely incomprehensible, in part because significance is determined by judgment after the fact, and in part because human activities are multidimensionally confused and confusing. Characteristic of this Romantic view is Turner's *Snowstorm: Hannibal and His Army Crossing the Alps* (Figure 7).

Turner's contemporaries perceived the historical fact of Hannibal's crossing the Alps as an event of ambiguous import, and Turner exploited the doubtfulness, principally by looking at history from what Neoclassicists would have considered its backside. The picture's foreground is the rear of Hannibal's army, the stragglers, the abandoned, the dying, and the dead. To the left of the center foreground an African is being despoiled of arms and clothing; above

him are flung corpses, while to the right, below a pyramidal rock, a man coolly ties on the footgear of a dead soldier. Behind him, another soldier pressed against a boulder is stripped of clothes and gear. The center of this foreground is a puzzling group of four figures. Over a supine, nearly naked body a man kneels with knife raised, his arm arrested by another man whose left hand supports a woman, naked to the waist, her head lolling in faintness or death. As storming vortices of cloud brighten over distant elephant and Italy, the heroic army has passed, leaving behind the forgotten of history, the sordid, personal "meaningless" violence of trivial anonymity. Commentators have disagreed as to whether we see Carthaginians robbing natives or mountaineers preying on army stragglers. No matter—Turner's historical vision focuses on little, nameless, unremembered acts of violence and fear.[8]

Romantic historical art often dramatizes the difficulties of historical representation. Primary in this tradition, of course, is *War and Peace*, founded on Tolstoy's belief in the impossibility of accurate historical representation, despite his conception of reality as in essence temporal processes. The trouble is that

> absolute continuity of motion is not comprehensible to the human mind. Laws of motion of any kind become comprehensible to man only when he examines arbitrarily selected elements of that motion; but, at the same time, a large proportion of human error comes from the arbitrary division of continuous motion into discontinuous elements. . . . To assume a beginning of any phenomenon . . . is in itself false.

This is the Romantic theory. Now for the fact of General Kutúzov, like Hannibal, "in the midst of a series of shifting events":

> It is suggested to him to cross the Kalúga road, but just then an adjutant gallops up from Milorádovich asking whether he is to engage the French or retire. An order must be given him at once, that instant. . . . After the adjutant comes the commissary general asking where the stores are to be taken, and the chief of the hospitals asks where the wounded are to go, and a courier from Petersburg brings a letter from the sovereign . . . the commander in chief's rival, the man who is undermining him . . . presents a new project. . . . and the commander in chief himself needs sleep and refreshment. . . . and a respectable general who has been overlooked in the distribution of rewards comes to complain, and the inhabitants of the district pray to be defended, and an officer sent to inspect the locality comes in and gives a report quite contrary to what was said by the officer previously sent.[9]

Tolstoy's Kutúsov and Turner's Hannibal are caught up in conti-
nuities of motion for which an appropriate form of representation
is the vortex, a complex, violent system of small contiguous yet dis-
tinct movements and antagonistic curvilinear forces. The vortex is a
dramatic manifestation of the multidimensional swelling curves of
vital processes, which are never isolated and single but always en-
gaged with other forces. Turner's and Tolstoy's involuted rhythms
represent history with all the fecund interactivity of life. In *Snow-
storm: Hannibal* each sweeping movement comprises re-echoing, re-
inforcing, yet diverse turnings, each whorl dependent on others so
that one cannot define any beginning or endpoint to the storm—an
exact analogue for the swirling of beginningless and diverse con-
tingent intersections Tolstoy represents as the nature of historical
experience. Continuous involuting of many "minor" conjoined
contrarieties, whose origins and conclusions are indeterminable,
center Romantic historical vision, and Romantic historical art there-
fore demands imaginative response from its audience.

To describe this exercise of imagination, however, is no simpler
than describing Romantic art, but in the remainder of this and
the next chapter I hope to delineate some of its most significant
features. It may be easiest to recognize Romantic involutedness in
the graphic arts. Turner needed not just whorls but swirling colors;
his vortical forms are inseparable from a transformation of Neo-
classical form-structuring into Romantic color-structuring. Only
through the infinite gradations of color could he achieve the con-
tinuous interactivity of minutiae that for him constituted visual ac-
tuality. Color is an antagonist of fixity. To structure by color is to
organize by dissolving, diffusing, dissipating qualities whose very
existence is determined through unstable relationships. The dy-
namics of color structuring is closer to the dynamics of liquid or
gaseous phenomena than to the definiteness of geometric solids.
Much of the obscurity, vagueness, and indistinctness in Turner's
art results from his accurate rendering through color of the flu-
idly vital, a rendering that seemed, and seems, to some merely
confused.

At issue is the difference between form-perception and color-
perception. The latter is more directly violent, less intellectual,
more evocative of affects. As Ernest G. Schachtel, who studied the
psychology of color in Rorschach tests, puts it, "Color seizes the
eye," whereas "the eye grasps form"; in Ernest Gombrich's termi-
nology, color is less dependent than form on schemata. Schachtel

notes how color frequently compels reaction without reference be-
yond itself. Color does not, he observes, require the memory nec-
essary for the appreciation of a form's meaning; often, he says, red
is fire or *is* blood without symbolic mediation.[10] Color moves the
viewer, which is what the Romantic wants (rather than allusiveness
or "deep" structure) because only if we are "in motion" can we
imaginatively respond to the continuity of actions that constitutes
reality.

Turner appeals to his audience's imagination by portraying the
full complexity of specific perceptions of a particular event. This
task requires the diffusive rendering of curves of action, since both
the act of perception and the object perceived are vital processes.
Turner was fascinated by physical exemplifications of continuous
movement, atmospheric phenomena such as tides, rain, steam,
and speed; the conjoining of fire and water delighted him. His
enjoyment of the burning of the Houses of Parliament is so un-
mistakable one wonders he wasn't imprisoned for treason. These
surface manifestations reflect a deep-rooted habit of regarding all
actuality as working according to principles more like those of or-
ganic chemistry than Newtonian physics. The shifting transforma-
tions of actuality cannot be identified through arithmetic relations
of fixed structures and defined consistencies because reality exists
in a perpetually interflowing and interfusing of conditions funda-
mentally plastic, porous, and equivocal. Reality can be perceived
only as we are meant to perceive it in *Snowstorm: Hannibal*—uncer-
tainly, provisionally, imaginatively.

SHELLEY'S VENICE, TURNER'S CARTHAGE

A significant inversion of the Romantics' efforts to render past ex-
perience as present occurs in the larger body of Romantic art that
historicizes the present moment, seeks to make us respond to a
situation not as an instantaneous event but as part of a continuity
connecting past and future. Thus in "Lines Written Among the Eu-
ganean Hills" Shelley "pictures" Venice in phrases evoking not so
much what the poet sees as what he imagines the city to have been
and what it may become.

> Sun-girt city, thou hast been
> Ocean's child, and then his queen;
> Now is come a darker day,
> And thou soon must be his prey,

If the power that raised thee here
Hallow so thy watery bier.
A less drear ruin then than now,
With thy conquest-branded brow
Stooping to the slave of slaves
From thy throne, among the waves
Wilt thou be, when the sea-mew
Flies, as once it flew,
O'er thine isle depopulate,
And all is in its ancient state,
Save where many a palace gate
With green sea-flowers overgrown
Like a rock of Ocean's own,
Topples o'er the abandoned sea
As the tides change sullenly.
The Fisher on his watery way,
Wandering at the close of day,
Will spread his sail and seize his oar
Till he pass the gloomy shore,
Lest thy dead should, from their sleep
Bursting o'er the starlight deep,
Lead a rapid masque of death
O'er the waters of his path.
 (lines 115–41)[11]

By displaying interrelations between natural and historical time and compromising images of immediate perception by references to a remote past and envisagements of an uncertain future, Shelley escapes the curse that would subject us to immediate impressions. In six lines Venice is multiply personified: once ocean's child, then ocean's queen, now fallen and doomed to become ocean's prey. Conditions succeed one another to construct not a picture but a process, how Venice has changed, is changing, may change.

Shelley's language, therefore, directs us less to objects than to systems—historical, artistic, and linguistic. In the third line "darker day" is a visual absurdity given "sun-girt city" two lines above, effective so far as its physical inapplicability verifies its metaphoric appropriateness, its power to evoke a stereotype of slavery, darkness, prison, and death. By thus interplaying verbal and visual, literal and metaphoric, Shelley establishes a variously tiered historical structure for the moment of the poem. The present, for Venice and for the poet perceiving the city, is created both by sensations, perceptions of what is, and also by references to what is not or to what may be, which recall, even as they differ from, what had been. We are made aware of Venice less as a place than as a temporal phe-

nomenon, rising from unpeopled marshes to the glorious mer-
cantilism of city-sea bride only to decline, perhaps finally, into a
superstition-haunted natural cenotaph.

The city as historical phenomenon is appropriately evoked by
language that calls upon stereotypes, which awaken our awareness
of conventions, especially those of the history of art to which the
poem contributes, the aesthetic *langue* of the poem's *parole*. Shelley
reminds us of two major traditions, one of descriptive meditation,
usually upon ruins, focused by the *ubi sunt* theme, and the other of
prospect landscape description. As the latter looks forward and the
former back, so in "The Euganean Hills" Shelley depicts a beautiful
prospect he sees, a past he remembers, and possibilities that he
foresees. Imagining the triumphant past, he envisages a desolate
horror that may in time be realized within the beauty perceptible
before him. The poet's foresight is the obverse of his historical
imagination, a power to see what *is* from the perspective of what
now *is not*, either no longer or not yet. If only at the end of the
poem's second line do most readers discover that what had seemed
an actual description in line one is metaphoric, the surprise pre-
pares for the poem's continual interchanging of the literal-visual
with the metaphoric-verbal, an interchange that depends on tem-
poral shiftings. The possibility of an island "healing Paradise" in
the poem's concluding lines then seems appropriate because we
have been conditioned to the poet's vision as an interfusing of
visible and visionary: perceptible *is*, reconstructed *was*, envisioned
might be. From the perspective of what Venice is, the city's past
glory has become unreal; from the perspective of that free, glorious
past, the present Venice, the city the poet looks upon, is unreal.
Likewise, from the point of view of the present, the city's future
is only an uncertain dream, but from the vantage point of that
time, the present city may appear only a superstition-haunted half-
memory.

Analogously, the interpolated lines in praise of Byron (lines
169–205) exploit Shelley's friend for another kind of historical per-
spective. The poet's fellow-exile and European celebrity conjoins
not only the history of England to that of Venice and the history of
British literature to Mediterranean literatures, but also Shelley's sad
private history to the sad history of post-Napoleonic Europe. That
Shelley is not indulging a personal eccentricity by interconnecting
private experience with cultural history is suggested by Turner's
Dido Building Carthage (Figure 8). Wanting his viewers to see his

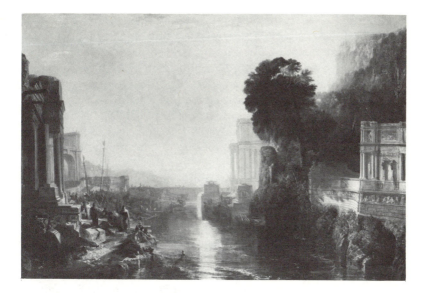

8. J. M. W. Turner. *Dido Building Carthage.* Reproduced by courtesy of the Trustees of The National Gallery, London. Perhaps only the original colors would permit us to recognize the reason for, if not the justice of, objections by critics, including Sir George Beaumont, to the "watercolor style" of this oil painting.

work as part of a historical development and as a comment on current events through its conscious role in art's history, Turner wished his picture hung next to a painting by Claude. To these Romantics, the individuality of art was not reduced but enhanced when thus doubly participating in history.

If Turner's painting, first exhibited in 1816, strikes us as academic, we may recall how topical was the founding of a great maritime empire at the moment of Napoleon's overthrow and the emergence of seafaring Britain as Europe's chief power. Turner's picture engages us in a temporal dialectic of which his academicism is a functional part, as is Shelley's stereotypical phrasing in the "Euganean Hills." As the canvas's title tells us, Turner paints not Carthage but the Carthage depicted in Virgil's *Aeneid* (which Turner probably read in Dryden's translation), thereby reaffirming the vitality of historical continuity. Even if the figures on the frieze of the building to the right are not easy to discriminate, the frieze recalls that recursive passage in which Aeneas sees a bas-relief depicting scenes

from the Trojan War, including episodes of his own heroism. Turner's picture layers another dimension onto Virgil's historical self-consciousness, showing the founding of the Carthaginian Empire, obliterated two centuries before Virgil recreated it in his celebration of imperial Rome, a Rome vanished for a millennium and a half when Turner reconstructed the ambitious Phoenician beginning. Turner's implicit comment on the fate of imperialism, his prophecy at the moment of the British Empire's burgeoning, is not based on any abstract, metaphysical, or apocalyptic argument. He simply foresees the British Empire vanishing into the continuity of history.

In *Dido Building Carthage* continuity and discontinuity are also suggested by the unfinished buildings. An incomplete edifice, whether a ruin, a Piranesi "fantasy," or Turner's not-yet-built Carthage, is discernible *as* incomplete, implying an invisible totality, an unseen whole, from which pieces once derived—or will derive—their functions and meanings. The ruin picture is meant to be imaginatively stimulating, not just appealing to the senses to evoke what is not there, but also provoking the viewer mentally to reconstruct the ruin. Turner's *Dido* is more complex still, for the viewer of the not-yet-constructed buildings knows they were obliterated by the Romans. And Turner wished his picture hung alongside Claude's painting of a different "classical" subject. Thus, *Dido Building Carthage* becomes a dramatic part of both political and artistic history, the history of imaginative reconstructions of historical events. This self-reflexive historicity was reinforced when Turner paired *Dido* with *The Decline of the Carthaginian Empire* (Figure 9), which portrays the city in apparently secure luxury. Its invisible fate is spelled out in the catalogue description.

> The decline of the Carthaginian Empire—Rome being determined on the overthrow of her hated rival, demanded from her such terms as might either force her into war, or ruin her by compliance: the ennervated Carthaginians, in their anxiety for peace, consented to give up even their arms and their children.

> ". . . At Hope's delusive smile,
> The Chieftain's safety and the mother's pride,
> Were to th'insidious conqu'rors' grasp resign'd;
> While o'er the western wave th'ensanguin'd sun,
> In gathering haze a stormy signal spread,
> And set portentous." [12]

As important as what is depicted in Turner's canvases is what is not visible—even to a contrast of Turner's sequential pairing

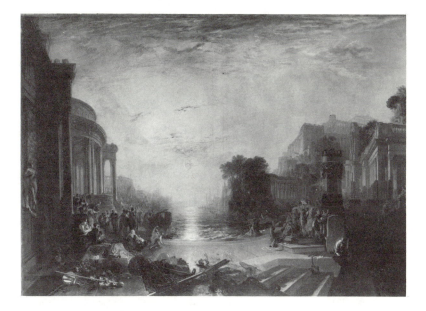

9. J. M. W. Turner. *The Decline of the Carthaginian Empire*. The Tate Gallery, London. Although the reflecting water does not here, as in *Dido Building Carthage* (Figure 8), reach the picture plane, this "distancing" only emphasizes the more diffused glare of the sinking sun that dramatizes Carthaginian "blindness."

against Claude's structural, topical, but never historical pairings. The presence of Claude (and with him an entire classical tradition of history painting) is deliberately evoked to be transformed. Were the Carthaginian pictures better preserved it would be easier to discern the details of Turner's tonal transformation of Claude, how he fills in Claudean shapes and shape arrangements with intricate colorations. Today one can only fall back on the critical response of Turner's contemporaries. In objecting to the original exhibition of *The Decline of the Carthaginian Empire*, Robert Hunt saw (but missed the meaning of) a "false splendour" in Turner's tones, complaining that they portray "a beautiful and noble personage, flushed with a burning fever, and arrayed in a profusion of shewy habiliments," presumably the impression Turner desired, as evidenced by the catalogue description. That Hunt saw colors now faded is suggested by Hazlitt's famous critique, which applied to the paintings of these years, before Turner's first trip to Italy:

They are pictures of the elements of air, earth, and water. The artist delights to go back to the first chaos of the world, or to that state of things when the waters were separated from the dry land, and light from darkness, but as yet no living thing nor tree bearing fruit was seen upon the face of the earth. All is without form and void. Some one said of his landscapes that they were *pictures of nothing, and very like.*

To Hazlitt's comments, we may add those of Sir George Beaumont, whose antagonism to Turner was focused by *Dido* and *The Decline.* Beaumont perceived a hateful "colouring discordant, out of harmony . . . violent mannered oppositions of brown and hot colours to cold tints, blues and greys."[13] One may properly speak of *a* tonality to a picture of Claude's but Turner's paintings were composed of a bright complexity of contrarily interacting lights, which provoked the uneasy suspicion among his contemporaries that he was not primarily interested in objects. Indeed, his central concern was primal forces, which to an object-oriented vision may seem nothing.

Turner's complicating of color gradients is inseparable from his inversion of the tonal spectrum so as to work "down" from white instead of "up" from dark. His "obscurity" increasingly comes from too much light, not too little. Claude's centered suns illuminate, but Turner's blind. Equivocation and confusion arise in Turner's later paintings from too much life, not, as in traditional ruins paintings, from too little. In any moment, Turner shows us, multitudinous possibilities coexist, and every perspective is provisional. Even ancient history and traditional art are not inevitabilities beyond time. Classical art can be viewed again; past visions, reseen; the shaping colors of vital forces can be restored to what had become frozen, broken, even obliterated monuments. Unlike traditionalist critics such as Beaumont, Turner conceives of art as inextricably in and of time, engaged in the vortex of its own history.

Like Turner, Shelley regards immediate experience as not accurately evoked for his audience unless his imagination invisibly embodies past and future within present sensory perceptions. *What* the poet sees from his Euganean hill is valuable in part because it manifests powers of historical culture, powers determining *how* he sees. For Shelley, as for other Romantics, imagination is not finally separable from the history of imagination, which is why so much of the "Defence of Poetry" is devoted to that history, even though the essay argues for poetry's creatively prophetic function.

The Romantic sense of history contributes to a sensibility that cherishes intrinsic uncertainty in experience. Keats's "Ode to a Nightingale" ends with the characteristic Romantic mark of punctuation, a question mark: "Do I wake or sleep?" This explicit question, in turn, poses an implicit one for the reader: When is that utterance made? Were the poet not now (whenever "now" may be) unsure, he would not fully have experienced what he describes nor fully have engaged his reader in his situation in the darkening garden when he imaginatively listens to the nightingale's song. Perhaps more difficult are Romantic poems, of which "The Euganean Hills" is one, ending not with a question but a hypothesis, which involutes their characteristic if-then structure, or a recognizably provisional affirmation, a flight of fancy, a tone shift, a movement that rounds off but does not definitively resolve the experience. In Romantic poetry even a "philosophic" statement, such as closes Keats's "Ode on a Grecian Urn," usually does not do away with incertitude but, instead, delimits it to protect its equivocality. The Romantic sensibility typically does not transcend the experiential by a turn to some metaphysical certainty (even that of the cosmos being absurd) or some profound structure such as an archetypal pattern.

In the "Euganean Hills," for instance, Shelley does not epitomize. He recounts the progress of an autumnal day from dawn to dusk to portray sequentialities of human affairs as related to, but distinct from, sequences of the physical cosmos. Nature and history are both temporal in essence, rhythmic, but the cyclic irreversibility of the former, for example, is not an inescapable feature of the latter. If "Freedom should awake" in Venice,

> Thou and all thy sister band
> Might adorn this sunny land,
> Twining memories of old time
> With new virtues more sublime.
> (lines 156–59)

Cultural decay is not inevitable in the same sense in which sunset is the inevitable consequence of dawn. Yet awareness that all things human, from civilizations to private sensations, are of and in time, and therefore impermanent, is conveyed by the lyric's details and total movement, particularly the use of the diurnal progress to structure its central portion. This ambiguity creates much of the poem's overt emotionality. In this poem, as in Keats's "Ode to Mel-

ancholy," joy and misery, despair and hope, do not so much balance as interact: one *becomes* the other. Dramatic confrontations melt into something like a narrative process, in which is lost most of the irony that discovers the permanent beneath the transient, the timeless within phenomenal change. Any certainty precludes the possible alternative futures Shelley envisions so equivocally.

In the "Euganean Hills," then, the audience is asked to adopt more than Shelley's physical viewpoint. We are offered the perspective created by the poet's still incomplete personal history, the course of life that momentarily makes of the volcanic hilltop in the "waveless plain of Lombardy" an "island," a temporary refuge from misery, a flowering isle of respite in the poet's life voyage across a sea of agony (perhaps leading to a paradisal isle and perhaps to bones and skull bleaching on a desolate shore). Perceiver and perceived also function as metaphors for one another. Venice, literally an island in the Adriatic and metaphorically one in the Lombard plain, embodies part of the agony of history through which the poet voyages. Simultaneously, the city recalls past glory and suggests a possibly glorious future, and therefore may also be one of the flowering isles for which he yearns. We are presented with not so much an ironic opposition of appearance to reality as a process by which (actually or potentially) one becomes the other. The gleaming towers of Venice are in fact

> Sepulchres, where human forms,
> Like pollution-nourished worms,
> To the corpse of greatness cling.
> (lines 146–48)

But from this grim reality new grace and virtue may come, just as Tyranny, which trampled learning's spark in Padua, has now rekindled the flame of "antique" liberty in many lands. Even the climactic moment keeps us in the world of time,[14] with a thirty-four line sentence whose molten grammar reveals no transcendent realm but the fluid interpenetrativeness of all phenomena upon which "noon descends,"

> Mingling light and fragrance, far
> From the curved horizon's bound
> To the point of Heaven's profound,
>
> Pointing from this hoary tower
> In the windless air;
>

And the Alps, whose snows are spread
High between the clouds and sun;
And of living things each one;
And my spirit which so long
Darkened this swift stream of song, —
Interpenetrated lie
By the glory of the sky;
Be it love, light, harmony,
Odour, or the soul of all
Which from Heaven like dew doth fall,
Or the mind which feeds this verse
Peopling the lone universe.
 (lines 285–319)

All of Shelley's elegant prose testifies that the syntactic dissolutions of this passage are as deliberate as Blake's distortions of grammar and omissions of punctuation. Shelley's grammatical fluidity seems, too, a linguistic equivalent to the blurring interpenetrations of color by which Turner dissolves to re-create. Shelley's language tries to overcome organization through the conventional separation of standard syntax, so as to reinstate the flowing simultaneity that is *now*, this particular ensemble of impressions emerging out of the past and shaping itself into an unfolding future. Analogously, Turner renders the *specificity* of a scene by freeing its colors from the separateness decreed by conventionalized representational forms. Interpenetration is essential for the Romantic because he individuates not by segregating one thing from another but by depicting *how* there occurs a uniqueness of conjoining and interfusing.[15] For him, the experiential process is realized only in an art made up itself of transformational activities, "the mind which feeds this verse / Peopling the lone universe."

Is it love, light, harmony, or odor? The poet does not offer a determinative answer. Unifying significance lies in the sheer interactivity of diverse phenomena, including diffusion of the poet's verse into an Italian landscape in which natural and cultural have blended, are blending, will blend—a totality we would perceive inadequately were we to see it as only one or the other.[16] Shelley's Euganean hill is not the still point of a turning world, but the opposite, a new, complex ensemble of sensations meaningful only because involuting past and future. This temporalizing of space, of which an analogue is Keats's "Ode on a Grecian Urn," is a developed mode of the Romantic imaginative deployment of language that enables the reader to participate in the poem's constitutive experience.

AMBIGUITIES IN ROMANTIC HELLENISM

Depiction of a classical scene in *Dido Building Carthage* led Turner to prophesy the fate of the British Empire. The parallel use of history as a foundation for prophecy in Shelley's *Hellas* enables us to perceive the ramifying significance of his attitudes and techniques in "Lines Written Among the Euganean Hills" and also provides insight into a central impulse animating all Romantic "classicism," especially Romantic Hellenism, a focal point for much second-generation Romantic art. As Earl Wasserman has demonstrated, *Hellas*—though written swiftly to raise money for the cause of the Greek rebellion, based on what Shelley called "newspaper erudition," and labeled by him a "mere improvise"—is in fact carefully organized thematically and imagistically so as to transform his model for improvisation, Aeschylus's *Persians*, into a significant new conception of historical process.[17] Although we need not agree with Wasserman's treatment of Shelley's historicism as equivalent to Hegelianism, his explanation of how an improvisation could be a serious aesthetic endeavor opens the way to appreciating improvisation in Romantic imagining. This topic has been explored so far only by Stanley Cavell, whose remarks about music are applicable to all the arts: "In listening to a great deal of music, particularly to the time of Beethoven, it would . . . be possible to imagine that it was being improvised. . . . Somewhere in the development of Beethoven, this ceases to be imaginable."[18] Observations about improvisation also lead to striking analogues between Shelley's attitudes toward his classical models and Turner's toward his.

But to keep for the moment to the purely literary, we can compare Shelley's creative challenging of his formal source to a simple imitation of the same source in *The Battle of the Nile*, a play published anonymously in London in 1799. The author of *Battle of the Nile* adapted *The Persians* to a celebration of Nelson's destruction of the French fleet at Aboukir Bay. The principal speakers are members of the Directorate; Buonaparte is cast in Xerxes' role, and King Louis's ghost replaces Darius's shade; and Aeschylus's description of Salamis in the messenger's speech is modified to fit the battle of the Nile. The contrast with this unpretentious dramatic entertainment highlights how unimitative is Shelley's improvisation, how *Hellas*, in fact, consciously questions the meaning of its relation to its original, thereby making problematic the relation of later Western culture to its Hellenic source. Shelley's play makes explicit the

underlying question animating all Romantic Hellenism: What does it *mean* that "we are all Greeks"?

This self-questioning historicity climaxes in the magnificent final chorus of *Hellas*, magnificent because it brings into focus the intense uncertainties that have been mounting from the play's opening lines, sung by a chorus of Greek captive women to the sleeping ruler of Constantinople, Mahmud.[19] The women hope that Mahmud never reawakens or at least that while he sleeps the forces of liberation may gather strength to destroy him. But opposing herself to the chorus is an Indian maiden, presumably a captive also, who loves Mahmud, and who accuses the Greek women, wrongly, of trying to disturb his slumber, and, rightly, of wishing him ill. This device launches the drama along a course of internal conflict and contradiction. Nothing in the play, from incidents to imagery, functions undialectically; no force appears in *Hellas* but releases a counterforce. The principal forces are emotional, for *Hellas* is a drama not of ideas but of feelings. Its effectiveness lies in the encounter between the Greeks' emotional desire for a seemingly impossible political freedom and Mahmud's fear that his culture's power, despite its military success, is inevitably failing.

Desire and fear are concentrated by the unanswered question of whether cyclic repetitions of history can be transcended. Ahasuerus, the seer from whom Mahmud gains access to vision, asserts that "Naught is but that which feels itself to be" (line 785), and then explains,

> Thought,
> Alone, and its quick elements, Will, Passion,
> Reason, Imagination, cannot die,
> They are, what that which they regard, appears.
> (lines 795–98)

Ahasuerus seems to identify thought, defined to encompass the total panoply of mankind's psychic powers, as an eternal vital principle; thought is immortal because truly existent, as distinct from the illusions of mutable things-that-are-thought; thought is (not seems) because it "feels itself to be." Though these lines may seem abstract, in context Ahasuerus's speech concretizes the play's fundamental conflict and precipitates the central peripeteia, Mahmud's visionary encounter with Mahomet II, his ancestor who had captured Constantinople in 1453.

This meeting, implying the inevitability of Mahmud's defeat as a

consequence of Mahomet's violent triumph three hundred and fifty
years earlier, does reveal, as Wasserman shows, Shelley's awareness
of the possible domination of cyclic processes in history.

> Mahomet's victory contained Mahmud's defeat, just as Aeschylus'
> *Persians* implies *Hellas*. . . . Mahmud's frightening prophetic dream
> [in the opening scene] . . . was actually of Mahomet II's capture of
> Constantinople from the Greeks three and a half centuries before.
> When, starting from his sleep, Mahmud shouted in astonishment
> that the "breach towards the Bosphorus / Cannot be practicable yet,"
> he was experiencing as his own loss of Constantinople his ancestor's
> conquest of it long before.
>
> (Shelley, p. 392)

But, as Wasserman also notices, *Hellas* is not a mere re-enactment
of *The Persians*. The cyclical nature of history implied by the en-
counter between Mahmud and Mahomet is perhaps more doubtful
than Wasserman here makes it appear or than Mahmud takes it
to be.

If Mahmud first encounters Mahomet in a dream, by Ahasuerus's
aid he later confronts his ancestor in a waking vision. The old king
convinces him, and presumably the reader, of the illusoriness of
the apparently decisive Moslem victories, whose celebration inter-
rupts Mahmud's vision. By confronting his origins, Mahmud does
not just dream or think but comes to feel how his past dooms him,
and the strength of his feeling impresses us with his conviction
that the apparent moment of triumph is in truth a harbinger of de-
feat. But the power of that emotional effect also makes us pause to
consider the relation of present Greek aspiration to earlier Hellenic
history. Will the triumph of the Greeks, then, be as transitory as
that of the Moslems? Does the pattern of Moslem triumph and de-
feat imply a similar repetitive cycle for the Greeks? And are we not
all Greeks? *Must* hate and death return?

> The world's great age begins anew,
> The golden years return,
> The earth doth like a snake renew
> Her winter weeds outworn;
> Heaven smiles, and faiths and empires gleam
> Like wrecks of a dissolving dream.
>
> A brighter Hellas rears its mountains
> From waves serener far,
> A new Peneus rolls his fountains
> Against the morning star,
> Where fairer Tempes bloom, there sleep
> Young Cyclads on a sunnier deep.

A loftier Argo cleaves the main,
 Fraught with a later prize;
Another Orpheus sings again,
 And loves, and weeps, and dies;
A new Ulysses leaves once more
Calypso for his native shore.

O, write no more the tale of Troy,
 If earth Death's scroll must be!
Nor mix with Laian rage the joy
 Which dawns upon the free;
Although a subtler Sphinx renew
Riddles of death Thebes never knew.

Another Athens shall arise,
 And to remoter time
Bequeath, like sunset to the skies,
 The splendour of its prime,
And leave, if nought so bright may live,
All earth can take or Heaven can give.

Saturn and Love their long repose
 Shall burst, more bright and good
Than all who fell, than One who rose,
 Than many unsubdued;
Not gold, not blood their altar dowers
But votive tears and symbol flowers.

O cease! must hate and death return?
 Cease! must men kill and die?
Cease! drain not to its dregs the urn
 Of bitter prophecy.
The world is weary of the past,
O might it die or rest at last!
 (lines 1060–1101)

Hellas thus does not merely re-enact but confronts its source to make the audience confront its past, as Shelley's earlier play *The Cenci* compels the audience to confront what must be thought and may be done. Contemplating his past and making us contemplate ours, Shelley demonstrates history to be not an abstraction for intellectual analysis but a vital activity requiring from each of us emotional commitment, will, reason, and imagination. *Hellas* questions the very idea it dramatizes, as Keats's "Ode on a Grecian Urn" questions the aesthetic ideal the poem embodies. Romantic Hellenism is of lasting interest because it evokes skeptical scrutiny of the idealizing it articulates, nowhere more anguishingly than in the final chorus of *Hellas*.

The same ambivalent Hellenism informs the performance of "The Isles of Greece" at the "wedding" of the foreign castaway Don

Juan and native Haidée in Byron's *Don Juan*, canto 4. The authentic and realistic passion of "The Isles of Greece" is circumscribed by qualifications that make it seem at least as likely that the bowl of Samian wine will be flung down and smashed as lifted high. Although the anti-Southey jokes in the patriot-bard's performance are amusing, portions of the description of the dubious bard and his diverse career might be as aptly applied to Byron himself as to anyone else. In depicting the celebration that climaxes the desecration of Lambro's home, Byron makes it clear that Lambro's political career is a kind of compensation for his country's enslavement. In this context, the irony of "The Isles of Greece" is quite disturbing, especially since Lambro has been humorously compared to Odysseus, though the outcome of the episode, a reversal of the Homeric hero's triumphant if bloody homecoming, is far from amusing.

> That isle is now all desolate and bare,
> Its dwellings down, its tenants pass'd away;
> None but her own and father's grave is there,
> And nothing outward tells of human clay;
> Ye could not know where lies a thing so fair,
> No stone is there to show, no tongue to say,
> What was; no dirge, except the hollow sea's,
> Mourns o'er the beauty of the Cyclades.[20]

Rather than merely inverting Homer, Byron, in keeping with his keenly realistic sociopsychological picture of Haidée's father, presents a singularly accurate description of how many isles of Greece now appear. The relation of desolate natural beauty to the richly human passions that once so dramatically clashed there provoke us to consider the darker possibilities of historical "progress," the significance of the decline from Odysseus to Lambro to a barren, nameless island.

If in this regard Byron's admiration for Scott is understandable, from his attitude we may also deduce that there is nothing eccentric in his friend Shelley's readiness to accept the possibility that history is no more than an inevitably repeating cyclic movement—all of history but one page, in Byron's phrase. Yet if Shelley perceived the fallacies of hope as acutely as Turner, he did not assume that all hope was fallacious. Hope is not assurance, but a response to uncertainty. True historical awareness produces for the Romantic neither pessimism nor optimism but a readiness to accept all the responsibilities of living in uncertainty. Because hope is possible, history is important, for hope that is not born of a thoughtful and critical meditation on history leads but to foolish utopianism.[21] To

ignore the past or its relevance to the present is to sever oneself from a fundamental aspect of one's humanity. The present is not merely a mechanistic continuation of what has gone before; it is complexly conditioned by history and extends into a variety of possible futures, to which this present will then itself be the past. The essence of human sociality consists of historical relations with one's kind through time as well as physical presence. Thus if social aspirations are to be something more than utopian fantasies—which the Romantics came to believe inevitably produced real dystopias—hope must be rooted in an awareness of social continuity, must be consciously related to past actualities as well as future possibilities.

Looking at "Lines Written Among the Euganean Hills" and *Hellas* in the light of these attitudes, one may discern in them two underlying fears implicit in "Michael," "Fears in Solitude," *The Heart of Midlothian*, as well as Byron's *Don Juan*. First, the fear that the trend of "progress" is toward a society devoid of significant social continuities, one in which all human encounters would be casual or meaningless. Second, the fear that the writers' countrymen were increasingly unwilling to confront the harshness of truths offered by any honest inspection of the past, that their audiences were as naively confident of the future as they were indifferent to the ominous lessons of their own history.

The hope expressed in *Hellas*'s final chorus for a finer culture in America than that of ancient Greece is genuinely impassioned, as is the captive women's aspiration for liberty, but the play tempers those hopes by showing the extent to which historical continuity consists in the self-degradation of idealism into cyclic repetitions of glory and defeat. We are in a position to appreciate, as Shelley's contemporaries could not, the aptness of these dubieties. Some parts of Greece did manage to get free of Turkish rule, only to fall under the subtler domination of Western European powers. The Greek struggle for genuine liberation from authoritarian rulers directly or indirectly supported by foreign powers continued throughout the nineteenth century; even today the question of Greece's subservience to foreign interests is far from finally decided. None of this would have surprised Shelley: the fallacies of hope and the uncertainty of historical movement are what *Hellas* seeks to make its readers imagine. Nor would it have surprised him, though it would have saddened him, that literature and criticism have increasingly turned away from the imaginative engagement he sought in the inevitable confusion of political actualities.

8

Pluralized Visions

I know of no method so efficacious as that of intermedia parallelism for highlighting features of a general aesthetic while preserving respect for unique qualities of individual works of art. Seeking out parallels between the arts is also useful for breaking down preconceptions fostered by too specialized criticism. That Romantic art is "expressive" has long been a premise of literary studies. The truth in this view, however, has obscured the significance of Romantic reflectiveness, both in the visual and the literary arts. In many of Constable's and Turner's paintings, for example, the most vivid parts are reflected lights. In Turner's *Burning of the Houses of Parliament*, the flames reflected in the water are more vivid than those consuming the buildings, though both "fires" are impressive. One sees in Turner's canvas both mirror and lamp, not just a representation of fire but also a representation of an image of fire. This plenitude through doubling and superimposition is an essential feature of Romantic art, which we may explore by focusing on Wordsworth's *Prelude* and some of Turner's later paintings.

IMAGINATIVE COLORINGS

The Burning of the Houses of Parliament (Figure 10) concretely illustrates why Wordsworth, Coleridge, and Shelley speak of the "coloring" of the imagination.[1] The Romantics disliked colorless reflections and usually avoided the exact duplication afforded by a flawless, vertical mirror, a kind of repetition favored by both their Neoclassical predecessors and Victorian successors. The Romantics preferred inexact reflections, distorted repetitions, uncertain echoes. Through differences between original and reflection they celebrate the diversity of redundancy or display the incremental power human consciousness introduces into nature. Turner's fire in the water is brighter than the burning buildings, and in *The Prelude* the profoundest significances are created by reflections on experi-

168

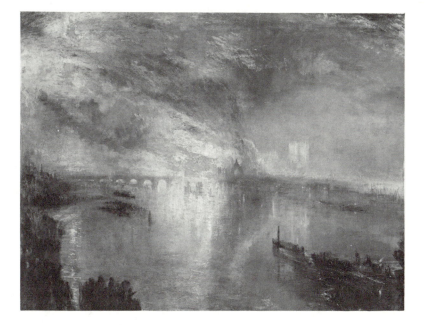

10. J. M. W. Turner. *The Burning of the Houses of Parliament*. The Cleveland Museum of Art, Bequest of John L. Severance. Turner sketched the actual event at night; his finished paintings of the scene vary the position from which the fire is observed as well as the colors of the conflagration and its diverse reflections.

ence. For the Romantics, reflections, echoes, and recurrences are not, as the mirror-lamp cliché inevitably suggests, mere secondary phenomena. Intensification and even simple differences in "color" enable the artist to challenge the primacy of original sources. The belief that reflection was not necessarily a pale or "weak" imitation but a potentially enriching or enhancing activity contributed to the Romantics' cheerful readiness to acknowledge the traditions from which their innovations emerged. More importantly, the Romantic fondness for natural mirrors, usually a body of water, for reflectors that were in motion, horizontal, and colored, suggests that coloring could be used to assert a place for the human and especially for human artistry in the natural world without denigrating nature's power—indeed, through human creativity the potency of the natural could be intensified to the highest degree.[2]

By coloring an object, one changes its appearance but not its

form: the colored object is identical to, yet different from, its un-colored counterpart. This transformative continuity becomes most apparent when original and reflection are juxtaposed in an art-work. Further, the perceiver's participation—the "colouring of the imagination" in Wordsworth's phrase—serves as another type of re-flector. Creative "reflection" is essential to effective perception, which is not merely a passive receiving of sensation.

A major aim of Romantic art was to strip away the veils of famil-iarity that obscure our vision, and the most enshrouding of veils are those of unconscious predispositions and prejudices. Nearly as insidious is the human tendency to be controlled by physical cir-cumstances, to become victim, in Shelley's words, to "the curse which binds us to be subjected to the accident of surrounding im-pressions" ("Defence of Poetry"; see Coda). The creative artist effects an escape from these immediate impressions, likely to be es-pecially enthralling for him, but his creation has the potential to become yet another external set of "surrounding impressions," ca-pable of re-entrapping his audience, again reducing it to a passive receptor. One means of encouraging audiences to respond crea-tively to artistic work is to present in it inexact duplications, imper-fect reflections, and asymmetrical repetitions—all of which imply the need for a more complex vision of a larger whole beyond the immediate focus of interest.

For the Romantics, the perceiver's nature significantly deter-mines the nature of what he perceives, as stated in extreme form by Shelley, "things exist only so far as they are perceived," and Blake, "the eye altering alters all."[3] As a coloring agent, the imagination can affect external actualities, and we often fantasize what is real, or will be real, though not at the moment actually perceptible. The solidity we perceive in three-dimensional objects, for example, is imagined, not optically registered, and all planning involves imag-ining a future to be realized. Such ordinary exercises of the mind in everyday life underlie the imaginativeness of Romantic art.[4]

The reflection of fire in water is not fire, but the image really exists. More subtle is the presentation of images not at the moment objectively perceptible or tangible, but not unreal—memories, for example. Imagination frees us from the prison of primary sensa-tion, that circumscribing environment in which animals seem to be confined and in which we trap ourselves when we fail to exploit our human creativity, our imaginative power. The cliché of Roman-tic escapism is thus a half-truth: the Romantic imagination is a lib-

erating force, but the best Romantic art helps us to escape from the inhumanly restricted to a more intensely human reality. Liberation occurs as limitations imposed by "transcendental" assumptions are challenged and specific situations are viewed in their larger context, as participating in processes of extended continuity. This naturally encompassing whole, not the transcendentalized "organic form" ascribed to particular entities, is what captures the attention of Romantic artists, and it is that vision their artistry seeks to evoke for their audience.

It may seem paradoxical that a painter should wish to free himself and his viewers from immediate impressions: Why paint a picture in which no one can be sure what is depicted? Yet Constable and Turner display ambiguities or obscurities that force viewers to question their immediate perceptions and respond imaginatively to the canvases. In poetry, Wordsworth attempts an equivalent enterprise in *The Prelude*, to which I now turn.

THE PRELUDE: INFRASTRUCTURE OF PLENITUDE

We may begin with the Boy of Winander passage, which Wordsworth first published as the second poem in the 1800 edition of *Lyrical Ballads*, and later printed as the opening selection to the section entitled "Poems of Imagination" in the 1815 edition of his poetry.

> There was a boy—ye knew him well, ye cliffs
> And islands of Winander—many a time
> At evening when the stars had just begun
> To move along the edges of the hills,
> Rising or setting, would he stand alone
> Beneath the trees or by the glimmering lake,
> And there, with fingers interwoven, both hands
> Pressed closely palm to palm, and to his mouth
> Uplifted, he as through an instrument
> Blew mimic hootings to the silent owls
> That they might answer him. And they would shout
> Across the wat'ry vale, and shout again,
> Responsive to his call, with quivering peals
> And long halloos, and screams, and echoes loud,
> Redoubled and redoubled—concourse wild
> Of mirth and jocund din. And when it chanced
> That pauses of deep silence mocked his skill,
> Then sometimes in that silence, while he hung

Listening, a gentle shock of mild surprize
Has carried far into his heart the voice
Of mountain torrents; or the visible scene
Would enter unawares into his mind
With all its solemn imagery, its rocks,
Its woods, and that uncertain heaven, received
Into the bosom of the steady lake.
(Book Five, lines 389–413)[5]

It has been much noticed that an early version of this passage identifies the boy as the poet. Less noticed is that in this early version the poet refers to himself first in the third person, rather in the manner of Coleridge in "Fears in Solitude."[6] From early on, then, indeterminacy of person lends an equivocalness to the lines. And the reader of the later version, like the poet narrating, is left "hanging," left in uninstructed contemplation of the narrator silently contemplating a memorial of "the boy" whose youthful death exacerbates the uncertainty of his precise function in the narrator's experience.[7]

Like "Tintern Abbey," the Boy of Winander passage does not depict a single, isolated experience, but a series of similar though diverse episodes. The boy mimics the owls "many a time," and "sometimes" his heart feels the shock of mild surprise, just as in the retrospective lines that follow the poet says "I believe that oftentimes . . . I have stood / . . . looking at the grave," the slight tentativeness of "believe" reinforced by the succeeding "Even now methinks I have before my sight" (lines 420–23). Such uncertainties contribute to the indeterminacy of the scene's climax:

while he hung,
Listening, a gentle shock of mild surprize
Has carried far into his heart the voice
Of mountain torrents; or the visible scene
Would enter unawares into his mind.

This "or," characteristically Romantic, presents the reader not with a single event but with alternatives, repeated but not identical experiences, inexact reflections and reduplications that, like one of Turner's canvases, require an imaginative response. The poet's relation to the boy is doubtful; the episode is not one event but different kindred events; so in connecting this passage with others in *The Prelude* one must connect uncertainties deriving from multiple possibilities while struggling with difficulties introduced by characteristic Wordsworthian ambiguities of diction and syntax.

Indeed, as Isobel Armstrong detects, throughout *The Prelude* two syntaxes, one "reciprocal" and one "reflexive," are interwoven with an accompanying deployment of images that both contravene themselves and reflect earlier forms of themselves.[8] Armstrong delineates the effect of these superimpositions and counteractions as making the poem an involute (in the geometric sense): out of nothing but its own processes of self-transformation the poem establishes meanings through accretion of ever new self-relationships. This fecund multiplicity of syntactic and imagistic forces animates the structuring of Wordsworth's asymmetrically self-reflective poetry, both at the level of episode and that of grammar. Everywhere in *The Prelude* destabilizings created by plenitude, the overabundance of possible interrelations, enable the reader imaginatively to respond to self-energizing processes of the poem's form evolving out of its imperfect self-repetitions.[9]

Literary analysis of *The Prelude* only intensifies our awareness of the text's multiple possibilities of meaning and relationship—the poem resists reduction to that which may be singularly defined or definitively understood. Wordsworth's "returnings" of various kinds—reflections, repetitions, and redundancies—may at first appear to function emphatically, serving to make explicit the poet's meaning. Yet the more closely we examine these reiterations the more possibilities they allow us to imagine, just as an examination of a Turner canvas produces more ambiguities and doubts than it resolves. Of the conclusion of the Boy of Winander—"and that uncertain heaven receives / Into the steady bosom of the lake"— Coleridge claimed that had he "[met] these lines running wild in the deserts of Arabia, I should have instantly screamed out 'Wordsworth!'" But at least one critic has confessed that he does not understand these lines, and the readings of others suggest that he is not alone.[10] Conventional attributes of lake and heaven are inverted but, more troublingly, we cannot know whether or not "uncertain heaven" refers to the "moving stars" of the earlier lines, and the referent of "that" eludes us. The difficulty arises from an abundance, not a shortage, of possible meanings and relations. We are confronted by the obscurity produced by overlappings and superimpositions, not exclusions or deletions. And the entire episode contributes to the polymorphous structure of *The Prelude* as a whole: its specific function is difficult to define because it relates to so many other portions of the poem in so many different ways; the poem's infrastructure is allotropic.

To place the Boy of Winander passage in relation to other parts of the poem, we may begin with its immediate context, the subsequent Drowned Man episode. But, as Peter Manning and several other recent readers point out,[11] a key to Wordsworth's use of context lies in the intricate simile in Book Four that compares the poet's progress in the poem to the experience of looking down from a boat drifting over a lake (lines 247–64). This extended simile is peculiarly illuminating of the blurred reflectiveness essential to the Romantic artist seeking to provoke a creative response. "Blurred reflections" determine the movement in Book Five, from the Boy of Winander to the present time of composition and then back to a memory of an earlier time, the incident of the Drowned Man, which ambiguously echoes and confusingly inverts themes in the preceding passages. The poet mentions the Boy of Winander's death and then describes his own mute meditations in the churchyard, which leads to a self-reference at the moment of writing, "Even now, methinks I have before my sight / That self-same church" that was "spoken of erewhile" (lines 425–26). However, the church, thus recalled from Book Four, lines 13–16, is envisioned as "forgetful of the boy" and "listening only to the gladsome sounds" at "play" around her from the schoolchildren of "today." The poet wishes that the church might in future years behold "a race of young ones, like to those with whom I herded," children who enjoy both "books and nature" and therefore possess "knowledge not purchased by the loss of power."

Retrospection thus leads to foresight, recollection produces hope, while memory begets forgetfulness, and the passage suggests that reading is most efficacious when linked to activities antithetical to reading. The praise of "knowledge not purchased by loss of power" gathers much force from concentrating, first, the problematic character of Book Five, whose subject, books, appears and disappears sporadically (as Wordsworth's description of his schooling tends to emphasize vacations and recesses), and, second, the problematic character of the entire poem insofar as its subject is the marshaling of self-knowledge to enhance the poet's power to write what we read.

Just as sentences in *The Prelude* are fabricated of more than one syntax and pronouns are likely to have more than a single antecedent, so the complexity of interreflections among the poem's parts and episodes is complicated by Wordsworth's revisions, particularly those alluding to earlier literary works. Manning presents pas-

sages that send the careful reader in "pursuit of echoes half-heard" from Shakespeare, Milton, and Gray, echoes "suggesting a story lying just beyond the one being told," as Wordsworth's narrative "doubles and repeats itself [and so] obscures the action it presents" (pp. 20, 8, and 10). Paying particular attention to the reference to Othello in the 1799 version, which Wordsworth excised from the 1805 *Prelude*, Manning observes that "Wordsworth rewrote, or wrote against, his previous writing, rather than wholly erasing it" (p. 26). This seems to me the most important revelation afforded us by the past decade's editorial recovery and promulgation of Wordsworth's many revisions of his longer works. Manning, for example, urges us to notice the difference between the main versions of the conclusion of the Drowned Man episode, including the shift in its placement: "A reader who compares the immediate context of the Drowned Man in 1799 with that of 1805 cannot help being struck by the symmetry of Wordsworth's reversal" (p. 24). Yet even this stability of symmetrical inversion is troubled by the change from the earlier suggestion that from such experiences as seeing the corpse rise from the water evolved pure and enduring mental forms in the poet's mind, to the later version's claim that earlier reading of romances had prepared the boy to respond to the grim event with emotions ennobled by dignity and grace.

Manning, following J. Hillis Miller, calls such differences *oscillations*, a term valuable in connoting that differences between the 1799 and 1805 versions are not determined by the poet's search for an ultimate true meaning of the episode but may arise from his sense of the appropriateness of both explanations, however seemingly contradictory. Wordsworth's revising, in fact, is best understood as equivalent to Byron's willingness constantly to extend *Don Juan* by accreting new incidents. The visions of *The Prelude* are not so much attempts to perfect the poem as to experiment with the alternative meanings of events, both at the time of their occurrence and at the time of writing and rewriting. That Wordsworth did not often erase or delete implies that, unlike the poet whose rewritings embody endeavors to find the most satisfactory expression, his revisions are intended to be additive, supplementary, and exploratory. As Armstrong puts it: "The ordering of Book VI is as much in terms of its breaks and transitions as its syntax . . . there are ellipses, junctions which do not join, connections which do not connect and often invert the ostensible meaning of their relationship" (p. 27).

DRIFTING INTO ECOLOGICAL
WHOLENESS

Memory slides athwart memory, one narrative usurps another,
an illustrative episode occludes what it is to illuminate. The palimp-
sestic principle is suggested by an extended simile in Book Four, a
passage that is diversely echoed and reflected in both the incidents
of the Drowned Man and the Boy of Winander and even recalls the
memory of the stolen rowboat in Book One:

> As one who hangs down-bending from the side
> Of a slow-moving boat upon the breast
> Of a still water, solacing himself
> With such discoveries as his eye can make
> Beneath him in the bottom of the deeps,
> Sees many beauteous sights—weeds, fishes, flowers,
> Grots, pebbles, roots of trees,—and fancies more,
> Yet often is perplexed, and cannot part
> The shadow from the substance, rocks and sky,
> Mountains and clouds, from that which is indeed
> The region, and the things which there abide
> In their true dwelling; now is crossed by gleam
> Of his own image, by a sunbeam now,
> And motions that are sent he knows not whence,
> Impediments that make his task more sweet;
> Such pleasant office have we long pursued
> Incumbent o'er the surface of past time—
> With like success.
>
> (Book Four, lines 247–64)

The poem's "progress" consists of the poet drifting over a hori-
zontal surface, perceived as the upper plane of a depth into which
he peers and sees in that verticality mingled stillness and motions
of varying clarity and shadowiness, vividness and indeterminacy.
The observer is "perplexed" by confusions between actual objects
seen through the water and both shadows and reflections in the
water of objects actually above it, including the "gleam / Of his own
image." The pleasure in this self-complicating vision in which true
perceptions and illusions mingle, confused both by the observer's
imaged presence and motions of unknown origin within a medium
simultaneously transparent and reflective, corresponds to the plea-
sure offered by both the poem's detailed language and its infra-
structure of episodic relations. Without provoking a sense of delib-
erately surrealistic distortion, the poem constantly urges its reader
to explore different possibilities of connection and contrast, diverse

significances of repetitions, reflections, and redundancies, including the ever-changing relations of sensory actualities and imaginings. The lake seen into, furthermore, precisely illustrates how we now read *The Prelude* through its various revisions.

Wordsworth's comparison is apt so far as his rewritings, superimpositions rather than erasures, regularly increase the associative abundance of connections between parts of the poem. Strict chronological order is betrayed by the poem's perplexing plenitude of self-reflexiveness, its pluralizing reflections upon reflections on events. And the poem's underlying chronological progression is often upset locally, as in the reversal of the order of the episodes of the Drowned Man and the Boy of Winander. Indeed, the poem begins so deceptively *in medias res* that not until line 55 does one realize that the present tense belongs to a past time. The more we study the different versions of the poem, the more we become aware of how many different kinds of distortion are included, even duplicities about its totality and total purpose. As Jonathan Arac points out, the poem is concluded arbitrarily by the poet's simple declaration that the originating problem has been solved; but the solution is nebulous, and the work that the completion of *The Prelude* was supposed to make possible, *The Recluse*, remained unwritten, while the poet continued to rewrite the supposedly finished *Prelude* until the end of his life.[12] The poem's lack of a title teaches the same lesson, and the ridiculed phrase, exceedingly awkward in its 1805 form, "my drift hath scarcely / I fear been obvious" describes well a dominant mode of the poem's movement, its conflicted "progress."

This drifting, associative, superimpositional character distinguishes *The Prelude* from the literary models to which it may superficially seem comparable, such as the epic or the autobiography. Many critics, from Irving Babbitt to Paul de Man, have mistakenly identified the poem with Rousseau's *Confessions*, but the two works are truly as radically different as Hogarth's progresses and Blake's prophecies.[13] A key difference concerns Wordsworth's intrusions at the moment of writing to question the possible meaning of an experience he describes. Rousseau, claiming to present definitive truth (to refute his enemies), cannot admit into his *Confessions*—as his title suggests—such open-ended reformulations, reinterpretations, or belated discoveries of possible alternative significances. Moreover, whereas Rousseau's intention was self-justifying, the modest, subordinate nature of *The Prelude*, written to help Words-

worth write other poetry, reveals its author's special sense of his proper place in the world:

> Ye presences of Nature, in the sky
> Or on the earth, ye visions of the hills
> And souls of lonely places, can I think
> A vulgar hope was yours when you employed
> Such ministry—when you through many a year
> Haunting me thus among my boyish sports
> On caves and trees, upon the woods and hills
> Impressed upon all forms the characters
> Of danger or desire, and thus did make
> The surface of the universal earth
> With triumph, and delight, and hope, and fear,
> Work like a sea?
>
> (Book One, lines 490–501)

These lines, even in their interrogative mode, foretell the vagueness and indefiniteness that will accompany the poet's delight in changing and uncertain reflections in the boat-gazing passage in Book Four. More significant still is the addressee, "presences of Nature." By definition, presences are indisputably important but cannot be particularized or visualized; such efficaciously indeterminant agents serve as the disembodied embodiments of humanlike qualities in the systematic workings of the natural world.[14]

Like the boat-gazing simile, this invocation to natural presences so engages in interactions of the physical and the psychological that one may have difficulty in deciding which aspects of the experience are physical and which are psychological, as when presences impress upon the caves, trees, woods, and hills the characters of danger and desire. Boundaries are so unclear that one cannot invariably distinguish reflected from reflecting, reversals that help to validate the attribution of human motivations to forces "outside" the poet, forces that increase his powers and so, in a sense, enter him. For this complexity Ruskin's term *pathetic fallacy*—based on an absolute distinction between the human and the natural-inhuman—is pathetically inadequate; a parallel distinction underlies some twentieth-century critics' postulating of an absolute separateness of "mind" from "nature."[15] *The Prelude* treats such segregation as pathological, a diseased rejection of nature's intrinsic benevolence, which is the primary effect of its integrity, completeness, fullness, and continuity. These qualities frustrate into perversity all reductive rationalizations of nature's potency, though

many readers tend to flinch at the literalness with which Wordsworth thus develops his belief that to dissect is to murder.

Wordsworth's view thus anticipates the concept of ecological wholeness defined by scientists in this century, in which neither man nor nature is viewed as existing independently of one another.[16] Because Wordsworth conceives man's place in nature ecologically, he can represent his individual life as exemplary in its commonplace character, in its accord with the ordinary processes of natural being, unwarped by defectively limiting social patterns that deny the completeness and grandeur of natural wholeness. If one belongs to a totally interdependent complex (which is inherently "benevolent" in that the totality sustains its minutest constituent parts), then "belongingness" and not "separateness" is the evidence of efficacious individuality. Whereas Rousseau, Hogarth, and most contemporary psychologists posit identity as a privative uniqueness established by exclusion, by difference, by autonomy, Wordsworth, in characteristic Romantic fashion, conceives of participative identity, individuality established by the unique fashions of relating, depending, interacting, and contributing to a whole that is constituted by and sustains a multiplicity of diverse interdependencies.

What has obscured this Romantic concept of participative identity is the Romantics' easy acceptance of the temporal dimension, an unbroken linkage of shiftings, as fundamental in a natural ecosystem. Wordsworth defines the fullest success of his life in terms of a continuity of growth, which implies change over time. For him, unusual dramatic, autonomous events tend to appear as interruptions or contrastive indicators of more significant underlying persistences. The poem's dominant metaphors, the river and the breeze, exist only as continuities of perpetual change.

Thus the poet "recovers" by regaining his place in the continuity of being, rejoining the "union of life and joy" (1:585) that he had willfully distorted by privileging intellectual judgment (the "enemy of falsehood" rather than the "friend of truth," 11:134–35) over his "natural graciousness of mind (11:44). In that original "spirit of pleasure" (11:322), analogous to the physical world's "motions of delight" (11:99), "feeling comes in aid / Of feeling" (11:325–26). Like a breeze or a river, the poet does not literally "go back" but returns to his original course or directionality, one not deliberately chosen ("I made no vows, but vows / Were then made for me: bond unknown to me / Was given," 4:341–43) and therefore

natural. This inclination to welcome "what was given" (11:206) re-vives in the poet "those mysterious passions" (11:84) that have made "one brotherhood of all the human race" (11:88), and permit him to re-enjoy the "renovating virtue" (11:259) by which "our minds / Are nourished and invisibly repaired" (11:263–64). Such restoration derives from a moving continuity comparable to a flow-ing river or blowing wind, a continuity wherein the "workings" of the poet's "spirit" are "brought" (11:388) without his knowing it—"unknown to me" (11:387)—to changed circumstances and later times from his antecedent reflections on the "spectacles and sounds" (11:382) of still earlier experiences. This continuity of being allows the poet's receptive and creative participation in all modalities of natural life, "enduring" and "transient" (13:97). He thereby realizes the mysterious "instinct" (13:96) through which to "build up greatest things / From least suggestions" (13:98–99), as in fact he does, not merely in the "spots of time" passages, but, more significantly, in *The Prelude* as a whole. The poem's poly-morphic, overlapping structures display the imaginative freedom that "alone is genuine liberty" (13:122), that is, ecological interac-tions that render one strong both in the pleasures of individual being "and in the access of joy / Which hides it like the overflowing Nile" (6:547–48).

Wordsworth, moreover, plays down the particularities that for most authors constitute the essence of autobiography. Because imagination grows only in individuals, he must speak of himself, yet his autobiographical poem endeavors to make accessible to others possibilities for joy that are the natural condition of being. The key to this accessibility, of course, is imagination, so the poem literally manifests its subject, striving to demonstrate the plastic, shaping, creative power that is natural to mankind. As a result, for the reader the poem is not so much a report of facts as the process of the poet restructuring and composing his life in his poem, most obviously through the reordering of events, more subtly through the rearranging or rethinking of the relations between events, and most frequently through the display of how imaginatively orga-nized language can modify and remodify sensations, ideas, and feelings. The poem simply refuses to grant fixity either to memo-ries of the past or to events remembered. Each act of remembering is a reliving of acts that even originally were not susceptible to de-finitive structuration. The act of remembering these nebulous acts

is restorative, revivifying in the present the mind that is reaching back toward them.

The Prelude, like *The Heart of Midlothian*, offers no single fixed time or place of absolute truth. The plenitude of existence, temporal and spatial, assures that any event, both in itself and as part of a vital continuity, is always undergoing change from within and from without. The spots of time are fountains to which the poet can repair, drink, and be refreshed; they are sources of life-giving strength, perpetually self-renewing. Of course, the poet is aware that his memories are invariably insufficient, even to a degree false, for exact reproduction of previous experience is impossible. A memory is one life moment curving back toward another, the nature of the action represented by the interplay of "true" and "false" in the lake-gazing passage, which validates the useful pleasure of the whole ever-changing vision, a vision "whole" because ever-changing.

The poet's mind, then, is not confined within already established limits of previous experience; his mind is alive, active, exerting pressure upon—so possibly distorting—past effects and events as well as present swarming impressions. The imaginative mind, of which the poet's is exemplary, is both acted upon and acts, is influenced and influences; this doubleness characterizes even such self-reflective events as remembering. Imagination is the power of the psyche that best displays mankind's fittedness to the great world of nature, this "universal earth." Imagination liberates the mind both from the restrictions of a particular environment and from a false conception of the past as fixed, as unchangeable because past. Imagination also frees us from the tyranny of utopianism, represented in *The Prelude* principally by Robespierre and his compatriots, whose schemes constrict the future by reducing its relation to the present to one of mechanistic predictability. Imagination enables us, to the contrary, to live in hope of what is "evermore about to be" (6:542), in cheerful expectation of a future unknown and uncertain, and therefore a vital source of wonder.

Thus Wordsworth's descriptions of his experiences in the natural world are less directed toward biographical peculiarities than to the exhibition of powers that, while they may make him the poet he hopes to be, are possessed by or possess others. Imagination distinguishes the poet from others by degree, not kind. What makes for a healthy and effective imagination are natural conditions of

being human, and the presences of nature are available to all. Just as none of Wordsworth's experiences is presented as intrinsically beyond the capacity of others, so he regularly emphasizes that the specially wonderful events he recollects with gratitude are his peculiar adventures among vast, widespread, ever-operative powers.

INTERFACES OF REFLECTIVITY

Analogous powers predominate in Turner's paintings, though parallelisms between Romantic poets and Romantic painters, however informative, must be somewhat qualified, if only because the social circumstances of writers and painters in Britain in the early nineteenth century were quite different.[17] And Wordsworth and Turner were in many respects as different as Grasmere and London. I believe, however, that although Wordsworthian "optimism" and Turnerian "pessimism" are impressively antithetical, these attitudes derive from similar perceptions of the newly equivocal and uncertain nature of modern life. The potency of Turner's dark view of human destinies reflects his equally powerful responsiveness to natural loveliness and cultural creations, as we see in the late *Sunrise: Norham Castle* and the Petworth pictures, for example. The balancing of dark and bright visions is as fundamental to *Ulysses Deriding Polyphemus* as is the balancing of idealism and skepticism in the narratives of Byron and Keats. As for Wordsworth, that we "belong" in the natural world never mitigates the facts of individual loss. "We die," he has the Wanderer say in *The Excursion* (Book One, lines 471–74):

> Nor we alone, but that which each man loved
> And prized in his peculiar nook of earth
> Dies with him, or is changed; and very soon
> Even of the good is no memorial left.

The "useless fragment of a wooden bowl" and the "ruined walls" of Margaret's cottage are, in fact, Turnerian details. Just as the fallacy-of-hope stories of Margaret and Michael testify to Wordsworth's acceptance of unrelieved suffering as a possibility of our lot, so his affirmations of the pleasure "which there is in life itself" is impressive because of the depth of his sympathetic insight into the commonness of human anguish.

Like Wordsworth, Turner sought contexts of fluid formlessness, and the dangerousness of the sea attracted him as insurrectionary turmoil attracted Scott, for energy is Turner's chief subject. Turner's early reputation as a superb draftsman was fully deserved, but that

11. J. M. W. Turner. *Tintern Abbey*. The Victoria and Albert Museum, London. Probably the finest of Turner's several depictions of the famous ruin, illustrative of his skill in a linear style that he abandoned for coloristic effects. Turner's stylistic versatility enabled him to imitate, and sometimes parody, innovations by contemporaries such as Girtin and Wilkie.

makes his later blurred, coloristic, delinearized style startling. His development owes something to the emergence of watercolor painting in England just as his career was beginning. As many critics have observed, his work moved oil painting in the direction of watercolor effects.

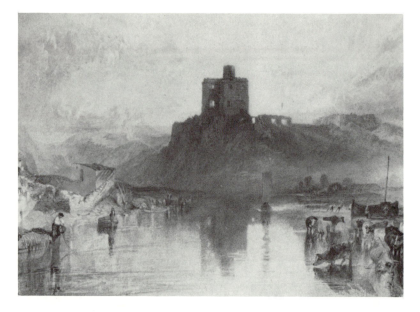

12. J. M. W. Turner. *Norham Castle*. The British Museum, London. To many this watercolor seems less "fluid" than *Sunrise: Norham Castle* (Figure 13), an oil painting of two decades later of the "same subject"—though the latter represents sunrise: the last version is a "first" vision.

The concurrence in Britain of master landscape artists and the development of watercolor painting is surely no coincidence. Watercolor encouraged the fluidity of British Romantic landscapes, and, as Turner illustrates spectacularly, encouraged brilliant light effects, especially light off water.[18] Flat water can reflect dazzlingly, and river, lake, or saturated field usually reflects brokenly, the reflection refracting into a diversity of lights. The effect is to arouse the viewer's awareness of light energy in itself, the power of light glancing into one's eyes. The relative translucency of watercolor also drew painters toward novel effects, for the viewer can see "through" the colors, that is, become aware of color as light. To this quality many watercolors owe their popularity, and popular accessibility contributed to a shift in the audience for paintings, from aristocratic to bourgeois, which is the fundamental socioeconomic condition of Turner's successful career.

A comparison of Turner's *Tintern Abbey* (1798; Figure 11)—which, like Picasso's *Science and Charity*, demonstrates the mastery by an adolescent genius of a tradition he will transform—and *Norham*

13. J. M. W. Turner. *Sunrise: Norham Castle*. The Tate Gallery, London. Here, as in *Snowstorm: Hannibal and His Army Crossing the Alps* (Figure 7) and *Snowstorm: Steam-boat off a Harbour's Mouth* (Figure 15), natural phenomena and historical place or event are conjoined. The "total reflectiveness" of this canvas seems to anticipate later nineteenth-century nocturnes.

Castle (1823; Figure 12) displays Turner's liquefaction of line and structuring by color rather than form.[19] The effect of these tendencies is fully developed in the later *Sunrise: Norham Castle* (1845; Figure 13), in which even the titular subject has become difficult to discern, substantial geometric forms having dissolved into an interactive play of lights.[20] Because the viewer must strain to perceive the ostensible subject, he pays attention to the act of vision. As the linear detailing of substantive objects disappears into complex nuances of perception, the viewer must continually make visual adjustments and reassessments. The viewer's positional security is destabilized, since one's vantage point in confronting *Sunrise: Norham Castle* (as in many of Turner's later canvases) cannot be precisely located. Unlike the exact lineations of *Tintern Abbey*, the fluid mode of perception evoked by *Sunrise: Norham Castle* is not dependent on focus from a defined vantage point. As the subject becomes more indeterminate, so vantage point becomes less definite,

and one is caught up in the subtle dynamics of perceptions of relativity.

Sunrise: Norham Castle represents "betweenness." It links the transient and immediate foreground to the eternal background of mountain and cloud. But even this specification misleads, because the relativities in the picture depend less on objects such as cow, castle, cloud as objects than as foci of light energy. Cow, castle, and cloud are not so much light-absorptive forms self-defined by their darkness as modalities of the total interplay of lights constituting the visual field that is the picture.[21] In looking at *Sunrise: Norham Castle*, we *experience seeing* as we do not in looking at the earlier version or *Tintern Abbey*. Mere perception of something is of minor importance in the later canvas: the precision of perceptible detail so impressive in *Tintern Abbey* has been replaced by a fluidity of interacting color energies. The viewer is confronted not with a static scene whose temporal meaning has to be extrapolated from the subject (the abbey is a ruin) but with an experience of vision to be participated in, and whose wholeness or unity *includes* time, for the vision we experience is the ensemble of evanescences of dawning light.

Much of the difficulty in "seeing" Turner's pictures arises from their presentation of multiform events of light action; the picture is a field for vision rather than a view of objects. As Ronald Paulson observes, Turner favors a centered sun—the essence of the blinding effect of looking into light.[22] But more often Turner paints pictures in which most of the light that glances into our eyes, "blinding" us, emanates not from the sun but from reflections, diffusions, and refractions—from a world seeming to emit light because conceived as a texture of energies, not a collection of things.[23]

It is not surprising, then, that Turner should so often have been drawn to painting the ever-moving and light-fragmenting sea. But he was also attracted by the cultural significance of the sea, for both formal and narrative or referential factors determine his art.[24] Subjectless, purely formalistic tendencies combine with efforts to transform radically the representational tradition to which he claimed to give allegiance.

The sea was island England's glorious means to mercantile wealth, as well as its best defense against continental tyrants. In the war with the French, for many years Britain's only victories were naval ones, and from the time of Cook's South Sea expedition Britons had gloried in their countrymen's explorations by sea. Dur-

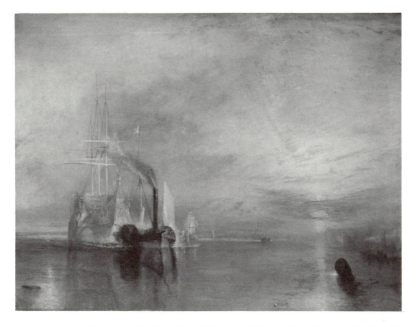

14. J. M. W. Turner. *The Fighting "Téméraire" Tugged to Her Last Berth to Be Broken Up*. Reproduced by courtesy of the Trustees of The National Gallery, London. Turner had previously painted the *Téméraire* in his *Battle of Trafalgar* (1808). A dynamic balancing of diverse oppositions, both formal and thematic, characterizes Turner's late work, both "violent" and "calm."

ing Turner's life the great transformation was from sail to steamship. If Turner preferred one to the other, his preference is not discernible in his work, where he not infrequently displays an "impure" mixing of the two types, perhaps most famously in *The Fighting "Téméraire"* (Figure 14). Perhaps this painting is a sentimental valedictory for the graceful sailing ship, but one can also argue for Turner's fascination with the smoke-belching, powerful little tug. Whether or not Turner disliked sailing ships because of the difficulty of drawing their rigging correctly, he certainly painted so much refracting smoke, smog, and sooty mist that one feels, as a painter anyway, he loved pollution. Turner was not hostile to technology and machinery, facilitators of energy. In *The Fighting "Téméraire,"* as in all of Turner's best canvases, the sociocultural reference and formalistic motives are equally forceful. As consistently as Scott in politics and Wordsworth in natural scenery, Turner fo-

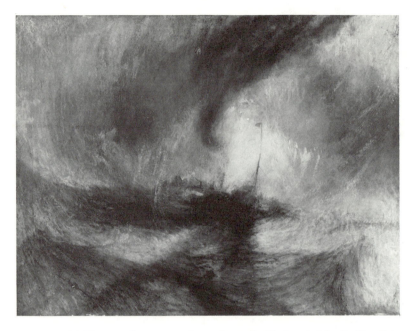

15. J. M. W. Turner. *Snowstorm: Steam-boat off a Harbour's Mouth*. The Tate Gallery, London. Here, in contrast to the storm in *Snowstorm: Hannibal and His Army Crossing the Alps* (Figure 7), the viewer is caught up *in* the tempest. The multiplicity of destabilized curvilinear forces creates a kinesthetic effect that challenges our conventional sense of what is imaginable.

cuses on borderings, the interfaces between different modes of activity. *The Fighting "Téméraire"* provides an interplay of direct and reflected lights, the obscuring smudge of the tug's smoke inverted by sharp shadows in water thick in contrast to the diffused aerial light. The "ugly" new commercial machine and "lovely" old sailing warship appear together to confront the viewer with the irreducible vitality of history in process that demands a complexity of emotional response beyond mere nostalgia or mere pleasure in progress.[25]

In *Snowstorm: Steam-boat off a Harbour's Mouth* (1840; Figure 15) Turner no longer uses oil in a fashion reminiscent of watercolor but with a substantive fluency impossible in the lighter medium. *Snowstorm* intensifies the destabilizing violence that characterizes Turner's seascenes as early as *Shipwreck* (1805): in the later work the viewer's position is undefined except as a place of dangerous uncer-

tainty.[26] Caught up within a mobility of dynamic relations, most viewers do not consider whether they approach the scene frontally or obliquely. One observes different effects from different viewing distances, as is true of Constable's *Salisbury Cathedral*,[27] but perspectival differences are also embodied within the picture. Even standing still in front of this canvas for a few minutes, one begins to perceive more and more possibilities of shifting relations between diverse elements—as one does not before the early *Shipwreck*. As Lawrence Gowing suggests, Turner's later art increasingly dramatizes connections, not what they connect.[28]

This "internalized mobility" is an extreme fulfillment of Turner's "redundancy," as Ruskin called it, referring to the painter's tendency to put twenty trees in a painting where others would feel natural plenitude was adequately represented by two.[29] Turner's genius, Ruskin recognized, lay in realizing a uniqueness in each repeated element. The redundant individuality of waves and spray and blowing snow breaking across each other in a superabundance of refracted and reflecting lights and shadows constitutes *Snowstorm* as a totality of perceptual nuances. Nowhere is the eye allowed to rest: the swirling paint, like evanescent spray and snow, ceaselessly confuses one's sight. The picture presents, to return to my earlier distinction, not so much an image as a vision, involving the viewer as eyewitness to violence, even of the medium through which he witnesses.

Snowstorm realizes the meaning of Coleridge's assertion that artistic imagination strives to "dissolve, diffuse, dissipate in order to recreate." *Snowstorm* is not a picture of chaos or entropic movement; it depicts, rather, radical flux, violent conflict, the uncertainties of crisis, both of an event and of the act by which the event is perceived. In a visual equivalent of Wordsworth's superimpositions, snowstorm, sea, and the distressed steamer appear only through veils of forces, overlapping, criss-crossing, intra-interfering; the bewildering event depicted is constituted by an interfusing of diversely systematic energies. Definite and definable principles of movement determine the action of waves, of snow, of laboring engine, of flaring rocket; the painting compels us to imagine their reason-dazzling interactions.

DISSIPATIVE STRUCTURING

Although Turner confines himself within what Blake condemns as experience of the fallen world, Turner's effects are analogous to

some of Blake's so far as they violently provoke the viewer into an imaginatively recreative response. Paintings such as *Snowstorm* may be likened to what scientists call *dissipative structures*, subsystems that dissipate entropy by using the decay of a larger system to organize more complex structures. The emergence of life out of the physical mechanism of the cosmos exemplifies the process, with culture, perhaps, a dissipative structure within life. The vortical movement of *Snowstorm* swings the viewer inward from its mouth, rather like a violent Wordsworthian involute, creating new self-relationships out of conflicting processes of transformation. At the heart of swirling natural systems of wind, snow, wave, and spray is a struggling steamer, a human artifact, sending up rockets to signal its distress. The outcome of the event is unsure, but however incoherent at first glance may appear its representation, however accidental may seem any specific portion of turbulent collisions of air, water, fire, and metal, everything in the scene, from tiny ice crystal to the steamer itself, participates in intersectings of systematic forces. Such clashings are irreducible to any simple mechanical regularity or explanation: their meaningfulness is only representable through imagination-evoking art. The picture makes use of seeming confusion to create the order of a painted vision of evanescent collisions of diversely organized energies.

Turner's acute appreciation of potent if unrationalizable systems born out of violence, of which the vortical form is an obvious manifestation, enables him effectively to render turbulence and disruption as meaningful.[30] Turner claimed that he had himself tied to the mast of a ship in a storm to observe what is depicted in *Snowstorm*, and one is tempted to believe him.[31] Though painting can represent but a single instant, the effect of this picture is not that of instantaneousness, not the moment Lessing thought painting's limit. Plunge of ship and sweep of waves Turner renders as erratically related rhythms kinesthetically intersecting the leap and fall of the observer's ship. The irregularity of such motions in conflict is represented not as random fragments of what is chaotic but as coherencies only imaginable, not perceptible, through the painter's literal and the viewers' vicarious involvement in their vehemently interfering encounter. Turner's visual paradox—that engagement in violent experience frees us from the constrictions of conventionalized perceptual habits and enables us to perceive imaginatively—parallels, say, Scott's use of social and political crises, preeminently war, to open up for the reader a diversity of interfering perspec-

tives. More generally, we see in *Snowstorm* the characteristic Romantic presentation of a view representing its own inadequacy, so that we must see through it, conceive the possibility of viewing otherwise.

Turner represents recreative powers: he intuitively resists accepting entropy as the ultimate condition, as it is more or less unthinkingly assumed to be in Modernist aesthetics. As Rudolph Arnheim points out, the homogeneous random distribution ultimately produced by entropy, the ultimate reduction of tension, is in fact a state of order, though, as he says, "nothing to brag about."[32] "Orderliness is only one aspect of order," requiring "something to work on," what in thermodynamics is called *negative entropy*, a term Arnheim justifiably rejects as "describing structure as the absence of shapelessness" (p. 31). He prefers to discuss the "anabolic tendency" toward "shape building" that accounts, for example, "for the structure of atoms and molecules" and contributes to the "structural theme" creating "orderly form through interaction" with the entropic "tendency to tension reduction" (p. 31). The order produced by this *interaction* is far more complex than that of mere orderliness, which

> leads to increasing impoverishment and finally to the lowest possible level of structure, no longer clearly distinguishable from chaos, which is the absence of order. A counterprinciple is needed, to which orderliness is secondary. It must supply what is to be ordered. I described this counterprinciple as the anabolic creation of a structural theme, which establishes "what the thing is about," be it a crystal or a solar system, a society or a machine, a statement of thoughts or a work of art. . . . When it comes to . . . human existence, whose only goal is its own fullness, the structural theme must not only be present but also as rich as possible.
>
> (*Entropy and Art*, p. 49)

As an example of a structural theme overly determined by orderliness, Arnheim wryly comments on minimalist tendencies in Modern art: "Some of the same people who profess to be repelled by the monotonous rows of identical human dwellings in so-called subdivisions, seem to admire rows of identical boxes in art galleries" (p. 52).

This minimalist functionalism of much modern aesthetics misleads some into identifying Turner as a sort of precursor of abstractionism. But on the contrary, his work vividly embodies the fundamental Romantic drive, in Arnheim's terms, toward a rich

structural theme. The Romantic quest is for plenitude, not essence, an affirmation of the multiplicity of competing vital principles and the self-transformative, self-destructive, and self-reconstituting character of fundamental energies of being. The anarchic or lawless had as little appeal for the Romantics as the mechanical regularity or perfected orderliness of geometric forms of the Enlightenment. They sought to present through their art the possibilities of recreative dynamism offered by imaginative engagement in the encounter of heterogeneous potencies.

From such engagement emerges the unusual humanistic bias of Romanticism. The experience of viewing *Snowstorm: Steam-boat off a Harbour's Mouth* is of confronting the ahuman. The snowstorm at sea is primary in the picture, but at the heart of its vortical violence is the distressed ship, man's technological expertise threatened by forces utterly indifferent to human aspirations and feelings. A good many of Turner's pictures display wreckage, the detritus of human accomplishment, flotsam and litter embodying the fallacies of hope, from which Turner never wandered very far. But, however dark his view, Turner's art is focused by the human. Litter and wreckage testify to human effort, the central theme of *Snowstorm*, though no people are distinguishable in it. The painting is a human vision of ahuman forces amid which we struggle, and thus evidence of possibilities for re-creating out of natural dissolution processes significant in the purely human realm of art and history.

PAINTING MYTHOLOGICAL NARRATIVES

For more than a century the chief stumbling blocks for critics of Turner have been his literary canvases, narrative pictures of scenes from ancient history, literature, and mythology. Even those pleased by his representations of nature have often been puzzled as to why he devoted so much effort to a genre already on its way to becoming old-fashioned and to a style contrary to the ever-more exclusive attention to painterly surface in European painting. Turner's classicizing might be easier to understand had he not concurrently created so many brilliant "color-beginnings," or "color structures," that seem to demonstrate an affinity with the direction of painterly "progress" beyond the representational.[33]

But Turner did practice extensively and felicitously in both color happenings and history paintings. One motive may have been economic. Turner's father was a London barber, his mother not right in

the head, and Turner made his precocious way by sheer facility of his pencil. His lifelong commitment to the Royal Academy is not surprising; had it not supported him when he was young, his career would not have been so successful. Only during Turner's lifetime did the support of art by wealthy and aristocratic patrons begin slowly to give way to support of artists through direct purchases by the middle-class public and through the extensive sale of reproductions to the less affluent; the first public exhibition of paintings in England was held just fifteen years before Turner's birth. As Scott was the first literary artist to become wealthy through sale of his original writing, so Turner was the first painter to achieve impressive financial success not solely through private or state patronage but also through the sale of his works, or reproductions of them, and the illustration of literary works. Like many boys from urban streets who succeed by sheer native genius, Turner remained attentive to the side of his bread on which the butter spread fastest.

Turner had limited verbal gifts, yet he was fascinated by words. He wrote a considerable amount of poetry, poor as most of it is, and he read more than one might imagine, often giving proof of having read with care and precision.[34] For a patriot like Turner, highly conscious of continental preeminence in the graphic arts, it was appropriate to attach his endeavors to literature, long the crown of England's artistic glory. After all, James Thomson had created verbal landscapes of international popularity long before any British painters had achieved even modest repute. We ought not, furthermore, to forget *our* circumstances in judging his preferences. Modern critics without exception regard the development of painting away from concern with subject and toward increasing emphasis on the medium itself as pure progress, realization at last of the "true" nature of painting. Fifty or a hundred years from now Turner's interest in narrative aspects of painting may appear less "backward" than modern critics have often assumed.

Consider Turner's greatest classical narrative, *Ulysses Deriding Polyphemus* (1829; Figure 16), an extraordinarily brilliant and complicated painting that should be contrasted with Jacques Louis David's *The Oath of the Horatiae*.[35] Few pairings so vividly illustrate the difference between late–eighteenth-century Romanized classicism, with its reductive structuralism of simplified form expressive of an intensely masculine ethos of political *virtu*, and Romanticism's involuted Hellenic classicism, with its almost androgynous

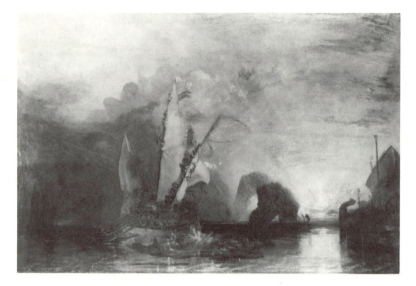

16. J. M. W. Turner. *Ulysses Deriding Polyphemus*. Reproduced by courtesy of the Trustees of The National Gallery, London. The ambiguous reflexive complexity of Romantic Hellenism is illustrated by Turner's choice of this incident and by his brilliant interplaying of "sublime" and serenely lovely aspects of nature.

blurrings of the historical, the natural and the magical. David's scene segregates the heroic, phallic, exhibitionist males from drooping females, yet the two groups, as emphasized by the setting within walls, constitute a powerful unity, a clear hierarchy of order, reflecting the picture's narrative assertion of the supremacy of sociopolitical considerations over personal or familial sentiment, an emotional clarity brilliantly confused by Turner's painting. Against David's structural distinctness and orderly moralistic fabling Turner offers a polychromatic interplay of diversely evocative elements filled with ambivalences and indeterminable relationships.

Turner's title refers us to an episode in a literary work of long ago, but the painting is a dazzling immediate experience. Much in it is obscure, not merely the shapeless agony of the giant, but all the landscape to the left, from the caves with the strange fire burning at water level to the snowy peaks vanishing among glowing Alpine-like clouds. On the ships the confusion of sailors and ornate carvings as well as the multiple sails and banners interfere with our sight, so perhaps we do not at once see Ulysses, raising

what I take to be a torch, perhaps a reminder of the fire-hardened stake that blinded the giant, visually resembling a "no man," his back toward us, just as his banner, denominating him by his true name, Odysseus, is torn, while another banner depicting the Trojan Horse overlaps a flag of blue and white that might foretell modern Greece. Sailors swarm in disturbing antlike contrast to the lone giant, suggesting perhaps the fragility of men and their artifices, even of this canvas itself, which seems to become more doubtful in its meaning as one reflects on the brilliance of its representation of blindness.

Another kind of obscurity and another mode of being appear with the water nymphs, probably derived from Pope's English translation of *The Odyssey*,[36] thereby adding an overlay of linguistic culture to the canvas's mixing of the protagonist's Greek and Latin names, heroic symbol in the former, arch-villain in the latter. The nymphs are painted so that we see them as half-formless, not just concealed by the water. They realize the watery element, as the sun god's horses of light realize the blaze in which they vanish. That over time the horses have faded as their pigments have deteriorated is wonderfully just, for they manifest the swiftly changing light and color of every beginning day, when colors are most transient. Their fate recalls the Romantic insistence on the provisionality characterizing the inexhaustible phenomena of the natural world to which humankind must accommodate itself.

Powerfully represented in several dimensions are continuities of change. The Homeric episode depicted is one of involuting reversals. Ulysses mocks in his pride as he escapes by sea, which will be his enemy as Polyphemus retorts to the derision of the "no man" boast with a successful prayer to Poseidon for a vengeance in which Helios is crucial. Ulysses, helped by a sea nymph, will finally be washed ashore companionless, without even a plank from these intricately ornate ships (so darkly contrasted to the vibrant delicacy of sunrise colors), and will then slowly move onward to the final triumph of bloody slaughter. We see, then, the beginning of doubtful victories in the hero's reasserting his identity as he exults escaping from recklessly unnecessary daring. Like Dante, Turner seems drawn to Ulysses by the ambiguity both of his motives and of his accomplishments, ambiguities that lead us to reimagine conventions of heroism. Dante brings Ulysses to Purgatory by the wrong route, provoking an admiration to be condemned. Turner forces us to perceive Ulysses's littleness in a blaze of glorious light and color

celebrative of man outfacing and deriding the superhuman—*or* of the terrible beauty of nature indifferent to all that man cherishes. The Polyphemus figure, which Turner's contemporaries judged rightly to derive from Poussin's representation of the giant in pastoral aspect, is naturalized into something virtually indistinguishable from volcanic vapor, though his indistinctness seems to emphasize how he images man distorting his finest capabilities. The principal effect of these various kinds of superimposition is to compel the viewer to move continuously from one kind of emotional response to another.[37]

To achieve this effect, Turner's formal aspirations not only accommodate but require narrative subject matter. In Paulson's simplified terminology, the "visual" (equivalent to formal elements) can only be explored fully through the "verbal" (equivalent to narrative elements), and the verbal only through the visual.[38] In this view, a painting based on narrative can become—even as a color happening—a vehicle for evoking a viewer's doubt about what he is seeing. For, as the episode of Polyphemus and Odysseus almost paradigmatically illustrates, narrative makes doubtful even what it clarifies. A story inevitably raises new questions about the answers it supplies.[39] This duplicity of narrative, which distinguishes it from rational exposition or scientific explanation, is perhaps its most attractive feature to all Romantic artists.

In *Ulysses Deriding Polyphemus*, as in *The Prelude*, diversified plenitude rules; relations between competing syntaxes are too densely complicated for easy interpretation. The painting's visual structure is established by its colors, but such unity, unlike that established by shapes, is inherently equivocal. We can never be certain of the significance of the similarity or complementarity of colors, which in their "superficiality," moreover, are always changing. Colors are unstable; they are transformed by time and light and even shifts in surrounding colors, as shapes are not.[40] So with *Ulysses Deriding Polyphemus*, as with *The Prelude*, the audience finds itself participating in an event of multiform possibilities, not one in which "depths" determine the meaning of "surfaces," but one in which satisfaction arises from exploring multiplying ranges of contrast, parallelism, and devious affiliation that recreatively transgress any definitive structure or final security. The Romantic work of art denies us the opportunity to stop imagining.

9

Narrative Infolding, Unfolding

The steady advance toward industrialization in Britain during the Napoleonic era created social, economic, and political dislocations that are well recognized. Such forces impelled the second generation of Romantics to reassess (partly consciously and partly intuitively) the first generation's assumptions about how art and its audience might interact. The result was poetry simultaneously more passionate and more skeptical. Byron, Shelley, and Keats carried forward the idealistic aspirations introduced by Blake, Wordsworth, and Coleridge while intensifying the contradictory, even potentially self-destructive, implications of their idealism.[1] The upshot was half a decade, 1818 to 1823, of extraordinary literary affluence in what may fairly be called high-risk poetry, much of it narrative.

The Romantic emphasis on continuity, evident in "Michael" and essential even to the "moment" of lyrical intensity in "Lines Written Among the Euganean Hills," assured that narrative modes would penetrate every variety of Romantic art. But these narrative modes had also to accommodate Romantic transformationalism, and, therefore, could never be simple, even when, as in *Lyrical Ballads*, they pretended to simplicity. There is not a single "story" in *The Prelude*, including the overarching autobiographical one, that is not made complicatedly uncertain by the mode of its telling. The disturbing power of *Ulysses Deriding Polyphemus* owes much to the picture's multiform confrontations between narrative subject matter and its representation.

The principle of multidimensional structuring undergoes two important evolutions in the poetry of the second generation. Keats folds multidimensional structuring back onto itself by intensifying its reflexivity; beginning by writing poetry about the possibility of writing poetry, he advances to composing poetic narratives about narrativity. Byron, moving in the opposite direction, unfolds multidimensionality and explores form-dissolving forms similar to those in works of Turner and Wordsworth.[2]

Infolded or unfolded, the later Romantic narratives do not aim to articulate "truth" in any abstract or essentialized sense. These narratives explore appropriateness of behavior; they are testings of diverse fashions by which individuals may act responsibly or irresponsibly in a world of friction, one constituted of unpredictable contingencies.[3] Keats's epiclike *Hyperion*, for instance, manifestly is not concerned with timeless truth. Its subject, the war of Titans and Olympians, is a piece of antiquated mythology, forgotten acts of neglected gods without significance for Keats's readers. As one kindly contemporary reviewer remarked, "We could scarcely have thought it possible, out of such materials, to have produced a poem of such interest."[4] The lineage of *Hyperion*, like that of *Don Juan*, leads back to *Don Quixote*, a major progenitor of "the inward turn of narrative," in which a story's symbolic import is created by the unique individuality of characters invented by the author and not derived from accepted systems outside the literary work.[5]

The supernaturals in *Hyperion* are stringently limited in their powers, Hyperion being circumscribed by natural law, natural supernaturalism with a vengeance:

Fain would he have commanded, fain took throne
And bid the day begin; if but for change.
He might not: —No, though a primeval God:
The sacred seasons might not be disturbed.
 (1:290–93)[6]

Supernatural potency is further weakened by Keats's Romantic conception of natural law as facilitating change, as not transcendent but evolutionary. As ruling divinities of the cosmos change, cosmic rules are transformed. Keats's view of the cosmos is analogous to Coleridge's judgment of Shakespeare's genius, that it could not be lawless because adhering to laws of its own origination—the core concept of Romantic historicism upon which its nationalistic fervors were founded.

In *Hyperion* Apollo emerges from the downfall of his predecessor, a process characterized by Oceanus as part of an inevitable evolution: "Thou art not the beginning nor the end" (2:190). Oceanus draws the obvious conclusion: as the Titans are surpassed by the Olympians, so the Olympians must expect in their turn to be surpassed: "'Yea, by that law, another race may drive / Our conquerors to mourn as we do now'" (2:230–31). In England by 1818 that prophecy had been realized, which may help to explain the incompleteness of each of Keats's versions of the Hyperion story.

Even more significantly, Stuart Sperry observes "how radically each version changed during the time Keats worked on them."[7] That Apollo's beauty can become as obsolete as the Titans' in his own world is a fundamental premise of *Hyperion*, as is suggested by Keats's manipulations of one of his major sources, Lemprière's *Classical Dictionary* (1788), which portrays most of the Titans as monstrous. Keats describes not evolutionary progress from the crude to the more refined but the superseding of one "perfection" by another: "on our heels a fresh perfection treads" (2:212). There is no absolute beauty or definitive truth. To know what truth and beauty are one must learn how these terms are manifested by Titans, Olympians, or, in "The Fall of Hyperion," by an early nineteenth-century English poet. Just as that poetic fragment is a turning back of the earlier poem into itself, a self-reformulation, so all of Keats's narrative art is self-exploratory, seeking to realize potencies concealed or obliterated by his own creative revelations.

Keats concentrates to its utmost intensity the fundamental Romantic commitment to the idea that truth and beauty exist only through specific articulations. For the Romantics, beauty comes into being through an individual *making* something beautiful, thereby defining something as beautiful. Thus the creation of poetry possessed of any truth or beauty involves the creation of a specific kind of awareness. Keats feels strongly, and makes us feel strongly in his best work, the profound truth in Wordsworth's remark that every original artist creates the taste by which he is enjoyed. The original artist concerns himself with more than self-expression or an audience's pleasure; his art seeks to enhance the capability of others. In Wordsworth's terms, the poet devotes himself to

> breaking the bonds of custom . . . overcoming the prejudices of false refinement . . . displacing the aversions of inexperience . . . divesting the reader of . . . pride . . . establishing that dominion over the spirits of readers by which they are to be humbled and humanised, in order that they may be purified and exalted.[8]

Thus no narrative can succeed merely by accurate expression of feelings, ideas, or events. The language of art must make accessible to others what is all too likely to be defaced, hidden, or dissipated in the telling, though only telling makes possible the calling forth of the reader's re-creative power to preserve ineluctably evanescent human experiences.

Keats's narratives extend and rearticulate complexities implicit in

Wordsworth's narrative "recovery" of past experience. He persistently returns to the difficulty dramatized as the pivotal event of "Lamia": Lycius precipitates the destructive conclusion by insisting on a public display of his infatuation with Lamia. This plot device exemplifies a spurring contradiction that troubled Keats from early in his career. To make public the pleasure of sensory experience is to violate the privacy that is a condition of the pleasure. Does the artist necessarily enact the destructive role of Lycius? Or, to turn the problem as Keats himself tended to do, is sensual enjoyment inherently morbid, physical desire secretly a desire for the silence that is death? *Hyperion* breaks off as Apollo ominously if ecstatically "dies into life" under the aegis of the forgotten Titaness Mnemosyne, ambiguities which reflect Keats's imagining death as "life's high meed" in "Why Did I Laugh Tonight" and his representation of art as potentially pathological in his sonnet "On Fame."

> "You cannot eat your cake and have it too."
> Proverb

> How fever'd is the man who cannot look
> Upon his mortal days with temperate blood,
> Who vexes all the leaves of his life's book,
> And robs his fair name of its maidenhood;
> It is as if the rose should pluck herself,
> Or the ripe plum finger its misty bloom,
> As if a Naiad, like a meddling elf,
> Should darken her pure grot with muddy gloom;
> But the rose leaves herself upon the briar,
> For winds to kiss and grateful bees to feed,
> And the ripe plum still wears its dim attire,
> The undisturbed lake has crystal space;
> Why then should man, teasing the world for grace,
> Spoil his salvation for a fierce miscreed?
>
> (p. 367)

The possibility that desire, even the desire to make poetry, may be a kind of deathward-progressing perversity was a major impetus for Keats's progressive explorations of poetic consciousness, as suggested by the sequence of his principal completed narrative poems, all love stories ending in multiple deaths.

"TASTE THE MUSIC OF THAT VISION PALE"

George Bernard Shaw's remark that Isabella's brothers are prototypical capitalists reminds us of how vividly physical are the sufferings of those in "Isabella, or the Pot of Basil" far distant from the

"easy wheel" of the entrepreneurs.[9] Of the swelting hand, melting loins, and ears gushing blood the brothers remain "half-ignorant," because "self-retired," close-fisted, secretively treacherous, their "jealous conference" of business "paled in . . . from beggar spies." These anxiously self-enclosed and hidden feelings darkly parallel the concealed passion of Lorenzo and Isabella. Their love begins in half-ignorance of one another's feelings, a frustration that is "sick longing" and feverous "malady." Healed by secret mutual confession, their malady turns to joy, a secret sharing of "the inward fragrance of each other's heart" through meeting "all close" and "unknown of any, free from whispering tale." Awareness gives power to articulate; knowing a secret enables one to whisper it; yet to disclose may be to destroy. Keats focuses the broad issue of revelation of private secrets on a narrow questioning of art's effects in its translating of private physical sensation into the imagined sensation of public art. Is the truly appalling parallel of "Isabella" the brothers at their "easy wheel" and the reader at his easy poem?

The "whispered tale," significantly, initiates the first of several interruptions of "Isabella" by the translating poet, "Ah, better had it been for ever so, / Than idle ears should pleasure in their woe" (stanza 11). The poem implies that its own performance may be not only unfortunate but also misleading. The lovers were happy in their love despite the sadness with which they have been portrayed in stories (like this) of their love, for like bees they find "richest juice in poison-flowers" (stanza 13). The dubiety of that piece of natural history may reflect the haunting equivocation in the simile: desire is deadly. That desire is self-destructive, its fulfillment being its self-extinction, the "Ode to Melancholy" displays with fine intensity, though Keats does not there address the desire to tell, to use language to arouse a listener's imagining of sensory experience.

In an amusing letter to Dilke, Keats treats lightheartedly the origin of the problem.

> Talking of pleasure, this moment I was writing, and with the other hand holding to my mouth a nectarine—good god how fine—It went down soft, pulpy, slushy, oozy, all its delicious embonpoint melted down my throat like a large beatified Strawberry.[10]

In the casual letter the simultaneity of ecstatically swallowing throat and joyously writing hand can be sustained. The trouble came when Keats composed "poesy," when he wrote with both hands, so to speak, and the precedence of public effect over private satisfaction precluded his enjoyment of the sensual luxury his art imagi-

natively evokes. The intensity of Keats's poetry owes much to his willingness to view skeptically his cherished belief in the beneficence of poetry, his readiness to question the moral efficacy of the writer's hand translating luxurious feelings into words. The morbidity of "Isabella" may arise not merely from the events narrated but also from the act of narrating.

The poem more than once presents itself as an unappealing act of exhumation, reflecting the basic pattern of events it recounts, the publicizing of hidden passions. In stanza 17, for instance, the "vision covetous" of Isabella's "ledger-men" brothers manages to "spy" Isabella's "downy nest" containing Lorenzo, whereupon the next two stanzas apologize to Boccaccio for reviving his forgotten story. In asking pardon "For venturing syllables that ill beseem / The quiet glooms" of Boccaccio's "piteous theme," and claiming "there is no other crime" than to make his "old prose in modern verse more sweet," the translator anticipates Isabella with her basil pot: he has dug up Boccaccio's tale to make a song lamenting his "gone spirit," as Isabella's grief inspires the song of which "still is the burthen sung—'O cruelty, / To steal my basil pot away from me!'"

When Isabella uncovers the decaying body, feeling "the kernel of the grave," the translator interrupts to ask for the reader, "wherefore all this wormy circumstance?" He then urges the reader to turn away from the present narrative to the "old tale" so as to "taste the music of that vision pale" (stanza 49). That synesthesia Keats never surpassed, for the phrase epitomizes his skill at translating into imagined sensations the qualities of intense sensory experience, including its privacy, which renders telling of it a violation—for which Isabella's loving violation of Lorenzo's grave and corpse is representative. Keats's attraction to the ludicrously morbid tale of Isabella recycling her lover's head does him credit so far as it shows his readiness to face all the hazards of reconstituting the sensory into the literary. The weakness in "Isabella" is not in its "wormy circumstance" but the poet's too direct appeals to an abstract music, as in stanza 55, appeals that are unsatisfactory substitutes for his making "poetic music" out of sensory circumstance, wormy or otherwise, which he does so well in "The Eve of St. Agnes."

MAGIC IN WORDS

Throughout "The Eve of St. Agnes" Keats appeals to his readers' power of imagining; the first stanza, for example, does not make us

feel cold but enables us to imagine the coldness of a winter night. Unlike "Isabella," which "literally" translates its source, this later poem recursively develops its source, the legend that Madeline believes in.[11] Her faith, which inspires Porphyro to invent his stratagem for enacting it, is justified: by adhering to the ritual she discovers her true love and husband, while Porphyro's device, which might have led only to satiation of lust, earns him a "peerless bride," perhaps because he accommodates his desire to Madeline's faith, no bad test of love. In short, in the poem we find no absolute right or wrong, ideal or real, actual or illusory beyond what is established by what is done. Madeline's naïveté exposes her to Porphyro's opportunistic stratagem, yet her superstitiousness is verified, its simplicity is made pure by the event, as Porphyro's "lust" loses itself within his love for her.

At the center of this process, Madeline's dream becomes real when Porphyro enacts the Agnes legend, reversing the desolating enchantment of "La Belle Dame Sans Merci" that he sings to her while she sleeps. That he enters through her dream is part of the narrative's consistent transgressing of conventional limits, for reality as defined in "The Eve of St. Agnes" includes dreams and "phantasies." One cannot interpret the poem as merely presenting an opposition between actuality and illusion, the real and the ideal, because the narrative explores what such terms may mean. The poem does not deploy already fixed and defined concepts but develops what such concepts might include within them, rather as *The Heart of Midlothian* explores justice, and "Michael" freedom. The guiding principle of such explorations is suggested by two lines from "Lamia": "It was no dream; or say a dream it was, / Real are the dreams of Gods." For the gods there is no antithesis, as there is for a modern positivist, between reality and dreaming. For Keats, Madeline's discovery of her fantasy's truth becomes the basis for the reader's analogous discovery of truth within a fantasy, which constitutes the genuine story of the poem.

What may jar many modern readers is that some truths are found to reside within the conventional: love possessing a component of lust remains love, while naïveté may lead to loss of virginity and a responsible husband. We have become much more suspicious of conventions and tend to scorn what is "romantic" in the most popular and vulgar sense. Keats is less fearful or fastidious; the plot of "The Eve of St. Agnes" works because at its core is an ordinary love story. The poem's elaborate setting, like the unpar-

ticularized legend of St. Agnes, surrounds with a "magical" aura a familiar event, the love of man and maid. The remarkable feat of the poem's verbal richness is to sustain a sense of the lovers' relations as normal, natural, and ordinary. The ostentatiously romanticized context reveals the enchanting power of the familiar emotions and sensations of sexual love.

Pre-Raphaelite paintings of Madeline in her bedchamber tend to vulgarize Keats's poem by emphasizing the exotic at the expense of the familiar. More revealing of the riskiness of Keats's exploration into the enchantments of ordinary eroticism, however, is the contrast with parallel scenes from popular eighteenth-century erotic fiction. Eliza Haywood's *Love in Excess* (1719) may be taken both as reasonably representative and peculiarly relevant. The attempted rape of Melliora by the Count D'Elmont, who truly loves and is truly loved by Melliora, begins with a description of the heroine asleep after her bath:

> her hair unbraided, hung down upon her shoulders . . . its Lovely Shadyness, being of a Delicate dark Brown, set off to vast advantage, the matchless whiteness of her skin: Her Gown and the rest of her Garments were white, and all ungirt, and loosely flowing, discover'd a Thousand Beauties, which modish formalities conceal.[12]

The direct conventionality of Haywood's concept and language enables us to appreciate Keats's complicated elaborations and stylizations of Madeline's circumstances, which pass beyond pornographic titillation even while intensifying our power to imagine the scene's sensual qualities. As D'Elmont bends toward Melliora, "Possibly Designing no more than to steal a Kiss from her," the heroine, dreaming of him, throws her arms about him and cries, "Embracing him yet closer,—'O too, too Lovely Count—Ekstatic Ruiner,'" which leads D'Elmont to "seize her with such a Rapidity of Transported hope Crown'd Passion, as immediately wak'd her from an imaginary Felicity, to the Approaches of a Solid one." Absurd as this is, it comes perilously close to Porphyro and Madeline's story. Keats's version, of course, has far superior imaginative energy. Through a complex interplaying of censorings, displacements, and reversings of expectations he succeeds in romanticizing a situation that in Haywood's novel is ludicrous, perhaps even objectionable in its sadistic implications.

Among Keats's devices probably the simplest and most fundamental is the exaggerated conventionalizing of the "medieval" set-

ting, its historical spuriousness accentuating its expressive and affective functions; as Stuart Sperry phrases it, "the framework of the entire poem, the conventions of romance themselves, are hardly above suspicion."[13] Analogously, the personalities of the characters could not be more stylized. So, too, the primal contrasts used to represent the lovers' actions, heat and cold, dark and light, noise and silence, freshness and exhaustion, strike our imagination with the unmitigated force of the simplest experience, familiar because primal.

This uncomplicated intensity is created by linguistic transformations, dissolvings, and threshold-crossings made palpable through the significatory and aural force of individual words. Whereas Wordsworth's poetry is distinctive for fluidity and multiplicity of grammatical orderings, Keats uses a far simpler syntax to exert severe pressure on single words, for example, in his compounds ("branch-charmed"), his transformations of parts of speech— nouns turning into verbs, adjectives into adverbs—and his stress on tactile sound patterns, the feel of a word in one's mouth as it is pronounced. The description of the feast Porphyro sets out for Madeline literally makes a reader's mouth water if he reads it aloud:

> And still she slept an azure-lidded sleep,
> In blanched linen, smooth, and lavender'd,
> While he from forth the closet brought a heap
> Of candied apple, quince, and plum, and gourd;
> With jellies soother than the creamy curd,
> And lucent syrops, tinct with cinnamon;
> Manna and dates, in argosy transferr'd
> From Fez; and spiced dainties, every one,
> From silken Samarcand to cedar'd Lebanon.
>
> (stanza 30)

Keats's contemporary reviewers, savagely divided over the merit of his poetry, unanimously noted his unusual exploitation of single words. Reviewers absolutely opposed in their general estimates of the poetry's worth selected identical examples for praise or blame. What Charles Lamb calls "beauty making-beautiful old rhymes" the reviewer for the *St. James Chronicle* dismisses as "affected peculiarity of expression." The reviewer for the *British Critic* objects to Keats's willingness to "strike from un-meaning absurdity into the gross slang of voluptuousness" and the "artifices of vicious refinement," noticing "slippery blisses" and "Honey-feels," along with "honey-whispers" that come "refreshfully" with "sigh-warm

kisses," and "a faint damask mouth tenderly unclos'd to slumbery pout." Francis Jeffrey, more favorably disposed, nonetheless believes the poet often had "taken the first word that presented itself to make a rhyme, and then made that word the germ of a new cluster of images . . . till he had covered his pages with an interminable arabesque of connected and incongruous figures."[14]

The Monthly Review, deploring Keats for "continually shocking our ideas of poetical decorum," urges him "to be less fond of the folly of too new or too old phrases"—which summarizes the contradictory criticism of Keats as too original or too archaic in his "prodigal phrases." "Quaint strangeness of phrase" is John Scott's epithet for this archaizing (that often led to comparison, for good or ill, to Chatterton), though Scott equally dislikes the poet's "flippant impatience." Reviewers repeatedly seize upon individual words as revealing the nature and significance of Keats's sensibility: Leigh Hunt acutely praises the demented Isabella's "chuckle," just as the British Critic understandably objects to whales that "sulk." Everyone agrees that the issue to be judged is what the Eclectic Review calls the "violence" Keats "lays upon words and syllables forced to become such; e.g., 'rubious-argent,' 'Milder-moon'd,' 'frail-strung heart.'" Whether such violence arises from a profound understanding of "the genuine resources of the language" or "impatience of its poverty," critics such as a second reviewer for the British Critic recur to terms like "tender-person'd Lamia" who "passioned to see herself," or "lips that posied with hers," "pleasuring" and "mirroring" things, doing a thing "fearingly," or walking "silken, hush'd and chaste," along with doubtful substantives such as "leafits."[15]

That Keats's small body of verse can sustain the enormous bulk of criticism raised upon it and remain fresh and exciting derives principally from his success at making individual words such potent centers of transformative energy. As Jeffrey noticed, Keats writes not from system but opportunistically, letting single words react to local exigencies, the verbal efficacy that allows a noun to become a transitive verb appearing in response to some pressure of immediate context. Keats's diction invites the twin criticisms that it is pointedly archaic and distressingly innovative because his words are forces variable in their possible effects, inherently powerful in their independence from standard definitions. That they can change in every way—in sound, in meaning, in grammatical form—is Keats's realization of the Romantic belief in the effective vitality of ordinary language.

Faith in such transformational potency, in the value of language really used by men as imaginatively forceful and therefore not fully definable by grammar, philosophy, or even custom, approaches a magical attitude toward language. "La Belle Dame Sans Merci," Keats's most successful "lyrical ballad," affirms as strongly as "Goody Blake and Harry Gill" or "The Rime of the Ancient Mariner" the fearful power of words to transform what seems certain, fixed, limited by either natural condition or cultural regulation.[16] Yet already for the second generation of Romantic poets, confidence in language's access to "magical" effects was challenged by the poets' intensified skepticism. Keats could write "La Belle Dame" but could also write a self-mocking letter:

> I lean rather languishingly on a Rock, and long for some famous Beauty to get down from her Palfrey in passing; approach me with— her saddle bags—& give me—a dozen or two capital roast beef sandwiches.
>
> (*Letters* 1:360)

Had Keats been granted another decade of life, the amusingly sardonic self-awareness we call Byronic might sometimes now be called Keatsian—a thought to trouble Byron's shade. But Keats's roast-beef sandwiches do not appear in "La Belle Dame Sans Merci," as similar self-deflating realisms do enter into *Don Juan*. Nevertheless, Keats moved toward the conjoining of such contrary attitudes, as is evidenced in diverse ways by "The Fall of Hyperion," the tortured fantasy of "The Cap and Bells," and "Lamia," wherein one recognizes a fusion of imagining and realistic skepticism as the source of the poetry's vigorous stylistic impurity. The prudish objections to "The Eve of St. Agnes" suggest that, like Byron, Keats might have encountered social censorship had he lived longer.[17]

FANTASY IN A NEWTONIAN UNIVERSE

"Lamia" is not so perfected a poem as "The Eve of St. Agnes." Reforegrounding the conflicts of "Isabella," "Lamia" confronts unqualified admiration for the fulfillment of passionate sensuality with vigorous post-Newtonian skepticism. The movement beyond the satisfyingly direct antitheses of "The Eve of St. Agnes" is signaled formally by a return to the couplets of Keats's early verse, but now with their logical structure tightened, their rhythms and rhymes made taut and precise, and the pairs linked into verse

paragraphs at once intellectually compact and fluid in developing themes and imagery. In a seemingly more casual fashion than "Isabella," "Lamia" is more probing in questioning itself, presenting its reader with a network of interlockingly recursive puzzles. The imagistic music of "The Eve of St. Agnes" is established so quickly and sustained so effectively that possible disjunctions between experience and its articulation do not trouble most readers until the final stanza breaks the enchantment with the reminder, "Aye, ages long ago / These lovers fled away."

"Lamia," however, opens with reference to faery and fantasy as long past. The first lines remind us of our distance from the poem's antique setting, a distance re-established throughout the poem by the time-shifting intrusions of the narrator. More subtly and penetratingly than "Isabella," "Lamia" thus centers the doubtful work of the imagination as its principal subject, though in the later poem the focus of conjecture is the relation of what may be called "illusory" to what may be called "real," a concern evolving out of "The Eve of St. Agnes." But whereas Porphyro melts into Madeline's dream and thereby dissolves it into reality, Lycius dies when Lamia's illusion dissolves into—what? No one can say of what consists the illusion called Lamia. Yet merely to define Lamia as illusory explains nothing, least of all anything about reality.

Keats's earlier narratives contrast secrecy and concealment with exposure and discovery, but "Lamia" employs a more intricate dialectic in which display becomes disappearance. Revealed to Hermes, the nymph fades from sight with him, whereupon in a pyrotechnic display of colors the snake vanishes. The sight of Lamia's female form enchants Lycius, who brings on his death and her final disappearance by insisting on public show of his enchantment. However illusory Lamia's playing the part of a real woman, her passion for Lycius is authentic. Lycius, then, is not so much deceived by Lamia-as-illusion as by the illusion of profiting from advertising a true passion. In contrast, Apollonius is destructive in his determination to see through the display of Lamia. The only reality he can uncover is a void: his insight discloses nothingness. Paradoxically, both Lycius and Apollonius fail to appreciate the intricate ambiguity Lamia enacts. To search for a reality hidden beneath an illusion is as disastrous as to celebrate illusion as reality.

"Lamia" thus leaves the reader in a quandary more complex than either the difficulty suggested by the old saying that men lack women's ability to accept the truth of falsity, though that insight is

implied, or the perplexity of the modern cliché that people survive only through their illusions, though that point, too, is suggested. The crux of the story is Apollonius, because he does not belong in a world of romance, magic, and imagination, a world to which the poem claims to transport us at its opening. Apollonius belongs with us, the skeptical readers who know magic to be delusion. There is no reason to doubt Apollonius's answer to Lycius's "death-nighing moan"—"from every ill / Of life I have preserved you to this day"—but with doctors like Apollonius, who needs disease? Or, in the larger context established by Keats's reference to Newton unweaving the rainbow, for an empirical, scientific society super-natural catastrophe becomes superfluous.[18]

"Lamia" thus explores the possibilities of imaginative narrative within social circumstances uncongenial to imagining. The poem ends with a footnote that would seem more logically to have pre-ceded the verse, for it gives Keats's source, Philostratus's version of the tale as retold by Burton, which poses another attitude toward the events. Philostratus might almost be Lycius; for him, the story is interesting because true, and it is true because a public event: "many thousands took notice of this fact, for it was done in the midst of Greece." But this is no recommendation of Apollonian de-structiveness. The totality of Keats's poem suggests a more com-plex mode of interpreting, one that assures the utmost uncertainty. We ought not Lycius-like to be beguiled solely by the poem's glitter-ing surface, to believe only because others can believe; yet, simulta-neously, we must resist the futility of Apollonian soundings into depths that must ring emptily because their presuppositions pre-clude anything magical. Because "Lamia" is both a fantastic story and a testing of creative fantasy in a society hostile to such fantasiz-ing, it calls for its readers to respond imaginatively but without sur-rendering any skeptical awareness.

The poem's abrupt conclusion and trailing note on sources carry us back to the undetermined postmagical era in which the poem began, but now with our awareness intensified as to the difficulty in recovering any magical past. What had seemed easy, to recover a time before Oberon, an age of classical paganism, turns out to be, perhaps, impossible, and the unresolved conclusion tempts us to invent explanations that undermine our earlier reactions. When, for instance, the narrator asks, "Do not all charms fly / At the mere touch of cold philosophy?" we tend readily to concur. But by the end of the poem the cold touch of Apollonius's philosophy has cre-

ated the poem's strongest "charm," its deepest mystery. Then the final note on sources compels us to realize how deceptive have been all the poem's indubitably logical sequences and causal structures. One might reasonably assert, for example, that the cause of later events is Hermes's rewarding Lamia for revealing the nymph to him, but that assertion immediately poses unanswerable questions germane to the logic of the events: What is the source of Lamia's power to make things visible and invisible? What is she doing imprisoned in serpentine form? Was she, indeed, "a woman once," or was she originally a snake? Inherent in every earlier cause is an irrecoverable prehistory that renders suspect the unmistakably orderly sequence of the narrative. Interpretation thus reveals its own uncertainties and cannot resolve the poem into a rationally consistent explanation, even one that simply denies the poem a rational order. Imaginative art is reducible to no logical or definitive, that is, unimaginative, explanation. Unlike a natural phenomenon, such as the rainbow, which is susceptible to scientific analysis, "Lamia," folding back upon itself, cannot be unwoven.

AN ENABLING ARTISTRY

Don Juan, which Byron began to write about two months after Keats finished "Isabella," overlaps the climactic work of Romanticism's second generation of poets. When different parts of the poem were written, though I pay no attention to such facts, is of real importance, as is its reception, another matter I do not address, except to observe here that nineteenth-century objections to the bawdiness and political outspokenness of *Don Juan* are no nearer the mark than twentieth-century critics' dismissal of Byron's position as a celebrity of European culture. However light-hearted *Don Juan* may be, even into our own century Byron has been a hero to nationalists seeking the liberation of their countries; in China, for example, two translations of *Don Juan* have been published in the past seventy years.

From Byron's notations we know that the order of the cantos essentially follows the order of their composition, which closely parallels Byron's life from 1818 to 1824, and the manuscripts show relatively few revisions.[19] Byron did not write carelessly, as he liked to pretend, but he did not return to finished cantos to make drastic alterations. With some exceptions, thus, one may read the poem as a record of Byron's evolving thoughts and feelings. In writing the

212 stanzas of the first canto between July and September 1818, for instance, Byron devised and mastered a style for the poem and gained full confidence in that style, a confidence that never really wavered, despite hostile criticism, worried warnings from friends, and pleadings by his inamorata. At her request he did once interrupt *Don Juan*, though the interruption probably suited his wishes for as soon as he wanted to resume, he gained Teresa's "permission" without delay.

Although Byron hit upon his style almost from the first, we see his technical skill and perspicuity develop as we read on. None of the early stanzas, for instance, equals the criticism of the Amundeville family pictures:

> Generals, some all in armour, of the old
> And iron time, ere lead had ta'en the lead;
> Others in wigs of Marlborough's martial fold,
> Huger than twelve of our degenerate breed:
> Lordlings, with staves of white or keys of gold:
> Nimrods, whose canvas scarce contained the steed;
> And, here and there, some stern high patriot stood,
> Who could not get the place for which he sued.
>
> (canto 13, stanza 70)

Nor in the early cantos has Byron perfected his facility at word play, a casual self-consciousness about the possibilities of language that simultaneously describes and exposes both social mores and literary traditions. Characteristic of the multipurpose punning frequent in the latter part of the poem are Byron's comments on how good society "Is no less famed for tolerance than piety":

> That is, up to a certain point; which point
> Forms the most difficult in punctuation.
> Appearances appear to form the joint
> On which it hinges in a higher station;
> And so that no explosion cry "Aroint
> Thee, witch!" or each Medea has her Jason;
> Or (to the point with Horace and with Pulci)
> *"Omne tulit punctum, quae miscuit utile dulci."*
>
> (canto 13, stanza 81)

We also see Byron learning to take advantage of what he has already written; his comments on what he is doing in *Don Juan* become increasingly self-reflexively illuminating. His remarks on *Don Quixote* (canto 13, stanzas 8–11) could not have appeared in earlier cantos, since his observations reflect his deepened insight into pos-

sible effects of his "real Epic" on society. The "great moral taught" by Cervantes is a disturbing alternative: either virtue, such as that possessed by Don Quixote, is a mere fancy, an amusing invention of an author escaping social actualities, or, if virtue does exist in real social practice, it may be destroyed by literary imagining, as "Cervantes smiled Spain's chivalry away," his glory being "dearly purchased by his land's perdition." This perplexity—how to tell the truth about society's evils without trivializing goodness or being socially destructive, the final "English cantos" address, as a key difference between Quixote and Juan assumes its full significance. Quixote is mad but purely virtuous in conventional terms; Juan is sane but corrupt in his adoption of conventional definitions of right and wrong. As the prototype of the young man from the provinces (a character ubiquitous in later nineteenth-century fiction), Don Juan opens the way for his audience to become more self-critical, for he demonstrates the fashion in which dubious moral attitudes are internalized.

Aside from *Don Juan*'s effect on other writers,[20] the poem served Byron as Wordsworth hoped *The Prelude* would serve him, in making possible the writing of other poems. For *Don Juan* was never Byron's exclusive preoccupation; it was an enabling work, written during the composition of other poetical works that were radically different from it. From the very first stanza we are aware that Byron has left behind *Beppo*, his test run with *ottava rima*, as a mere incident. *Don Juan*'s opening words, "I want a hero," though defining an absence, point to scope and violent action. As in *Mazeppa*, a poem of striking diversity in scene and effects, completed more or less concurrently with the initiation of *Don Juan*, from the very first the protagonist appears as a focus for adventuring. But the reader's relation to Juan, unlike Mazeppa, commences with his origins and develops as he develops. A second contrast with *Mazeppa* is even more significant: Don Juan does not tell his own story; he exists only as related.[21]

Three accomplishments of the first canto are specially illuminating of how *Don Juan* as a whole functions. First, Byron eliminates any kind of mask, even the "Byronic" role, freeing himself from the inhibitions of disguise or displacement. Second, he establishes a fundamental premise of the poem that moral integrity is grounded in an acceptance of human life as social and therefore complex, unpredictable, contingent, perpetually transformative because relational. Third, he attains mastery of a comic art that enables him to

bring together the trivia of life and its most spectacular experiences, grandeur and absurdity, without recourse to transcendence or retreat into nihilism.

Peter Manning, reading the poem from a psychoanalytic perspective, suggests that in *Don Juan* Byron liberates himself from his past and drops his earlier disguises, the simplified, static self-portrayals we see in works such as *Manfred*.[22] Byron "fictionalizes" himself, projecting now an undisguised personality, and no longer distances himself from events in his past. Though Don Juan is but a boy in canto 1, Byron the narrator repeatedly brings in as relevant, or partly relevant, or possibly relevant, information about his own adulthood. As the poem progresses, Byron's confidence soars and he steadily develops his autobiographical resources. Increasingly, he cannot truly digress, for the poem becomes one in which whatever he recollects will be relevant, simply by the fact of his recollecting it. Byron's liberation is thus inseparable from his discovery of the liberating possibilities inherent in artistic form that requires no closure, demands no formal telos or conclusion other than the arbitrary one brought about by the author's demise.[23]

Byron's growing freedom to project an unfalsified, however paradoxical, personality effects an author-reader relationship that is progressively less defensive. Despite outcries of hostility from some quarters, most readers have found Byron's voice steadily more relaxed and therefore more engaging as the poem progresses. In canto 1 Byron does not so much find his voice as learn to direct it effectively at the reader. Compare the first stanzas with the last thirty in the canto: at the beginning one feels that he is using his poem as something separate from us to talk *about*; later, he seems to be speaking to us directly and personally, though not necessarily without guile or intricate motive. Rapidly the poem becomes the medium for a bond between narrator and reader. The final deception of quoting Southey in stanza 212, for example, depends for its humorous effectiveness on the existence of a bond between poet and reader: he knows we will enjoy his fooling us. Byron, one might say, learns how to address his reader as he was coming to address his correspondents in his marvelous letters. Even his rhetorical tricks and falsely direct addresses—"chaster reader"— appear as facetiously affectionate pseudoformalities by which the achieved intimacy of the relation is confirmed.

The designation of Byron's style as conversational is apt in that local, immediate purposes are never subordinated to or limited by

any extrinsic or overriding purpose, since the poem has none. Like ɡood conversation, the poem is free to respond to opportunities offered by chance, by contingencies that it creates itself. The peculiarly discontinuous continuity, the occasional checking or redirecting of the self-sustaining flow, resembles that of actual conversation. Though Byron does all the talking, the effect is surprisingly unegotistic, chiefly because *Don Juan* is organized toward its reader.[24] When the narrator speaks of himself, "I like an eye," as important as the autobiographical reference is the telling to us, the social interplay of conversation. Byron allows the poem to be carried by the immediate flow of ideas and language because he assumes the reader's interest, and therefore his participation, in the movement.

<center>SELF AND ROLE: THE POLITICS
OF RHETORIC</center>

After completing the first canto of *Don Juan* Byron wrote—but later suppressed—a preface and dedication, both of which summarize his developing political and aesthetic ideas. The preface opens with an attack on Wordsworth for asking the reader of "The Thorn" to suppose that "the narrative is narrated by 'the Captain of a Merchantman . . . lately retired upon a small annuity . . . etc., etc.'" Byron's objection to the use of such a persona seems founded primarily on his dislike of the demand that the reader "suppose" fictive conditions for the telling of a story. Byron's motives for opposing one of fiction's oldest traditions were doubtless complex, but a central point is that he wants to distinguish fiction from fraudulence, with which it is easily confused. By speaking honestly as himself to his reader, Byron justifies his claim for the moral seriousness of *Don Juan*'s amusing fictions—fictions that usually have some firm roots in fact. In *Don Juan* the presence of a blatantly fictitious narrator would both have constrained such pleasurable moralizing and have impeded the poem's efficacious formlessness. Once again, an interesting contrast is provided by *Don Quixote*, which gives the impression of free formlessness yet becomes progressively self-enclosing, as *Don Juan* does not.[25]

In the preface and dedication Byron also expresses his contempt for what he regards as the political and moral debasement of the Lake Poets, whose artistic defects reflect their political fraudulence. Byron's prime target in the dedication, Robert Southey, is

also the object of Byron's scorn at the conclusion of the preface, in which the central charge is that the poet laureate lacks integrity, self-respect, and talent:

> What Mr. Southey's deserts are, no one knows better than Mr. Southey; all his later writings have displayed the writhing of a weakly human creature, conscious of owing its worldly elevation to its own debasement (like a man who has made a fortune by the Slave-trade, or the retired keeper of a Gaming house or Brothel), and struggling convulsively to deceive others without the power of lying to himself.
>
> (p. 4)

The dedication is an extension in *ottava rima* of this savaging of Southey, whose official position dramatizes what is most deplorable in those Byron called the Lakers, their linking of poetry and personal political ambition in a fashion destructive to both good art and good politics. Byron attacks them (as in our day Solzhenitsyn has attacked Soviet toady-writers) as apostates to their libertarian impulses and heritage who choose to serve causes they themselves have identified as evil. Through selfishness, envy, and pettiness of mind, such false artists choose their own enslavement. In contrast, the free artist moves with history and, like Milton, continues to call tyrants tyrants without fear about losing his place in society. But the Lake poets, Byron charges, prefer security to the continuous dangerousness of liberty and so ensnare themselves in extrinsically determined roles and patterns of relation.

Byron's confidence that mobility of personality, however risky, enables an artist to keep alive a commitment to freedom probably contributes to his choosing for his protagonist someone who never quite fits into any established social category. Juan does not truly belong anywhere. Though a native Spaniard, he "intrudes" into Spanish society and has to be sent away. Through this displaced protagonist Byron dramatizes what "belonging" entails, and explores the Romantic conception of identity as participative rather than privative. Self is created by social relationships, yet socialization may lead one to internalize attitudes that betray one's authentic self. Insecurity, a struggle between self and role that Morse Peckham perceives as fundamental to Romanticism,[26] is a focal problem in *Don Juan*. The poem never moves toward any solution, presenting the difficulty as continuous, diverse, intractably insoluble. Don Juan never quite belongs because the complex intricacies of human relationship are both infinitely heterogeneous and mobile. There

are no absolute rules for the right way to behave. The most humanly vital life is lived in the ever-shifting margin between individual impulse and social conventions, in the incertitude of social dynamics. Yet the uncertainties of Don Juan reveal the practical political assurance of his creator, for the acceptance of continuous undecidability makes possible a vehement idealism whose roots are deeper than moral or metaphysical abstractions.

It happens that *Don Juan* was to provide Byron with an opportunity to exemplify the open constancy of a free spirit. When his first publisher, John Murray, was made timid by both prudish and ideological objections to the poem after five cantos had appeared, Byron changed publishers, allowing John Hunt to bring out cantos six through eight, to which the poet supplied a preface. The central portion of this preface is directed to the circumstance that these cantos contain "a stanza or two . . . relative to the Late Marquis of Londonderry . . . written some time before his decease." The Marquis was, of course, Castlereagh (with whom Byron delighted to associate the Lake Poets), who had recently committed suicide. Of the stanzas on Castlereagh Byron observes:

Had that person's oligarchy died with him, they [the stanzas] would have been suppressed; as it is, I am aware of nothing in the manner of his death or of his life to prevent the free expression of the opinions of all whom his whole existence was consumed in endeavouring to enslave. That he was an amiable man in *private life*, may or may not be true; but with this the public have nothing to do; and as to lamenting his death, it will be time enough when Ireland has ceased to mourn for his birth. As a minister, I, for one of millions, looked upon him as the most despotic in intention, and the weakest in intellect, that ever tyrannised over a country. It is the first time indeed since the Normans that England has been insulted by a *minister* (at least) who could not speak English, and that Parliament permitted itself to be dictated to in the language of Mrs. Malaprop.

Of the manner of his death little need be said, except that if a poor radical, such as Waddington or Watson, had cut his throat, he would have been buried in a cross-road, with the usual appurtenances of the stake and the mallet. But the minister was an elegant lunatic—a sentimental suicide—he merely cut the "carotid artery," (blessings on their learning!) and lo! the pageant, and the Abbey! and "the syllables of dolour yelled forth" by the newspapers—and the harangue of the Coroner in a eulogy over the bleeding body of the deceased— (an Anthony worthy of such a Caesar)—and the nauseous and atrocious cant of a degraded crew of conspirators against all that is sincere and honorable.

(p. 198)

The ad hominem character of this rhetorical ferocity, of which Southey and Wordsworth are elsewhere notable victims, is essential to the political efficacy of Byron's art. Genuine political passion focuses on persons. It is even rarer in politics than in religion to hate the sin but to forgive the sinner. Byron is concerned with specific abuses and particular tyrants and their sycophants, not abstractions such as political scientists devise. This specificity endeared him to many diverse kinds of patriots, who would not have found him so appealing had he not been so abusively ad hominem in his own voice. A political view to which the self with all its personal vulnerabilities is not committed is usually trivial, often hypocritical.

Ad hominem rhetoric, moreover, is congruent with the poet's mode of defining his relation to his reader in *Don Juan*, a relation not fictive not only because Byron speaks in his own voice but also because he addresses the reader as "real," as differing from the poet. In the later portions of the poem especially, the wandering Byron speaks to his English audience as someone a little out-of-date and unfamiliar with truly current events. His Italian and European travels mark him as different from his readers, a difference he exploits to create a dialogical relation with them, even though only he speaks.[27] Not only does the narrator talk to the reader, but Don Juan never becomes a mere prop or convenience; he remains essential to the realization of Byron's personality through his poem. For Byron, as for Jane Austen, "individual" personality exists only through relationships with other personalities.[28] Don Juan exists because of the existence of Byron the narrator, but Byron's personality gains some of its reality through Don Juan. The parallel with Jane Austen is helpful on this point, for no one will dispute that we recognize "her voice" as narrator in her novels through its difference from the voices of her characters. Austen's authorial voice thus is to a significant degree created through dialogical interaction with the voices of her characters. Byron, the creator of *Don Juan*, in creating the character to a degree creates himself.

This complexity produces the poem's strongest effect—our trust in the narrator. The poem is often lighthearted; we often feel Byron enjoying the spinning out of stanzas, and we recognize his readiness to indulge in fooling. Yet we do not lose our trust in him because we are confident in his opposition to dishonesties fostered by exigencies of social behavior. Such abuses, which he condemns as cant, are produced by the coercion of social demands on individual im-

pulses, desires, and aspirations. But Byron always makes us aware that our private fears and insecurities make us vulnerable to cant. Much of the liberating effect of *Don Juan* arises from its revelation of our own participation in a cant that, of course, we claim to abjure. Don Juan's sexual adventures are amusing beyond mere bawdiness because they provoke us to recognize the variety of ways in which we conceal from ourselves, and thereby distort, our actual desires. For this purpose, the foreign women possessed of power, especially Gulbeyaz and Catherine, are most useful. They force us to think, for example, about which parts of the body we regard as proper or improper to kiss, or about the ambiguity of maternal love, another aspect of which is presented through Inez's multiple motives for not obstructing the completion of her son's education with Julia. In reverse fashion, the Haidée episode authenticates uninhibited desires by representing the "natural" love of Haidée and Juan as "idealized" for our sophisticated, that is to say corrupted, vision. We are continuously reminded of our unnatural attitudes by Byron's realistic comments, characters, and narrative, which surround young passion with every kind of cynical practicality in langauge, in the characters of Zoe, Lambro, and the other islanders, and, most important, by the encircling episodes of Julia, shipwreck, slavery, and Gulbeyaz. But Byron's presentation of war perhaps best illustrates how he engages his readers' vulnerability to cant and uses the conversationality of his poem to evoke a complex interplay between realism and idealism that illuminates the self-confusing characteristic of modern life.

COADUNATING IDEALISM
AND SKEPTICISM

The "War Cantos" (cantos 7 and 8) are the first extended and detailed picturings of modern warfare in a popular literary work. Byron dramatically contrasts the actualities of mass "brain-spattering and windpipe-slitting" and the reports of these activities, the written words that influence how events are imagined by readers. Underlying Byron's presentation is the difference between Homer's ability to find true glory in warfare and modern propagandizing of hypocritical glory. *The Iliad* is germane to *Don Juan* in that it depicts the horrors of war beyond brain-spattering and windpipe-slitting. The groin-piercing and bowel-ripping, the image of Achilles day after day abusing the corpse of Hector—these scenes scarcely embody

an ideal of martial glory. Homer's achievement is to convince us that though there may be honor and heroism in warfare, one cannot ignore its senselessness and brutality. Byron was no pacifist—he died in the Greek war for national independence—but he wants his reader to recognize society's hypocrisy in ignoring the anguish of war. The commitment to die for a cause is for Byron the final test of any political position, but the wild-eyed or naïve patriot who does not understand the truth of war makes a meaningless sentimental gesture.

Like "Fears in Solitude," *Don Juan* claims modern reports of war foster unconscious hypocrisy. The reporting conceals the horror of the actual experience, even to the point of misnaming the killed. Whereas Coleridge stresses only the details of the suffering, the personal anguish that reports obscure by bad writing, Byron, without slighting these matters, emphasizes also the falsifications in social orderings produced by admiration for "heroic" leaders. The absurdity of people admiring leaders of mass actions of uncontrollable bestiality is focused by his brilliant portrait of General Suvarov. To the Russian's military skill and professionalism Byron does justice, but he shows that the source of the general's effectiveness is his coarsely dehumanized personality (illustrated by his victory dispatch to the Empress). Society's esteem for military genius is thus made to challenge its own value system.

The attack on "Villainton" in canto 9 (stanzas 1–10) is more direct, yet its placement after the siege description (a relatively rare example of Byron's holding a set of stanzas to find the most efficacious context) compels us to realize that any military action must be judged in the context of its political function. For this purpose, the siege of Ismail suited Byron admirably. Since the engagement was a matter of indifference to his British readers, they were more likely to discern the horrible absurdities of battle and to take to heart the skepticism with which Byron recounts his protagonist's bravery. The comment that it would have been no shameful or unusual thing for Juan to have run from his first battle, moreover, is part of Byron's steady involuting of the triangular narrator-protagonist-reader relation to bring into question the unreasoned value system we tend unthinkingly to apply to social actions. So, after Juan saves the little girl Leila, Byron comments,

> If here and there some transient trait of pity
> Was shown, and some more noble heart broke through
> Its bloody bond, and saved, perhaps, some pretty

Child, or an agéd, helpless man or two—
What's this in one annihilated city,
Where thousand loves and ties and duties grew?
(canto 8, stanza 124)

The poet subverts sentimentality not only to expose its evils but also to undermine the opposing callousness that so often passes itself off as pragmatism or realism. When, at the end of the frightful descriptions, Byron makes us smile at widows of forty wondering "wherefore the ravishing did not begin," we have been readied to recognize the grim significance of being able to smile while reading of war.[29]

The stanzas on Wellington, Britain's greatest military hero, develop this kind of awareness by pressing the question: "And I shall be delighted to learn who, / Save you and yours, have gained by Waterloo?" (canto 9, stanza 5). Here, Byron's attitude resembles that of Carlyle when he observes that, despite all that has been published to the contrary, the ordinary Frenchman was well off under what propagandists have called "The Terror." And, like Clausewitz, Byron insists that we recognize war to be an extension of politics.

For Byron "[it] is the part / Of a true poet to escape from fiction" and to liberate his reader from "that outrageous appetite for lies / Which Satan angles with for souls, like flies" (canto 8, stanza 86). But he does not advocate any simplistic doctrine of realism; like other Romantics he attacks the social fictions that we are taught to accept as real. Much of Don Juan originates in idealism, in Byron's belief, for example, in the possibility of just wars fought for liberty and national independence—though just wars, too, are horrible. He is determined that we are not to be fooled by propaganda, which, playing on idealistic impulses, indulges in a hypocritical patriotism that damns us, not in some afterlife, but here and now in our conduct toward our fellow beings. With this argument, which continues Coleridge's in "Fears in Solitude," Byron tries to lead us between moral nihilism and the rigidity of moral conventions by applying to passionate ideals what Blake called "corrosive fires" of rigorous skepticism. The latter accounts for Don Juan's consistent denial of every kind of systematic dogmatism—even systematic skepticism— accompanying its constant celebration of human inconstancy.

"One system eats another up," Byron observes cheerfully in the first stanza of canto 14, as "from great Nature's or our own abyss / Of thought" we seek to "snatch a certainty," though none exists— "Except perhaps that you are born to die," which, however, may

"turn out untrue" (stanza 3). One must welcome alternatives, not seek the false security of dogmatic systematizers nor yield up moral questions in despair. One may fully enjoy the human condition by making choices in an uncertain and changing world. To be human is to be both idealistic and skeptical, a combination that requires the openness or indeterminacy that characterizes the Romantic artists' best work.

The dynamic coherence in *Don Juan*'s "formlessness" is suggested by the relevance of the issues raised in cantos 8 and 9 to the poem's opening words, "I want a hero." We begin with desire for a true hero, though there is no shortage of fake ones sponsored by falsifying organs of "good" society. Byron's search produces the very odd figure of "our ancient friend" (whom we have all seen sent to the Devil) as a young man. As Byron's consistent rhyming assures our noticing, his protagonist is both the legendary Don Juan ["wan"] and somebody quite different, Don Ju-an, a pluralizing reinforced by the repeated but vague identifications of Juan as "friend." In such ways, though ways that are ever-changing, most tellingly in the final cantos, the reader's relation to Juan always remains somewhat unstable. Within that zone of vital uncertainty Juan most effectively exists. Always more and yet less than a legendary character renewed, Juan becomes as the poem advances, especially in England among very uncertain "friends," a dubious legend *within* the poem. This complexity is promising to attain new intricacies with Fitz Fulke enacting the legendary Black Friar, of whom Lady Adeline sings and whom her unimaginative husband claims to have seen, when the poem is broken off by Byron's death.

Although in the course of the poem Juan's character develops some specificity, his fit with possible roles remains insecure, and the narrator's attitude toward him never crystallizes. The poem advances in terms of shifting margins, relational slippages, precisely the areas excluded from traditional epic. The antiepical thrust is emphasized from the beginning of the poem, first by the joke about the "regularity of my design" forbidding the poet to begin "*in medias res*" (stanzas 6–7). So to begin, of course, would imply the existence of a determinative structure, which the continuing extensions of *Don Juan* make more and more impossible. This is but the first of many comments in the poem about its plan or design, comments that tend to become increasingly outrageous as the poet gains confidence in having found a mode that supersedes any traditional circumscriptive order. Byron's openness keeps the poem

vitally engaged with nonliterary actualities. As Wordsworth's revisions and extensions of *The Prelude* generate alternative interpretations and reconsiderations of earlier episodes, so Byron's additions and attachments dissolve any ready-made extrinsic definitions, such as generic classifications, that might limit his poem's complex interplaying of assertion and self-questioning by which he affirms the pleasures of provisionality.

Don Juan does not conclude; it is interrupted by Byron's sudden death. The poem is not deliberately fragmentary; the only end it allows itself to conceive, however, is a probability—that junction point between the inevitable and the accidental. Throughout the Juan-Julia-Alphonso episode in canto 1 Byron emphasizes that Juan is sixteen and Alphonso is fifty. The disparity of their ages does not excuse twenty-year-old Julia's behavior; her berating of Alphonso in stanzas 108–10 makes it clear that Juan is by no means her only solace. But Byron does not blink that a sixteen-year-old is usually more sexually potent than a fifty-year-old. Likewise in stanza 167 the narrator does not pity Juan, but does recognize that the conscience of an adolescent has more to distract it than the conscience of a mature man. These matters assume their real importance when, after announcing in stanza 188 "Here ends this canto," Byron goes on at length to promise (threaten?) the extended continuation of his "true" epic, which is to shame all previous efforts, and from that on to a discussion of *his* age, thirty, with a lament for what he has lost, which concludes:

> My days of love are over; me no more
> The charms of maid, wife, and still less of widow,
> Can make the fool of which they made before,—
> In short, I must not lead the life I did do;
> The credulous hope of mutual minds is o'er,
> The copious use of claret is forbid too,
> So for a good old-gentlemanly vice,
> I think I must take up with avarice.
>
> (stanza 216)

The productivity of life even in its diminishment, exemplified by the narrator's increasing fascination with money as the poem advances, foreshadows Juan's probable fate as not Hell but old age. As in the Haidée episode, Byron uses the "advantage" of his experience to authenticate the lovers' naïve romantic notions, so here he creates a perspective in which we can foresee Juan willy-nilly not leading the life he does lead. Yet this is but one perspective that, in its very commonplaceness, reminds us that human beings continu-

ously readjust their aspirations while being subjected to the frictions of existence. This view permits Byron to avoid retreat into either moral cynicism or aesthetic detachment, and the poem's uncompromising provisionality allows him to remain interested in what his work is creating as he continues to create it. In this way the object he is creating not only becomes a subject for further creative efforts but also an agent that begets its author. Such art might be called maximalist (as opposed to minimalist) in its ready accommodations to all sorts of changes and variations that preclude closed formal structures or reductive essentializing symbolism. As Keats productively turns his plots back upon themselves, Byron attains an analogous richness through a poem that is not merely open-ended but also "open-sided," responsive throughout its progress to interactions between its contingencies and those of the circumambient world into which it happily intrudes.

This inclusive self-creativity of Romantic poetry, of which *Don Juan* is a splendid embodiment,[30] forces us to speculate as to why the last major Romantic poem should be also almost the only truly funny one. Comedy would seem a natural result of attention to the contingent and indeterminate. Friction at times produces amusing effects, such as—though the sage of Rydal Mount could not have relished the irony—that no Romantic poem realizes more fully than *Don Juan* Wordsworth's ideal of a poetic language like that "really used by men." Perhaps the paradox of that formulation, the idealizing of the real, explains the relative paucity of Romantic humor.

The Romantics idealistically engaged their poetry not with *langue*, which is purely virtual, but with language used, what we now call speech acts. What Romantic poetry plunged into is what Bakhtin describes as *heteroglossia*, the multiplicity of spoken and written languages that constitute the complex reality to which the abstraction *language* so reductively refers. The Romantics strove to intensify their readers' awareness of the dynamics of this heteroglossia, because it gives deepest insight into evaluations of how and to what effect we can, and should, act and interact with our fellows.[31] Such idealistic aspiration toward modifying actual behavior does not encourage wit, and if to many of his era Byron seemed to epitomize, for good or ill, the romanticness of their age, it was not because of his humor. From the perspective of nearly two centuries later, however, we can appreciate that Byron's humor as fully as his passion contributed to that engagement of art in the improvement of social realities which is characteristically Romantic.

Coda: Shelley's "Defence of Poetry"

What today seem shortcomings in early twentieth-century criticism of Romantic art mostly originate in the pervasive influence of Modern art, which rejected or reoriented many Romantic ideals. Critics came to think of Romanticism as either something that had to be overcome for the truly Modern to emerge or as a primitive, undeveloped version of what only in the twentieth century was fully realized. The Romantics did, of course, initiate some ideas and techniques that flowered more spectacularly later. But with the waning of Modern art, critical attention veered toward the analysis of the complex play of processes responsible for differences and divergencies between Modern and Romantic art. These might be brought into sharpest focus by detailed study of the history of criticism, as a few comments on one of the major critical documents of the Romantic era, Shelley's "Defence of Poetry," may suggest.

Shelley's essay is too complicated to be analyzed adequately in anything less than a monograph, and I make no pretense of explaining its intricacies, inconsistencies, and paradoxes, most of them deliberate, for Shelley's view of his subject urged him into a style "vitally metaphorical." Without enumerating his many debts to earlier aestheticians and theorists of language, such as John Locke, Hugh Blair, and Adam Smith,* I focus on features in Shelley's argument that emphasize why we need to recast the terms in which Romantic art has been discussed for nearly a century.

Shelley's immediate purpose in the "Defence" is to refute the essay of his friend Thomas Love Peacock, "The Four Ages of Poetry," a clever piece that skillfully makes the case that poetry is useless in an advanced industrialized society. In simpler societies, says Peacock, poets are among the intellectual leaders, but as society be-

*The best work on the Romantics' indebtedness to earlier language studies, and not merely in Britain, is Hans Aarslef, *From Locke to Saussure: Essays on the Study of Language and Intellectual History* (Minneapolis: University of Minnesota Press, 1982).

comes more complicated "intellectual power and intellectual acquisition have turned themselves into other and better channels," for poetry "can never make a philosopher, nor a statesman, nor in any class of life a useful or rational man."* "A poet," Peacock asserts, "in our times is a semi-barbarian in a civilized community," for "it is not to the thinking and studious, and scientific and philosophical part of the community, not to those whose minds are bent on the pursuit and promotion of permanently useful ends and aims, that poets . . . address their minstrelsy." As Shelley feared, Peacock's view has largely triumphed, so that even some artists and critics now take the triviality of art for granted.

With rhetorical shrewdness, Shelley seizes the offensive. Against Peacock's view that poetry does nothing, he asserts that poetry is the source of everything worthwhile in human life. He launches his attack from a distinction between reason and imagination, stressing the superiority of the latter, reason being "the enumeration of quantities already known," whereas imagination perceives "the value of those quantities." Reason is merely "mind *contemplating* the relations of one thought to another," but imagination is "mind *acting* upon those thoughts so as to colour them with its own light, and composing from them, as from elements, other thoughts, each containing within itself the principle of its own integrity" (p. 480).† Language rooted in imagination, what we would call poetic discourse, unlike rational discourse, "marks the before unapprehended relations of things" (p. 482), will "inevitably innovate" (p. 484), and "awaken and enlarge the mind itself by rendering [it] the receptacle of a thousand unapprehended combinations of thought" (p. 487). Only the language of imagination, which Shelley calls poetry, can create "forms of opinion and action never before conceived" (p. 495).

In identifying how innovations can occur, how originality in ideas, practical devices, and social orderings is possible, Shelley takes a position similar to Blake's in his argument in the series "There Is No Natural Religion." Blake stresses the hopeless circularity of explanations offered by "the calculating faculty." Like

*Thomas Love Peacock, *Memoirs of Shelley and Other Essays and Reviews*, ed. Howard Mills (New York: New York University Press, 1970), pp. 117–132; citations in this paragraph are from pp. 132, 130, 129, and 131.
†For the "Defence" I follow the well-edited text in *Shelley's Poetry and Prose*, ed. Donald H. Reiman and Sharon B. Powers (New York: Norton, 1977), pp. 480–508; emphases throughout are mine.

Blake, Shelley is aware that imagination, being "connate with the origin of man" (p. 480), cannot be defined by reduction to a brief formulation modeled on scientific equations. He delineates some of imagination's qualities and effects, not a few of which appear contradictory, so as to illuminate the process—and its mysteriousness—by which we may succeed in apprehending what previously we had been unable to apprehend.

Imagination for Shelley, as for the other Romantics, is inseparable from our nature as essentially social beings, one reason Shelley's "poets" include institutors of law, founders of civil life, and nonrhymesters like Bacon. Language "arbitrarily produced by the Imagination" (p. 483) practically effectuates its power. But this does not definitively decide the question of whether thought creates language, or language thought. The "vitally metaphorical" (p. 482) language of poetry revealing previously unapprehended relations and perpetuating their apprehension constitutes a true organizing of social intercourse, which always involves the interdependence of thinking and articulating. In the absence of imagination these interanimating structurings of relation become reified through the splitting apart, the disorganizing of conception and expression, a cliché being a final form of this division. Language thus disorganized hardens and desiccates as words become "mere signs for portions or classes of thought" (p. 482), functioning as signs, not symbols. Social life contracts into a torpid mass. The universe ceases to have meaning for us, individuals become hypocrites pledged to "the principle of Self, of which money is the visible incarnation" (p. 503), and disown their deepest desires and fears. These disavowals are writ large in the false arts that then flourish, arts that can only "affect sentiment and passion" (p. 491), appeal to a narcissistic hedonism, and pander to "caprice and appetite" (p. 491).

The sociohistorical direction of Shelley's thinking explains his paradoxical deployment of veil imagery. Poetry, he tells us, lays "bare the naked and sleeping beauty of the world" (p. 505). But each of Dante's words is a spark, "a burning atom of inextinguishable thought," many still "covered by the ashes of their birth" and still charged with a "lightning which has yet found no conductor," because "all high poetry is infinite. . . . Veil after veil may be withdrawn, and the inmost naked beauty of the meaning never exposed" (p. 500). The paradox of poetry revealing naked beauty yet never exposing its inmost naked beauty begins in Shelley's understanding that poetic accomplishments always emerge from specific

historical conditions. A great poet such as Dante offers improve-
ment or restoration to his society. But since genuine poetry is in-
finite, its potential can never be entirely realized. Dante's contribu-
tion to thirteenth-century Italian culture is not the limit of his
attainment, some aspects of which could be realized only in the
nineteenth century, still others only in the twentieth. Every unveil-
ing initiates the possibility of another unveiling; so Shelley con-
flates processes we usually consider to be opposites, veiling and
unveiling.

We must remember that in Shelley's view reification of language
results not merely from repetition and routine but more signifi-
cantly from those disownings and falsifications by which we con-
ceal our true selves from ourselves. In unimaginative art, the only
art that can flourish in the society Peacock idealizes, there appear
"doctrines, which the writer considers as moral truths; and which
are usually no more than specious flatteries of some gross vice or
weakness with which the author in common with his auditors are
infected" (p. 491). The dialogic drama between artist and audience
that characterizes true art is reduced to a monologue in which the
artist flatters his audience's prejudices. In contrast, great art ex-
poses its audience to itself because "neither the eye nor the mind
can see itself, unless reflected upon that which it resembles," in-
culcating not only "Self-knowledge" but also "self-respect" (p. 491).
The argument that within our self-deceptions and disownings are
possibilities for genuine self-respect recalls the crux of *The Cenci*:
"knowing what must be thought," Beatrice wrongly shifts the ac-
companying "what may be done" into "what I must do" (1.2.112),
changing a psychic possibility into a willful imperative. Her deci-
sion leads to the "casuistry with which men seek the justification of
Beatrice, yet feel that she has done what needs justification," as
Shelley defines her tragedy (and all Romantic tragedy) in his pref-
ace to the play.

For the Romantics the veil of familiarity is a source of self-
loathing, a sense of self-worthlessness whose social manifestations
are prejudice, hatred, injustice, and feelings of impotence and
whose intellectual consequences are the metaphysics of mean-
inglessness and an aesthetic that denigrates the value of art. The
cornerstone of the Romantic ideal of self-revelation is that "Poetry
is a mirror which makes beautiful that which is distorted" (p. 485)—
or "disfigured," as Coleridge puts it in the *Biographia Literaria*. The
acuity of Romantic psychological insight rests in this surprising
blend of skepticism and idealism.

Shelley's observations sometimes anticipate trends in twentieth-century criticism. His comment that *Paradise Lost* "contains within itself a philosophical refutation of that system of which, by a strange and natural antithesis, it has been the chief popular support" (p. 498) carries him toward deconstruction, while his remark that Milton's poem and Dante's will someday serve, as Homer's epic now does, as the means of and reason for recovering an otherwise useless set of obsolete religious beliefs points toward an idea exploited in modern hermeneutics. Even more surprising, perhaps, are his thoughts about intertextuality and the irrelevance of the artist's person. Insisting on poets' lack of control, "speaking words which they understand not . . . and feel not what they inspire" (p. 508), Shelley approaches Foucault's author-function. But Shelley attributes the unimportance of the individual in imaginative exercise to inspiration—a power "*above* consciousness" (p. 486)—while psychoanalytic theory has led most of us to peer below. Working from the Romantic conception of the identity of invention and execution as essential to the exercise of the imagination, Shelley seizes as a key to the failure of imagination in modern life the refusal, originating in the Enlightenment, to consider art inspired, a rejection of the continuing testimony of artists that "their" creations are indebted to a power beyond their control. This point is crucial to Shelley's rebuttal of Peacock, for were Peacock to admit any significant form of inspiration, his argument would disintegrate.

The profound importance for Shelley of the possibility of inspiration is implicit in his comment on "sparks" of Dante's thought still "covered in the ashes of their birth," and is explicit in his famous comment that "the mind in creation is as a fading coal" (p. 503), so that the "most glorious poetry that has ever been communicated to the world is probably a feeble shadow of the original conception of the poet" (p. 504). That works we regard as totally successful—those of Dante, Shakespeare, and Homer—may be but weak realizations of what might have been accomplished is a daring conception, one to which Shelley is drawn by his conviction that poetry is not created by will. If a poem helps to liberate a reader from socially induced misconceptions, that effect is less the deliberately targeted achievement of the poet than a happy effect of the shadow of liberated vision that inspired him to write. It is this power beyond any individual's control that renders superior poetry "infinite," possessed of future effects beyond what even the greatest artist can predict. Thus the creative capacity itself manifests the evanescence of the eternal.

To understand Shelley's concept of inspiration, we must refrain from the current critical tendency to associate the term with mystical or vaguely transcendental activities. For the Romantics inspiration was not a communion with a transcendental source but a response to the actual nature of the cosmos. Blake and Shelley viewed inspiration or poetical genius as connate with the origin of man, and for them, as well as the other Romantics, poetry is not a special language but ordinary language used imaginatively.

The disastrous triumph of the "principle of self" in modern society, the diminished power of love, a "going out of our own nature" (p. 487), Shelley can unhesitatingly identify as founded in imaginative failure because, as emphatically as Blake, Coleridge, and Wordsworth, he links poetry and pleasure: "poetry is ever accompanied by pleasure" (p. 486); "the strength of the bucolic poets is that their work endows the sense with a power of sustaining its extreme delight" (p. 492); "poetry ever communicates all the pleasure which men are capable of receiving" (p. 493). Art begins in an "excess" of pleasure that "communicates itself to others, and gathers a sort of reduplication from that community" (p. 482), an idea exactly paralleled in Wordsworth's Preface to *Lyrical Ballads*. Conceived in pleasure, the work of art is indeterminate not because fragmented or inadequate but because it is like "a fountain for ever overflowing with the waters of wisdom and delight":

> After one person and one age has exhausted all its divine effluence which their peculiar relations enable them to share, another and yet another succeeds, and new relations are ever developed, the source of an unforeseen and an unconceived delight.
>
> ("Defence," p. 500)

Few critics in our time, however, do not work from the opposite premise, that art comes into being through injury or dislocation, a fault or fracturing of some kind, either psychological or sociological, perhaps both, and, consequently, that the endless interpretability of a work of art is due not to its being a fountain forever overflowing but a *mise en abîme*. For the Romantics art is an ever self-renewing surplus; for us art is an unfathomable chasm. Yet if we view all literary works as inherently unstable we are positioned, as earlier twentieth-century critics were not, to appreciate the destabilizing vitality in Romantic art, although in our compulsive gazing into the abyss we have perhaps moved farther away from understanding art as "a fountain for ever overflowing."

Notes

INTRODUCTION

1. David Simpson, "Criticism, Politics, and Style in Wordsworth's Poetry," *Critical Inquiry* 11:1 (1984): 52–81, argues cogently for the importance of this recent development, citing half a dozen publications contributing to it. In his earlier *Wordsworth and the Figurings of the Real* (Atlantic Highlands, N.H.: Humanities Press, 1982), Simpson develops readings at points substantially different from mine, yet we share, however uncomfortably, a horizon, for he writes also of the Romantic "ethic of the polymorphous" that strives to "keep in play as many figurings as possible" (pp. 120–21).

2. *Selected Prose Works of G. E. Lessing*, trans. E. C. Beasley and Helen Zimmern, ed. Edward Bell (London: George Bell and Sons, 1899), p. 20. I discuss this issue in chapter 4. In fairness to Lessing, we should remember that one of his principal targets in *Laokoön* was a group of contemporary German descriptive poets who (rightly) have been forgotten.

3. The inversion of Romantic ideals is painfully illustrated by the fate of the nationalistic aspirations fundamental to their historicism. On March 28, 1811, Wordsworth wrote to a Captain Paisley:

> I wish to see Spain, Italy, France, Germany formed into independent nations; nor have I any desire to reduce the power of France further than may be necessary for that end. Woe be to that country whose military power is irresistible! . . . If the time should ever come when this island shall have no more formidable enemies by land than it has at this moment by sea, the extinction of all that it previously contained of good and great would soon follow.
>
> (Christopher Wordsworth, *Memoirs of William Wordsworth*, ed. Henry Reed [Boston: Ticknor, Reed, and Fields, 1851] 1:406)

That this characteristic Romantic call for national diversity was rapidly warped into ambitions for hegemonic power has been too little recognized by Anglo-American scholars. Hans Robert Jauss cites as exemplary Gervinus, whose *History of the Poetic National Literature of the Germans* (1835–1842) changed Humboldt's Wordsworth-like interest in separate manifestations of the idea of national individuality into a nationalistic ideology. As Jauss notes, for Gervinus, "the multiplicity of the history of national individualities . . . narrows itself to the literary myth that 'the Germans alone

in their purity' were 'true successors of the Greeks'"; Jauss, "Literary History as Challenge," in *Toward an Aesthetic of Reception*, trans. Timothy Bahti (Minneapolis: University of Minnesota Press, 1982), p. 6.

4. A stimulating and judicious study of this subject is Diane Hume George's *Blake and Freud* (Ithaca: Cornell University Press, 1980). Students of the history of psychiatry are unanimous in dating the emergence of the concept of the *unconscious* in the final three decades of the eighteenth century. Henri F. Ellenberger, *The Discovery of the Unconscious* (New York: Basic Books, 1970), specifically locates the origin of the idea of the unconscious in the years between 1775 and 1784, focusing on the work of Mesmer and Puységur (chap. 3), and he traces out Romantic developments of this "first dynamic psychiatry," which he regards as the foundation of modern psychiatry (chap. 4). Ellenberger's predecessor, Lancelot Law Whyte, *The Unconscious Before Freud* (New York: Basic Books, 1960), explored "the great transformation" in European self-awareness that "from 1750 onward . . . coincided closely with the progressive recognitions of unconscious mental processes," and first used the phrase "discovery of the unconscious" to mean not a scientific discovery supported by systematic tests, but "a *new inference*, the bringing to light of what was previously unknown in a particular culture," specifically, "the spreading out of the intellectual illumination that Descartes had focused too sharply" (p. 49 and p. 60).

5. Karl Kroeber, "The Relevance and Irrelevance of Romanticism," *Studies in Romanticism* 9:4 (1970): 297–306.

6. P. N. Medvedev and M. M. Bakhtin, *The Formal Method in Literary Scholarship*, trans. Albert J. Wehrle (Baltimore: Johns Hopkins University Press, 1974), p. 123.

7. Stuart Sperry, *Keats the Poet* (Princeton: Princeton University Press, 1973), is one of the few critics to explore seriously the rich field of the concurrence of Romantic art and science; see his chap. 3, "The Chemistry of the Poetic Process."

8. Through this book I mean by *creative* that which brings into being something both new and valuable, a definition that accords with the usual lexical ones. Albert Rothenberg has tellingly observed how casually and vaguely *creation* is used by critics laborious and minute in their dissection of *interpretation*, but Rothenberg himself does not satisfactorily elucidate *creation* through his concept of articulated interpretation; see his "Commentary," *New Literary History* 15:2 (Winter 1984): 397–410; this entire issue of *NLH* is devoted to "The Interrelation of Interpretation and Creation." See also Wolfgang Iser's summary comment in the same issue, pp. 387–95; Iser demonstrates that by bringing something new into being "creation" at the least comes close to being *ex nihilo*, implying some discontinuity or disruption. So far as one must see creation as decomposition, "valuableness" tends to be attributed to it only after a time. More immediately, creation is likely to be regarded as the destroyer of something cherished. Relevant,

too, is Rothenberg's *The Emerging Goddess: The Creative Process in Art, Science, and Other Fields* (Chicago: University of Chicago Press, 1979).

1. INVENTING THE UNCONSCIOUS

1. Ronald Paulson, *Literary Landscape: Turner and Constable* (New Haven and London: Yale University Press, 1982), p. 4. My understanding of Hogarth is profoundly indebted to Paulson's work over the past fifteen years.

2. Gérard Genette's distinction between *récit* (telling) and *histoire* (what is told), analogous to the Russian formalists' *fable* and *sujet*, is a distinction perhaps more useful in describing the transformation of Neoclassical into Romantic art than has been generally recognized. While the Neoclassical mimetic mode emphasizes the distinction between *récit* and *histoire*, the Romantics frequently blur it, as exemplified by the pictures in *Urizen*, which are not "of" or "about" anything other than themselves.

3. Paulson's most thorough discussion of the series, a brilliant piece of criticism to which I owe much, appears in *Emblem and Expression* (Cambridge, Mass.: Harvard University Press, 1975), pp. 58–78.

4. I cite the text in *Six Eighteenth-Century Plays*, ed. John Harold Wilson (Boston: Houghton Mifflin, 1963), pp. 219–220, and all subsequent citations are from this edition. In an appendix this volume presents an interesting scene, interpolated in the late eighteenth century, between Millwood and Barnwell before their execution in act 5.

5. William Hogarth, *The Analysis of Beauty* [1753], ed. Joseph Burke (Oxford: Clarendon Press, 1955), pp. 141–42 and p. 137.

6. W. J. T. Mitchell, *Blake's Composite Art* (Princeton: Princeton University Press, 1978), p. 163. Mitchell's discussion of *The Book of Urizen*, pp. 107–164, is to my mind the most useful detailed critique of the prophecy (though I disagree with Mitchell on several points—I do not share his view that for Blake the imagination is "the supreme fiction," for example). Mitchell is consistently sensible, judicious, and full of original and stimulating insights. The two most elaborate recent studies of Blake's art are Leopold Damrosch, Jr., *Symbol and Truth in Blake's Myth* (Princeton: Princeton University Press, 1980), and Nelson Hilton, *Literal Imagination* (Berkeley: University of California Press, 1983), although I find Morris Eaves, *William Blake's Theory of Art* (Princeton: Princeton University Press, 1982) more sensitive to both the originality of Blake's artistry and its relation to the broader developments of Romantic art. Although Robert N. Essick's splendid *William Blake, Printmaker* (Princeton: Princeton University Press, 1980) is the best published work on the processes by which Blake created his illuminated works, I have profited even more from the analyses and reconstructions of Joseph Viscomi, "The Workshop of William Blake" (Ph.D. dissertation, Columbia University, 1980), which taught me most of what I know about how and why Blake worked as he did.

7. All quotations from Blake, unless otherwise noted, are from *The Complete Poetry and Prose of William Blake*, rev. ed., ed. David V. Erdman (Berkeley and Los Angeles: University of California Press, 1982) cited by page number, plate number, and line. The two lines quoted here are 71:4:12 and 71:3:39. Plates that do not have a text are cited as numbered in *The Illuminated Blake*, annotated by David V. Erdman (Garden City, N.Y.: Anchor, 1974).

8. Mitchell, *Blake's Composite Art*, p. 129. Mitchell, however, oversimplifies slightly, for trouble begins *before* the promulgation of law, at that unidentifiable moment at which Urizen "breaks away" from the Eternals. The truly primal transgression for Blake is, I think, like that which Stanley Cavell identifies in "The Ancient Mariner": the crossing of the line that *precedes* the shooting of the Albatross and thereby makes possible the "obvious" sin. For Cavell's analysis, see *Romanticism and Contemporary Criticism*, ed. Morris Eaves and Michael Fisher (Ithaca: Cornell University Press, forthcoming).

9. Stephen Leo Carr, "Visionary Syntax: Nontyrannical Coherence," *The Eighteenth Century: Theory and Interpretation* 22:3 (Autumn 1981): 222–48. Carr's central argument concerns how Blake arrived at the view that "Every Line is the Line of Beauty." In "Graphic-Poetic Structuring in Blake's *Book of Urizen*," *Blake Studies* 3:1 (Fall 1970): 7–18, I discuss in detail the "plot" of the prophecy as rendered both graphically and linguistically, and so do not here repeat the analysis.

10. As Coleridge's discussions of differences between copy and imitation suggest, a most interesting but complex issue is at the heart of this problem of "imitability." Put simply, my point is that (forgery aside) it would be self-contradictory to imitate the manner of Blake's work for one who understands how and why it succeeds, and the same is true, *mutatis mutandis*, of Wordsworth's poetry or Turner's painting. Contrarily, to perceive how Hogarth succeeds is to recognize the applicability of his techniques to an array of socio-aesthetic situations—so Cruikshank in the middle of the Victorian era consciously modeled his series *The Drunkard* and *The Drunkard's Children* on Hogarth, who would hardly have welcomed Cruikshank's enthusiasm for the temperance movement. Imitability in art is not merely a question of the excellence of the original work, as seems often to be assumed, but also of the nature of the art: imitative art lends itself to imitation.

On the tricky but fascinating topic of forgery broadly considered, the crucial modern work is Nelson Goodman, *Languages of Art* (Indianapolis: Bobbs-Merrill, 1968), a genuinely exciting study; see also *The Forger's Art: Forgery and the Philosophy of Art*, ed. Denis Dutton (Berkeley: University of California Press, 1983).

11. Concerning the studies by Essick, Viscomi, and Eaves, see note 6.

12. John Berger, *The Look of Things* (New York: Viking, 1971), p. 148, defines the "undramatic" quality of the "theatrical": "In the theatre the spec-

tator faces events from whose consequences he is immune." Romantic art, in contrast, is intended to have practical consequences.

13. *The Book of Urizen* would admirably reward an intelligent Lacanian analysis. Blake's central problem may be described as devising discourse that could reach his audience's unconscious, and his solution as luring his reader into an identification with a protagonist that the logic of the prophecy then compels the reader to reject. A Lacanian could regard this process as a kind of forced "regression" from the "symbolic" to the "imaginary," while the action of the prophecy embodies, one might argue, Urizen's movement from the imaginary into the symbolic, for Urizen shrinks from the plenitude of eternity into restricted structures very like linguistic symbols. The prophecy as a whole thus could be regarded as a reflection *back* upon "the state of the mirror." Romantic "anticipations" of twentieth-century psychology will not seem such isolated, and therefore surprising, phenomena if we recall the emergence of the root concepts of linguistics at the end of the eighteenth century. As Hans-Georg Gadamer puts it: "the concept 'language' is a recent development. The word *logos* means not only thought and language, but also concept and law. The appearance of the concept 'language' presupposes consciousness of language. But that is only the result of the reflective movement in which the one thinking has reflected out of the unconscious operation of speaking and stands at a distance from himself"; *Philosophical Hermeneutics*, trans. and ed. David E. Linge (Berkeley: University of California Press, 1976), p. 62.

2. VICTORIAN ANTI-ROMANTICISM

1. Allen Staley in his excellent *The Pre-Raphaelite Landscape* (Oxford: Clarendon Press, 1973) emphasizes Pre-Raphaelite preference for "bright colour . . . minimum of shadow" (p. 5) and "insistence upon bright local colours at the expense of tonal modulation" (p. 185). Staley's careful and informed discussion of *The Blind Girl* (pp. 53–55) notes that the background of the painting was done at Winchelsea two years before the figures were painted in Scotland, and that Millais has some trouble with the picture's spatial recession, which is established only by the smaller size of background objects. *The Blind Girl* is one of the earliest Pre-Raphaelite paintings that attempts to make weather a significant part of the picture. To do this, interestingly, Millais did not rely on direct observation. As Staley puts it: "The double rainbows are a studio concoction whose colours Millais got wrong . . . and had to repaint" (p. 54). John Ruskin praises *The Blind Girl* elaborately in "The Three Colours of Pre-Raphaelitism," which first appeared in *Nineteenth Century* (1878), though he notices the distortion in the representation of the crows: "he paints the spark of light in a crow's eye a hundred yards off, as if he were only painting a miniature of a crow close by"; *The Complete Works of John Ruskin* (New York: Thomas Crowell, n.d.), 27: 230. Robert Rosenblum in a review of the Museum of

Modern Art's exhibition of British painting in 1957 (*Partisan Review* 24 [1957]: 95–100) anticipates Staley in stressing the two-dimensional patterns and overall surface activity of Pre-Raphaelite paintings, which he sees as suggestive of Tobey or Pollock (p. 97) and not offensive to "the contemporary predilection for a flat, continuous picture surface undefiled by detailed modeling or sudden plunges into space" (p. 95).

2. On windows, see-through devices, and mirrors in Victorian art, one may consult Gerhard Joseph, "Victorian Frames: The Windows and Mirrors of Browning, Arnold, and Tennyson," *Victorian Poetry*, 16 (Spring-Summer 1978): 70–87, although Joseph ignores "Enoch Arden." Like his predecessors, including J. Hillis Miller in *The Disappearance of God* and W. David Shaw in *Tennyson's Style*, Joseph concentrates on representations of looking *out*. This focus neglects the situation of the audience toward the "spectators" *within* this art, as well as the spatializing of time implicit in such Victorian representations of looking. Perhaps most fascinating in this regard is Holman Hunt's *Awakened Conscience*, an attempt to portray a moment of revelation. While the man looks up at the woman, she looks out of the picture seemingly at us, but, thanks to the oddly located mirror behind her, we can see what she sees, a natural scene, presumably emblematic of her former innocence. That in the climactic scene of "Enoch Arden" we analogously see what Enoch sees as the family (like the man in Hunt's picture) does not, paralleling the blind girl and her companion, suggests how fundamental a Victorian inconographic structure is this seeing–not-seeing. Hunt's use of an interior vertical mirror that perfectly reflects an outdoor scene inverts the characteristic Romantic horizontal, natural mirror that reflects imperfectly, and is seen into, that is, has depth; see my discussion in chapter 8.

3. Thanks in part to Harold Bloom, *The Anxiety of Influence: A Theory of Poetry* (New York: Oxford University Press, 1973), most critics now are readier than their predecessors to recognize that vital aesthetic traditions include resistance, rejection, and contradiction of what had gone before.

4. Exhibited in 1831, but worked over and over again by Constable subsequently; indeed, he refers to the painting in the last letter he wrote in 1837. For reviews and commentary on the painting, see item 282 in *Constable: Paintings, Watercolours and Drawings*, catalogue to the great London exhibition, by Leslie Parris et al. (London: Tate Gallery, 1976), p. 164. Sue Boulton, "Church Under a Cloud: Constable and Salisbury," *Turner Studies* 3:2 (1984): 29–44, provides a fine survey of the painting in Constable's career. Many of Michael Rosenthal's comments on Constable in *The Painter and His Landscape* (New Haven: Yale University Press, 1983) are useful.

5. Our uncertainty may be heightened by the fact that the rainbow, whatever one thinks of its coloring, is meteorologically impossible given the position of the sun; see the important article by Paul Schweitzer, "John Constable, 'Romantic Science and English Color Theory,'" *Art Bulletin* 64 (Sept. 3, 1982): 424–45. Like Turner's "impossible" reflections in *The Fight-*

ing "Téméraire" (which I discuss in chapter 8), such "inaccuracy" by an artist who manifestly could get his natural facts right when he wished to I regard as a graphic analogue to the Romantic poets' deliberate use of the "pathetic fallacy."

6. Boulton, "Church Under a Cloud," p. 41, aptly notes that the eye observing the picture "never rests, not merely because of the quantity of detail, but also because of the vibrancy with which it is rendered . . . [conveying] the feeling of unrelenting turbulence. . . . the original has a radiant quality." The painting provoked caustic reviews expressing outrage at its violent brushwork and its unnaturalistic intensities, which one ought to study in terms of Constable's total oeuvre, not just his Salisbury works. It seems almost to invert *The Haywain*, the least threatening of great paintings, even to treating high summer, not harvest, and in which we do not see anyone sweating, though the benefits of labor are placidly implied. *Salisbury Cathedral, From the Meadows* presents a multitude of precarious unbalancings, from thematic dubieties to perspectival inconsistencies and natural impossibilities so that the picture is simultaneously threatening and uplifting.

7. Bagehot's essay "Wordsworth, Tennyson, and Browning: Or Pure, Ornate, and Grotesque Art in English Poetry" first appeared in the *National Review* (Nov. 1864), pp. 27–66, and has often been reprinted; my citations are from John D. Jump, *Tennyson: The Critical Heritage* (London: Routledge and Kegan Paul, 1967), pp. 289 and 291.

8. *The Letters of William and Dorothy Wordsworth: The Early Years, 1787–1805*, ed. E. De Selincourt, 2d ed., rev. Chester L. Shaver (Oxford: Clarendon Press, 1967), p. 313; subsequent citations are given by page number in the text. One should also notice the letter to Thomas Poole of 9 April 1801, in the same volume, the key passages of which are quoted by De Selincourt in *The Poetical Works of William Wordsworth*, 2d ed. (Oxford: Clarendon Press, 1952), 2:478–85, in the valuable notes to "Michael." All quotations from "Michael" are from this edition, cited by line number in the text.

9. All quotations from "Enoch Arden" are from Christopher Ricks's edition, *The Poems of Tennyson* (London: Longmans, 1969), pp. 1130–52, cited by line number in the text.

10. The immediate source of "Enoch Arden" was a prose sketch given to Tennyson by Thomas Woolner, who had read of the incident, though on publication both Crabbe's "The Parting Hour" and Mrs. Gaskell's *Sylvia's Lovers* were recognized as contributing influences. Ricks summarizes well the sources, though he calls Adelaide Anne Procter's "Homeward Bound" an analogue, on the basis of Hallam Tennyson's remark that his father only encountered her poem after composing his own (*Poems of Tennyson*, p. 1129). In the light of close parallelisms between the two works I find Hallam's claim unlikely. Earlier commentators on Tennyson, for example, Morton Luce, *A Handbook to the Works of Alfred Lord Tennyson* (London: G. Bell and Sons, 1895; rev. ed. 1914), take it for granted that Tennyson reworked

Procter's poem (published in 1858.) Luce, for example, cites lines 633–77 of "Enoch Arden" as evidence that Tennyson "does not alter; he merely adds detail and colour" (p. 204) to Procter's "rough sketch" in her lines:

> It was evening in late Autumn,
> And the gusty wind blew chill;
> Autumn leaves ever falling round me,
> And the red sun lit the hill.

11. Ronald Paulson, *Literary Landscape* (New Haven: Yale University Press, 1982), calls attention to Constable's use of a highlighted segment of the middle distance; Rosenthal, *The Painter and His Landscape*, discusses inconsistent perspectives; on the importance of "spot" as indeterminate form and Keats's use of emptiness as fulfillment, see my discussion in chapter 4.

12. The conversations in "Michael" are impressive, for Wordsworth, without attempting verbal literalism, creates a remarkable imitation of the manner of "country" speech. Isabel's apparently sudden assertion to Luke, "Thou must not go" (line 295), in fact springs from two nights of feeling Michael's uneasy sleep in the bed beside her. Appropriate, too, is her recovery of heart as soon as "she had told her fears" and her son answered with "jocund voice," for Michael's fears are not hers. Wordsworth, moreover, never loses sight of the discrepancy between what a shepherd like Michael seems able to express in answer to questioning by a casual tourist and what, to someone better attuned to his modes of feeling and thinking, he would be capable of expressing. In lines he finally did not use in the poem, Wordsworth represents this difference powerfully:

> No doubt if you in terms direct had ask'd
> Whether he lov'd the mountains, true it is
> That with blunt repetition of your words
> He might have stared at you, and said that they
> Were frightful to behold, but had you then
> Discours'd with him in some particular sort
> Of his own business, and the goings on
> Of earth and sky, then truly had you seen
> That in his thoughts there were obscurities,
> Wonders and admirations, things that wrought
> Not less than a religion in his heart.
>> (De Selincourt,
>> *Poetical Works of*
>> *Wordsworth* 2:482)

13. Joseph Frank, *The Widening Gyre* (New Brunswick, N.J.: Rutgers University Press, 1963), p. 59.

14. Victorian visual intensity is epitomized by John Ruskin in *Modern Painters*: "the greatest thing a human soul ever does in this world is to *see* something, and tell what it *saw* in a plain way. Hundreds of people can talk for one who can think, but thousands can think for one who can see. To

see clearly is poetry, prophecy, and religion,—all in one"; 2d ed. (London: George Allen, 1900), 3:268.

Insight into how such Victorian emphasis on visualization developed into modern fiction's emphasis on seeing is provided by Edward W. Said's illuminating discussion of the change in Joseph Conrad from "storytelling as a useful, communal art to novel writing as essentialized, solitary art"; *The World, The Text, and the Critic* (Cambridge, Mass.: Harvard University Press, 1983), p. 101. Said stresses how interesting is Conrad's "ambition to move toward the visual," since thereby "writing is denied its importance in the writer's work itself" (p. 107), a phenomenon that I have suggested begins to become apparent in Tennyson, whereas Wordsworth *subsumes* storytelling as a useful, communal art into writing—rather (as I show in my next chapter) as music is subsumed within lyricism by Romantic poets.

15. In a word, Wagner (1813–1883) belongs to the Victorian age, not the Romantic. That seems too simple, but the Romantics were neither enthusiastic conflators of media nor fanatic separators of media, like Lessing. Blake's transgressions are deliberate and founded on a keen awareness of what the underlying *craft* of each art requries, just as Turner's and Byron's explorations into "formlessness" (see chapters 8 and 9) are built upon their acute sensitivity to "classical" admiration for distinctness in style and genre. The Romantics were little interested in Lessing's abstract dicta about differences between the arts.

16. In the essay "On Poesy and Art" Coleridge specifically identifies imagination as "the power of humanizing nature," *Biographia Literaria*, ed. J. Shawcross (London: Oxford University Press, 1962 [1907]), 2:253.

3. DITTIES OF NO TONE

1. So reports Eloise Hay, "Songs of William Blake and Music of Blake's Time," *Soundings: Collection of the University Library* [University of California, Santa Barbara] 8:2 (1974): 31–36. Hay believes Blake composed music to accompany his poems. Perhaps he did; my point is not that Blake was unmusical, nor that he lacked interesting ideas about music, but that music is not an integral part of his *Songs of Innocence* and *Songs of Experience*. Martin K. Nurmi, *William Blake* (London: Hutchinson, 1975), offers a good commentary on Blake's musicality; see also Zachary Leader, *Reading Blake's Songs* (London: Routledge and Kegan Paul, 1981). Among the avalanche of commentaries on individual songs and the two collections, E. D. Hirsch, Jr., *Innocence and Experience: An Introduction to Blake* (New Haven: Yale University Press, 1964), remains useful although I sometimes disagree with his readings and my conception of Blake's purposes in *Songs of Innocence* differs from his. Heather Glen, *Vision and Disenchantment: Blake's Songs and Wordsworth's Lyrical Ballads* (London: Cambridge University Press, 1983), carefully juxtaposes Blake's lyrics with Wordsworth's *Lyrical Ballads* to dem-

onstrate the significance of both poets' subversions of the popular forms they employ. James R. Bennett, "Comparative Criticism of Blake and Wordsworth: A Bibliography," *The Wordsworth Circle* 14 (1983): 99–106, presents an excellent compilation with succinct but helpful annotations.

2. *The Complete Poetry and Prose of William Blake*, rev. ed., ed. David V. Erdman (Berkeley and Los Angeles: University of California Press, 1982), pp. 8–9. As Jim S. Borck points out, Erdman was the first editor not to introduce misleading punctuation into "The Lamb"; see Borck, "Blake's 'The Lamb': The Punctuation of Innocence," *Tennessee Studies in Literature* 18 (1974): 163–75.

3. What is involved in the problem of naming is well represented by Ursula K. Le Guin in a science fiction novel in which settlers of a new planet identify as a "heron" a different creature,

> not a heron; it was not even a bird. To describe their new world the exiles had had only words from their own world. The creatures that lived by the pools, one pair to a pool, were stilt-legged, pale-gray fish eaters: so they were herons. The first generation had known that they were not really herons, that they were not birds . . . the following generations did not know what they were not, but did, in a way, know what they were. They were herons.
>
> ("The Eye of the Heron," in *Millennial Women*,
> ed. Virginia Kidd [New York: Dell, 1978], p. 170)

For more on inclusiveness, see chapter 9.

4. B. H. Fairchild, Jr., "*Melos* and Meaning in Blake's Lyric Art," *Blake Studies*, 7:2 (1975): 131. A fine discussion with keen observations on relations of syntactical and metrical characteristics is Alicia Ostriker's "Metrics: Pattern and Variation," in *Twentieth-Century Interpretations of Songs of Innocence and Experience*, ed. Morton Paley (Englewood Cliffs, N.J.: Prentice-Hall, 1969), pp. 10–29.

5. As N. Scott Momaday observes in *The Names* (New York: Harper and Row, 1977), p. 92:

> Children trust in language. They are open to the power and beauty of language, and here they differ from their elders, most of whom have come to imagine that they have found words out, and so much of magic is lost upon them. Creation says to the child: "Believe in this tree, for it has a name."

6. Bloom, *Blake's Apocalypse* (London: Gollancz, 1963), p. 43; Hirsch, *Innocence and Experience*, pp. 26–27. According to this view the angel must be a liar. Hirsch's comment is an unusual slip, since he elsewhere sensitively discusses Blake's relating of innocence to virtue (see p. 42). Blake wrote his most vigorous statement on the back of a page of *The Four Zoas*: "Innocence dwells with Wisdom, but never with Ignorance"; *Blake's Complete Writings*, ed. Geoffrey Keynes (London and New York: Oxford University Press, 1979), p. 380.

7. John Hollander, *The Untuning of the Sky: Ideas of Music in English Poetry, 1500–1700* (Princeton: Princeton University Press, 1961), p. 3. For a historical survey, see Arthur Jacobs's chapter on Britain in *A History of Song*,

ed. Denis Stevens (London: Hutchinson, 1960). Byron's *Hebrew Melodies* are most germane; see the admirable study by Thomas L. Ashton, *Byron's Hebrew Melodies* (Austin: University of Texas Press, 1972). Ashton begins by observing that "Byron's Hebrew Melodies are not melodies" (p. ix) and places the composer Isaac Nathan's enterprise of setting the poems to his own arrangements of supposed ancient melodies within the context of similar contemporary collections; Ashton also calls attention to the importance of underlying nationalistic motives.

8. Leopold Damrosch, Jr., "Burns, Blake, and the Recovery of Lyric," *Studies in Romanticism* 21:4 (1982): 637–60, provides a series of useful juxtapositions that link the two poets to mid–eighteenth-century poetic traditions (which, therefore, I omit here). Damrosch observes how by "merging himself with folk tradition, Burns is able to be personal and impersonal at once" (p. 646), and he discusses with sensitive judiciousness the importance of drinking in Burns's troubled life.

9. Edward T. Cone, "Words into Music: The Composer's Approach to the Text," *Sound and Poetry*, ed. Northrop Frye (New York: Columbia University Press, 1957), pp. 4–5. In *The Composer's Voice* (Berkeley: University of California Press, 1974) Cone provides a fascinating extended discussion of the issues I touch on here. The entire book is splendid, but of special interest to literary scholars of Romanticism are chap. 1 ("Some Thoughts on *Erlkönig*") and chap. 4 ("Text and Texture: Song and Performance").

10. Donald Ivey, *Song: Anatomy, Imagery, and Styles* (New York: Free Press, 1970), p. 94.

11. Hollander, *Untuning of the Sky*, pp. 17, 173 and 19. In *Vision and Resonance: Two Senses of Poetic Form* (New York: Oxford University Press, 1975), Hollander explores further the relations of music and poetry with more attention to Neoclassical and Romantic practices. My debts to Hollander and to James A. Winn's lucid and intellectually provocative *Unsuspected Eloquence: A History of Relations Between Poetry and Music* (New Haven: Yale University Press, 1981) are extensive. Readers interested in the problems of intermedia criticism of literature and music might consult Robert K. Wallace, *Jane Austen and Mozart: Classical Equilibrium in Fiction and Music* (Athens: University of Georgia Press, 1982), a work that daringly invades what has been a critical wasteland.

12. Bertrand Harris Bronson, *The Ballad As Song* (Berkeley and Los Angeles: University of California Press, 1969), pp. 74–75.

13. *The Poems and Songs of Robert Burns*, ed. James Kinsley, 3 vols. (Oxford: Clarendon, 1968), 1:209; except where otherwise indicated, all references are to this edition, cited by volume and page in the text. Kinsley usually includes the relevant musical settings and fully delineates textual and bibliographical problems, with references to standard critical commentaries. For his notes and remarks on "Love and Liberty," see 3:1148–62. Also valuable is the centenary edition of *The Poetry of Robert Burns*, ed. W. E. Henley and T. F. Henderson (Edinburgh: T. C. and E. C. Jack, 1896–

1897). Kurt Wittig, *The Scottish Tradition in Literature* (Edinburgh: Oliver and Boyd, 1958) is excellent on the vernacular background. David Daiches, *Robert Burns* (New York: Rinehart, 1950) is a good critical study, and Thomas Crawford, *Burns, A Study of the Poems and Songs* (Edinburgh and London: Oliver and Boyd, 1960) is excellent; see pp. 130–45 for a discussion of "The Jolly Beggars." David Johnson, *Music and Society in Lowland Scotland in the Eighteenth Century* (London: Oxford University Press, 1979) discusses the relations between folk and classical music. Johnson stresses the antiquarian aspect of Burns's achievement, ranking him as "the outstanding folk-song collector of his generation," and calling attention to the frequency with which he set words to instrumental pieces (p. 148).

14. See Kinsley, *Poems and Songs of Burns* 3 : 1347. As usual, there is textual confusion, but Kinsley seems right to deny authority to the lines quoted, even though as he says, "the sentiments are characteristic of Burns." Because they are, and accurate to genuinely popular attitudes, it was natural for someone to tack them on and for them to become accepted as Burns's. Much of the textual uncertainty in Burns's poetry springs from analogous circumstances.

15. For Kinsley's commentary, see *Poems and Songs of Burns* 3 : 1467–68. Damrosch, "Burns, Blake, and the Recovery of Lyric," aptly contrasts Burns's ode with Swift's satires.

16. *The Merry Muses of Caledonia*, ed. James Barke and Sydney G. Smith (New York: Capricorn, 1959), p. 144; this edition of a collection first printed after Burns's death includes the indecent version of "John Anderson, My Jo" (pp. 147–48). Also relevant is "The deuks dang o'er my daddie," as noted by Catarina Ericson-Roos in *The Songs of Robert Burns: A Study of the Unity of Poetry and Music*, Studia Anglistica Upsaliensia, no. 30 (Uppsala: University of Uppsala, 1977), pp. 83–86. Her discussion of the union of music and words in "John Anderson" is a valuable addition to those of Kinsley and Crawford.

17. The word *horrors* I have chosen deliberately to follow Stanley Cavell's distinction between "horror" and "terror" such as the sublime arouses:

> I can be terrified of thunder, but not horrified by it. And isn't it the case that not the human horrifies me, but the inhuman, the monstrous? Very well. But only what is human can be inhuman. —Can only the human be monstrous? If something is monstrous, and we do not believe there are monsters, then only the human is a candidate for the monstrous.
>
> If only humans feel horror . . . then maybe it is a response specifically to being human. To what, specifically, about being human? Horror is the title I am giving to the perception of the precariousness of human identity, to the perception that it may be lost or invaded, that we may be, or may become, something other than we are, or take ourselves for.
>
> (*The Claim of Reason* [New York: Oxford University Press, 1979], pp. 418–19)

18. *The Poetical Works of William Wordsworth*, 2d ed., ed. E. De Selincourt and Helen Darbishire, 5 vols. (Oxford: Clarendon Press, 1954), 3 : 77.

Among the most notable commentaries are Geoffrey H. Hartman, *Wordsworth's Poetry, 1787–1814* (New Haven and London: Yale University Press, 1964), pp. 3–18; Frederick Garber, *Wordsworth and the Poetry of Encounter* (Urbana: University of Illinois Press, 1971), pp. 1–28 and 84–85; and Michael G. Cooke, *The Romantic Will* (New Haven and London: Yale University Press, 1976), pp. 41–47. As ingenious as any modernist reading is Helen Reguiero, *The Limits of the Imagination* (Ithaca and London: Cornell University Press, 1976), pp. 84–88.

19. For the circumstances of the poem's composition, see *The Poetical Works of William Wordsworth* 3:444–45; see also John Beer, *Wordsworth and the Human Heart* (New York: Columbia University Press, 1978), which contains a perceptive discussion of Wordsworth's attitudes toward Burns, especially pp. 5–10 and pp. 134–36; Beer's careful analysis of "The Solitary Reaper" includes the observation that Dorothy's journal gives "the impression that the reapers they saw were silent, and that their impressiveness was . . . [their] expression of the implicit and noiseless rhythms of nature" (p. 134).

20. John Hollander's excellent phrasing is: "It is with Romantic poetry that we begin to get a poetic confrontation of the realms of the two reigning senses . . . [we observe] the frequent event of the eye giving way to the ear at a particular kind of heightened moment" (*Vision and Resonance*, pp. 24–25). Hollander persuasively argues that the English Romantic "world of the ear" subordinates the "power of music" to the celebration of "the ear's larger, undomesticated vastnesses, those regions in which real poetry, rather than cultivated verse, is to be found" (p. 43). Critics whose arguments are specially impressive include Larry J. Swingle, whose "Wordsworth's Contrarieties: A Prelude to Wordsworthian Complexity," *ELH* 44 (1977): 337–54, is but one of his several fine essays treating these matters, and Stephen M. Parrish, whose *Art of the Lyrical Ballads* (Cambridge, Mass.: Harvard University Press, 1973) marshals the factual evidence about Wordsworth's intentions and purposes. Much in Paul D. Sheats, *The Making of Wordsworth's Poetry, 1785–1798* (Cambridge, Mass.: Harvard University Press, 1973) is germane, as is James Averill's more recent *Wordsworth and the Poetry of Human Suffering* (Ithaca: Cornell University Press, 1980).

John Danby, in *The Simple Wordsworth* (London: Routledge and Kegan Paul, 1960), observes that Wordsworth felt "the poet still had a responsibility to society. He was the spokesman and the guardian of social health" (p. 33). But the task of guardianship had become more complicated than Danby acknowledges, and the Romantics were cut off from the direct association with the earlier rhetorical tradition.

21. Danby, *The Simple Wordsworth*, p. 123, cites the original version of line 29, "I listened till I had my fill," as indicative of the poet's focus on himself rather than the girl, leading to "a sense of satisfaction amounting to repletion."

22. *The Letters of William and Dorothy Wordsworth, The Middle Years*, pt. 1,

1806–1811, 2d ed. rev., ed. Mary Moorman (Oxford: Clarendon Press, 1969), p. 146. Though I have emphasized the differences between Wordsworth and Burns, we should recall the English poet's extraordinarily anti-Victorian defense of his predecessor's earthiness:

> It is the privilege of poetic genius to catch, under certain restrictions of which perhaps at the time of its being exerted it is but dimly conscious, a spirit of pleasure wherever it can be found,—in the walks of nature, and in the business of men.—The poet, trusting to primary instincts, luxuriates among the felicities of love and wine, and is enraptured while he describes the fairer aspects of war: nor does he shrink from the company of the passion of love though immoderate—from convivial pleasure though intemperate. . . . Frequently and admirably has Burns given way to these impulses of nature.

Wordsworth then defends "Tam o'Shanter" for all that its hero "is a desperate and sottish drunkard":

> I pity him who cannot perceive that, in all this, though there was no moral purpose, there is a moral effect.
>
> > Kings may be blest, but Tam was glorious,
> > O'er a' the *ills* of life victorious.
>
> What a lesson do these words convey of charitable indulgence for the vicious habits of the principal actor in this scene, and of those who resemble him!—Men who to the rigidly virtuous are objects almost of loathing, and whom therefore they cannot serve! The poet, penetrating the unsightly and disgusting surfaces of things, has unveiled with exquisite skill the finer ties of imagination and feeling, that often bind these beings to practices productive of so much unhappiness to themselves and to those whom it is their duty to cherish.
>
> *(Letter to a Friend of Robert Burns,*
> *Prose Works* 3:124)

4. NATURAL PATRIOTISM

1. *Complete Poetical Works of S. T. Coleridge*, ed. E. H. Coleridge, 2 vols. (Oxford: Clarendon Press, 1912), 1:256. All quotations from "Fears in Solitude" and other poems by Coleridge are from this edition, cited in the text by line number. A thorough analysis of the poem would take account (as I do not) of the poem's complex textual history. The most substantial and penetrating commentary remains Carl R. Woodring, *Politics in the Poetry of Coleridge* (Madison: University of Wisconsin Press, 1961), pp. 189–93. Coleridge might have had reason to believe that his kind of patriotism would be welcomed in the last years of the eighteenth century. In 1799 Christopher Moody praises "Fears in Solitude" in the *Monthly Review* for showing Coleridge to be

> solicitous to consecrate his lyre to truth, virtue, and humanity. He makes no use of an exploded though elegant mythology, nor does he seek fame by singing of what is called Glory. War he reprobates, and vice he deplores. Of his country he speaks with a patriotic enthusiasm, and he exhorts to virtue with

a Christian's ardor. He tells, as he says, "Most bitter truth without bitterness"; and though, as we learn from his own confession, he has been judged an enemy of his country, yet, if we may judge from these specimens, no one can be more desirous of promoting all that is important to its security and felicity.

> (Moody, *Monthly Review*, 2d ser., 29 May 1799, pp. 43–44; reprinted in *The Romantics Reviewed*, ed. Donald H. Reiman [New York and London: Garland, 1972], Part A, 2:710–11)

2. See the *Complete Poetical Works* 1:257. Despite Woodring's reports of manuscript evidence (*Politics in the Poetry of Coleridge*, p. 255), Coleridge's phrase is often misquoted; W. J. Bate, *Coleridge* (New York: Macmillan, 1968), p. 42, for instance, resuscitates E. H. Coleridge's inaccurate *sermoni propriora*.

3. In a letter to Bowles on 16 October 1797, *Collected Letters of Samuel Taylor Coleridge*, ed. E. L. Griggs, 4 vols. (Oxford: Clarendon Press, 1956–1959), 1:356.

4. See Jerome J. McGann, *The Romantic Ideology* (Chicago: Chicago University Press, 1983) for an affirmation of the need for critics to break through conventionalized abstractions (such as "industrial revolution") in order to usefully assess Romanticism's "self-representing concepts" (p. 40). However, unlike McGann, I think it easier to recognize the limitations in the self-representations of an earlier era than to reconstruct the underlying aspirations and anxieties that gave rise to them.

5. *The Friend*, ed. Barbara E. Rooke, 2 vols. (London: Routledge and Kegan Paul, 1969), 1:xcviii and xxxvi. Further references to this edition are cited by volume and page number in the text.

6. For a history of the term *sublime*, see Jan Cohn and Thomas H. Miles, "The Sublime: In Alchemy, Aesthetics and Psychoanalysis," *Modern Philology* 74:3 (Feb. 1979): 289–304. Jeffrey Barnouw, "The Morality of the Sublime: To John Dennis," *Comparative Literature* 35 (1983): 21–42, discusses the term's earlier history. Cohn and Miles note Burke's emphasis on sublimity as giving not pleasure but "delight," by which he means relief from tension rather than "positive pleasure"; see Edmund Burke, *A Philosophical Inquiry into the Origin of the Sublime and the Beautiful*, ed. James T. Boulton (1959; rpt. Notre Dame: University of Notre Dame Press, 1968), pt. 4: sec. 5, p. 134; pt. 1: sec. 4, pp. 35–37; and pt. 1: sec. 18, p. 51. All subsequent quotations from this work are cited by part, section, and page number. Freud's "pleasure," of course, is very nearly Burkean "delight," relief from unpleasure, but Freud has little to say about the "positive" pleasures that are the principal concern of the Romantics.

7. My understanding of the picturesque has been reshaped by Jayme Blackley Hannay, "Jane Austen and the Picturesque Movement: The Revision of English Landscape" (Ph.D. dissertation, Columbia University, 1982), the first effective study into the function of picturesqueness; see

also Martin Price, "The Picturesque Moment," in *From Sensibility to Romanticism: Essays Presented to Frederick W. Pottle*, ed. Frederick W. Hilles and Harold Bloom (New York: Oxford University Press, 1965), 259–92. The works of John Barrell, cited in note 12 below, are also of great value for defining the circumstances in which picturesque attitudes developed.

8. Anthony, Earl of Shaftesbury, *Characteristics*, ed. John M. Robertson, 2 vols. (Gloucester, Mass.: Peter Smith, 1963), 1:136, 1:94, 2:267, 2:268. All further quotations from this edition are cited in the text by volume and page number.

9. The key figure for an understanding of the picturesque is William Gilpin; the best analysis of his work and attitudes remains Carl Paul Barbier, *William Gilpin: His Drawings, Teaching, and Theory of the Picturesque* (Oxford: Clarendon Press, 1963). Barbier explains Gilpin's influence by pointing to his emphasis on "practical" aspects of the picturesque "involving man in a direct and active relationship with the natural scenery through which he travels" (p. 99). Barbier also draws attention to Gilpin's strong bias toward the creative as opposed to the imitative, noting that "most of Gilpin's output consists of imaginary landscapes" (p. 107) and discussing the manuscript fragment of a totally invented "picturesque tour" of an imaginary country built around twenty-four of his drawings (see especially p. 138).

10. "If the qualities which I have ranged under the head of the sublime be all found consistent with each other, and all different from those which I place under the head of Beauty; . . . I am in little pain whether any body chooses to follow the name I give them or not; provided he allows what I disclosed under different heads are in reality different things in nature" (*Inquiry*, Preface to the second edition, p. 5). For Burke the sublime is invariably associated with pain, danger, terror; see *Inquiry* 1:7, p. 39, and "unnatural tension," 4:5, p. 134.

11. *The Prose Works of William Wordsworth*, ed. W. J. B. Owen and J. W. Smyser, 3 vols. (Oxford: Clarendon Press, 1974), 1:128. All quotations from Wordsworth's prose are from this edition. Stanley Cavell, in analyzing the Romantic "quest for the ordinary," identifies Wordsworth's principal target as that torpid indifference which finds the commonplace uninteresting and can only be aroused by superficial sensationalism; see his essay in the forthcoming *Romantic Poetry and Contemporary Criticism*, ed. Morris Eaves and Michael Fisher.

12. Excellent though strongly opinionated is John Barrell, *The Dark Side of Landscape: The Rural Poor in English Landscape Painting* (Cambridge: Cambridge University Press, 1980). His *Idea of Landscape and the Sense of Place* (Cambridge: Cambridge University Press, 1972) centers on John Clare, and has much of relevance to the subject of this chapter. The best surveys of agricultural history for the period are J. D. Chambers and G. E. Mingay, *The Agricultural Revolution 1750–1880* (New York: Shocken, 1966), and

Chambers, *Population, Economy, and Society in Pre-Industrial England* (London: Oxford University Press, 1972).

 13. "The Sublime impresses the mind at once with one great idea . . . it is a single blow," Sir Joshua Reynolds, *Discourses on Art*, ed. R. R. Wark (New Haven: Yale University Press, 1975), discourse 4, p. 65. The same emphasis on the potent "instant" of great art is found in other conservative aestheticians. Interest in development and continuity turned the Romantic aesthetic toward the "commonplace," the "new world" not "hitherto reflected" by books and paintings "in life's everyday appearances"—see *The Prelude* 12: 359–70.

 14. In "Moment and Movement in Art," *Journal of the Warburg and Courtauld Institutes* 27 (1964): 293–306, E. H. Gombrich argues that we must give up "the sharp *a priori* distinction between the perception of time and space" (p. 299), for "the way in which the problem of the passage of time in painting was traditionally posed" by critics such as Lessing "doomed the answers to relative sterility" (p. 293). For a good discussion of these issues, see Martin Meisel, *Realizations* (Princeton: Princeton University Press, 1983), pp. 17–20. Meisel's concern with Victorianism leads him to attend to Wilkie's art, virtually ignored by students of Romanticism beguiled by Turner and Constable, and to revive the Victorians' sharp discrimination between John Martin's alienating art and Turner's dissolutional art (pp. 166–88).

 Almost all Anglo-American comments on Lessing ignore the complexity of the debates in Germany from which Lessing's arguments arose and which led to their almost instantaneous "refutation" by Herder. Robert T. Clark, Jr., *Herder* (Berkeley: University of California Press, 1955), correctly observes, for example, that although Herder in his *Critical Forests* recognized Lessing's superiority to the Berlin school, he resisted Lessing's implicit dependence on the authority of the Greeks, as well as his rationalistic bias, so as to emphasize "constant historical flux" and to insist that the "energy" of poetry has little to do with mere succession of its signs as it "exists in both the poet and the reader or listener" (p. 82). Unfortunately, Lessing's ideas of perception as a process of mechanical aggregation (notably in chap. 17) and his rigorous separation of invention and execution (chap. 11) have not yet been the subject of serious analysis.

 15. Although the sublime does have a role in Romantic art, one must beware of too simple an identifying of Romantic with sublimity. This point is made by Bruce Clarke, "Wordsworth's Departed Swans: Sublimation and Sublimity in *Home at Grasmere*," *Studies in Romanticism* 19 (Fall 1980): 355–74; Clarke sees sublimity as accentuating or creating "disparities" that "break continuities" which sublimation restores. Clarke urges us to see Wordsworth as "*the* poet of this psychological interaction [sublimation]" which teaches us to convert the "great experience [of] sublimity into daily use" (p. 360). Paul H. Fry, "The Absent Dead: Wordsworth, Byron, and the

248 · Notes to Pages 98–102

Epitaph," *Studies in Romanticism* 17 (Fall 1978): 413–33, shows how epi-
taphic verse reveals a Romantic "poetics of the anti-sublime" (p. 413). Of
course, neither Fry nor Clarke, any more than I, wish to deny that sub-
limity has importance in Romantic art; we share a desire that the impor-
tance of countervailing tendencies be properly appreciated. Angela Leigh-
ton, *Shelley and the Sublime* (London: Cambridge University Press, 1983)
sees Shelley's skepticism toward the sublime as the origin of his explora-
tions of creativity in all his major poems.

16. Barbier, *William Gilpin*, p. 137, stresses Gilpin's desire to create "am-
biguity" and "mysteriousness" so as to stimulate the imagination, "open-
ing up his landscape, . . . suggesting more than he can actually depict,"
and notes how this practice accords with the preference of picturesque art-
ists for "low vantage points" that render the obscurity and mystery in pic-
turesque work so different from sublime versions of these qualities.

17. Richard Haven, *Patterns of Consciousness: An Essay on Coleridge* (Am-
herst: University of Massachusetts Press, 1969), emphasizes that Cole-
ridge's notion of organic form includes the audience. Haven refers to Cole-
ridge's dictum that "the artist must imitate that which is within the thing
. . . the Natur-geist . . . which puts the form together," and explains that
" 'Natur-geist' refers not to a metaphysical concept 'beyond' the image" but
to the "spirit and unity which are 'within' and prior to the image"; there-
fore, "if organic form involves such a relationship it follows . . . that it
must be characteristic not of the poem as object but of the poem as we
experience it" (p. 172).

18. The Russian formalists' concept of defamiliarization seems a nega-
tive, reductive version of Romantic practice, especially as it is applied to
the work of Tolstoy, who inspired formalist theorizing. Tolstoy is much con-
cerned with the intrinsic equivocality of the ordinary, recognizing that not
merely habit but also internalized systems of disavowal prevent us from
acknowledging the importance of the commonplace, so that to "make
strange" for him, as M. M. Bakhtin has observed, meant to enrich as well
as de-automatize. For a succinct formalist discussion of defamiliarization,
see Victor Shklovsky, "Art as Technique," in *Russian Formalist Criticism:
Four Essays*, trans. and ed. L. T. Lemon and M. J. Reis (Lincoln: University
of Nebraska Press, 1965).

19. Hannay, "Austen and the Picturesque Movement," pp. 38–39; see
also Alexander Cozens, *New Method of Assisting the Invention in Drawing
Original Compositions of Landscape* [1785] (London: Paddington Press, 1977).

20. "As our poets warm their imaginations with sunny hills, or sigh
after grottoes and cooling breezes, our painters draw rocks and precipices
and castellated mountains, because Virgil gasped for breath at Naples, and
Salvator wandered amidst Alps and Apennines. Our ever-verdant lawns,
rich vales, fields of haycocks, and hop-grounds are neglected as homely
and familiar objects"; Walpole, *Anecdotes of Painting in England* [1765–

1771], ed. Ralph N. Wornum, 3 vols. (London: H. G. Bohn, 1862), 2: 717–18.

21. Anne K. Mellor, "Coleridge's 'This Lime Tree Bower My Prison' and the Categories of English Landscape," *Studies in Romanticism* 18 (Summer 1979): 253–70, juxtaposes theoretical statements about landscape with passages from the poem.

22. I return to the issue of the pathetic fallacy in chapter 8. To understand the significance of Stanley Cavell's observation that the crux of the Romantic "quest for the ordinary" lies in Romantic "animism" (see note 11), one should recognize, first, that this animism is not anthropomorphism, and, second, that it is a reaction against that "enlightened" cast of mind, manifested in Ruskin's term *fallacy*, that denies the capacity of mankind to humanize the world through conscious use of the imaginative powers embodied in language. People have always attributed human feelings to nonhuman creatures and phenomena, but with the spread of scientific rationalism intellectuals like Ruskin began to regard such attributions as a retrogressive betrayal to primitivism or childishness.

In "Lines Written in Early Spring," however, Wordsworth says that "I must think, do all I can" ("do all I can" I take to mean that he resists with the best strengths of internalized commands of Enlightenment culture) that "every flower / Enjoys the air it breathes." He does not say that flowers feel like us, which would reduce his animism to anthropomorphism, but more subtly because more skeptically says that his "faith" is that they find pleasure in the process of respiration. We breathe differently, but if to breathe is to enjoy, then the basis of being, what we and flowers share in our differences, is what Wordsworth in the Preface to *Lyrical Ballads* calls "the grand elementary principle of pleasure." Twentieth-century critics who have been influenced by Freudian psychology, in which a distinction between "the pleasure principle" and "the reality principle" is fundamental, have difficulty doing justice to the Romantic tendency to subsume the latter principle in the former. Some implications for criticism in the Romantics' celebration of pleasure are suggested in the Coda.

23. Helen Vendler, *The Odes of John Keats* (Cambridge, Mass.: Harvard University Press, 1983), pp. 233–88, provides some useful insights through a reading deeply indebted to Geoffrey Hartman's "Poem and Ideology: A Study of Keats's 'To Autumn,'" (1973; rpt. *The Fate of Reading* [Chicago: Chicago University Press, 1975], pp. 124–46). But her analysis moves in a direction quite different from mine. Although Vendler concentrates on literary tropes, she makes some parade of judging Keats's account of natural actualities, observing, for example, that the bees in the first stanza are "out of sequence" because the flowers they harvest arrive "after the appearance of fruit" (p. 247). This is to risk confusion, for the ripeness of the fruit proves the bees did their proper job in the spring; in September the bees, properly, are visiting quite different plants. This small point illustrates the

Keatsian-Romantic tendency to overlap and superimpose temporal processes and often to foreground such processes in the natural world.

24. To make such observations is not to ignore the validity of Jerome J. McGann's objection to oversimplified claims for the "nationalism" of poems such as "To Autumn"; see McGann, "Keats and the Historical Method in Literary Criticism," *Modern Language Notes* 94 (1979): 988–1032. McGann is correct that Keats's lines bring forward "archaic" qualities of the natural world that precede the developments of England's agriculturally based society, changes described by Mingay and Chambers (see note 12). This happens, however, because the Romantic poet does not, like a picturesque sentimentalizer, ignore the changes in his land, but founds his nationalistic feelings in the natural reality of his country.

5. FRICTION

1. Quoted by Peter Paret, *Clausewitz and the State* (New York: Oxford University Press, 1976), p. 129. My discussion of Clausewitz's life and the development of his ideas draws heavily on Paret's excellent study of Clausewitz's life, writings, and letters and the political intricacies of Romantic Prussia.

2. Of all the officers who chose this course, Clausewitz seems to have most irritated the king, and Clausewitz's subsequent career was shadowed by peculiar royal disfavor.

3. For Clausewitz's discussion of friction, see *On War*, ed. and trans. by Michael Howard and Peter Paret (Princeton University Press: Princeton, 1976), p. 119–21; all subsequent quotations are from this splendid edition. Of note are the volume's valuable essays and commentary by the editors and by Bernard Brodie.

A sampling of Clausewitz's comments:

> Everything in war is very simple, but the simplest thing is difficult. The difficulties accumulate and end by producing a kind of friction that is inconceivable unless one has experienced war.

> Countless minor incidents—the kind you can never really foresee—combine to lower the general level of performance. . . . Friction is the only concept that more or less corresponds to the factors that distinguish real war from war on paper.

> The good general must know friction in order to overcome it whenever possible, . . . it is a force that theory can never quite define. . . . the force that makes the apparently easy so difficult.

4. Walter Scott's parallel interest in different kinds of war is well illustrated by his discussion in *The Legend of Montrose*, chap. 15, a passage that might almost have been written by the Prussian general.

5. "Politics . . . is the womb in which war develops—where its outlines

already exist in their hidden rudimentary form, like the characteristics of living creatures in their embryos" (*On War*, p. 149).

6. "No other human activity is so continuously and universally bound up with chance" (*On War*, p. 85); "War is the realm of chance . . . no other human activity gives it greater scope" (p. 101); "War is dependent on the interplay of possibilities and probabilities, of good and bad luck, conditions in which strictly logical reasoning often plays no part at all and is always apt to be a most unsuitable and awkward intellectual tool" (pp. 580–81).

7. For example, Clausewitz cites "the faculty of *quickly and accurately grasping the topography of any area* which enables a man to find his way about at any time. Obviously this is an act of the imagination. . . . *it can only be achieved by the mental gift that we call imagination.*" The emphases are Clausewitz's and that he is not casually employing a metaphor is further proved by the discussion that follows, which begins: "A poet or painter may be shocked to find that his Muse dominates these activities as well" (p. 109).

8. Substantive questions about the possible relations between Scott and Clausewitz remain unanswered. Clausewitz moved in intellectual and literary circles in Berlin, and it seems certain he knew of Scott, but there is no evidence that Scott, though he read German, ever heard of Clausewitz. But Scott was deeply interested in contemporary military events. In the *Edinburgh Annual Register*, for instance, he published long accounts of the last two years of Napoleon's military career, material he extensively revised on the basis of later information when he published his *Life of Napoleon* in 1827. Earlier he had written an essay on contemporary French battle tactics.

9. Scott's use of "fictional logic" to represent historical "illogicalities" is exemplified by his invention of Cornet Grahame as a nephew of Claverhouse and also his invention of the motive for the murder of the fictitious character. Burley, who answers for the Presbyterians, is recognized by Grahame as one of the murderers of Archbishop Sharpe, and the Cornet explicitly exempts him from the pardon offered the other Covenanting troops. This breach in the rules for military parleying is Burley's excuse for shooting Grahame, an excuse that dramatizes the violence masquerading as legality that characterizes fanatics on both sides in the romance.

10. After the victory we are told:

> The whole army appeared at once to resolve itself into a general committee for considering what steps were to be taken in consequence of their success, and no opinion could be started so wild that it had not some favourers and advocates. Some proposed they should march on Glasgow, some to Hamilton, some to Edinburgh. . . . Some were for sending a deputation of their number to London to convert Charles II to a sense of the errors of his ways; . . . others . . . to call a new successor to the crown, or to declare Scotland a free republic. . . . In the meantime a clamour arose . . . for bread and other necessaries, and while all complained of hardship and hunger, none took the necessary measures to procure supplies. In short, the camp of the Covenanters,

even in the very moment of success, seemed about to dissolve like a rope of
sand.

(*Old Mortality* [New York and London:
Dent and Dutton, 1969], chap. 18, pp. 188–89)

I cite from the Everyman edition as the most generally accessible, and
from the same edition (1978) for *Waverley*.

My commentary owes much to Jennifer Fleischner, "Class, Character,
and Landscape in *Old Mortality*," *Scottish Literary Journal* 9:2 (Dec. 1982):
21–36. A. O. J. Cockshut, *The Achievement of Walter Scott* (London: Collins,
1969), provides an excellent analysis of the battle at Loudon Hill (pp. 66–
71), with special attention to the paragraph just quoted. Scott was chal-
lenged by some Presbyterians as an anti-Covenanter; see Thomas McCrie,
Miscellaneous Writings (Edinburgh: John Johnstone, 1841), pp. 247–50, for
a major attack. On Scott's historical accuracy and attitudes current in his
day, see James Kirkston, *The Secret and True History of the Church of Scotland*
(Edinburgh: Ballentyne, 1817); John Howie, *The Scots Worthies* (Glasgow:
Dunn and Wright, n.d.); and Robert Wodrow, *A History of the Sufferings
of the Church of Scotland* (Glasgow: Blackie, Fullerton, 1829). These works
suggest that Scott attributed to the extremists among the Covenanters divi-
sive actions for which the moderates, in fact, may have borne principal
responsibility.

11. See *Waverley*, chap. 30. In Scott's romances there is little of the type of
coincidence we associate with either the providential order of eighteenth-
century comic fiction or the solemnity of Victorian novels, notably those of
Dickens and Hardy in which "chance events" function as part of the sys-
tematized plot structure. An equivalent systematizing of the random in-
forms symbolic modern works such as *Ulysses*. Scott's romances allow for
authentically and purely chance events because they deal with friction and
accept the possibility of diverse kinds of strangeness—see note 15.

12. Scott's perception anticipates Marx's comments on the French peas-
antry in *The Eighteenth Brumaire*, where he compares their unity to that of a
sack of potatoes. Scott's advantage over Marx lies in his firsthand knowl-
edge of agrarian life—he had none of Marx's urban prejudice against
"rural idiocy."

13. Notice the description of the troops' approach to the Castle of
Tillietudlem (chap. 11, pp. 123–25) and Morton's view of the Royalists
(chap. 15, p. 161), a view that foretells their difficulties against opponents
so effectively positioned within natural defenses.

14. Berlin, "Nationalism," in *Against the Current* (London: Hogarth
Press, 1979), p. 348. Quite relevant is the point made by Eric Hobsbawm,
The Age of Capital (New York: Scribners, 1975), that nationalistic ideas tend
to be formulated and disseminated first by intellectuals, often penetrating
to the least-educated, and therefore the most tradition-oriented, segments
of society last.

15. For an excellent analysis of Scott's techniques for presenting such

material, see Daniel Cottom, "The Waverley Novels: Superstition and the Enchanted Reader," *ELH* 47 (1980): 80–102. On the romances' effects on the reader, Cottom observes that "the enchantment which leads his protagonists into confusion and distress is entirely parallel to that which he expects to exert through his narratives. The reader of Scott's romances faces the same problems of deciphering their treacheries, dangers, and spells as are faced by the characters within those romances" (p. 86). In the following chapter I deal at length with implications of this view, pursuing the same insight that underlies Cottom's readings: "Scott treats the enchantments of literature exactly as he does those of superstition, criticizing their unreality within the very novels which resuscitate and give even greater life to that unreality" (p. 87).

16. Another way of defining the unusual nature of Scott's romances is to observe that his purposes require diverse kinds of defamiliarizing. The reader's response to Maccombich in the courtroom, for example, is almost the exact opposite of his sympathetic understanding of Waverley's situation when he, among some of MacIvor's clan, prepares to ambush the troop in which he so recently had served as an officer, "what seemed at the moment a dream, strange, horrible, and unnatural" (chap. 46, p. 331). Because Scott emphasizes different structurings of reality, his readers confront diverse kinds of estrangements.

6. HISTORICAL FICTION TO FICTIONAL HISTORY

1. See Scott's 1830 introduction to *The Heart of Midlothian*, ed. John Henry Raleigh (Boston: Houghton Mifflin, 1966), pp. 3–7, from which we learn, for example, that Helen Walker, unlike Jeanie, "lived and died in poverty" (p. 7). Subsequent citations are from this edition, by chapter and page number. For a discussion of the distinctions between implied author, a historical figure, and a novel's narrator, see Michel Foucault, "What Is an Author?" [1969], in *Language, Counter-Memory, Practice*, ed. David F. Bouchard (Ithaca: Cornell University Press, 1977), pp. 113–38. When I use the name of an author I am referring to what Foucault calls "author function."

2. As Richard Waswo observes, "in the novels history becomes the fictions that individuals and groups tell about each other and themselves"; "Story as Historiography in the Waverley Novels," *ELH* 47 (1980): 304–30, p. 314. Waswo also notes that "the relation between the writer and reader *by* the text is construed in the same way as that between the hero and society presented *in* the text" (p. 324). Another key article in the ongoing revaluation of Scott is: Ernest Bevan, Jr., "*Waverley* and the Forms of Temporal Perception," *Massachusetts Studies in English* 5:4 (1978): 11–17. Two other fine articles illustrate a more directly historical approach that determines my reading of *Midlothian*. Francis R. Hart, "Scott's Endings: The Fictions of Authority," *Nineteenth-Century Fiction* 33 (1978): 48–68, analyzes

the complexity of Scott's response to "the crisis of authority through which he lived" (p. 48); the article is an admirable companion to Hart's *Scott's Novels: The Plotting of Historical Survival* (Charlottesville: University of Virginia Press, 1966). Even more valuable is John Macqueen, "Scott and 'Tales of My Landlord,'" *Scottish Studies* 15 (1971): 85–97, which examines the radical transformations in Scottish life produced by the agricultural revolution of the late eighteenth century and shows how this perspective led Scott to his unusually fluid representations of historical processes as interplayings of continuity and change.

More generally, I am indebted of course to Georg Lukács's pages in *The Historical Novel*, trans. Hannah Mitchell and Stanley Mitchell (London: Methuen, 1962), the starting point for all critical analyses of the Waverley novels for the past quarter century. Another eastern European who has written well on Scott is Nina Diakonova; her "The Aesthetics of Walter Scott," *Zeitschrift für Anglistik und Amerikanistik* 24 (1976): 5–21, provides a good general overview. Robert C. Gordon, *Under Which King?* (Edinburgh: Oliver and Boyd, 1969) is an excellent study of the Scottish novels. Also relevant are A. D. Hook, "Sir Walter Scott and the Historical Novel," *Clio* 5:2 (1976): 181–92, an assessment of Scott's relation to Jane Porter; and James Anderson, *Sir Walter Scott and History* (Edinburgh: Edina Press, 1981), in which Anderson concludes, apparently to his own surprise, that "Scott was, considering his romantic reputation, almost incredibly down-to-earth in his dealings with history" (p. 107). This is exactly the point that Victorians like Carlyle and Ruskin ignored in romanticizing Scott's medievalism—see notes 4 and 8 below.

3. Readers who think Scott wrote casually, if unimpressed by his use of "tow," Snap's fate, or Maggie Dickson's neck "a wee agee," might consider the bitter appropriateness of "discern" in this passage.

4. Victorians, particularly Victorian illustrators, regularly attributed nostalgic sentiments to Scott, a misapprehension repeated by some modern readers; see Catherine Gordon, "The Illustration of Sir Walter Scott: Nineteenth-Century Enthusiasm and Adaptation," *Journal of the Warburg and Courtauld Institutes* 34 (1971): 297–314. Jeanie and Effie Deans were perhaps the most popular subjects for these illustrators, for reasons analyzed by Nina Auerbach, *Woman and the Demon* (Cambridge, Mass.: Harvard University Press, 1982), pp. 190–98; Auerbach's reinterpretation treats many issues central to my work.

5. Characteristic is Scott's remark in the general preface to the "Magnum Opus" edition of the Waverley novels. He notes that he "has studied (with the prudence of a beauty whose reign has been rather long) to supply by the assistance of art, the charm which novelty no longer offers"; *The Prefaces to the Waverley Novels*, ed. Mark A. Weinstein (Lincoln: University of Nebraska Press, 1978), p. 101. The dominant figure in Scott's presentation of art throughout his career is that of his first major narrative, the last minstrel.

6. *Barnaby Rudge* has not usually been highly regarded. Recent praise, as in John P. McGowen, "Mystery and History in *Barnaby Rudge*," *Dickens Studies Annual* 9, ed. Michael Timko et al. (Carbondale: Southern Illinois University Press, 1981), tends to be weakened by too simplistic conceptions of history and historical fiction, the flaw in Avrom Fleishman's commentary in his *English Historical Novel* (Baltimore: Johns Hopkins University Press, 1971). Contorted but more significant is the essay by Paul Stigant and Peter Widdowson, "*Barnaby Rudge*—a Historical Novel?" in *Literature and History* 1:2 (1975): 2–44, which takes account of earlier commentaries of merit by Lindsay, Lukács, and Dyson. See also Steven Marcus's chapter on the novel in *Dickens: From Pickwick to Dombey* (New York: Simon and Schuster, 1968). All citations are from the New Oxford Illustrated Dickens, ed. Kathleen Tillotson (1954) by chapter and page.

7. The nature of Dickens's innovations is suggested by the unanimity with which Victorian scholars insist that his second historical novel, *A Tale of Two Cities*, owes more to Carlyle than does *Barnaby Rudge*. The later novel *is* conventionally dependent on Carlyle, from whom Dickens borrowed a cartload of reference books, yet such deliberate modeling excludes the more diffuse but intense emotional response animating *Barnaby*. In 1836 Dickens was planning a novel under the title of *Gabriel Varden, Locksmith of London*, a novel that did not appear until 1841, after the climactic Chartist uprisings and the sensational success in 1837 of Carlyle's *French Revolution*, whose fiery portrayal of mob violence must have inspired some changes that transformed *Gabriel* into *Barnaby*. At issue is inspiration not imitation. Dickens had plenty of imagination, but the explosiveness of the riot scenes in *Barnaby* was surely ignited by Carlyle's epic imagery of fire and mob madness.

Carlyle, born the same year as Keats, began his career as a Romantic historian, but later changed his views and developed an antipathy to Scott. Carlyle's transformation is too complex, and the issues it raises too broad and subtle, for me to deal with here: The evolution of Carlyle's thinking about history and historians takes one to the very heart of Victorian resistance to Romanticism. The complexity of this antagonism may be suggested by the observation that Scott, a child of the Scottish Enlightenment, did not—from the Victorian point of view—sufficiently admire the Middle Ages. He seldom writes of the medieval world without mentioning sottish drunkards, and he does not romanticize the era. In sum, Dickens's rejection of Scott's kind of historical fiction is not merely a personal choice but is linked to large shifts in intellectual history.

8. A. O. J. Cockshut, *The Achievement of Walter Scott* (London: Collins, 1969), p. 145, discusses Scott's effectiveness in terms of Mause's denying the "Covenant of Works" in *Old Mortality*:

> To Mause the Covenant of Works is the Arminian or Catholic doctrine of salvation by works as well as faith. It denies total depravity, irresistible grace, and all the glory and terror of the Calvinist tradition. . . . Cuddie knows her

feeling well enough to play on it and deceive Bothwell, but cannot grasp its seriousness for her. . . . For Bothwell "covenant" is no more than a word used as a badge. That it really contains meaning, still more that it may contain a variety of meanings . . . is entirely beyond his comprehension.

9. George Eliot, *Middlemarch*, ed. Gordon Haight (Boston: Houghton Mifflin, 1956), p. 3.

10. The next-to-last sentence of the "Prelude" reads: "Here and there a cygnet is reared uneasily among the ducklings in the brown pond, and never finds the living stream in fellowship with its oary-footed kind" (p. 4). The final sentence of the "Finale" reads: "But the effect of her being on those around her was incalculably diffusive: for the growing good of the world is partly dependent on unhistoric acts; and that things are not so ill with you and me as they might have been, is half owing to the number who lived faithfully a hidden life, and rest in unvisited tombs" (p. 613).

11. Letter to John Blackwood, 12 November 1873, in *The George Eliot Letters*, ed. Gordon S. Haight (New Haven: Yale University Press, 1955), 5:459. (The emphasis on "structure" is Eliot's.)

12. Ian Watt, *Conrad in the Nineteenth Century* (Berkeley and Los Angeles: University of California Press, 1979) provides a comprehensive and judicious survey of most of these issues in relation to *Heart of Darkness* (pp. 126–253).

13. *Heart of Darkness*, ed. Robert Kimbrough (New York: Norton, 1963), p. 47.

14. Leo Tolstoy, *Master and Man and Other Stories*, trans. Paul Foote (Harmondsworth, Eng.: Penguin, 1977), p. 270. John Bayley's discussion of this novel, the best I know of in English, appears in his *Tolstoy and the Novel* (New York: Viking, 1967).

Nicola Chiaramonte, *The Paradox of History* (London: Weidenfeld and Nicolson, n.d.) describes well the ironic complexity of Tolstoy's attitude toward history, whose roots lie in the Romantic use of history to deny any absolute value to history, illustrated by Scott's refusal in the Scottish novels to encourage hero worship, a refusal extended and developed by Byron in *Don Juan*. Chiaramonte observes that Tolstoy "wants us to dismiss as irrelevant . . . the ideological constructions and supposedly rational explanations of events that lead to hero worship. This position implied the radical rejection of the nineteenth-century idea that since the truth about human life could no longer be found in religion, in nature, or in the individual, it had to be looked for in the historical adventure of man" (pp. 45–46).

15. The topic, of course, of Joseph Frank's famous essay, "Spatial Form in Modern Literature," in a later form in his *Widening Gyre* (Bloomington: Indiana University Press, 1968), pp. 3–62, and in the less noted but important essay by William V. Spanos, "Modern Criticism and the Spatialization of Time," *Journal of Aesthetics and Art Criticism* 29:1 (1970): 87–104.

7. HISTORY, HELLENISM, AND ETERNAL EVANESCENCE

1. Montesquieu, *Considerations on the Causes of the Greatness of the Romans and Their Decline*, trans. David Lowenthal (New York: Free Press, 1965), p. 23 (from the edition of 1848).

2. I cite Hume's *Enquiry Concerning Human Understanding* as quoted by Emery Neff, *The Poetry of History* (New York: Columbia University Press, 1947), p. 230; Neff was the first American literary scholar seriously to discuss the relevance of historiographic changes to developments in poetry.

3. Barthold Niebuhr, *The History of Rome*, trans. Julius Hare and Connop Thirlwall (London: Walton, 1855), 1:1.

4. Thomas Carlyle, "On History" [1830], in *English and Other Critical Essays* (London: Dent, 1940), pp. 82–83.

5. I cite from the Modern Library three-volume edition of Gibbon's *Decline and Fall* (New York, n.d.).

6. I quote from the two-volume Everyman edition (London: Dent, 1966) of Carlyle's *The French Revolution*.

7. An excellent study of these shiftings is H. M. Leicester, Jr., "The Dialectic of Romantic Historiography: Prospect and Retrospect in *The French Revolution*," *Victorian Studies* 15 (1971): 5–17. See also Philip Rosenberg, *The Seventh Hero* (Cambridge, Mass.: Harvard University Press, 1974), as well as René Wellek's essay "Carlyle" in *Confrontations* (Princeton: Princeton University Press, 1965), and Hedva Ben-Israel, *English Historians on the French Revolution* (Cambridge, Mass.: Harvard University Press, 1968). Morse Peckham, "*Frederick the Great*," in *Carlyle Past and Present*, ed. K. J. Fielding and R. L. Tarr (London: Vision Press, 1976), pp. 198–215, argues persuasively that even Carlyle's last history is primarily a drama of the historian struggling to learn how to read historical documents.

8. Ruskin, in "Of Truth in Space," is excellent in using Turner to exemplify how representation can be mysterious without being vague, precise without being recognizable. He says, for instance, of Turner's distance, "not one atom . . . which does not suggest more than it represents; nor does it suggest vaguely . . . not one line . . . without meaning, yet there is not one which is not affected and disguised by the dazzle and indecision of distance. No form is made out and yet no form is unknown"; *Modern Painters* 2d ed. (London: George Allen, 1900), 1:139.

9. I cite from the Maude translation of *War and Peace*, ed. George Gibian (New York: Norton, 1966), pp. 917–18 and 922.

10. Ernest G. Schachtel, "On Color and Affect," *Psychiatry* 6 (1943): 393–407, p. 396. Gerald Wilkinson, *Turner's Colour Sketches* (London: Barrie and Jenkins, 1975), p. 147, commenting on two sunset sketches, observes that Turner has "concentrated on what seems to be the struggle of the colours of fire and blood against the encroaching purple of night, or

death. There are many indications in his notebooks that Turner thought of his colours in just such terms."

11. All citations from Shelley are from *Selected Poetry*, ed. Neville Rogers (Boston: Houghton Mifflin, 1968), checked against G. M. Matthews's corrected second edition of the *Poetical Works*, ed. Thomas Hutchinson (London: Oxford, 1970), and those passages reproduced by Judith Chernaik, *The Lyrics of Shelley* (Cleveland and London: Case Western Reserve Press, 1972). Chernaik's commentaries, pp. 61–74 and 168–75, and Donald H. Reiman, "Structure, Symbol, and Theme in 'Lines Written Among the Euganean Hills,'" *PMLA* 76 (1962): 404–13, are invaluable. I have also relied on Carl Woodring's commentary in *Politics in English Romantic Poetry* (Cambridge, Mass.: Harvard University Press, 1970), pp. 252–62; Earl Wasserman, *Shelley* (Baltimore: Johns Hopkins University Press, 1971), pp. 197–203; and Kenneth N. Cameron, *Shelley: The Golden Years* (Cambridge, Mass.: Harvard University Press, 1974), pp. 267–70.

12. Quoted by A. J. Finberg, *The Life of J. M. W. Turner, R.A.*, 2d ed. (Oxford: Clarendon Press, 1961), pp. 247–48. Any comparison of *Dido* and Claude's *Seaport* requires mention of Turner's *Apullia in Search of Appullus* of the previous year, which derived from another Claude painting and was possibly a deliberate provocation of Sir George Beaumont. Wilkinson, *Turner's Colour Sketches*, argues persuasively that Turner's Italian journey of 1819 followed a decisive advance in his techniques, a position supported by John Gage, *Color in Turner: Poetry and Truth* (New York: Praeger, 1969), an indispensable book. Philip Fehl, "Turner's Classicism and the Problem of Periodization in the History of Art," *Critical Inquiry* 3 (1976): 93–129, intelligently delineates the positive aspects of Turnerian "regressions," to which I return in the next chapter.

Turner also challenged Claude in his first exhibition at the Royal Academy, pairing *Dido* with *Crossing the Brook*, thus juxtaposing "contemporary" with ancient, landscape with history. In a thorough and thoughtful survey, Michael Kitson, "Turner and Claude," *Turner Studies* 2:2 (1983): 2–15, points out that *The Embarkation of the Queen of Sheba*, which Turner chose to hang beside *Dido Building Carthage*, his *first* "seaport" picture, was the *last* of Claude's seaports; there was "nothing comparable painted in the century and a half between them" (p. 11). Michael Wilson, *Second Sight: Claude, "The Embarkation of the Queen of Sheba" and Turner, "Dido Building Carthage"* (London: National Gallery, 1980) provides detailed analyses of the pairing. To my mind the most significant consistent difference between the two landscapists is their skies: Claude's are usually clear, that is to say, empty, while Turner's are clouded, that is, crowded and alive.

13. Comments by Hunt, Hazlitt, and Beaumont quoted by Finberg, *Life of Turner*, pp. 240–41.

14. On this point I find Wasserman's reading (*Shelley*, p. 200) unpersuasive but exemplary of modern criticism of the Romantics: "the poet's

moment of noon . . . is a timeless moment," even though it is, Wasserman admits, "his historical revelation." For many twentieth-century critics it is inconceivable that a climactic experience should not transcend time: "the unifying noontime radiance endows the poet with his own personal experience of perfection, his external moment of absolute illumination, his insight into eternity and into the unity of which he is a part" (Wasserman, p. 200). "Eternal moment" is imported by the twentieth-century critic; Shelley strives to recreate a vision in and of time—*an* instant, to be sure, but conceived as evanescent and existing only through its participation in an emcompassing flow of temporality. The deepest critical confusion about Romanticism is the introduction of an overly simplified antithesis between the *transitory* and the *eternal*. Romantics like Shelley, as Alfred North Whitehead points out, were interested in the eternality of evanescent phenomena, such as color; see Whitehead, *Science and the Modern World* (New York: Macmillan, 1931), chap. 5.

15. Chernaik observes that "throughout the poem the relationship between scene and the thought it occasions is complex" (*Lyrics of Shelley*, p. 68). The chief complexity is that the thought also "occasions" the scene. To Shelley, because the mind quite literally "feeds" verse, the poet can "people" the lone, companionless universe.

16. Careful critics have noticed the shiftings within metaphors: "the 'green isle' is not only a physical refuge but a moment of time, a metaphor for the poet's day . . . the moment is but an interlude: it passes with the day, and the poet resumes his original metaphor" (Chernaik, *Lyrics of Shelley*, pp. 65 and 71). See Woodring, *Politics in English Romantic Poetry*, p. 261, on the Lombard cities as dancing graces and chained slaves.

17. See Wasserman, *Shelley*, pp. 374–414; on improvisation, pp. 378–80; on Shelley's view as Hegelian, pp. 402 and 411, where Wasserman identifies Shelley's position with Hegel's *Philosophy of History*, "each successive culture degenerates from its prime and returns to a new state of possibility, but with each return Spirit gains new strength and greater purity." Although Shelley's intellectual roots ran deep within Enlightenment traditions, he, like Scott, arrives finally at a position more "counter-Enlightenment" than some of his Romantic contemporaries, like Hegel. Maurice Mandelbaum, *History, Man, and Reason: A Study in Nineteenth-Century Thought* (Baltimore: Johns Hopkins University Press, 1971) has perhaps most clearly distinguished these trends: "There were two distinct . . . sources of the view that the category of development provided the basic means of understanding reality and human history. One can be identified with the Romantic rebellion against the Enlightenment, whereas the other was . . . a continuation of the Enlightenment tradition" (p. 47). Of the second source, Mandelbaum observes that its "deterministic conception of social change could only be upheld so long as it was assumed that 'history' was not in fact a series of different streams . . . but that . . . all peoples

could be said to be part of a single history, the history of Mankind" (p. 49).

18. Stanley Cavell, *Must We Mean What We Say?* (Cambridge: Cambridge University Press, 1976), pp. 200–201. Cavell's comments on music seem to me apt, but the circumstances of literature and art, though analogous, are sufficiently different to warrant more careful analysis. I would hope the reader will relate "imagined improvisation" to the issues raised regarding "fictionalized music" in chapter 3.

19. An excellent essay by Constance Walker, "The Urn of Bitter Prophecy: Antithetical Patterns in *Hellas*," *The Keats-Shelley Memorial Bulletin* 33 (1982): 36–48, argues that "the antithetical structure of the work itself thus ultimately allows for both scepticism and hope" (p. 48). Earlier discussions germane to this approach to *Hellas* are Timothy Webb, *Shelley: A Voice Not Understood* (Manchester: Manchester University Press, 1977), pp. 199–208, and Stuart Curran, "The Siege of Hateful Contraries: Shelley, Mary Shelley, Byron, and *Paradise Lost*," in *Milton and the Line of Vision*, ed. Joseph A. Wittreich, Jr. (Madison: University of Wisconsin Press, 1975), pp. 209–30.

20. *Don Juan*, ed. Leslie A. Marchand (Boston: Houghton Mifflin, 1958), canto 4, stanza 72.

21. On the development of Shelley's intellectual career, his social and political thought, from its origins in the idealistic utopianism of *Queen Mab*, see Cameron, *Shelley: The Golden Years* (cited in note 11) and his *Young Shelley: Genesis of a Radical* (New York: Macmillan, 1950).

8. PLURALIZED VISIONS

1. At the beginning of the famous fourteenth chapter of the *Biographia Literaria*, Coleridge speaks of "the modifying colours of imagination"; in the Preface to *Lyrical Ballads* Wordsworth says his principal object was to "throw over" incidents and situations from common life "a certain colouring of the imagination, whereby ordinary things should be presented to the mind in an unusual aspect"; and Shelley in "A Defence of Poetry" describes imagination as "mind acting upon . . . thoughts so as to colour them with its own light," and compares imagination to "the colour of a flower which fades and changes as it is developed." These passages are particularly interesting because the poets also use "coloured" in the sense of "falsified" or "distorted"—Wordsworth does so later in the 1802 Preface from which I have just quoted, for example, when he condemns deviations "from the real language of nature . . . coloured by a diction of the Poet's own." Because the imagination is powerful in its effects, it is dangerous; the strength to create implies strength to deform.

2. Two fine essays on the Romantics' use of reflections are James A. W. Heffernan, "Reflections on Reflections in English Romantic Poetry and Painting," *Bucknell Review* (Fall 1978): 15–37; and William C. Stephenson, "The Mirror and the Lute: Wordsworth's Fine Art of Poetic Ascultation,"

Yearbook of English Studies 6 (1976): 101–12. Heffernan stresses the importance of the double meaning of *reflect*, which foregrounds the temporal dimension implicit in many reflections.

3. Blake's well-known phrase is from "The Mental Traveller," and I cite Shelley's words from "A Defence of Poetry," though equivalent statements can be found elsewhere in his work. One detects, of course, some influence of Berkeley on this Romantic view, but a decisive difference can be phrased crudely thus: the Romantics regard perception as active, literally having effects on external phenomena. What upset their contemporaries, and has baffled many subsequent critics, is the literalness with which they conceived the effective potency of imagination. Most of us find it difficult to believe Blake's *alters* is transitive—but it is. For him, the eye can change what it sees. This conception we understand best in relation to ideology, as when Shelley asserts that tyrants are a creation of a slavish state of mind. But even in this realm, because we do not share the literalness of the Romantic conception, we underestimate their awe, even fear, of imaginative power. The power to make "the familiar appearance and proceedings of life . . . wonderful and heavenly," as Shelley describes imagination in his "Defence," can produce deleterious effects. Humans can and have created savage gods and vicious tyrants; often what we have made of the world has been to our detriment.

4. James Engell, *The Creative Imagination: Enlightenment to Romanticism* (Cambridge, Mass.: Harvard University Press, 1981), traces the "growth of the concept" of imagination from its inception in the Enlightenment, "with its more philosophical underpinnings." Though he only touches Wordsworth's poetry "as it reflects or extends these major issues," Engell finds the poet "carrying out theories and values prized by many associationist critics he read" (p. 265). My focus on how Wordsworth used imagination leads to a somewhat different understanding of "associationalism" in his poetry, but it is worth noting the tendency of recent scholarship to take up the topic of Wordsworth and associational psychology, a relationship asserted by Arthur Beatty more than half a century ago. Mary Warnock, *Imagination* (London: Faber and Faber, 1976), a more philosophic work than Engell's, stresses Wordsworth's and Coleridge's attributing to imagination a capacity to shape by means of an inner power while allowing us to feel.

5. All references are to the 1805 version from *The Prelude 1799, 1805, 1850*, ed. Jonathan Wordsworth, M. H. Abrams, and Stephen Gill (New York: Norton, 1979), identified by book and line number. For an extensive survey of scholarship dealing with *The Prelude*, including a subsection devoted to Book Five, see my "Wordsworth," in *The Romantic Poets: A Review of Research*, 4th rev. ed., ed. Frank Jordan (New York: Modern Language Association, forthcoming).

6. See John Crow Ransom's fine commentary on Wordsworth's repre-

sentation of powerful experiences befalling a boy who is "about a boy's business," in *Wordsworth Centenary Essays*, ed. Gilbert Dunklin (Princeton: Princeton University Press, 1951).

7. On this point, see Ian Gilchrist, *Against Criticism* (London: Faber and Faber, 1982), chap. 5, especially the discussion of *suspension* on pp. 193–99.

8. Isobel Armstrong, "Repetition and Doubled Syntax in *The Prelude* Book VI," *The Oxford Literary Review* 4:3 (1981): 20–42. Also impressive is Armstrong's earlier "Tintern Abbey," in *Augustan Worlds*, ed. J. C. Hilson, M. M. B. Jones, and J. R. Watson (New York: Harper and Row, 1978), pp. 261–79. Relevant also are Gilchrist, *Against Criticism*, and Frances O. Austin, "Time, Experience, and Syntax in Wordsworth's Poetry," *Neuphilologische Mitteilungen* 70 (1969): 724–38. Such doublings remind us that the perception of reflection as reflection is, as Wordsworth implies in the Preface to *Lyrical Ballads*, perhaps the fundamental act of imaginative perception; *this* is an image of *that*, the same but different, "similitude in dissimilitude" in Wordsworth's language. The Romantic fondness for representing this basic human proclivity encourages the audience to reflect on the nature of perception and thereby to reperceive.

9. Only rarely in *The Prelude* does Wordsworth use the most basic techniques for attaining coherence in a long work: exact repetition, clear parallelism, accurate echoing. Hence the aptness of Kenneth R. Johnston's observation on Wordsworth's "compositional crises" in *The Prelude* as "crises in which the reader must participate" so that "the sensation of losing one's way that occurs in reading almost every book of *The Prelude* . . . properly accompanies every re-reading of the poem"; *Wordsworth and The Recluse* (New Haven: Yale University Press, 1984), p. 122.

10. Heffernan, "Reflections on Reflections," p. 29.

11. Peter Manning, "Reading Wordsworth's Revisions: Othello and the Drowned Man," *Studies in Romanticism* 22 (Spring 1983): 3–28. As characteristic of recent interest in what I term Wordsworth's "associationalism" is Michael G. Cooke's discussion in *The Romantic Will* (New Haven: Yale University Press, 1976), especially pp. 99–101, in which he describes the lake-gazing lines of Book Four as "a reflective, metaphorical reprise of the rowboat episode" of Book One, and as a "Heisenbergian situation in the biography of the spirit" (p. 99).

12. Jonathan Arac, "Bounding Lines: *The Prelude* and Critical Revision," *Boundary* 2:7 (1979): 31–48.

13. Margery Sabin, *English Romanticism and the French Tradition* (Cambridge, Mass.: Harvard University Press, 1976), brilliantly analyzes the differences between Rousseau's *Confessions* and *The Prelude*.

14. Here again one sees Wordsworth's prepositions contributing significantly to his development of an efficacious indeterminacy, as presences *of* nature *in* the sky or *on* the earth haunt the poet *among* his sports (on "among" see Gilchrist, *Against Criticism*, pp. 196–97, consistently excellent

on prepositional functions). The small words of relation, as Armstrong has observed, give Wordsworth's verse its unique fluidity, in the present instance making convincing the closing lines of the passage that describe a liquefaction of the solid earth.

15. For a judicious and informed discussion of Ruskin's development of the pathetic fallacy, see Elizabeth K. Helsinger, *Ruskin and the Art of the Beholder* (Cambridge, Mass.: Harvard University Press, 1982), especially chap. 2, pp. 41–66, in which she locates Ruskin's uses of the term within his changing opinion of Wordsworth's poetry.

16. On ecological wholeness, see Charles Elton, *The Ecology of Animals* (London: Methuen, 1950); Charles J. Herrick, *The Evolution of Human Nature* (Austin: University of Texas Press, 1956); Werner Heisenberg, "The Representation of Nature in Contemporary Physics," *Daedalus* 87 (Summer 1958): 95–108; William Thorpe, *Learning and Instinct in Animals* (Cambridge, Mass.: Harvard University Press, 1963). The only explicit discussion of Wordsworth's views as ecological in a scientific sense is Edith Cobb, *The Ecology of Imagination in Childhood* (New York: Columbia University Press, 1977):

> Even among naturalists and biologists the realization that in ecology as a biological science we have, for the first time in the history of thought, an instrument for the study of reciprocity and mutuality among categories of thought, as well as among divisions and levels in nature, seems strangely lacking.
> Ecology as a science permits us to evaluate reciprocal relations of living organisms with their total environment and with one another as living interdependent systems. This reciprocity includes many "layers" of natural history and extends into a counterpoint between universe and geographical place. Plants, animals, and humans must now be thought of as living ecosystems, in a web of related, interacting, dynamic energy systems.
>
> (p. 24)

This view has recently been effectively popularized in the essays of Lewis Thomas. Heisenberg argues that "the Cartesian differentiation of *res cogitans* and *res extensa* is no longer suitable" to a modern physicist, noting that "Science no longer is in the position of an observer of nature, but rather recognizes itself as part of the interplay between man and nature" ("Representation of Nature," p. 107).

17. To state the difference between the situations of writers and artists oversimply, at the end of the eighteenth century painting was just beginning to obtain the social and intellectual respectability serious literary endeavor had for some time possessed. Aside from social circumstances, critics need to keep in mind when they compare the arts the simultaneous warning and encouragement of Jean Laude: "Absolutely everything distinguishes a literary text from a painting or a drawing: its conception, its method of production, . . . its autonomous functioning. Nevertheless . . . a text and a painting cannot be disassociated from the synchronic series to

which they are linked"; "On the Analysis of Poems and Paintings," *New Literary History* 3:4 (1972): 471–86, p. 471.

18. Thomas Girtin and David Loshak, *The Art of Thomas Girtin* (London: Black, 1954), p. 6, call attention to two technical advances—which Turner "more than any other individual, was responsible for developing"—at the end of the eighteenth century: *stopping out*, a method for "obtaining highlights by dampening the surface of the paint and wiping out with a rag, sponge, or breadcrumbs" (the last favored by Turner), and *scraping*, which gives "effects of sparkling light."

19. Turner first painted Norham in 1798 and made more than a dozen renderings of the castle during his career; see John Gage, *Color in Turner* (New York: Praeger, 1969). Turner said that *Norham* made his fortune, and Gage's comments on the evolution of this scene and the *Fall of the Clyde*, likewise many times reworked, are consistently apt. Of the latter half of Turner's career, Gage remarks "both art and nature were seen increasingly in terms of process, a dialogue between artist and subject, evolving in time" (p. 126). Without pressing the analogy, I find a parallel between Turner's reworkings of *Norham* and *The Fall of the Clyde* and Wordsworth's revisings of *The Prelude*, especially if one takes Gage's term *dialogue* seriously.

20. On the date of this version, see Martin Butlin, "Turner's Late Unfinished Oils," *Turner Studies* 1:2 (1981): 43–45, p. 44.

21. Mid-foreground cow and mid-background castle both "float" in their reflections within the scene's total diffusion of refracting sunlight, whose general brightness increases as one steps back from the canvas. The effect is a full realization of what Girtin and Loshak see as the direction of Thomas Girtin's development of landscape, in which the "locality or object" (the Romantic "spot") instead of "being defined as something apart from, and essentially different from, the space of the surrounding landscape, which was conceived in a negative fashion, as merely an environment, now . . . tends to be absorbed by the infinite flux of this surrounding space . . . in which no one point has *a priori* a greater significance than any other" (*Art of Thomas Girtin*, p. 76).

22. Ronald Paulson, "Turner's Graffiti: The Sun and Its Glosses," in *Images of Romanticism: Verbal and Visual Affinities*, ed. Karl Kroeber and William Walling (New Haven: Yale University Press, 1978), pp. 167–88.

23. *Sunrise: Norham Castle* distinguishes Turner's art from that of the French Impressionists. The Impressionists did not conceive of light as energy; they painted placid scenes. Nor were they particularly concerned with relativity, and so usually provided a definitive vantage point for the viewer. An important source of such differences seems to lie in Turner's indebtedness to watercolorism.

24. See Luke Herrmann, "Turner and the Sea," *Turner Studies* 1:1 (1981): 4–18, and A. G. Bachrach, "Turner, Ruisdael, and the Dutch," ibid., pp. 20–30. Bringing nautical expertise to bear, especially on *Calais*

Pier, Bachrach explains why "lee shores in squally weather" were attractive to Turner.

25. The light of both sun and moon are reflected in the water. Less literal reflections have perhaps been insufficiently noted, such as the distant full-rigged ship behind the tug and *Téméraire*. The naturalistic impossibilities of lighting, like the meteorologically impossible rainbow or inconsistent perspectives in Constable's *Salisbury Cathedral, From the Meadows*, evidence an appeal not to factual memory or analytical reason but to our imaginative capability to enhance nature.

26. The fundamental compositions of *Snowstorm* and *Shipwreck* are surprisingly similar: the rocket lights in the later picture form a square rather like that of the sail in the earlier canvas; the sterns of the two ships are also alike. But in the organization of *Snowstorm* we see an increased emphasis on reflection and refraction. Is the black-brown swirl in the foreground, for instance, a broken reflection of the steamer's smoke?

27. John Landseer, in his review of the opening of Turner's Gallery, praises Turner's "indefinity" and suggests that, because the artist "delights to paint to the imagination," his rendering of contemporary scenes may call to mind a vision of antiquity, so the *View of Margate* may lead a scholar "to think of the temple of Minerva on the promontory of Sunium," even though there is no physical resemblance; *Review of Publications of Art* 2 (1808): 151–69.

28. Lawrence Gowing, *Turner: Imagination and Reality* (New York: Doubleday and The Museum of Modern Art, 1966), p. 51. Gowing asserts that Turner's strokes of paint "portray movements of the eye into distance," and that "looking at *Snow Storm*, we lose our bearings with the ship" (p. 48). Gowing believes that with *The Burning of the Houses of Parliament* Turner broke through "a barrier between reality and imagination," releasing the "fantastic force" that distinguishes his later canvases (p. 45).

29. Ruskin, *Modern Painters*, 2d ed. (London: George Allen, 1900), vol. 4, pt. 5, chap. 2, para. 18 and chap. 17, para. 42.

30. The meaning might best be defined negatively as the opposite of what virtually every artist of sublimity strove for, John Martin providing the perfect contrast, for there is no intrinsic meaning in his representations of spectacular natural phenomena, which have only referential significance ("the Deluge," etc.). For a means to approach Turner's work through the avenue of the sublime, one may turn to Albert O. Wleke's thoughtful *Wordsworth and the Sublime* (Berkeley and Los Angeles: University of California Press, 1973), which takes Wordsworth's "sense sublime" from "Tintern Abbey" as referring to the activity of the power "of the imagination during which consciousness becomes reflexively aware of itself as an interfusing energy dwelling within the phenomena of nature" (p. 8).

31. The evidence, however, suggests that the adventure must be apocryphal; see Luke Herrmann, *Turner* (Boston: New York Graphic Society,

1975), p. 234, and Jerrold Ziff, *The Art Bulletin* 62 (1980): 170, a review of Butlin and Joll's catalogue. The appeal of the story of Turner as eyewitness is due in part to the fashion in which, in contrast to earlier sea pictures such as *Shipwreck*, the entire canvas seems to move with the intraswirling forces, and the picture's "depth" is created by our difficulty in seeing into the storm.

32. Rudolph Arnheim, *Entropy and Art* (Berkeley: University of California Press, 1971), p. 30.

33. Some "color-beginnings" are reproduced in three volumes edited by Gerald Wilkinson, published in London by Barrie and Jenkins: *Turner's Early Sketchbooks, 1789–1802* (1972), *Turner's Sketches, 1802–1820* (1974), and *Turner's Colour Sketches, 1820–1834* (1975). I prefer to call these sketches *color happenings*, since they are neither abstractions nor incomplete beginnings; these color events are frequently "about" nothing but themselves.

34. Kathleen D. Nicholson, "J. M. W. Turner's Images of Antiquity: Classical Narrative and Classical Landscape" (Ph.D. dissertation, University of Pennsylvania, 1977), provides a balanced and comprehensive survey, stressing the painter's attitude toward antiquity "as a richly textured fabric, woven of many different threads of meaning and seriousness" (p. 68). See also John Gage, "Turner and the Greek Spirit," *Turner Studies* 1:2 (1981): 14–25.

35. The fullest interpretation of *Ulysses Deriding Polyphemus* is that of Gage, *Color in Turner*, pp. 142–47, in which "Turner's most Hellenic picture" is seen as equivalent to Shelley's later poetry. Nicholson discusses the painting ("Turner's Images of Antiquity," pp. 359–64), with reference to Ruskin's discussions and Thornbury's anecdotes about the picture. Luke Herrmann points out that Turner had the composition in mind for twenty years: there is an outline drawing in a sketchbook of 1807, and Turner made seven oil studies in Rome before finishing the picture on his return to England (*Turner*, p. 35). Herrmann links the picture to Constable's *Hadleigh Castle* of the same year, both representing a "wholly successful fusion of nature and imagination" (p. 36). The value of this comparison is suggested by Louis Hawes's splendid analysis, "Constable's *Hadleigh Castle* and British Romantic Ruin Painting," *Art Bulletin* 65 (Fall 1983): 455–70. Among older commentaries, W. L. Wyllie, *J. M. W. Turner* (London: George Bell and Sons, 1905), best reveals a significant nineteenth-century fashion of looking at such a canvas: "It is quite impossible even to try to criticize such a picture, for it is so utterly unlike anything we have ever seen (unless perhaps in the transformation scene at a pantomime), so that we can only stand and wonder at its magnificence" (pp. 80–81). It is but a short step from this impossibility of criticizing, of course, to a Modernist turning from the picture in wonder that anyone could attend to such a subject. The pantomime, as Martin Meisel demonstrates, was the genre *par excellence* in which transformation was embodied for Victorian audiences;

Realizations (Princeton: Princeton University Press, 1983), p. 184. The wonder of metamorphosis for which Turner until the modern age served as the exemplary model occurs when

> the perceiver is implicated in the dissolution of boundaries and objects, in the unity of perception and experience. . . . Even in storm, there is an identity of self with the universe of perception, of experience, of imagination, and of process. Experience, in and of the painting, is kinesthetic, and the pictorial image is liberated from the "imaginable"—from the abstraction of bounded forms.
>
> (*Realizations*, p. 188)

36. Turner may have read the *Odyssey* more carefully than is usually recognized. In Book 1 of the epic we learn that the mother of Polyphemus was Thoösa, a nymph daughter of Phorkys, who lay with Poseidon in the hollows of caves. In Book 13 Athena proves to Odysseus that he has in truth returned to Ithaca, showing him that he has awakened in the harbor of the Old Man of the Sea, Phorkys, at hand an olive, and nearby a cave sacred to Nymphs of the Wellsprings, naiads, to whom he used to sacrifice, and to whom Odysseus then prays. Odysseus and Polyphemus thus are more closely linked through nymphs of water than is often appreciated.

37. William Chubb, "Minerva Medica and the Tall Tree," *Turner Studies* 1:2 (1981): 26–35, explores Turner's use of landscape to represent history, emphasizing Turner's allegorical allusions. Chubb cites the horses of the sun in *Ulysses* as probably deriving from Poussin's *Cephalus and Aurora* as well as, in line with Gage's earlier identification, from Stuart and Revett's engraving of the east pediment of the Parthenon. At least as important, however, are Turner's challenges to the concept of "history" as transmissible "exclusively through the medium of the human figure" (p. 30). The foundation of Turner's claim that landscape can convey history lies in his implicit denial of Reynolds's view that history painting depicts "man in general" and that landscape painting can represent only the "accidents of Nature" in and for themselves (discourse 4). Chubb's observation opens up a new line for the analysis of Romantic historicism.

38. Ronald Paulson, *Literary Landscape* (New Haven: Yale University Press, 1982), pp. 98–103, 168–72.

39. A point elegantly elaborated by Frank Kermode in *The Genesis of Secrecy* (Cambridge, Mass.: Harvard University Press, 1979).

40. Rudolph Arnheim, *Art and Visual Perception: The New Version* (Berkeley: University of California Press, 1974), observes that "in no reliable sense can we speak of a color 'as it really is'; it is always determined by its context" (p. 345). See also Julia Kristeva, *Desire in Language*, ed. Leon S. Roudiez, trans. Thomas Gora, Alice Jardine, and Leon S. Roudiez (New York: Columbia University Press, 1980), p. 225: "All colors . . . have a non-centered or decentering effect, lessening both object identification and phenomenal fixation."

9. NARRATIVE INFOLDING, UNFOLDING

1. The work of older artists, notably Turner, whose style changed radically between 1816 and 1819, and Walter Scott, who moved from verse narrative into fiction in 1814, of course also reflects the impact of dislocating changes in British society as well as reassessments of earlier aesthetic ideals.

2. George Cheatham, "Byron's Dislike of Keats's Poetry," *Keats-Shelley Journal* 32 (1983): 20–25, evaluates persuasively Byron's various references to Keats to suggest that Byron's final view was more sympathetic than some of his earlier vehement condemnations might lead one to think possible.

3. As Jerome J. McGann observes of *Don Juan*: "For Byron, ideas do not determine behavior, but the other way around. This does not mean that 'Virtue' or 'Freedom' are meaningless concepts for Byron, but that the meanings which they have are determined by their use"; *"Don Juan" in Context* (Chicago: University of Chicago Press, 1976), pp. 113–14.

4. Richard Woodhouse in *The Sun*, July 10, 1820, p. 84, cited by Dorothy Hewlett, *A Life of John Keats*, 2d ed. (New York: Barnes and Noble, 1950), p. 326.

5. Erich Kahler, *The Inward Turn of Narrative*, trans. Richard Winston and Clara Winston (Princeton: Princeton University Press, 1973).

6. All citations are from *The Poems of John Keats*, ed. Jack Stillinger (Cambridge, Mass.: Harvard University Press, 1978).

7. Stuart Sperry, "Toward a Definition of Romantic Irony in English Literature," *Romantic and Modern*, ed. George Bornstein (Pittsburgh: University of Pittsburgh Press, 1977), pp. 3–28, p. 10.

8. Wordsworth, "Essay Supplementary," *The Prose Works of William Wordsworth*, ed. J. W. B. Owen and J. W. Smyser, 3 vols. (Oxford, Clarendon Press, 1974), 3:80–81.

9. *George Bernard Shaw's Nondramatic Literary Criticism*, ed. Stanley Weintraub (Lincoln: University of Nebraska Press, 1972), p. 135.

10. 22 September 1819. *The Letters of John Keats*, 2 vols., ed. Hyder E. Rollins (Cambridge, Mass.: Harvard University Press, 1958), 2:179.

11. As W. J. Bates notes, *John Keats* (New York: Oxford University Press, 1963), p. 448, "the most complete worksheet we have of any of Keats's poems is the first draft of *The Eve of St. Agnes*." Keats's revisions and rerevisions are described in detail by M. R. Ridley, *Keats' Craftsmanship* (Oxford: Clarendon Press, 1933), pp. 112–90. A source for much discussion of the poem in recent years is Jack Stillinger's effective articulation of Keats's developing skepticism in "The Hoodwinking of Madeline," *Studies in Philology* 58 (1961): 533–55 (rpt., *The Hoodwinking of Madeline and Other Essays on Keats's Poems* [Urbana: University of Illinois Press, 1971]).

12. Quotations from *Love in Excess* are from John J. Richetti's excellent *Popular Fiction Before Richardson* (Oxford: Clarendon Press, 1969), pp. 194–96.

13. Stuart Sperry, *Keats the Poet* (Princeton: Princeton University Press, 1973), p. 209. My reading's deep indebtedness to Sperry's excellent analysis may be indicated by another quotation: "our consciousness of artificiality, at times of deliberate contrivance, makes up a necessary part of our enjoyment of the work and constitutes a vital element in its effect" (p. 208). Sperry's various brief suggestions about the "music" of the poem, with reference to Berlioz, Prokofiev, and Tchaikovsky, are particularly illuminating. See also Robert Kern, "Keats and the Problem of Romance," *Philological Quarterly* 58:2 (Spring 1979): 171–91, a fine essay also based on Sperry's analysis.

14. Charles Lamb, *The Examiner*, 30 July 1820, p. 494; *The St. James Chronicle*, 1 July 1820, p. 4; *The British Critic*, June 1818, pp. 651–52; Francis Jeffrey, *Edinburgh Review*, August 1820, p. 204. Perceptive are Jeffrey's suggestions that Keats's originating point was often a word itself, rather than its function or reference, and his observation about Keats's "connected and incongruous" figures.

A convenient survey of contemporary reviews is provided by *The Romantics Reviewed*, ed. Donald H. Reiman (New York: Garland, 1972); on Keats, see part C, vols. 1 and 2.

15. *The Monthly Review*, July 1820, pp, 305–10; John Scott, *The London Magazine*, September 1820, pp. 315–21; Leigh Hunt, *The Indicator*, 2 August 1820, p. 343; *The British Critic*, June 1818, p. 652; *The Eclectic Review*, September 1820, pp. 158–71; *The British Critic*, September 1820, pp. 257–64.

16. Sperry describes "La Belle Dame" as "about the essence of poetry itself, the gift of 'natural magic' that transforms common experience into enchantment" (*Keats the Poet*, p. 240).

17. Changes in "The Eve of St. Agnes" were "enforced by the publishers *against* his wishes," Jack Stillinger, *The Texts of Keats's Poems* (Cambridge, Mass.: Harvard University Press, 1974), p. 218. Sperry is certainly correct to see the difficulty in publication as reflecting that which within the poem is one of the "major thematic preoccupations . . . the devices of disguise and censorship" (*Keats the Poet*, p. 213).

18. Sperry, *Keats the Poet*, pp. 306–7, argues persuasively that the reference to Newton held a private allusion for Keats: Sir William Herschel's demonstration that different parts of the spectrum differed in their caloric intensity. Sperry also offers unusually illuminating comments about Keats's powerful but subtle engagement with the science of his day; see *Keats the Poet*, pp. 30–71.

19. Throughout I follow the detailed accounts of Byron's revisions given by Truman Guy Steffan, *The Making of a Masterpiece*, vol. 1 of *Don Juan* (Austin: University of Texas Press, 1957). Steffan demonstrates that in the later cantos Byron increased his speed of composition and made fewer revisions.

Among critical works, the most valuable to me is Jerome J. McGann, *"Don Juan" in Context* (Chicago: University of Chicago Press, 1976). Several

of my comments on the poem's form and style are elaborations of McGann's observations, and obviously I agree with his remark that *"Don Juan* encourages almost endless commentary but frustrates almost every sort of formal analysis" (p. 107).

Other helpful works include M. K. Joseph, *Byron the Poet* (London: Gollancz, 1964); George M. Ridenour, *The Style of "Don Juan"* (New Haven: Yale University Press, 1960); Carl Woodring's comments in *Politics in English Romantic Poetry* (Cambridge, Mass.: Harvard University Press, 1970); A. B. England, *Byron's "Don Juan" and Eighteenth-Century Literature* (Lewisburg, Penn.: Bucknell University Press, 1978); and Anne K. Mellor, *English Romantic Irony* (Cambridge, Mass.: Harvard University Press, 1980).

On *Don Juan's* reception, see Jerome J. McGann, "The Text, the Poem, and the Problem of Historical Method," *New Literary History* 12:2 (Winter 1981): 269–88. My quotations from the poem are from *Don Juan,* ed. Leslie A. Marchand (Boston: Houghton Mifflin, 1958), cited by canto and stanza, by page number for prefatory material.

20. Most notably, perhaps, Pushkin. British Victorians tended to shy away from *Don Juan.*

21. The best recent essay on *Don Juan* is that of Andrew Cooper, "Shipwreck and Skepticism: *Don Juan* Canto II," *Keats-Shelley Journal* 32 (1983): 63–82, which effectively addresses the relation of *Don Juan* to *Mazeppa.*

22. Peter J. Manning, *Byron and His Fictions* (Detroit: Wayne State University Press, 1978), especially pp. 220–43. Although Byron uses various narrator roles in the poem, each of these is what Eleanor Wikborg calls a "transparent disguise," a temporary identity played off against another to convey "his view of experience as consisting inescapably of emotional and moral incongruities—a view which he uses continually to challenge and sensitize his reader's own perceptions"; "The Narrator and the Control of Tone in Cantos I–IV of Byron's *Don Juan,*" *English Studies* 60:3 (June 1979): 267–79, p. 279.

23. McGann, *"Don Juan"* in *Context,* observes: "As Byron said, *Don Juan* is a poem which depends more on its materials than upon the planned use of those materials. The plan for the poem develops locally and operationally as Byron decides to use or not to use certain materials" (p. 121).

24. *Don Juan* might well be considered a *display* in the sense in which speech-act linguists use the term; see Mary Louise Pratt, *Toward a Speech Act Theory of Literary Discourse* (Bloomington: Indiana University Press, 1977), especially pp. 136–48.

25. Aside from the question of narrators, of course, Quixote's *idée fixe* assures closure; Juan's "normality" permits continued openness because of the intrinsic relativity of what is "normal"—there are endless ways of being normal, but only one way of imitating Amadís. What Byron resists is the closing off of play between narrator and narrative, upon which depends the total openness, rather than mere openendedness, of his poem.

Play between narrator and narrative is the Byronic device most fully exploited by Pushkin in *Eugene Onegin*.

26. Of Morse Peckham's many studies of Enlightenment and Romantic culture, perhaps *Beyond the Tragic Vision* (New York: Braziller, 1962) is most central, but *The Triumph of Romanticism: Collected Essays* (Columbia: University of South Carolina Press, 1970) conveniently gathers together his most important rethinkings of his principal insights.

27. J. Michael Robertson, "Aristocratic Individualism in Byron's *Don Juan*," *Studies in English Literature* 17 (1977): 639–55, provides a sophisticated analysis of Byron's self-presentation to the reader, concluding, "just so much as *Don Juan* flatters Byron by underlining his personal aristocracy even as it discredits group aristocracy, it also flatters the reader. . . . Byron's personal aristocracy is the guarantee of the truth and wisdom of both his denunciation of and separation from the aristocratic community; it is also an attraction that makes the reader proud to be in the confidence of so doubly-elevated a poet" (p. 655). See also Robertson, "The Byron of *Don Juan* as Whig Aristocrat," *Texas Studies in Literature and Language* 17 (1976): 709–24.

28. I have discussed this feature of Jane Austen's art in *Styles in Fictional Structure* (Princeton: Princeton University Press, 1970).

29. As McGann observes, "The whole point of the style of *Don Juan* is to explore the interface between different things, events, moods. . . . [it] is a poem that is, in fact, always in transition" (*"Don Juan" in Context*, p. 95).

30. Michael G. Cooke, *Acts of Inclusion* (New Haven: Yale University Press, 1979), describes *Don Juan's* form as "idiocratic" (p. 238), and discusses with originality the "aesthetic discipline" making possible Romantic inclusiveness.

31. On this point, McGann is helpful in revealing why today, in contrast to the Modernists' views, Byron seems quintessentially Romantic: "History, tradition, facts are Byron's ground not because Byron is a materialist, but because, for him, use and act are logically prior to ideas. . . . language is used before it is conceptualized" (*"Don Juan" in Context*, p. 114).

Index

273

276 · Index

Designer:	Betty Gee
Compositor:	G & S Typesetters
Text:	10/12 Palatino
Display:	Palatino
Printer:	Braun-Brumfield
Binder:	Braun-Brumfield